W9-BVB-668

STROGANOFF

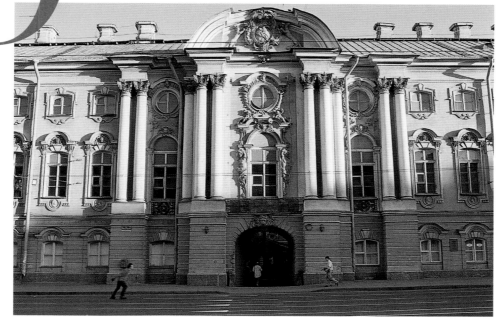

THE PALACE AND COLLECTIONS
OF A RUSSIAN NOBLE FAMILY

PORTLAND ART MUSEUM
IN COLLABORATION WITH
HARRY N. ABRAMS, INC., PUBLISHERS

STROGANOFF

THE PALACE AND COLLECTIONS OF A RUSSIAN NOBLE FAMILY

PENELOPE HUNTER-STIEBEL, *General Editor*
Introduction by JOHN E. BUCHANAN, JR.

Published on the occasion of "Stroganoff: The Palace and Collections of a Russian Noble Family,"
an exhibition organized by the Portland Art Museum, The State Hermitage Museum,
and The State Russian Museum, in cooperation with the Stroganoff Foundation, Ltd.

Portland Art Museum, Portland, Oregon
February 19–May 31, 2000

Kimbell Art Museum, Fort Worth, Texas
July 2–October 1, 2000

Major funding for this exhibition was provided by Julie and Peter Stott, Portland, Oregon.
Additional support was provided by an indemnity from the Federal Council on the Arts and Humanities.

Support for this catalogue was made possible by Gordon D. Sondland and Katherine J. Durant,
U. S. Trust Company, N. A., and Charles and Caroline Swindells.

Major funding provided by the Robert Lehman Foundation, Inc.

For Harry N. Abrams, Inc.:
Editor: BARBARA BURN
Designer: ANA ROGERS

For the Russian museums:
Academic editor: DR. GEORGE VILINBAKHOV

See page 13 for the full list of contributors.
Half title: The Stroganoff Palace facade; photo by Michael Lloyd
Title page: The Stroganoff Palace; photo by Michael Lloyd
Pages 10–11: Views of Kazan Cathedral; photos by Michael Lloyd

Library of Congress Cataloging-in-Publication Data

Stroganoff : the palace and collections of a Russian noble family / Penelope Hunter-Stiebel, general editor.
p. cm.
Published on the occasion of an exhibition held at the Portland Art Museum, Feb. 19–May 31, 2000,
and at the Kimbell Art Museum, Fort Worth.
Includes bibliographical references.
ISBN 0–8109–4196–1 (Abrams : hardcover) — ISBN 0–8109–2946–5 (Portland Art Museum : pbk.)
1. Stroganov family—Art collections—Exhibitions. 2. Art—Private collections—Russia—Exhibitions.
3. Stroganov family—Art patronage—Exhibitions. I. Hunter-Stiebel, Penelope, 1946–
II. Portland Art Museum (Or.) III. Kimbell Art Museum.
N5276.2.S88 S76 2000
708.47–dc21 99–43671

Copyright © 2000 The State Hermitage Museum, St. Petersburg
Copyright © 2000 The State Russian Museum, St. Petersburg
Copyright © 2000 The State Reserve Museum "Pavlovsk", St. Petersburg
Copyright © 2000 Portland Art Museum, Portland, Oregon
Copyright © 2000 The Research Museum of the Russian Academy of Arts, St. Petersburg
Copyright © 2000 The Russian State History Archives, St. Petersburg
Copyright © 2000 Museum of History and Art, Solvychegodsk

Published in 2000 by Harry N. Abrams, Incorporated, New York
All rights reserved. No part of the contents of this book may be reproduced
without the written permission of the publisher.

Printed and bound in Japan

Harry N. Abrams, Inc.
100 Fifth Avenue
New York, N.Y. 10011
www.abramsbooks.com

CONTENTS

INTRODUCTION

WHILE A NUMBER OF EXHIBITIONS HAVE DOCUMENTED THE WEALTH, STYLE, AND impact of the Russian imperial family, "Stroganoff: The Palace and Collections of a Russian Noble Family" is the first art exhibition to examine an aristocratic Russian family's influence on the growth and development of a national cultural aesthetic in art, architecture, and scholarship. This exhibition tells the story of an extraordinary family whose impact over five centuries included aggressive entrepreneurship as well as social vision and patronage of the arts.

The inspiration behind this remarkable project, from its very conception, has been Baroness Hélène de Ludinghausen, a Stroganoff descendent whose goal is to insure that neither her family nor its accomplishments are forgotten. In 1992 Baroness de Ludinghausen formed the Stroganoff Foundation, a not-for-profit organization dedicated to preserving the artistic legacy left to Russia by her family, as well as supporting Russian institutions and museums that are desperately in need. Through her influence and personal relationships in Russia, Hélène de Ludinghausen has guided me through the labyrinth of galleries and reserves of the State Hermitage and the State Russian Museums to identify works of art acquired, sponsored, or commissioned by members of her family for over five centuries. Russian curators and museum directors have joined in this effort to bring together a spectacular visual saga, the story of how one family helped to shape the culture of a nation.

The Stroganoffs were discerning collectors with a universal eye and an interest in objects of the finest quality, representing a diversity of artistic achievements and cultures. Combining entrepreneurial energy with intellectual dedication, the Stroganoffs maximized the opportunities of historic circumstance. By the end of the nineteenth century, the family had amassed an encyclopedic collection covering classical antiquities, religious icons, old master paintings, decorative arts, and archaeological objects. More than just a showcase of treasures from a distant land, the Stroganoff exhibition is a paradigm of art in context. Tracing the connection of these works of art to one family illustrates the circumstances by which they were either introduced from foreign cultures or generated from within Russia itself to enrich the matrix of the national culture.

The Portland Art Museum is particularly proud to be the originator of this examination of the Stroganoff family and its collections, the first in either exhibition or book form. This is a project of great significance, providing for both the American public and Russian scholars a cultural narrative of a family forever linked to the history of Russia. Dispersed by time and politics, the collections of the Stroganoff family now reside in various Russian museums and palaces, where individually they have become celebrated treasures. Through the organization of our exhibition, we have reassembled many of these works for the first time since they were removed from the Stroganoff Palace early in the twentieth century.

I am deeply indebted to Dr. Mikhail Piotrovsky, director of the State Hermitage Museum, and Dr. Vladimir A. Gusev, director of the State Russian Museum, for their enthusiasm and personal support of this exhibition concept. The Portland Art Museum project instigated an unprecedented exploration by Russian curators and administrators of national museum collections in terms of private provenance. Through this spirit of scholarly cooper-

ation, works with Stroganoff provenance were identified and brought together, including some of the most remarkable works of Russian art, many of which have never before left the country, such as icons and embroideries from the famed Stroganoff School.

This project which has been more than four years in the making, was first introduced to me by Deeda Blair and Waring Hopkins. Working with me as my partner every step of the way has been my wife, Lucy M. Buchanan, the director of development and marketing for the Portland Art Museum. Her indefatigable spirit and valuable contributions are inestimable.

I would also like to recognize the extraordinary efforts undertaken on behalf of the exhibition by Natalia Metelitsa, the Stroganoff Foundation's liaison in St. Petersburg. She has worked tirelessly as our representative in Russia, coordinating the details of everything from contracts to photography to travel accommodations. Also, Pierre F. V. Merle, the New York liaison of the Stroganoff Foundation and his legal associate, Igor Mishin, have contributed invaluable guidance and encouragement throughout the organization of the exhibition.

The exhibition has benefitted greatly from the curatorial eye of coordinating curator Penelope Hunter-Stiebel. Understanding the crucial role of patronage in art history, she undertook the enormous responsibility of reviewing with me the vast collections of the Stroganoffs. In refining the checklist and selecting the most important and exquisite works to be included in the exhibition, she has provided a spectacular visual exploration of how great collections are built. Through the prodigious talents of the exhibition designer, Clifford La Fontaine, this vision of the Stroganoff family, their palace and their collections is translated into reality for the public to experience firsthand.

Paul Gottlieb and Barbara Burn of Harry N. Abrams, Inc., along with our Russian colleague Olga Borodyanskaya have provided invaluable expertise in the publication of this magnificent catalogue, the first book to document the Stroganoff family and its role in the art and culture of their nation. The realization of this volume was made possible with the generous assistance of Gordon D. Sondland and Katherine J. Durant, U.S. Trust Company, N.A., and charles and Caroline Swindells.

For understanding the importance of this project and sharing the vision of this exhibition with a broader audience, I would like to thank Hélène David-Weill, president of Les Musées de l'Union Centrale des Arts Décoratifs, Paris, and Dr. Timothy Potts, director of the Kimbell Art Museum, Fort Worth, Texas.

A project of this magnitude depends upon the support of private philanthropists. I wish to express my deepest gratitude to the patrons of the exhibition, Julie and Peter Stott of Portland, Oregon, whose generosity serves as an inspiration to us and to future benefactors.

I also extend my most heartfelt thanks to the museum's trustees and staff, especially Margaret Bullock, Susan Egger, Ann Eichelberg, and Sharon Johnson for their dedication to this exhibition.

JOHN E. BUCHANAN, JR.
Executive Director
Portland Art Museum

DIRECTORS' FOREWORDS

IT IS A GREAT PLEASURE AND PRIVILEGE FOR THE KIMBELL ART MUSEUM TO HOST THIS EXHIBITION as its second American venue. The past few decades have witnessed a flurry of scholarship on the history of collecting and patronage, bringing a heightened appreciation of the importance of contemporary taste and style to a broader understanding of art history. The Stroganoff exhibition is the first to apply this approach to one of the great Russian entrepreneurial families, drawing upon research that has been undertaken in museum archives since the creation of the Russian Federation. Collections that entered the Russian museums in the wake of the Bolshevik revolution, thereby losing touch with their aristocratic origins, are now once again being studied by Russian scholars from a historical perspective.

It is particularly appropriate that this exhibition be presented at the Kimbell Art Museum whose collection originated in the passion and largesse of a private family—a public-spirited generosity that thankfully remains very much alive today. In a different social and historical context than their European counterparts, American collectors such as the Kimbells have helped to shape the depth and quality of our society through their generous patronage of art and museums.

TIMOTHY POTTS
Director, Kimbell Art Museum

STROGANOFF IS ONE OF THE MOST VIVID NAMES IN RUSSIAN HISTORY. MUCH MORE THAN JUST A family name, the word resonates as the designation for an entire phenomenon that is quintessentially Russian. The Stroganoffs were talented and innovative entrepreneurs who became perhaps the richest men in the world. Able and strict administrators, they successfully governed extensive territories and the unruly people who lived there. As wealthy men of distinction, the Stroganoffs played a major role in politics and social life, giving Russian history a number of remarkable and unusual personages who were equally at home in Russia and in Europe.

The name Stroganoff is used to describe both a school of icon painting and a special style of decorative stonework with gilded bronze. The Stroganoffs themselves were both the guardians of ancient Russian traditions and Westernizers enthralled by France, including even its revolution. They represent the essence of a nation that over the course of several centuries was a great world power, and they served as a wellspring of original talent combining the refinement and severity that was the foundation for Russia's centuries-old strength—and its aspirations.

Stroganoff collecting grew out of Stroganoff wealth. The Stroganoffs enriched their lives with remarkable objects and collected artistic treasures, out of pure love and because they understood that art collections were a symbol of secular power. Great entrepreneurs have a superior instinct for genuine art that will last through the ages (and increase in value), and great aristocrats cultivate fine taste in themselves and in their heirs. The natural combination of these features in members of the Stroganoff family found expression in the remarkable objects displayed in their palaces. Their collections were renowned, and their contemporaries were enraptured. Today, many museums and private collectors take pride in possessing works of art that once belonged to the Stroganoffs, but wars and revolutions have dealt harshly with what took centuries to gather. Decorative art from the Stroganoff palaces can now be found in numerous other collections, and their objects still turn up at auction from time to time. Their paintings have also survived abrupt twists of fate; one of the Stroganoff Rembrandts that ended up in the Louvre spent some time in Hitler's private collection.

Most of the Stroganoff holdings, thankfully, have remained in Russia. The first special branch of the Hermitage—a museum in the Stroganoff palace—was broken up, the palace itself lost a significant number of its furnishings, and some Stroganoff objects were sold abroad, but since then Russia's museums, especially the Hermitage and Russian Museum, have done everything possible to preserve the Stroganoff collections. Dispersed to various locations, the individual items have continued to live their own separate life, delighting and educating people and serving that fatherland to which the very Stroganoff name is intrinsic.

This name was not always safe to mention, but every inhabitant of Leningrad knew that the magnificent building on the corner of Nevsky Prospect and the Moika embankment was the Stroganoff Palace. In science and culture, the name came up constantly, if only because the names of so many things preserved its memory,

such as the Stroganoff school of icon painting. Clearly, the Stroganoffs could neither be forgotten nor silenced. The memory of what they accomplished is stronger than any political vagaries or distortions of history.

There is a sin upon us, though. For all our respect for the Stroganoffs and our concern about their collections, we, the museums of Russia, have done too little to perpetuate their memory. It is not enough to remember that they were great collectors; we need to study how they went about their collecting and to remind others of their achievements. The exhibition we are presenting and the book created to go with it represent a partial attempt to atone for our sin and repay some of our debt by restoring the natural connection between the Stroganoff name and these remarkable masterpieces of art, these astonishing treasures of world culture.

Artistic works often go through private collections but sooner or later end up in museums. Most often in the process they become separated from their companion pieces and are displayed in different interiors and a new context. This is natural. The time comes, however, when one gets an irresistible urge to picture how these objects looked together, to compose with them a living image of the collector or generations of collectors. This is a normal step in the process of coming to terms with a cultural legacy. One wants to glimpse once again the people in the objects—not only the individuals who created them but also those who acquired and enjoyed them. Out of this desire, the Hermitage has created many popular exhibitions in recent years. This is very important for Russia, for it is a way to restore to the people not only remarkable names but also the human, personal dimension of our cultural history.

The Stroganoff exhibition belongs to this series but is exceptional in that it covers an immense range and is directed simultaneously at both Russia and the world. One of its principal creators is herself a magnificent representative of the Stroganoff family, Hélène de Ludinghausen, who was the organizer, inspiration, and living image of this exhibition. Thus the Stroganoffs continue to serve Russia and delight the world. Their vital legacy has been matched with the work of many people and institutions, each grateful to the others and to fate for this opportunity to pool their efforts, so that the world can begin talking once again about the Stroganoff collections and about the great caprices of Russia's cultural history.

DR. M.B. PIOTROVSKY
Director, State Hermitage
Professor, St. Petersburg University
Corresponding member, Russian Academy of Sciences
Corresponding member, Russian Academy of Fine Arts

IT GIVES ME GREAT PLEASURE TO PRESENT TO YOU THE HISTORY OF ONE OF THE OLDEST AND MOST distinguished Russian families, the Stroganoffs. It is a history that spans the centuries and is so rich and captivating that dozens of adventure novels could be written from it. Or even a chronicle of the entire Russian state, which it served faithfully and righteously for so many hundreds of years, acquiring new lands, mining and processing salt and ore, creating factories and plants, building palaces and churches, and facilitating the development of trades, science, and art, all the while multiplying their wealth in accordance with their own nature and God-given talents (which they were blessed with in abundance), though never forgetting the greater good of their fatherland. And so the Stroganoffs became famous and carried their proud, unsullied name down to the present day, through the most onerous of trials.

This brief introduction is a declaration of my love and gratitude to all the generations of Stroganoffs. This exhibition is a modest sign of the gratitude of the Russian Museum, where many items from the Stroganoff collections are carefully preserved. Destiny and history have deemed such that several years ago the museum came into possession of another priceless treasure—the magnificent Stroganoff Palace, which is located in the very heart of St. Petersburg, on Nevsky Prospect. By way of restoring the temporal linkage, the Baroness Hélène de Ludinghausen, a Stroganoff heir not only by blood, descent, and traditions, but also by character, has been helping us to resurrect what her ancestors built two and a half centuries ago. May this exhibition serve our common noble cause.

VLADIMIR GUSEV
Director, The State Russian Museum

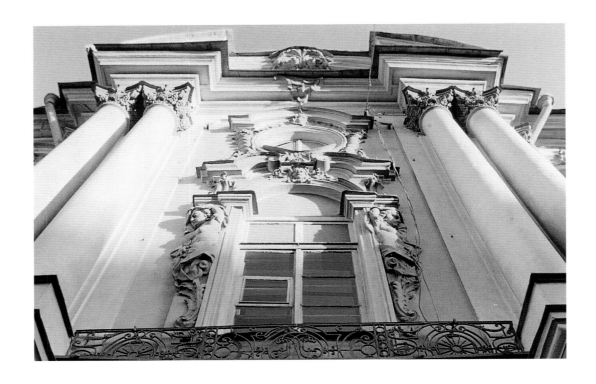

INTERNATIONAL COMMITTEE Of HONOR

Baroness Hélène de Ludinghausen, *Chairman*

Anne Bass
Pierre Bergé
Mrs. William McCormick Blair, Jr.
H.R.H. Prince Michel de Bourbon-Parme
François Catroux
Mr. and Mrs. Michel David-Weill
H.R.H. Prince Dimitri of Yugoslavia
Mrs. Ben J. Fortson
Count Michel de Ganay
Mrs. Henry Grunwald
Waring Carrington Hopkins
The Countess of Iveagh
Mrs. Thomas Kempner
Mr. and Mrs. Paul Lowerre
Pierre F.V. Merle
S.A.S. Princess Tatiana Metternich
Khalil Rizk
Baroness Elie de Rothschild
Mr. and Mrs. Otto J. Ruesch
Yves Saint Laurent
Mr. and Mrs. Julio Mario Santo Domingo
H.R.H. Princess Maria Pia di Savoie
Peter L. Schaffer
Princess Xénia Scherbatoff
Mrs. Pierre Schlumberger
Robin Smith-Ryland
Danielle Steel
Mrs. Oscar Wyatt

CONTRIBUTORS TO THE EXHIBITION AND CATALOGUE

Exhibition Conception and Planning

Baroness Hélène de Ludinghausen,
 Founding Director and Chairman,
 the Stroganoff Foundation
John E. Buchanan, Jr., Executive Director,
 Portland Art Museum
Dr. Mikhail Piotrovsky, Director, The State
 Hermitage Museum
Dr. Vladimir Gusev, Director, The State
 Russian Museum
Dr. George Vilinbakhov, Deputy Director,
 The State Hermitage Museum

Lenders to the Exhibition

The State Hermitage Museum, St. Petersburg
The State Russian Museum, St. Petersburg
Pavlovsk Palace Museum, Pavlovsk
Research Museum, Academy of Fine Arts,
 St. Petersburg
The Russian State History Archives,
 St. Petersburg
Museum of History and Art, Solvychegodsk
Higgins Armory Museum, Worcester,
 Massachusetts
All-Russian Grabar Art Conservation
 Center, Moscow

Exhibition Organizing Committees

Portland Art Museum
 John E. Buchanan, Jr.
 Lucy M. Buchanan
 Margaret Bullock
 Penelope Hunter-Stiebel
 Clifford La Fontaine
 Igor B. Mishin

The State Hermitage Museum
 Dr. Mikhail Piotrovsky
 Dr. George Vilinbakhov
 Dr. Vladimir Matveyev
 Yekaterina Deriabina
 Maria Kosareva
 Dr. Olga Kostiuk
 Maria Menshikova
 Anna Trofimova
 Yuna Zek

The State Russian Museum
 Dr. Vladimir Gusev
 Dr. Yegeniya Petrova
 Sergei Liubimtsev
 Dr. Sergei Kuznetsov
 Dr. Tatyana Vilinbakhova

Pavlovsk Palace Museum
 Dr. Nikolai Tretyakov
 Alexei Guzanov
 Dr. Liudmila Koval

Research Museum, Academy of Fine Arts
 Dr. Yekaterina Grishina
 Dr. Veronica Irina Bogdan

Russian State History Archives
 Dr. Alexander Sokolov

Museum of History and Art, Solvychegodsk
 Alexei Biltchuk

Stroganoff Foundation
 Pierre F.V. Merle
 Natalia Metelitsa

CATALOGUE

Academic Editors

Penelope Hunter-Stiebel
Dr. George Vilinbakhov

Coordinating Editor

Olga Borodyanskaya

Authors of the Catalogue

The State Hermitage Museum
 YeA Yelena Ananyich
 IA Dr. Irina Artemyeva
 TB Tatyana Bushmina
 MD Dr. Miriam Dandamayeva
 LD Dr. Liudmila Davydova
 YD Yekaterina Deriabina
 IG Irina Gogulina
 NG Dr. Natalia Gritsai
 NPG Nadezhda P. Guliayeva
 NYG Dr. Natalia Yu. Guseva
 JK Dr. Julia Kagan
 YeKh Dr. Yelena Khodza
 MK Maria Kosareva
 MKo Militsa Korshunova
 OK Dr. Olga Kostiuk
 IK Dr. Irina Kotelnikova
 AK Dr. Alexander Kruglov
 MJK Dr. Marta J. Kryzhanovskaya
 TK Dr. Tatyana Kustodieva
 ML Dr. Marina Lopato
 BM Dr. Boris Marshak
 NM Natalia Mavrodina
 MM Maria Menshikova
 ON Dr. Oleg Neverov
 TR Dr. Tamara Rappe
 NB Natalia Serebriannaya
 YeSh Yelena Shlikevich
 IS Dr. Irina Sokolova
 SS Sergei Stroganov
 IOS Igor O. Sychov
 ET Evelina Tarasova
 AT Anna Trofimova
 LU Liubov Utkina
 SV Svetlana Vsevolozhskaya
 VZ Dr. Vera Zalesskaya
 LZ Larissa Zavadskaya
 YZ Yuna Zek

The State Russian Museum
 RD Raissa Dashkina
 GG Grigory Goldovsky
 OKa Olga Kaparulina
 YeK Dr. Yelena Karpova
 PK Pavel Klimov
 NK Nikolai Krylov
 SK Dr. Sergei Kuznetsov
 LL Liudmila Likhachova
 SL Sergei Liubimtsev
 SM Dr. Svetlana Moiseyeva
 IP Izila Pleshanova
 Nsh Natalia Shtrimer
 AS Alla Soboleva
 YeS Yelena Stolbova
 LV Lada Vikhoreva
 TV Dr. Tatyana Vilinbakhova

Research Museum, Academy of Fine Arts
 VB Dr. Veronica Irina Bogdan
 VSh Dr. Valery Shuisky

Pavlovsk Palace Museum
 AA Alexandra Alexeyeva
 AG Alexei Guzanov
 NSt Nina Stadnichuk
 AV Albina Vasilyeva

The Russian State History Archives,
St. Petersburg
 YeA Yelena Agafonova

Higgins Armory Museum
 WK Walter Karchesky

Translator of Essays

Marian Schwartz

Translators of Entries

Eleonora Andreyeva
Alexander Chernoglazov
Valery Fateyev
Catherine Phillips
Natalia Rogovskaya
Yelena Tabaniukhina
Paul Williams

Photographers

The State Hermitage Museum
 Leonard Kheifets
 Yury Molodkovets
 Vladimir Terebenin
 Darya Bobrova

The State Russian Museum
 Vladimir Dorokhov
 Vassily Vorontsov
 Valery Küner
 Valentin Skliyarov
 Alexander Ganiushin

Pavlovsk Palace Museum
 Natalia Solovyova

Research Museum, Academy of Fine Arts,
and the Russian State History Archives
 Victor Yeremeyev

Richard Davies, pages 193–97, 199

Michael Lloyd, *The Oregonian*, pages 1, 2–3,
10–12, 136–37, 140–41, 169, 190

Victor Savik, pages 18–19, 46

Map

Marleen Adlerblum
Dr. Sergei Kuznetsov

Special credit

Joseph Baillio
Allan S. Chait
James Lally
Khalil Rizk
Peter L. Schaffer
Gerald G. Stiebel
Michael Ward

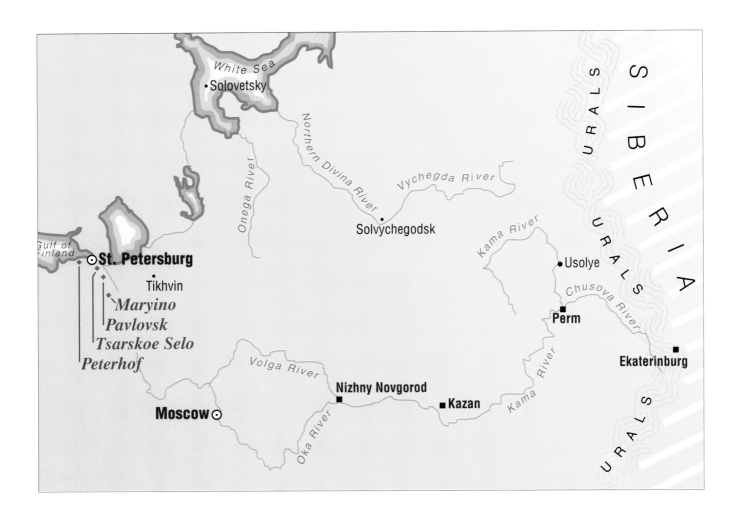

EDITOR'S NOTE

My aim as coordinating curator for the Stroganoff exhibition has been to edit and amplify a spectacular list of potential loans from St. Petersburg and Solvychegodsk to make this more than simply another show of traveling treasures. At the close of the twentieth century, we are witnessing a profound rethinking of society's approach to art: it is being discussed less as aesthetic object and more as cultural property. The very propriety of the private ownership of art has been brought into question. Art, by the new definition, is seen as belonging to a nation state, such as Italy, or an ethnic culture, such as a Native American tribe. A growing body of international regulations restricting the movement of art and the proliferation of legal claims for repatriation has created an environment in which no society is immune to the politics of those who use the issue of art as patrimony to wield global influence. The Stroganoff exhibition, comprised of acknowledged treasures of the Russian state, illuminates the role of private patronage in developing national identity. It is a case study that allows the examination of the notion of cultural property through the lens of history.

Over four centuries, members of the Stroganoff family were patrons as well as collectors, and their involvement in art went far beyond the display of their considerable wealth. This story, never before told, is here pieced together with words contributed by specialists from Russian museums and reproductions of the Stroganoff works of art now in their care.

Some of these objects were made for the Stroganoffs in Russia, while many others originated in vastly different times and places. Each has its own aesthetic presence, but as with all works of art, the significance of that presence changes according to the circumstances of history through which the object travels. This exhibition allows us to reestablish the connective tissue that once existed between these works under Stroganoff stewardship. In exploring the context of their Stroganoff provenance, we discover the values of religious piety, patriotism, and morality that brought these objects into the family's purview. Sometimes the connection is obvious, as with the embroideries undertaken as acts of religious devotion by the ladies of the family in the late sixteenth and early seventeenth centuries; sometimes the link is more subtle, as with the antiquities assembled in the nineteenth century by Sergei Stroganoff in the belief that their study would provide stabilizing values to Russian society.

The starring role in this story is unquestionably played by Alexander Stroganoff, who plucked outstanding paintings of various national schools from the eighteenth-century Paris art market and transported them to Russia, where he made them part of the visual education of a new generation of Russian artists, as well as a source of personal delight. The works of art paid for by Stroganoff monies became part of Russia's patrimony long before they were confiscated by the Soviet government as state property. Looking at the history of this dynasty, we see the family's continuing conscious determination to bring what was seen as the finest in art into the developing cultural matrix of their beloved homeland.

I have witnessed firsthand the Stroganoffs' expression of piety and patriotism through art in the last representative of this great family, Hélène de Ludinghausen. On a recent visit to St. Petersburg, she was so moved by the reconsecration of Kazan Cathedral (the great monument of Stroganoff philanthropy converted by the Soviets to the Museum of Religion and Atheism) that she committed Stroganoff Foundation funds to refurbishing it. When she arrived in the northern outpost of Solvychegodsk, bells rang out and children ceremonially held a platter of bread and salt in a greeting remembered from the era of the tsars, as the village welcomed the first member of its founding family to return in two hundred years. Tears flowed as she pledged her support to the cathedral built by her ancestors, now a state museum starved of government financing. This was not casual largesse, for Hélène de Ludinghausen works hard to raise the funds for the benefactions of her foundation, which carries on the spirit of Stroganoff patronage today.

I would like to take this opportunity to thank the dynamic team of John and Lucy Buchanan for not accepting my first refusal to take on the unprecedented challenges of this exhibition, which only their boundless commitment could bring to realization, and Barbara Burn for making it possible to record it in book form. Above all, I am grateful to my husband, Gerald G. Stiebel, who serves on the President's Cultural Property Advisory Committee, for quite literally bringing the question home to me: How do you reconcile the private joys of owning a work of art with the interests of communal cultural property and national patrimony?

The issue dissolves before the evidence of the Stroganoffs' cultural contributions to Russia. The exercise of curating the Stroganoff exhibition has confirmed my own belief that art collecting and patronage should be celebrated, as the community stands only to gain by the individual exercise of the joyous, passionate, and personal commitment that art generates.

PENELOPE HUNTER-STIEBEL

Spiridon
(b. 1395)

Kouzma
(1381–1445)

Louka
(1428–1478)

Feodor
(d. 1497)

Anika
(1497–1569)

Yakov Grigory Semeon
(d. 1579) (d. 1578) (d. 1586)

Maxim Nikita Andrei Piotr
(1557–1631) (1560–1616) (1581–1649) (1583–1639)

Maxim Ivan Dmitry Feodor
(1603–1627) (d. 1647) (d. 1673) (1628–1671)

Danilo Grigory *m.* *Maria Vorontsova Novoseltseva*
(1623–1668) (1656–1715) *(1678–1734)*

Alexander Nikolai Sergei
(1698–1751) (1700–1758) (1707–1756)

 Alexander Alexander *m.* *Anna Vorontsova in 1758, no children*
 (1740–1789) (1733–1811) *Catherine Trubetskaya in 1769*

 Grigory Paul *m.* *Sophia Vladimirovna Golitsyn*
 (1770–1857) (1772–1817) *(1775–1845)*

Alexander Sergei *m.* Natalia Alexander Adelaide Elizabeta Olga
 (1794–1882) (1796–1872) (1795–1814)

Alexander Paul Grigory Nikolai Elizabeta Sophie
(1818–1864) (1823–1911) (1829–1910)

Sergei Marie Olga *m.* *Prince Alexander A. Shcherbatov*
(1852–1923) (1850–1914) (1860–1944) *(1850–1915)*

 Alexander *m.* *Princess Sonia Vasilichikov* Helen George
 (1881–1915) (b. 1889) (1897–1979)

Marie Olga Xénia *m.* *Baron André Ludinghausen-Wolff* Sophie
(1909–1956) (1910–1992) (b. 1912) (1914–1996)

 Hélène *m.* *Robin Smith-Ryland*

PRELUDE

THE MORE ONE LIVES, THE MORE ONE COMES TO REALIZE THAT THE WORDS "never" and "impossible" are hardly ever correct. My grandparents would never have thought it possible to leave Russia and everything they possessed and believed in. Later, my parents never thought they would be able to return to Russia. Having been brought up between these dreams, hopes, sorrows, and disappointments, I learned to live with Russian traditions, but without Russia.

It is today an immense happiness for me to have rediscovered my country and its extraordinary people. One sees many upsetting things that are a result of the war and of a regime I cannot approve of, but things are moving, though sometimes too slowly, toward a more normal situation.

Through the foundation I have created, I try to collaborate in the renovation of historical sites. I am constantly amazed by the talent and knowledge of so many artists who work on these projects, but most of all my deep admiration and respect go to all levels of people involved in the museums. I can only say that they offer a lesson in dignity, love, and abnegation. They represent the elite of Russia and have maintained unparalleled devotion and generosity, the heart and soul of Russia.

I am extremely proud, happy, and grateful that the exhibition of my family's collection will be shown. I hope that this will be an opportunity for people to learn and interest themselves in a family that was able to do so much through the love they had for their country. Society has changed, and my wish is that people should be inspired by these achievements.

Today in my heart no bad feelings remain for what one might say we lost, because I have learned to love Russia and its people again, and I feel God has shown me a road that brings me purpose and happiness by indicating my destiny.

HÉLÈNE DE LUDINGHAUSEN

THE STROGANOff DYNASTY

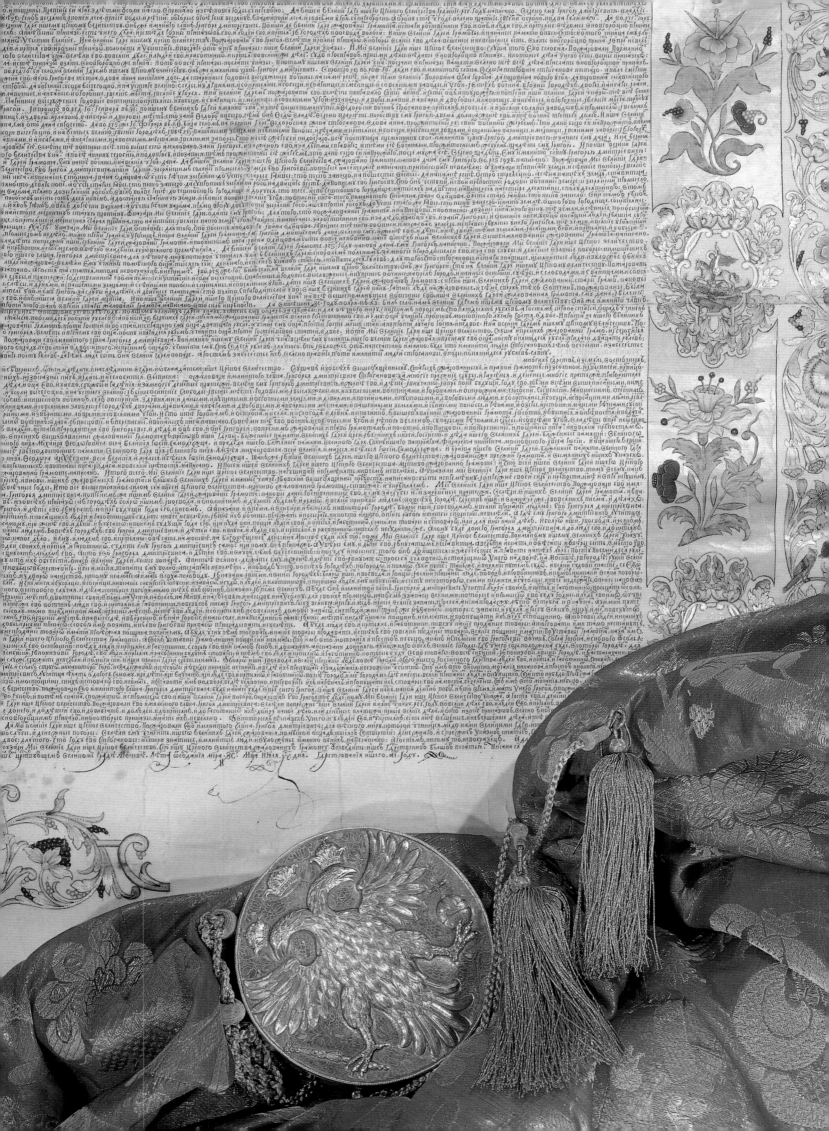

A fAMILY CHRONICLE

Sergei Kuznetsov

OVERLEAF: *Annunciation Cathedral, Solvychegodsk. The first stone church in Russia's far north was envisioned four hundred years ago by Anika Stroganoff on the banks of the Vychegda River, where the family had found wealth.*

BELOW: *This rare charter signed by Ivan the Terrible in 1564 (cat. no. 117) reveals the means by which Russia expanded to the east. After conquering the Tatar kingdom of Kazan, the tsar rewarded the Stroganoffs for their financial backing and granted them vast tracts of land on the new eastern border to settle and fortify.*

OPPOSITE: *Detail of the charter of 1692 (cat. no. 119)*

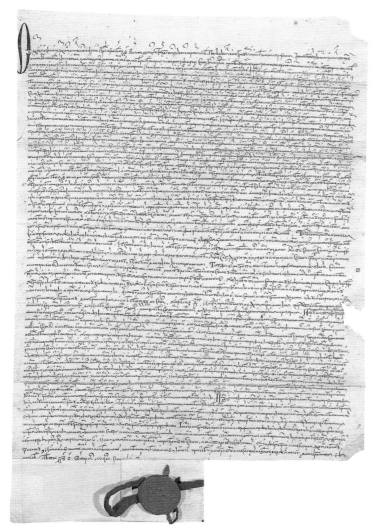

A HISTORY OF WEALTH PUT TO THE SERVICE OF RELIGION, EDUCATION, patriotism, and art links the old Russian saying "Richer than the Stroganoffs you'll never be" to the obituary of Alexander Stroganoff: "The death of this man is honored because of his great stature, so very nearly did they enlist this man among the saints." The Stroganoff history is a dynastic tale intertwined with that of Russia's rulers, from Ivan IV (the Terrible) to Joseph Stalin. The Stroganoffs regularly supplied financial backing to the Russian tsars, who rewarded them for their services with enormous land grants and noble titles. The apotheosis of the family's indefatigable energy and enterprise was in the sixteenth century with the series of expeditions the Stroganoffs mounted into Siberia, which became a part of Russia largely as a result of their efforts. To commemorate the achievement, the sable, indigenous to Siberia and famed for its unsurpassed fur, became a part of the family coat of arms.

The Stroganoffs probably came originally from the Moscow region, but they rose to importance in the far north of Russia, in Solvychegodsk, a relatively small town by modern standards. The town's name enshrines both the product that bore gold for the Stroganoffs (*sol'* = salt) and the river (Vychegda) down which the salt was carried to central Russia. It was in Solvychegodsk that, in 1560, the Stroganoffs laid the foundation of the Cathedral of the Annunciation, the first in a series of beautiful churches and monasteries that was to mark the path of the Stroganoffs from the Urals to Nizhny Novgorod and to St. Petersburg. In the eighteenth century the Stroganoffs were drawn to Paris, the center of trade and the intellectual and artistic capital of Europe, whence they returned to St. Petersburg to make their magnificent art-filled palace on the city's main boulevard, Nevsky Prospect, into an outpost of the Enlightenment.

The pinnacle of the family's philanthropy was the construction of Kazan Cathedral near the family residence in St. Petersburg, a grandiose building that was the principal Orthodox church of its day, as well as a major monument of Christian architecture. It remains today an inspiring monument not only to the dynasty of the Romanovs, who occupied the Russian throne for three centuries, but also to this great family, which occupied a unique place in Russia's history. The Stroganoffs were unequaled in their sustained contribution to Russia's glory over such a prolonged period of time. Indeed, the centuries passed, tsars replaced princes on Moscow's throne, dynasties changed, and tsars became emperors, but all the while, from the mid-fifteenth century to the present—as the present exhibition demonstrates—the Stroganoffs contributed in numerous ways to the economic and cultural flowering of their homeland. On many occasions Russia's rulers sought so much military and financial assistance from these

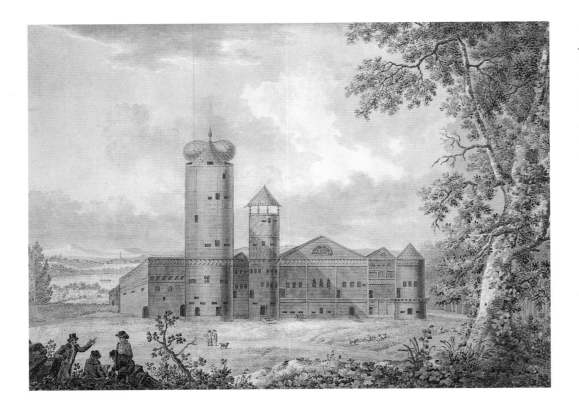

OPPOSITE: *This charter of 1692 sets forth the privileges of Grigory Dmitrievich Stroganoff, who consolidated the family holdings to become the single wealthiest citizen of Russia. Lined with crimson and gold brocade and illuminated with emblems of the great cities of the Russian Empire, this magnificent document (cat. no. 119) unrolls to a length of more than 11 feet. It is made up of six parchment sheets signed on the reverse at each join (to prevent deletions or insertions) by the tsars Ivan Alexeievich and Peter Alexeievich (Peter the Great), half-brothers who ruled together from 1682 to 1696.*

ABOVE: *The Stroganoff house in Solvychegodsk—commemorated in this watercolor (cat. no. 100) by Yermolai Yesakov, an artist employed by the Stroganoffs from 1810 to 1824—was both residence and administrative center for enterprises that ranged from salt production to freshwater pearl cultivation and fur trading. Only 2,500 souls today inhabit the town where more than 6,000 laborers and serfs were employed by Anika Stroganoff in the 16th century.*

RIGHT: *In this document of 1614 (cat. no. 118), the first Romanov tsar, Mikhail Feodorovich, confirmed Stroganoff rights to the territory beyond the Urals that had been secured late in the 16th century for the previous ruling family.*

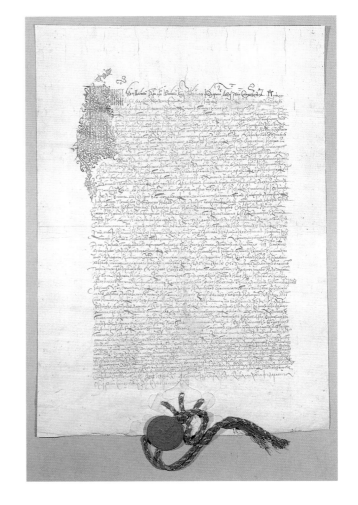

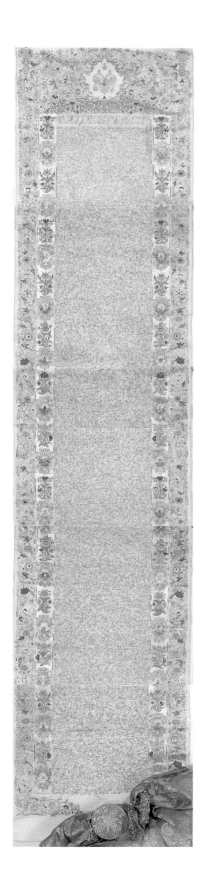

wealthy subjects that at one time the Stroganoffs were responsible for one-fifth of the state's tax income. In 1448 they helped ransom the Muscovite prince Vasily (Basil) the Dark from Tatar captivity, and during the following century, they came to the aid of Ivan the Terrible in defending the country's borders. In 1572 the Stroganoffs, at their own expense, mounted a force of a thousand cossacks and supplied the necessary ammunition and stores to defend the city of Serpukhov against the Crimean Tatars.

During the Time of Troubles in the seventeenth century—the interregnum between the Riurik and Romanov dynasties—Tsar Vasily (Basil) Shuisky rewarded the Stroganoffs for their frequent subsidies and participation in the country's defense against the Polish-Swedish forces with the special title *imenityie lyudi* (illustrious men). Thus, within two centuries after the start of their successful entrepreneurial activities, the Stroganoffs had become honored citizens, distinguished from the general mass of commoners by being allowed to write their name with a patronymic and being granted many legal and economic privileges. Four representatives of the family in succession were given the title of *imenityie lyudi* between February 20 and May 29, 1610, and the Stroganoffs were registered as such in the 1649 legal code of the new Romanov dynasty. This special status gave the merchant-industrialists a place at court and allowed them to forge relationships among the boyars (landed nobility).

The last of the *imenityie lyudi,* Grigory Dmitrievich Stroganoff (1656–1715), was of no small assistance to Peter I (the Great) during the Great Northern War of 1700–1721 against Sweden, building four fully armed ships for the Russian navy and extravagantly celebrating the victories of the young military force with the construction of the first of two magnificent triumphal gates in Moscow. According to legend, on one occasion, when the tsar was entertaining, Grigory Dmitrievich gave him a barrel of gold on which dinner was served. Peter reciprocated with honors and in 1692 granted the Stroganoffs the right to own their lands in perpetuity.

Although the family was not officially ennobled until 1722, they claimed to have noble origins in the Tatar kingdom of Kazan in the thirteenth and fourteenth centuries and were said to have taken their name in memory of the martyrdom of the first family member to convert to the Orthodox faith: after falling captive to the Tatars, he was *isstrogali*—tortured and cut into pieces—and thus his descendants were called Stroganoff. Among other possible if more prosaic sources for the name are *strogaet* (the verb for working wood with a plane) and *strogan* (a term used in the Moscow region for someone who speaks quickly). It is also possible that the name comes from *stroganina,* a culinary specialty of the north, where meat was often preserved in thin slices. This is the likely origin of the famous dish beef Stroganoff, a family recipe dating to the late eighteenth century.

ANIKA STROGANOff AND THE ACCUMULATION Of WEALTH The patriarch of the Stroganoff dynasty was Anika Feodorovich (1497–1569), who in 1515 set up a salt works in the settlement that became Solvychegodsk, at a unique salt lake situated not far from where the Vychegda River flows into the Northern Dvina. Key to his success was that he managed by various means, not all of them consistently noble, to rid himself of most of the competition, as well as to organize the transport and sale of salt to other towns in Russia. By the middle of the sixteenth century, Anika already had an enormous enterprise going—grain production and trade, money lending, pearl cultivation, fur trading, and much else—and

employed approximately six thousand serfs and hired laborers. Anika was an educated man who maintained relations with foreigners and shipped his goods to many foreign places, including Paris. He founded a library in Solvychegodsk, built a large house there in 1558, and two years later laid the foundation for Annunciation Cathedral.

The Stroganoff possessions on the Vychegda River were only the beginning, as they moved on through the expanses of Eurasia. The family established offices in the towns of central Russia, which lay to the west of Solvychegodsk, but the Ural mountain range blocked eastward expansion. While Anika was still alive, the family tried to circumvent the mountains to the north and south in search of salt-rich locations. The northerly direction did not prove propitious, although a body of water in Novaya Zemlya still bears the name Stroganoff Bay. Rewards lay to the south. Immediately after Ivan the Terrible conquered Kazan in 1552, he gave the Stroganoffs vast tracts of land along the Chusovaya and Kamaya Rivers to stabilize Russia's new eastern border. Anika's youngest son, Semeon, remained in Solvychegodsk, but the two older sons, Yakov and Grigory, became settlers, fortifying the new Stroganoff lands on the western flank of the Urals around what was to become the city of Perm and the gateway to Siberia.

Recognizing the value of contact with the local population and of knowing special routes into Siberia, the Stroganoffs managed to set up a business in sables and other rare furs. Their desire to obtain a monopoly over the fur trade motivated them to expand beyond the Urals into the territory of the Siberian khan. Authorities in Moscow urged them on, and the constant warfare between neighboring Tatar khans afforded ample pretext. Even before it was decided in the capital to attack the eastern kingdom, the merchant Stroganoffs had come up with a plan for a two-pronged invasion. The initial naval expedition to the mouth of the Ob' River with two ships built and manned by the Stroganoffs met with failure; but the second part of the plan, which was to take boats up the Chusovaya River, was a success. To head the expedition, the Stroganoffs had recruited Vasily Timofeievich Alenin, the leader of a large gang of bandits. Known in history as Yermak, this semilegendary hero came from Stroganoff territories on the Volga. Arming his volunteer army of more than five hundred cossacks cost the Stroganoffs a princely sum, and on September 1, 1581, Yermak's troops set off on a campaign that resulted in a string of victories. Yermak was killed on August 6, 1584, but the Stroganoffs helped mount several new campaigns. It was largely thanks to the perseverance of the Solvychegodsk merchants that Siberia became a part of the Russian state, and for this the name of Stroganoff will be forever writ large in the chronicles of the nation.

In the eighteenth and nineteenth centuries, the Stroganoffs researched and painstakingly recorded the course of Yermak's campaigns, and Yermak memorabilia was brought from Siberia to occupy an honored place in their palace in St. Petersburg. The broken helmet that supposedly belonged to the outlaw, as

BELOW: *In 1579 Nikita and Maxim Stroganoff boldly enlisted the notorious outlaw Yermak to secure and pacify border territories in the east, using his cossacks to serve as the Stroganoffs' private army. There are no contemporary portraits of Yermak, but imaginative depictions abound, such as this early-19th-century example (cat. no. 34).*

OPPOSITE ABOVE: *In this huge composition,* Yermak Conquering Siberia *(1895), housed in the State Russian Museum, Vasily Ivanovich Surikov created a monument to Russian nationalism. Evoking a dramatic scene from the Stroganoffs' victorious campaign against the Tatars, he shows Yermak leading his cossacks up the Chusovaya River to lay claim to Siberia for the Russian tsar.*

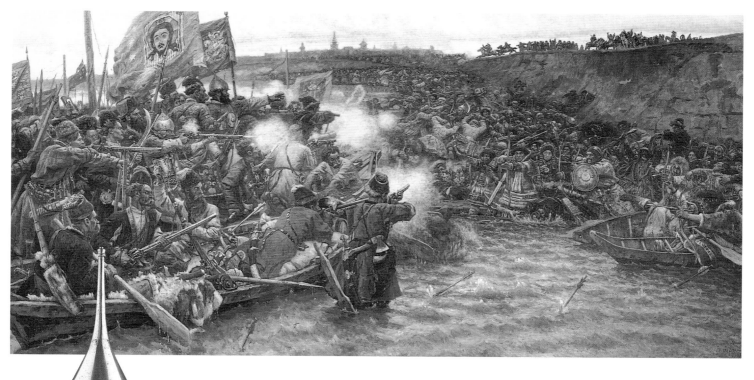

In reward for his victories, Yermak received gifts of armor from the tsar, which indirectly caused his death. As a cossack he would not normally have worn armor, and it is said that he drowned under its weight when his boat was ambushed on the Chusovaya River in 1584. In their St. Petersburg palace the Stroganoffs installed a display of arms and armor believed to have belonged to Yermak, including a spiked helmet like this rare 16th-century Russian example (cat. no. 50).

well as his rifle and spear and an arquebus, was exhibited and labeled: "In the city of Kergedan, on the River Kama, I, Maxim Yakovlev, a Stroganoff son, did give this to ataman Yermak."

Although the Stroganoffs were enterprising merchants, they financed the Siberian campaign and other military undertakings primarily from the wealth they amassed from the production of salt. Despite the fantastic opportunities it afforded for enrichment, producing salt was a difficult business that required substantial investments from the very outset, attention to constant improvements in technology, and a huge amount of manpower, to say nothing of the colossal expense of transporting and selling the salt. The initial discovery of a salt lake at the site of the future Solvychegodsk could not guarantee an income in perpetuity. To expand their business the Stroganoffs had to be constantly on the lookout for promising new sites, which they did by questioning local inhabitants and observing the habits of the domestic livestock and wild animals. Once a salt-rich site was discovered, a procedure began that was much like drilling for oil. A long pipe constructed of hollowed-out logs was driven through the lake bottom. The aim was to tap underground salt water, which would then naturally gush up the pipe to the surface. The water was caught in buckets and transported to buildings that housed shallow iron pans six to twelve feet in diameter. Large quantities of firewood were burned to heat the water to the point of evaporation, after which the salt was collected and put into sacks for storage or transport. A single wooden pipe, strengthened by salt buildup, would last several years and supply four to six salt pans in year-round production.

At the time of Anika's death in 1569, there were ten Stroganoff salt pans. Later, despite the discovery of rich new salt deposits, the Stroganoff business did not enjoy quite the same success. Not until 1672 did a single member of the family manage to gather up all the Stroganoff land holdings and salt works under his control; this was Anika's great-great-grandson Grigory Dmitrievich (1656–1715), who enjoyed phenomenal success in the salt industry. In later years, however, a shortage of wood and transportation problems took their toll on the family business, as did the Russian government's introduction of a monopoly on salt

production in 1703. These developments transformed the Stroganoffs' once extremely profitable business into a losing proposition. In 1720 the Stroganoffs relinquished the Solvychegodsk salt works, which were increasingly less productive, and the following year they were given permission to prospect for and mine iron ore. This proved to be a successful venture, and in subsequent decades the family built several iron works on their lands in the province of Perm in eastern Russia. New regulations obliged merchants to deliver all their salt to Nizhny Novgorod in central Russia, where it was to be sold to the state, and for a decade and a half this city was the capital of the declining salt empire. Grigory Dmitrievich Stroganoff, Russia's wealthiest inhabitant and the last *imenityie lyudi,* endowed the city with the enormous Church of the Nativity of the Virgin. For the services that he and his ancestors had provided to Russia, Peter the Great bestowed upon Grigory Stroganoff's sons—Alexander, Nikolai, and Sergei—the title of baron. The fledgling aristocrats commissioned a huge platter emblazoned with their new coat of arms from one of England's greatest silversmiths, Paul de Lamerie (cat. no. 161). The title of baron would prove to be very useful as the Stroganoffs sought out new spheres of activity in industry and state service.

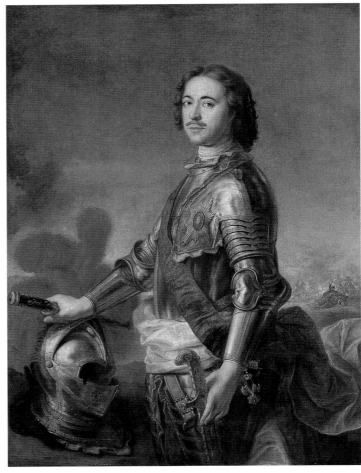

Meanwhile, the family was able to increase the yield at the salt pans in Perm, which in 1731 produced half of all the salt in Russia. This was their last successful year, however. By 1742 the problem of hiring men to deliver the salt had become acute, as the government required the hiring of only peasants with passports, who were impossible to find. Then the silting up of the Volga and Kama Rivers in 1743 hindered distribution, causing huge losses for the Stroganoffs. They made repeated petitions to the senate to have their mandatory contributions to the treasury reduced, but the results did not offset their substantial losses. In an attempt to save the family business in 1749, all the operations were divided up among the three sons of Grigory Dmitrievich, but even so, 1751 was the last year that the famous salt producers supplied their usual quantity of salt, and this was followed by a precipitous decline in production.

ABOVE: *To help establish his image, Peter the Great sat for Jean-Marc Nattier, a leading portraitist of the French court (cat. no. 134), who depicted him not as a conventional prince but as a military leader in armor with a battle raging behind him. For all his desire to adopt the modern ways of Western courts, this powerful emperor, like his predecessors, relied heavily on Stroganoff backing for the military operations that turned Russia into an empire.*

LEFT: *The baronial coat of arms on Paul de Lamerie's great silver platter (cat. no. 161) exhibited the noble status conferred on the Stroganoffs by Peter the Great in 1722.*

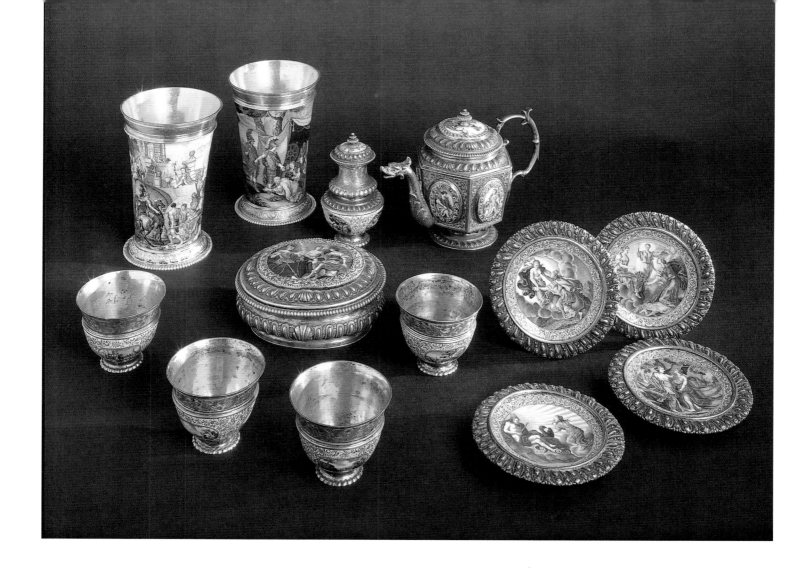

Like Peter the Great, the Stroganoffs sought to adopt the style of western European courts by acquiring furnishings produced for that market. The German courts provided the example closest to hand, and it is not surprising that the Stroganoffs should purchase superb examples of the gilded and enameled Baroque silver being produced by goldsmiths in the city of Augsburg (cat. nos. 170, 172, 173).

THE STROGANOFF PALACES Although the Stroganoffs distinguished themselves in military affairs, diplomacy, and the arts, their most visible achievements were their palaces. In 1716 the family built its first residence in St. Petersburg, on Vasilievsky Island, near the fork of the Neva River. The building's extraordinarily effective location could be called typically Stroganoff, as their residences in Solvychegodsk, Nizhny Novgorod, and Moscow stood on similarly prominent spits of land. This palace, however, was constructed at the behest of the monarch, because Peter the Great required his subjects to erect buildings according to the number of "souls" (serfs) they owned, in order to speed the construction of his new capital. The vast edifice remained empty until half a century later, when it was donated to the university.

In point of fact, for the first three decades of the eighteenth century the Stroganoffs preferred to live in Moscow. Alexander Grigorievich (1698–1751) was the first Stroganoff to marry into the nobility when he wed Princess T. B. Sheremeteva in 1723, just one year after he and his brothers were given the title of baron. "His home was one of the finest in Moscow, both for its beauty and for its location. . . . It enjoyed a marvelous view the likes of which no other home in Moscow possessed," wrote the Holstein courtier von Berholz. "How magnificently the young Baron Stroganoff lives, although his father was nothing more than a wealthy peasant. . . . He always keeps a lavish table, dresses well, and parades his carriages, but he also maintains his own troupe of musicians consisting of eight men. . . . In the room where we danced, a sideboard had been set, filled with beautiful crystal and expensive silver service, and there was a large dining table. . . . In another room there was yet another table

OPPOSITE: *This splendid cabinet (cat. no. 171) represents the ultimate in Baroque palace furniture. It incorporates an elaborate timekeeping instrument and features sumptuous materials, such as the tortoiseshell veneers and silver miniature sculptures on the outside of the doors (see detail at left). The bright green color of the Stroganoff piece distinguishes it from comparable cabinets in the Munich Residenz and Rosenborg Castle in Copenhagen.*

appointed in true tsarist fashion and with the kind of taste I never imagined I would see here. . . . In the middle of it stood an immense silver tray of exquisite craftsmanship. . . . The entire table was set with porcelain dishes finer than which I have never had occasion to see anywhere."

Alexander Grigorievich also built the first Stroganoff country house on the estate of Kuzminki, near the grand estate of Kuskovo that belonged to his Sheremetev in-laws. Upholding the intellectual traditions of the family, he left his mark on the history of Russian literature with his translation of Milton's *Paradise Lost.*

By the middle of the eighteenth century, the court life the Stroganoffs had once found so foreign had become desirable, not to say indispensable. Without abandoning their entrepreneurial activities altogether, they maneuvered to gain a place at court, where Sergei Grig-

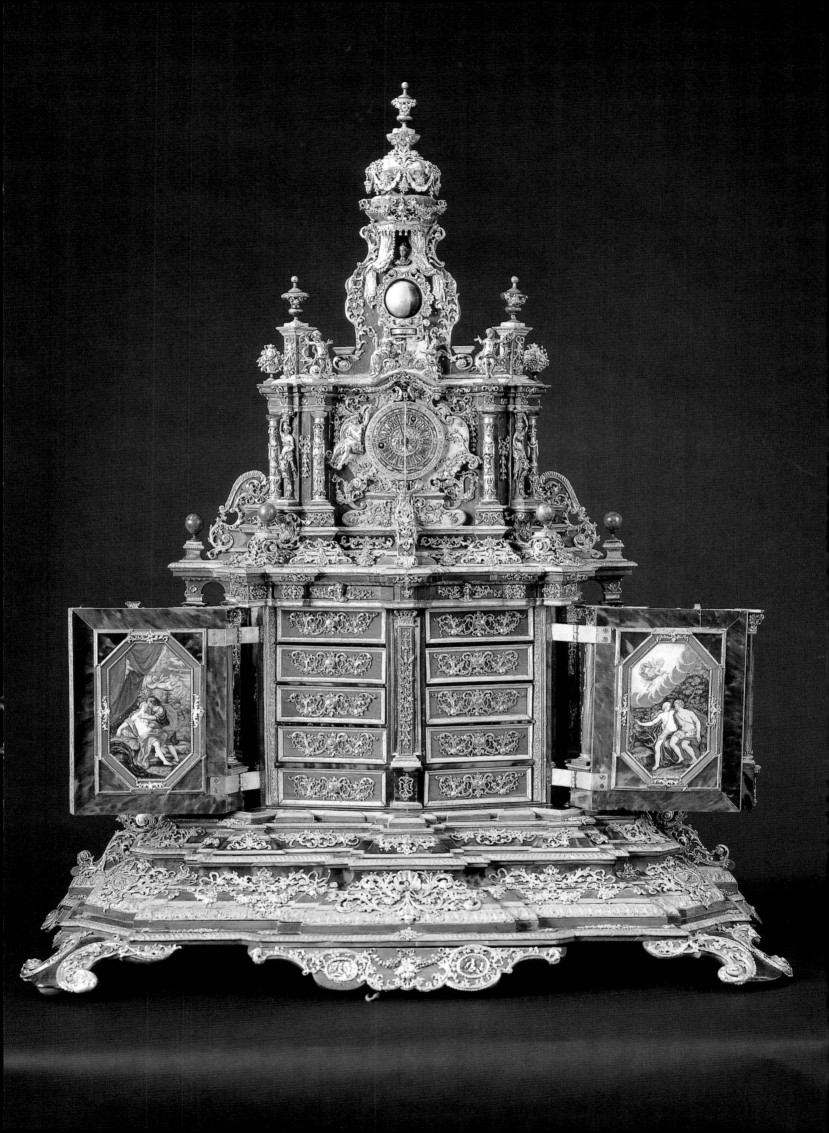

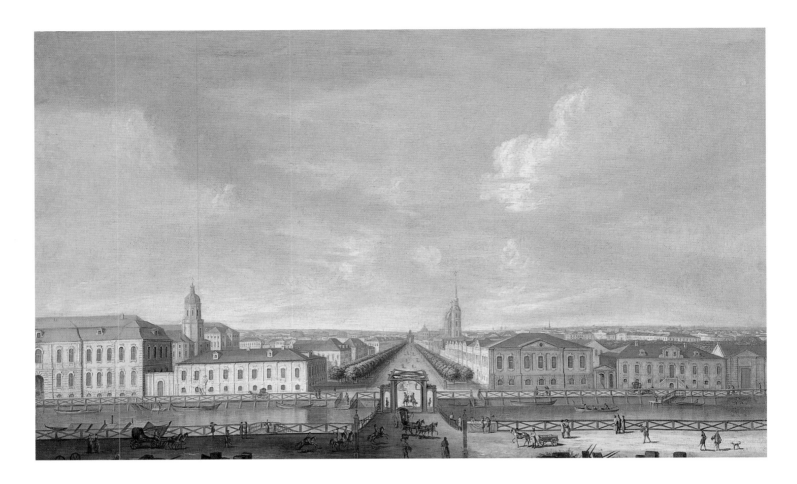

orievich (1707–1756), who became a lieutenant general, won the greatest successes, becoming both chamberlain and a cavalier of the Order of Saint Anne. Sergei married Sophia Kirillovna Naryshkina, who descended from an old aristocratic line and was a relative of Peter the Great. Immediately after Elizabeth Petrovna ascended to the throne, Sergei resolved to establish himself in St. Petersburg. In 1742, he purchased from the court tailor an unfinished building on Nevsky Prospect, which was in the process of becoming the brilliant, principal avenue of a European city. Financial and family affairs—settling with his brothers, running the chaotic salt business, and raising his only son, Alexander—kept him from focusing his attentions on his own home until late in his life. In four short years, however, between 1752 and 1756, with the assistance of court architect Francesco Bartolomeo Rastrelli, combined the building with an adjacent property on the Moika River, creating two magnificent Baroque facades and palatial interiors.

Continuing work on the palace did not stand in the way of lavish festivities, including most notably a celebration in honor of the birth of Grand Duke Paul Petrovich in October 1754. As a European newspaper reported: "The entire building was illuminated on the inside with wax candles and on the outside with lampions [oil lamps of colored glass]. . . . In the grand salon, the guests danced to splendid music, and in other chambers they were fêted with expensive drinks, fruits, and confections in grand abundance the whole night long. . . . Everyone present at this merrymaking, which lasted until the wee hours of the morning, was forced to admit that nothing more could have been desired for the most perfect satisfaction."

The palace on Nevsky Prospect set the tone for half a century of continuous building activity on the part of the Stroganoffs, who managed to engage nearly every famous archi-

This view of Nevsky Prospect (cat. no. 23) shows at the right the two houses on the Moika River purchased by Sergei Grigorievich Stroganoff in 1742 and combined into an impressive palace reflecting his decision that the family's interests could best be served in St. Petersburg. A highly visible town palace would advance them at court, so to this end Sergei secured the services of Rastrelli, the architect working on the Winter Palace for Empress Elizabeth.

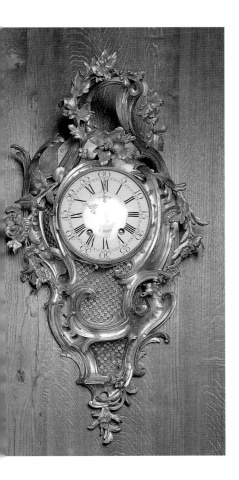

tect available, beginning with Rastrelli. In particular, the best-known representative of St. Petersburg Rococo, the Italian architect Antonio Rinaldi, built the Stroganoff country home on the so-called Vyborg side of the city—a dacha surrounded by a magnificent park on the bank of one arm of the Neva. A home on the Peterhof road was erected by J. B. Vallin-Delamothe, a master of early Neoclassicism who was responsible for the building of the Academy of Fine Arts. The construction of these magnificent winter and summer homes enhanced the position of the former merchants at court and may have helped secure a good match for Alexander Sergeievich (1733–1811), one that would ensure the family's advancement. In 1758 he was married to Anna Vorontsova, the daughter of the powerful vice chancellor to Empress Elizabeth. With the empress in attendance at his wedding, a bright future seemed assured for the Stroganoff scion, who was slated for a career in the military.

ABOVE: *By the mid-18th century France attained preeminence in the arts of the interior, and the Stroganoffs naturally chose examples of the best French Rococo design, such as this wall clock (cat. no. 162), which perfectly complemented the style of Rastrelli's architectural ornament.*

RIGHT: *In choosing this secretary desk (cat. no. 164), a masterpiece of Parisian cabinetry by Jean-François Dubut, the Stroganoffs demonstrated their predilection for full-bodied form and rich color. The robust contours are enlivened by vivid polychromy, achieved by incorporating mother-of-pearl and tinted ivory into the wood marquetry.*

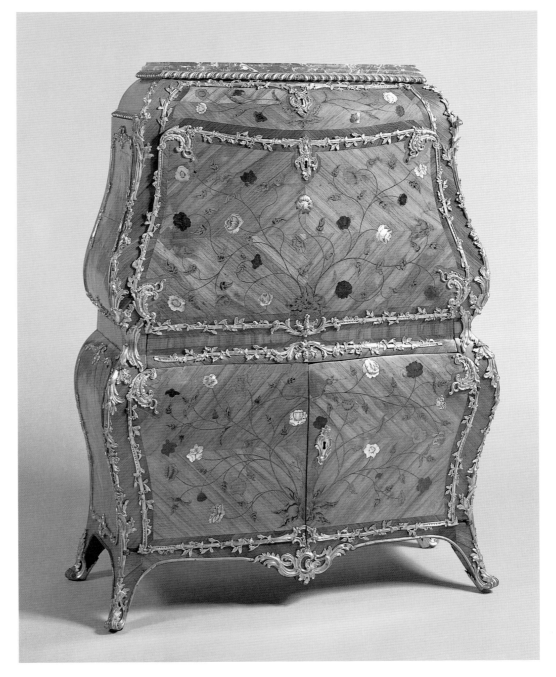

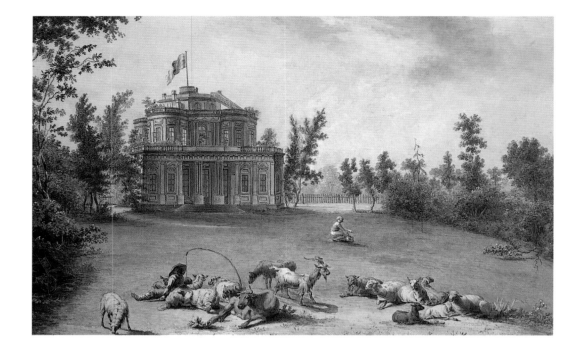

A dacha, or country house, was essential to a titled family of means in Russia, and in 1754 Sergei Stroganoff commissioned the Italian architect Antonio Rinaldi, who was much in demand in St. Petersburg, to build the family's suburban villa, pictured in this charming watercolor (cat. no. 99).

ALEXANDER STROGANOFF AND THE ACCUMULATION OF ART Following the custom of the nobility, Sergei had enrolled Alexander in a regiment when he was still a child, but he extended the boy's education beyond military disciplines and worked out a plan for him to study abroad. In Geneva Alexander studied music and languages—Latin and Italian (he already knew French and German). Moreover, we know from his own words that Alexander took a deep interest in scholarship, trying to come to an understanding of the things that had surrounded him since childhood. He wrote to his father on February 9, 1753: "I beg of you to instruct someone to draw from every side the silver vessel that was found in the earth in Perm and sent to Uncle Nikolai Grigorievich, where it now is." After a stay in Switzerland, Alexander traveled in Italy, where he became familiar with a great many private and public collections and libraries in Turin, Milan, Venice, Florence, and Rome. He also visited Herculaneum. It was in Italy that Alexander acquired the first painting for his future gallery (an oil sketch for Correggio's *Holy Night* in Dresden). He arranged for the serf painter Matvei Pechenev to train with the famous portraitist Pompeo Batoni and gave the master fur coats by way of payment.

Alexander's experiences in Paris proved to be the strongest influence during his formative years. "Let France teach us to dance," Sergei wrote to his son, but Alexander absorbed more than French elegance and manners. Connoisseurs such as Dezallier d'Argenville, whose 1770 guidebook *Voyage pittoresque de Paris* pointed out and commented on every feature of artistic significance in the French capital, fired the young Stroganoff's ambition to assemble his own collections of natural history and art. Alexander was not cut out for the military, as became evident on his return to Russia. With clumsiness unbefitting an officer, the story goes, he stumbled on a bridge right in front of Empress Elizabeth, the result of which seems to have been his transfer into court service. In 1761 he was sent as the official Russian delegate to an imperial wedding at the court in Vienna. On this occasion, the Austrian emperor named him a count of the Holy Roman Empire (cat. no. 120). Half a year later Elizabeth died, and after the brief reign of her nephew, Emperor Peter III, Peter's widow, Catherine

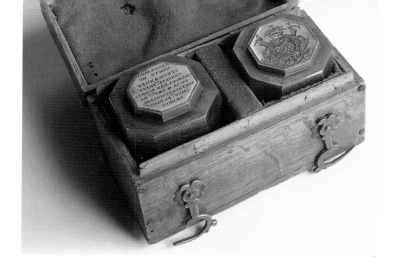

found herself on the Russian throne. Stroganoff decided to separate from his young, frivolous wife, whose relatives had lost their former influence at court. During the 1760s he took active part in the efforts of the Legislative Commission to codify Russian law and in drawing up a design for the public library. His plans were not realized at this time, largely because Catherine II (the Great) did not take him seriously as a statesman, despite the enthusiasm they shared for the art and literature of France. Alexander was eager for an opportunity to plunge back into Parisian life, and it came in 1769 with the sudden death of his estranged wife, Anna. He immediately remarried and set off for Paris, where he spent a full eight years, 1771 to 1778, with his new wife, Princess Catherine Trubetskaya.

Alexander Stroganoff left his mark on Paris with a unique form of metal calling card stamped by these dies with his titles and coat of arms (cat. no. 165). Remarried in a love match to Princess Catherine Trubetskaya, Alexander returned to Paris to spend the years 1771–78 happily immersed in Enlightenment culture.

Well prepared by his European education, Alexander Sergeievich Stroganoff became absolutely his own man in the French capital. He joined a Masonic lodge, whose membership included the astronomer J. N. Delisle, the painters Jean-Baptiste Greuze and Claude-Joseph Vernet, the sculptor Jean-Antoine Houdon, and Benjamin Franklin. Stroganoff became a friend of the painter Hubert Robert (see page 145), from whom he commissioned a series of paintings in 1773 to decorate his home in St. Petersburg. The paintings were subsequently allotted their own hall in the family palace, where they were later joined by a series of busts by Houdon depicting Voltaire, Diderot, and Catherine the Great. Other artists he knew and patronized were Marie-Louise Élisabeth Vigée-Lebrun (cat. nos. 142–44) and

With this 1761 document (cat. no. 120) the Hapsburg emperor Francis I bestowed the title of count on Alexander Sergeievich Stroganoff, who was sent to Vienna as the envoy of the Russian empress Elizabeth. His father had groomed Alexander for a career at court by educating him abroad and marrying him in 1758 to Anna Vorontsova, the daughter of Elizabeth's powerful vice chancellor. Their unhappy and childless union ended with Anna's death in 1769.

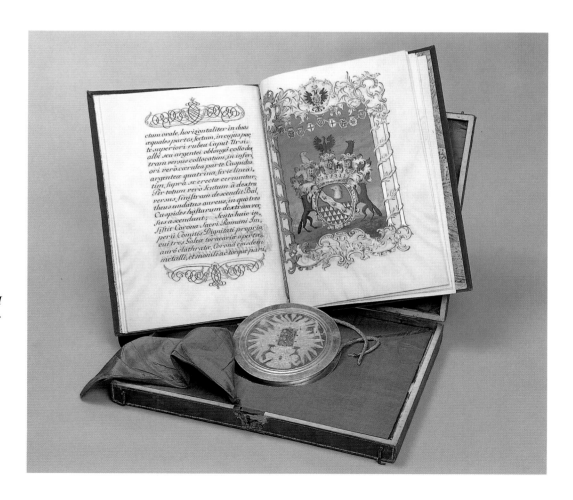

Greuze (cat. no. 135), and he also visited the studio of the sculptor G. P. Tassaert, from whom he acquired a statue of Minerva, transformed at his behest into a portrait of the empress. Baron Melchior Grimm, who corresponded frequently with the empress, wrote about Stroganoff's departure from Paris in 1778: "At last . . . we have seen Count Stroganoff gone with all his baggage and equipment. . . . His long sojourn has almost naturalized him here, and he has left behind many friends and many regrets in this regard. He would be an ungrateful man if he forgot Paris." But he did not forget, and in fact he decorated his St. Petersburg home in the Parisian manner and brought the French painters Jean-Louis Voille and later Jean-Laurent Mosnier (see cat. nos. 138–41) to Russia in his employ.

No sooner had the Stroganoffs returned to Russia than Alexander's second wife left him to run off with a cavalier named Korsakov, who was a paramour of Catherine II (the Great). Alexander further incurred Catherine's disapproval with his enthusiastic espousal of Freemasonry. She wrote several plays ridiculing its cult of secret knowledge, and a number of contemporaries claimed that these were aimed chiefly at Stroganoff. Probably referring to the balance between his wealth and his expenditures on his collection, Catherine presented him to the Austrian emperor Joseph with the barbed compliment "Here is a man who does everything he can to ruin himself, but without success."

During the 1790s, Stroganoff devoted his energies to reconstructing the interiors of his St. Petersburg palace and creating a park for his country house on the Vyborg side. In this endeavor he made full use of the talents of a young architect, Andrei Voronikhin, born a Stroganoff serf and believed by everyone in St. Petersburg society to be the count's natural son. It was under Voronikhin's supervision that the palace on Nevsky Prospect acquired its most renowned interiors—the Mineral Cabinet (cat. no. 80), the Dining Room (cat. no. 83), and the Picture Gallery (cat. nos. 79, 82) designed for Alexander's great collection of European paintings. At the dacha Voronikhin laid out an English park with a pavilion and diverse monuments in the spirit of the Age of Enlightenment.

At virtually the same time, in 1800, Alexander Stroganoff was appointed by the new emperor, Paul I, to the post of president of the Imperial Academy of Fine Arts, and the first stone was laid for Kazan Cathedral, whose building committee Alexander headed. There is no doubt that Alexander accepted the latter position in order to see that Russian artists obtained the commissions for the cathedral, which was his pet project. The cathedral was named Kazan in honor of the locale where the Stroganoffs believed the family originated and where they had received recognition with the status of *imenityie lyudi*. The Stroganoff connection with the cathedral was soon forgotten, however, because Alexander died in 1811, two weeks after the cathedral's consecration. Unfortunately, instead of being remembered as the glorious apogee of the Stroganoff dynasty, the cathedral came to be regarded as a memorial to Russia's victory over Napoleon Bonaparte in his struggle to conquer Europe.

Russia had plunged into the war against Napoleon in 1805, and, as they had done two centuries earlier, during

LEFT: *At the time Alexander was living in Paris, gold boxes carried for the inhaling of snuff were the ultimate collectible in fashionable society. This Stroganoff box (cat. no. 166) is an exquisite example of a Neoclassical* boîte à cage. *The gold "cage," delicately worked and accented with enamel and pearls, holds glass-covered miniature gouache paintings that depict classical reliefs.*

OPPOSITE BELOW: *Lacking a government appointment on his return to Russia, Alexander focused on renovating the family properties, as documented in this Parisian snuffbox (cat. no. 163), which on the lid and the bottom shows the dacha as it was built in 1754, while the sides record Alexander's additions to the gardens.*

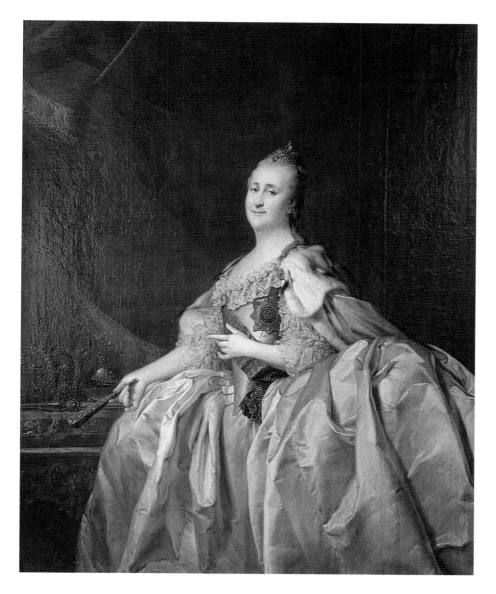

ABOVE: *The ambivalent relationship between Alexander Stroganoff and Catherine the Great, portrayed here by Dmitry Levitsky (cat. no. 24), has never been fully explained. Alexander was for many years part of the empress's inner circle, but she did not deem him worthy of high political office. They shared a passion for art collecting, but in spite of her ability to amass one of the world's greatest painting collections, she envied Alexander's personal involvement in the market, while she was obliged to buy pictures sight unseen, and usually en bloc, through agents.*

the Time of Troubles, the Stroganoffs did a great deal to help the imperial army. For a time Emperor Alexander I maintained an alliance with Napoleon, to which the segment of Russian society led by the Stroganoffs strenuously objected. A vivid episode in the unusual standoff between the monarch and his subjects was the refusal of Alexander Stroganoff, at the time he was chief chancellor of the court, to receive Napoleon's ambassador. Alexander Stroganoff donated funds in 1807 for the creation of a militia, and his son, Paul, was constantly involved in the fighting from that time on.

It was on the field of battle and in politics rather than in the arts that Paul Alexandrovich Stroganoff (1772–1817) found his calling. He had been born in Paris, where he spent the first six years of his life, and back in Russia, after his mother left, his father appointed a Frenchman, Gilbert Romme, to direct his studies and to accompany him on travels around Russia and to Geneva. By 1788 he was back in Paris under the assumed name of Paul Ochter, and he eagerly followed Romme into revolutionary politics, actively participating in the Club des Amis de la Loi that his tutor had founded. On August 7, 1790, Paul joined the Jacobins, the most radical political group in France, and news of this caused Catherine the Great to order the Russian ambassador in France, on August 26, 1790, "to inform all Russians in Paris of my order for their speedy return to the fatherland." Paul was brought back to Russia by a cousin, Nikolai Novosiltsev. Seeing himself as a Russian Mirabeau, Paul eventually formed a triumvirate with Novosiltsev and Prince Adam Czartoryski to advise Alexander I on reform. On May 9, 1801, Paul composed his famous note on the creation of the so-called Unofficial Committee, which he felt must meet to discuss "measures having as their goal the removal of the tainted administration and its replacement by laws intended to eliminate the effect of the existing tyranny." The committee held informal sessions with the emperor from 1801 to 1803 in the palace on Kamennya Island, which was separated

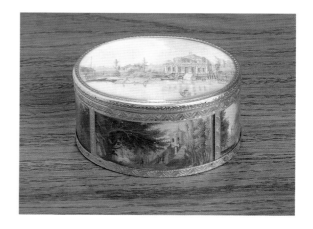

from the Stroganoff dacha by a floating bridge. At these meetings, Paul directed the emperor's attention to the peasants: "The majority of them are gifted with a great mind and enterprising spirit, however, deprived of the opportunity to put either one or the other to good use, they have been condemned to stagnate in inaction and thereby deprive society of the works of which they are capable. They enjoy neither rights nor property. Nothing of any note can be expected from men placed in a situation such as this." The emancipation of the serfs, however, did not come about for another sixty years. After his plan for reforms fell through, Paul occupied the rather modest post of deputy minister for internal affairs and went on a diplomatic mission to London before taking up an active military career.

Paul was also preparing his only son, Alexander, for the military, and together they set out on a campaign to Paris in 1814, but the youth was killed in one of the battles by a shot through the head. Three years later Paul himself died, wracked by consumption. A pall had been cast over the last years of his life by the tragic loss of his son and his search for ways to cover the debts left behind by his father's furious artistic activity. Refusing to permit even the thought of selling his palace and estates, Paul obtained a loan in Holland that was guaranteed by the emperor himself.

At Paul's death in 1817, Alexander I directly intervened to save the Stroganoff fortunes. He signed a decree declaring the inviolability of the most important parts of the Stroganoff inheritance—the Perm patrimony, the Nizhny Novgorod estate, the two homes in St. Petersburg, including the contents of the Picture Gallery, and the Stroganoff dacha. The text of the document stated that the legal act to avert a sale was made "out of respect for the excellent zeal and devotion of Paul to the person of the sovereign emperor, but in equal measure in reward for his fervor and the services he and his ancestors have rendered to the Russian throne." The inheritance passed in its entirety into the capable hands of Paul's widow, Sophia Vladimirovna, née Princess Golitsyna. She applied the experience of a social program she had started on her own estate of Maryino to the Stroganoff Perm holdings, which were a thousand times larger. The countess wrote

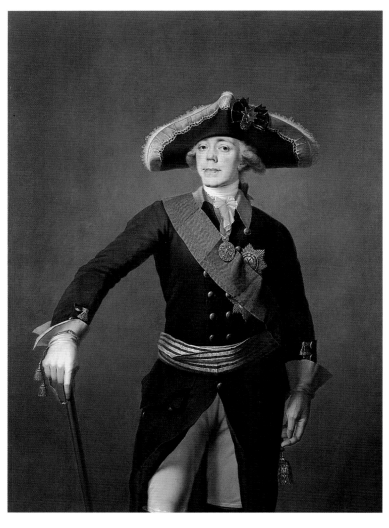

Stepan Semeonovich Shchukin, **Portrait of Emperor Paul I,** *1796–97 (cat. no. 29). Unlike his mother, Paul I gave Alexander Stroganoff honors, including the title of count of the Russian Empire, and the opportunity to use his talents to the fullest by appointing him to important cultural posts, such as president of the Imperial Academy of Fine Arts and head of the committee to build Kazan Cathedral.*

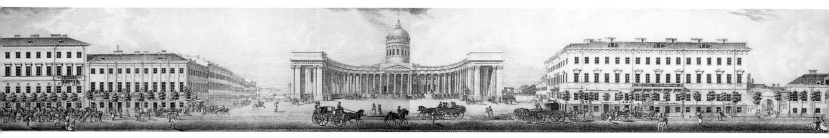

KAZAN CATHEDRAL

Jean-Laurent Mosnier, a French artist Alexander Stroganoff persuaded to come to Russia, portrayed his patron in 1804 (cat. no. 138) proudly wearing the new uniform of the Academy, where the portrait was to hang, and displaying a rendering of Kazan Cathedral, then under construction.

BELOW: *These four sections from a panorama (cat. no. 107) that documents both sides of Nevsky Prospect in the 1830s illustrate the Stroganoffs' commitment to the city of St. Petersburg. The curved colonnade of Kazan Cathedral draws passersby into its embrace, while the facade of the palace, whose columns flank the carriage entrance, provides an interface between the Stroganoff family and citizens of St. Petersburg. Unlike city palaces of the great families of western Europe, where the residence, on the far side of the courtyard, was shielded by a wall or servants' quarters, the principal rooms of the Stroganoff Palace opened directly onto the life of the city.*

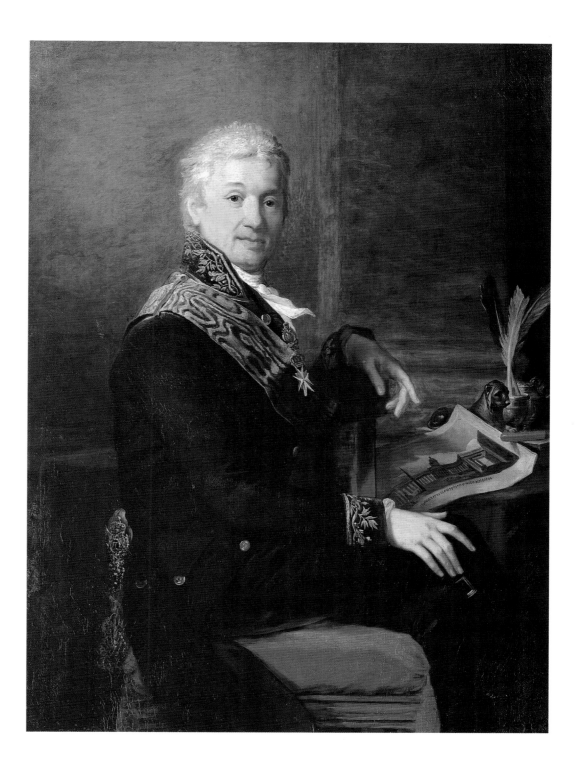

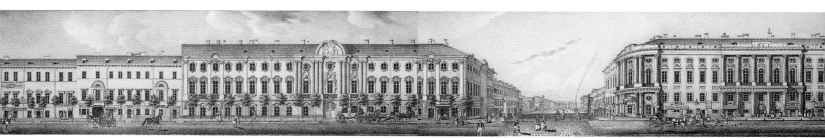

STROGANOFF PALACE

a great number of regulatory acts, covering such institutions as a court of arbitration and a savings bank, and found a way to increase Stroganoff capital with a new enterprise of mining for gold. Her crowning achievement was the creation in 1824 of a school of agriculture and mining, whose director was Prince Vasily Golitsyn, the husband of her second daughter, Adelaide.

While her husband was consumed by political ideas, Sophia had been involved in the artistic life of his family. In the 1790s she had worked closely with Voronikhin on his projects for the family apartments. Sophia herself painted and had members of the Academy instruct her daughters in art. They in turn became friends and patrons of Karl Briullov, the most outstanding representative of the Academic school in Russia. According to the conditions of the act of primogeniture, the Stroganoff name and possessions were supposed to devolve after Sophia's death on the husband of Paul's eldest daughter, Natalia, who married her cousin Sergei Grigorievich Stroganoff (1794–1882), thus consolidating the dynasty's fortunes.

Above all else an educator, Sergei reinforced the Stroganoff principle of collecting art for instructional purposes. He was by nature oriented toward the treasures of the past. His stay in Paris from 1814 to 1815 informed his perception that the monuments and artifacts of history could inspire nationalist sentiment and revive moral principles in a society infected with the ideas of Bonapartism. On his return, he occupied several important provincial posts—a mark of this service is the gold cup from the province of Minsk (cat. no. 57)—but in the end he settled in Moscow. He was appointed curator of Moscow University, and from 1837 to 1874 he chaired its Society for Russian History and Antiquities, which published the journal *Antiquities of the Russian State*. During his tenure Sergei attracted many gifted professors to teach there, among them Sergei Solovyov, author of the standard history of Russia. Further, in 1859, Sergei Grigorievich founded the Imperial Archaeological Commission, which he chaired until his death.

With his own funds, Sergei opened a tuition-free school for the applied arts in Moscow in 1825, the first democratic educational institution in Russia, which accepted students from all social classes. Its regulations, which were drafted by the count as "a lover of the practical arts," were to provide for craftsmen to study the basic laws of practical geometry, architecture, and various types of drawing relevant to the mechanical arts. Each of the sixty pupils studied for six years under the supervision of professors, using a constantly growing collection of works of art as examples. There were three different classes: architectural drawing, the drawing of figures and animals, and the drawing of flowers and ornaments. In 1842 the school was transferred to the Ministry of Finance and was later renamed the Stroganoff Institute for Technical Design, dedicated to the purpose of finding a national style in the decorative applied arts and to the restoration of old icons, including Stroganoff icons.

Rather than undertaking new building projects Sergei embraced restoration, publishing a book in 1849 on the twelfth-

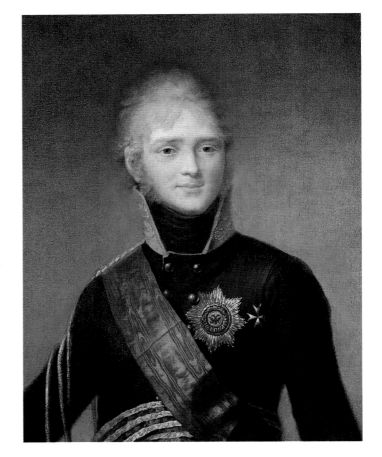

Stepan Semeonovich Shchukin: **Portrait of Alexander I, Emperor of Russia,** *no later than 1805 (cat. no. 30). After assuming the Russian throne, Alexander I was persuaded to focus on social reform by a trio of young nobles that included Paul Alexandrovich Stroganoff, but his attention was soon occupied by war with Napoleon. When Paul died without leaving a male heir, the emperor heeded the pleas of his widow, Sophia, by issuing an edict that prevented the dissolution of the Stroganoff fortune, "in reward for the services [Paul] and his ancestors have rendered to the Russian throne."*

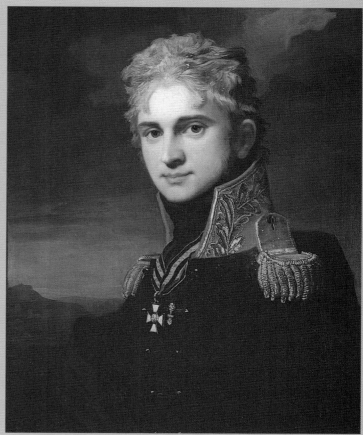

Jean-Laurent Mosnier depicted all three members of Paul Alexandrovich Stroganoff's family. Above is Sophia Stroganoff (cat. no. 141), a remarkable woman who kept a place of favor with Alexander I after her husband quit the court in frustration at the emperor's vacillation on reform. After the death of both her son, Alexander (at right, cat. no. 139), and her husband (above right, cat. no. 140), Sophia obtained an imperial edict that the Stroganoff fortune should pass intact to the future husband of her eldest daughter, Natalia, and she found a suitable spouse in the person of a cousin, Sergei Grigorievich Stroganoff.

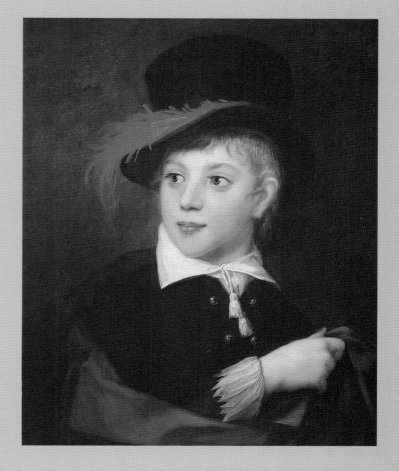

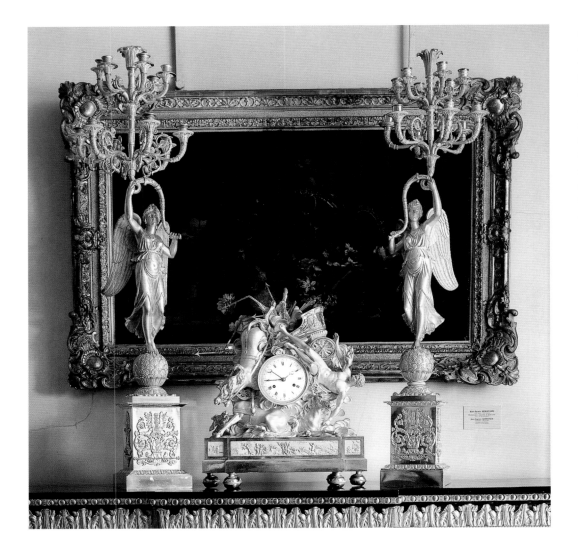

Although French gilt-bronze candelabra of figures representing Victory (cat. no. 169) are to be expected in the Stroganoff collections, as similar objects were acquired for other Russian palaces after the defeat of Napoleon, this mantel clock (cat. no. 168) is an unusual piece of exceptional quality. The design dates from the era of the French Revolution, when the symbolism of its subject, the Fall of Phaeton, must have had political resonance. One can only speculate on Paul Stroganoff's reaction to this spectacular sculptural ornament, whose theme echoed his own career.

century Cathedral of Saint Dmitry in Vladimir, whose restoration he funded. Pursuant to his enthusiasm for Russian antiquities, Sergei made great efforts to recover Stroganoff icons that had been acquired by Old Believers after a fire in the Solvychegodsk cathedral (see pages 57–58). He decided to use them in family churches and gave strict orders to his administrators: "As long as Natalia Pavlovna and I are alive, do not put examples of academic drawing in the iconostases. . . . Strictly maintain the ancient icon painting. . . . Place the icons in accordance with the old examples."

As a collector Sergei Grigorievich had a wide range of interests. He put together one of the world's foremost representations of Byzantine coins and an extraordinary collection of Precolumbian works from Mexico. What interested him most of all, however, were the early Italian Renaissance painters. He amassed a large collection of photographs of their works and owned paintings by Botticelli that later found their way into the Hermitage. Although he was at heart a Muscovite, Sergei returned to St. Petersburg in the 1860s when Emperor Alexander II called on him to serve as tutor to the heir, Nicholas, who did not live to rule. Among Sergei's ten children were two outstanding collectors: Grigory, who moved to Rome, where he amassed a great collection of European paintings and medieval ivories, and Paul, who devoted himself to creating an artistically perfect home filled with paintings, sculptures, Chinese vases, and the decorative arts of Italy. The construction of Paul's house on Sergievskaya Street marked the Stroganoffs' return to St. Petersburg. The architect, Ippolito

Monighetti, a graduate of Stroganoff's drawing school, built a variant on Rastrelli's Stroganoff Palace in the French Revival style. According to a contemporary writer, Dmitry Grigorievich, "As the collection grew and the objects multiplied, the idea occurred to him to create a building to hold them. The building was arranged with an eye to the placement in them of the items purchased. . . . Each object was preassigned a suitable corner, each wall and window built with the goal of advantageous installation and illumination" (cat. nos. 101–5).

Sergei Grigorievich had a brother, Alexander. From his youth Alexander Grigorievich had been known for his eccentricity and arrogance. He bequeathed his personal library to the university at Odessa and his father's library and archive to the university at Tomsk. Evidently he had no desire to familiarize posterity with his personal secrets, however, as he sank two ships carrying Stroganoff archives at Odessa.

Primogeniture brought the artistic legacies of his grandfather Sergei and uncles Grigory and Paul to Sergei Alexandrovich (1852–1923), but the last count was more interested in yachts, hunting, and raising Arabian horses with his sister Olga. Choosing a career as a naval officer, he participated in the Russo-Turkish War of 1877–78 in his own torpedo cutter. In 1897, in honor of the coronation of Emperor Nicholas II, the count offered the palace of his ancestors for the exhibition of historical artistic objects, and there, for perhaps the very last time, the marvelous collections of the Russian aristocracy were put on display. In 1914, Count Sergei Alexandrovich decided to open the palace to the public. Sculptures from the Stroganoff garden, which had been sold off in parcels, were brought in, and he wrote a detailed plan for the publication of catalogues and supplements of the library and restoration. Four halls were readied for visitors, but in the end they had to be used for those injured in the world war that had broken out. Four years later, revolutionary sailors occupied the fourth floor, and later, in 1919, the palace became one of Petrograd's many museums. That same year the count sold his rights to his Perm estate. The papers from his archives were taken by the cartload to be sold in the local market. Sergei Alexandrovich died childless, leaving as heir Prince Shcherbatov, the son of his sister Olga.

These dog portraits by Carl Friedrich Knappe (cat. no. 25) were recently discovered in storage, separated from the fire screens made to hold them. A Stroganoff inventory identifies the dogs as personal pets of Alexander Stroganoff and his daughter-in-law, Sophia. The gentle spaniel, Mouton, was Alexander's, and, contrary to social convention, which held that ladies should have lapdogs, the large poodle, Moustafa, was Sophia's. Prophetically, Moustafa is shown here aggressively chasing coins thrown onto the floor for him to retrieve, just as his mistress years hence would defend and reestablish the Stroganoff fortune.

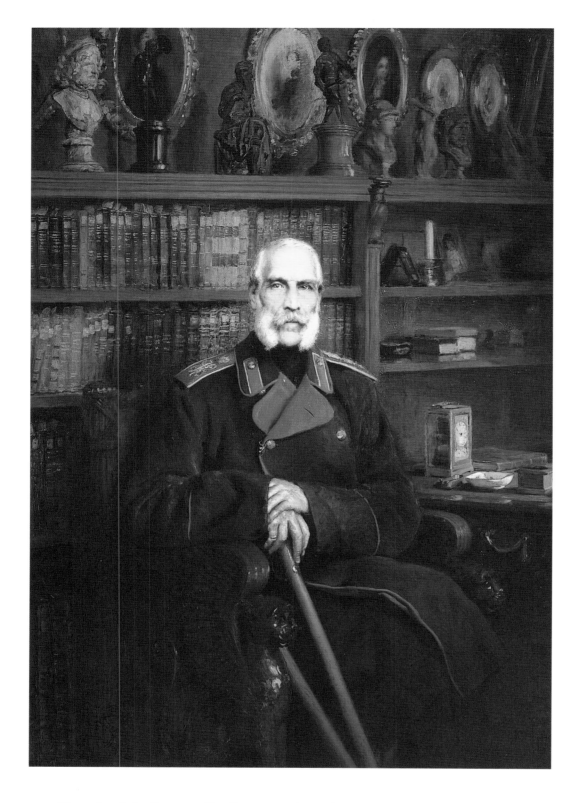

Konstantin Makovsky portrayed Count Sergei Grigorievich Stroganoff (cat. no. 37) during the last year of his life, seated in his study in the Stroganoff Palace surrounded by objects that reflect his lifelong interests. The portraits on the wall witness his dedication to family tradition, and the antiquities displayed on a bookcase filled with scholarly volumes tell of his achievements in developing the study of archaeology in Russia.

OPPOSITE: *This gold cup (cat. no. 57), presented by the citizens of Minsk Province to Count Sergei Stroganoff, is studded with symbols of war, science, art, abundance, and justice, representing his duties as their military governor. The cup's neo-Gothic decoration must have appealed to Sergei's veneration of the forms and artifacts of history; certainly, its symbolism coincided with the sense of civic responsibility that motivated him to extend his career as an administrator into an enormously influential role as an educator.*

The sale of the Stroganoff collection is the epilogue to this story. A special auction, painstakingly prepared by Stalin's regime, was held at the Lepke Gallery in Berlin in May 1931. The museum in the Stroganoff Palace was closed so that the government could dispose freely of its contents. Wishing to do away with any witness to these events, the regime purged the curator. The Bolsheviks emptied the palace and dispersed its treasures, but they could not destroy the Stroganoff legacy. At the moment of the collapse of the Soviet regime, the palace on Nevsky Prospect still stood as tangible evidence to the scope of Stroganoff grandeur, as it does to this day.

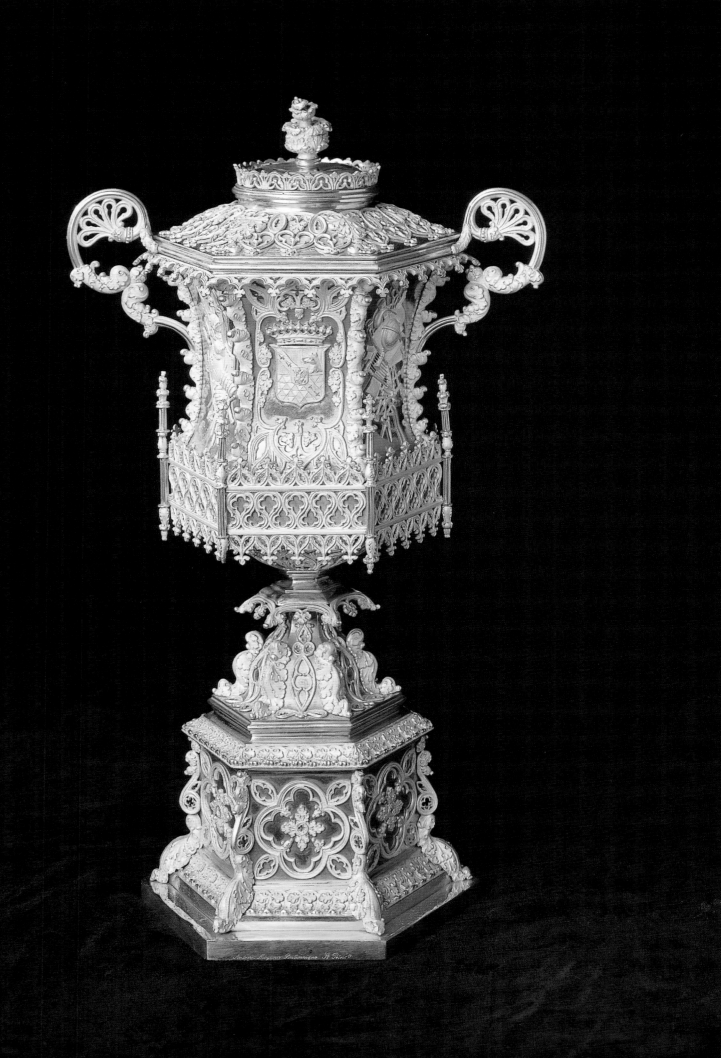

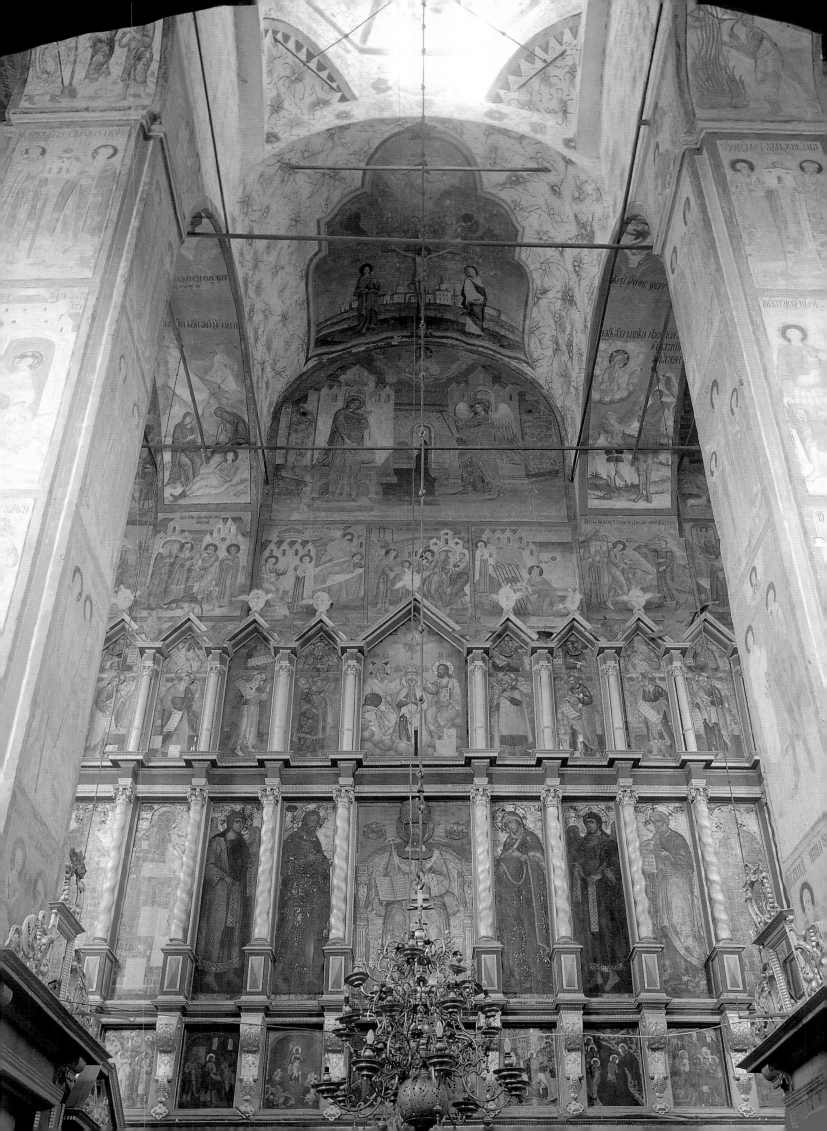

THE ART OF FAITH

Tatyana Vilinbakhova

THE STROGANOFFS WERE DEEPLY RELIGIOUS PEOPLE. EVEN IN TIMES WHEN religious devotion was nearly universal, theirs was special in the way it reflected their talents and their creative energy. As they acquired new lands in eastern Russia, the Stroganoffs became missionaries for the Orthodox Church. In each of their settlements and towns they built churches, founded monasteries, and filled them with icons, religious utensils, and books. In 1565 Anika (Ioniky) Feodorovich Stroganoff (1497–1569) even obtained permission from Moscow's metropolitan to convert heathens to Orthodoxy by having priests baptize converts in churches and monasteries on Stroganoff lands, and his descendants carried on his cause. Over the course of several centuries, the Stroganoff family maintained these religious institutions at its own expense.

ANNUNCIATION CATHEDRAL, SOLVYCHEGODSK The first two centuries of Stroganoff family history are linked with Solvychegodsk, a town far from Moscow, situated in the north of Russia where the Usolka River flows into the full waters of the Vychegda. The Stroganoffs first appeared in this area in the late fifteenth century, and it was here, in 1515, that Anika Stroganoff set up his first salt works, which quickly brought him prosperity, as it did to the town itself, then only a small settlement. Salt meant wealth and development, for it was a precious commodity in the Middle Ages, and, by the middle of the sixteenth century, Solvychegodsk had become one of the most prominent towns in the north and a major center for salt production, as well as a market for sable pelts. Merchants converged on Solvychegodsk from many different towns of Old Russia and from foreign coun-

OVERLEAF: *Detail of the Shroud of the Entombment (cat. no. 43)*

OPPOSITE: *View of the interior of Annunciation Cathedral in Solvychegodsk showing frescoes and the iconostasis, which supports painted icons arranged in tiers*

BELOW: *The construction of Annunciation Cathedral was begun in 1560 by Anika Stroganoff and completed by his grandchildren 24 years later.*

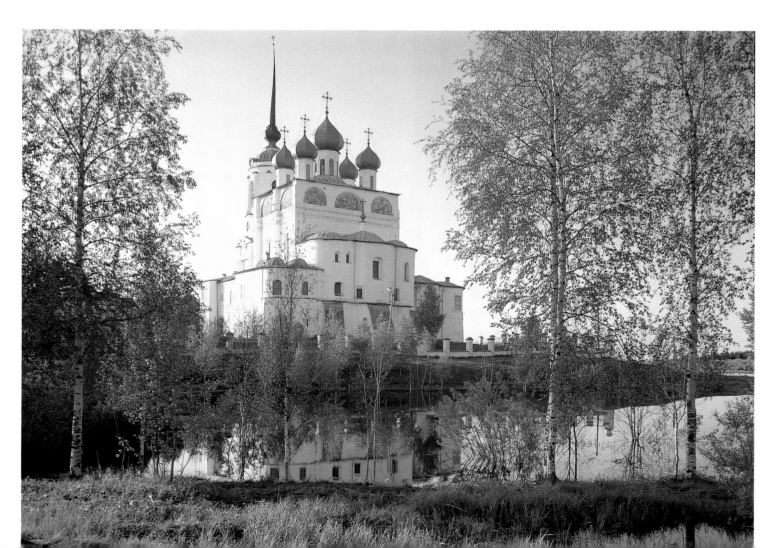

tries to buy salt and fur. By the second half of the sixteenth century, there were already eight churches in town, although all of them were wooden. In 1560 the foundation was laid for the first stone church—Annunciation Cathedral—by the same Anika Stroganoff, who by this time had left behind the vanity of worldly affairs and taken monastic orders following his wife's death. The church took twenty-four years to build; after Anika died in 1569, construction was completed by his sons and grandsons. The cathedral was testimony not only to the Stroganoffs' deep piety but also to their sense of enterprise and love of beauty, qualities that became distinctive family traits and were passed along intact to their descendants, together with their wealth.

The large, five-domed cathedral rises above the river even today, although it has undergone certain changes over the centuries. The church building was originally enclosed on three sides by a gallery with side chapels at the corners, nine chapels in all, one for each member of Anika's family. The crypts beneath the building served as storerooms, where the family archives were kept. Local legend has it that a dungeon existed in a separate section under the church where prisoners were left to languish. Family members were buried nearby, which gave the cathedral additional significance as the family burial vault. The church proper was surrounded by various wooden structures, including the houses and farms belonging to Stroganoff family members. Until the mid-seventeenth century, Annunciation Cathedral was the only stone church in this region.

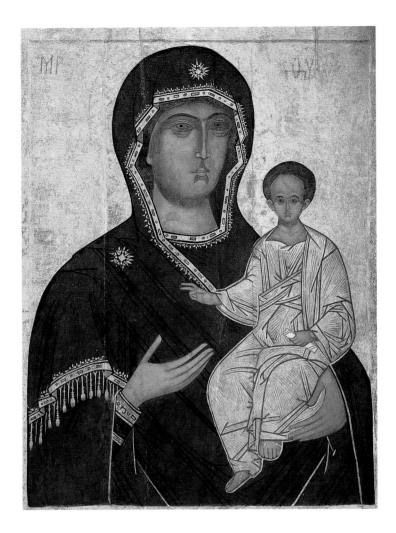

The interior decoration was remarkable as well. The walls of the entire church were covered with frescoes dating from the late sixteenth to the early eighteenth century and depicting the same subjects as murals in the churches of Moscow and nearby towns that date to the second half of the sixteenth century. The Stroganoffs had close ties to the tsar's court, and their Moscow orientation can be traced in many spheres of their multifaceted activities. As artistically sensitive and educated people, they kept close tabs on developments in Moscow's spiritual life and responded to them immediately, creating in their remote northern homeland their very own Moscow, their very own fiefdom. Even the dedication of the family cathedral to the Annunciation brings to mind the Annunciation Cathedral in Moscow's Kremlin, and many themes from the Moscow cathedral's paintings were repeated in the Stroganoffs' cathedral. The Stroganoffs were also among the first to commission icon painters to depict Moscow's new patron saints, Basil the Blessed and Tsarevich Dmitry (cat. nos. 7, 9). The latter was one of the Stroganoff family's most revered saints, and it was for him that Dmitry Andreievich Stroganoff (who died in 1673) was named. The icon of Tsarevich Dmitry, one of the earliest known images of this saint, was placed in a prominent position in the iconostasis of the Solvychegodsk Annunciation Cathedral, not far from the Royal Doors.

At this point it might be useful to examine the significance of icons for those who lived in Old Russia. Foreigners who visited Russia in the sixteenth and seventeenth centuries were

ABOVE: *This icon of the Virgin Hodegetria of Smolensk (cat. no. 6) is an example of the continuing presence of Byzantine art from which Russian icon painting sprang. Painted in the 16th century, the icon is one of many replicas made of a much-venerated icon carried from Byzantium to Russia in the 11th century.*

OPPOSITE LEFT: *This late-16th-century icon of Saint Basil the Blessed (cat. no. 7), an early depiction of the Muscovite saint canonized in 1588, is painted with a stylization typical of Moscow painters.*

OPPOSITE RIGHT: *The rapid development of the new Stroganoff school of icon painting is demonstrated in this early-17th-century icon (cat. no. 9) of Saint Tsarevich Dmitry, the son of Ivan the Terrible. It was painted for Andrei Stroganoff by Nazary Istomin Savin, who has rendered the face and hands with a miniaturist's delicacy despite its 5-foot height.*

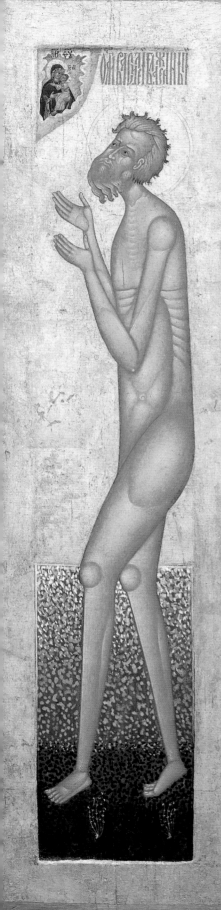

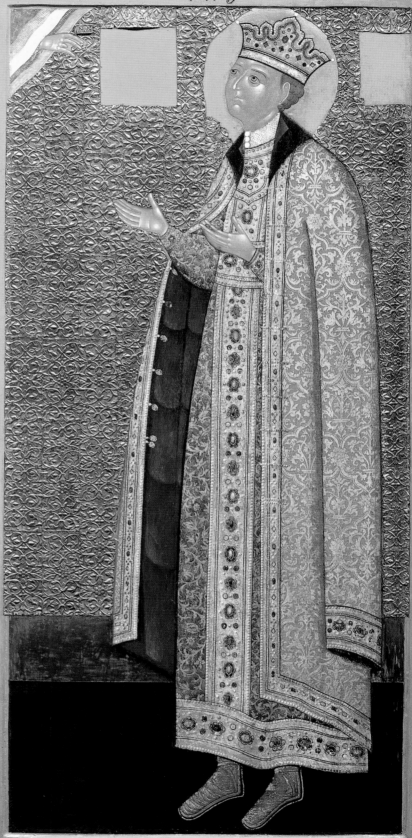

often struck by how many icons could be found in churches and private homes, above entrance gates, and even in structures used for livestock, but in fact the Russian people have for centuries believed in the ability of icons to help in all of life's circumstances. The art of icon painting arose in Russia with the acceptance of Christianity in the year 988. Russia took its pantheon of saints from Byzantium, and the first icons to be brought to Russia can be dated to the tenth and eleventh centuries. These icons were placed in newly built churches, where they were revered as sacred objects for centuries. Russian artists made numerous copies of these Byzantine icons, and these copies made their way throughout the land, even into the most remote corners of the country. The first icons in Russia are connected with Kiev, the capital of the Old Russian state, although there were not many icons in those churches, because frescoes and, more rarely, mosaics played the principal role in church decoration. The grand scale of building and painting projects in Russian towns during the Kievan period inevitably created a need in Russia for native-born artists, who did indeed appear, working at first as apprentices to the Greeks, but very quickly acquiring creative independence. In the twelfth century, local schools of architecture and painting were formed, especially in Novgorod, Ladoga, Polotsk, and the Vladimir-Suzdal area. The swift development of these schools was interrupted by the Tatar Mongol invasion and the towns of south and northeast Russia nearly ceased artistic activity after being destroyed by the hordes. Church construction was either halted altogether or was limited to small, usually wooden churches that did not call for luxurious interior decoration but whose main appointments were icons.

Icon painting began to develop in Russia in the mid-thirteenth century, especially in regions that had avoided the devastation. Local features and differences were evident in the icons, resulting from idiosyncracies of local observance and the distinctive historic and psychological makeup of each region's inhabitants and traditions. Most fortunate was the fate of Novgorod, which was protected from the Tatar hordes by impenetrable forests and thus did not experience the horror of destruction. Novgorod remained a large and powerful artistic center, where magnificent icons were painted; in the fourteenth century wall-painting ensembles were created there that are internationally known, such as those of the Church of the Dormition in Volotovo field (1363), the Church of the Savior in Kovalyovo (1380), and the Church of Theodor Stratilates in Ruchyo. In them one finds not only exceptional artistry but also a profound philosophical understanding of the events depicted. In both style and vocabulary one clearly sees connections with southern Slavic culture and a familiarity with the most recent variations in iconography worked out by the Byzantine world. It is no accident that Theofanes the Greek, a brilliant Byzantine artist whose wall paintings have survived in the Church of the Transfiguration of Our Savior on Ilya Street in Novgorod, found a haven and base of operations here for many years. The local Novgorod icon school demonstrated its highest achievements in the fifteenth century, which is usually considered the classical age of Russian icon painting.

During this era, which witnessed a movement for Russia-wide unification and was made sacred by the memorable victory over the Tatars on Kulikovo field, works of the highest artistic level were created. In spite of terrible poverty and devastation—"the deep hostility that had corrupted Russia," as P. A. Florensky wrote—themes of amicable unity, brotherly love, and mercy were increasingly expressed in art. These themes came through with unprecedented purity and sublimity in the icon painting of Moscow, finding their supreme

The border scenes of this icon of the Virgin of Vladimir from the original iconostasis of Solvychegodsk (cat. no. 4) retain the overlay of intricately embossed silver whose richness is characteristic of Stroganoff taste. The precious metal was stripped and melted down from many icons during the 17th century, making this icon and that of the Tsarevich Dmitry (cat. no. 9) objects of extreme rarity.

OVERLEAF: *More than 6 feet in height, the monumental* Trinity *icon at the left (cat. no. 2) and the closely related* Annunciation *icon (cat. no. 3) from the original Solvychegodsk iconostasis were among the most important images in the church, whose mural decoration repeats the same subjects. The border scenes of both panels are so complex in their iconography that it is thought they were painted in Moscow.*

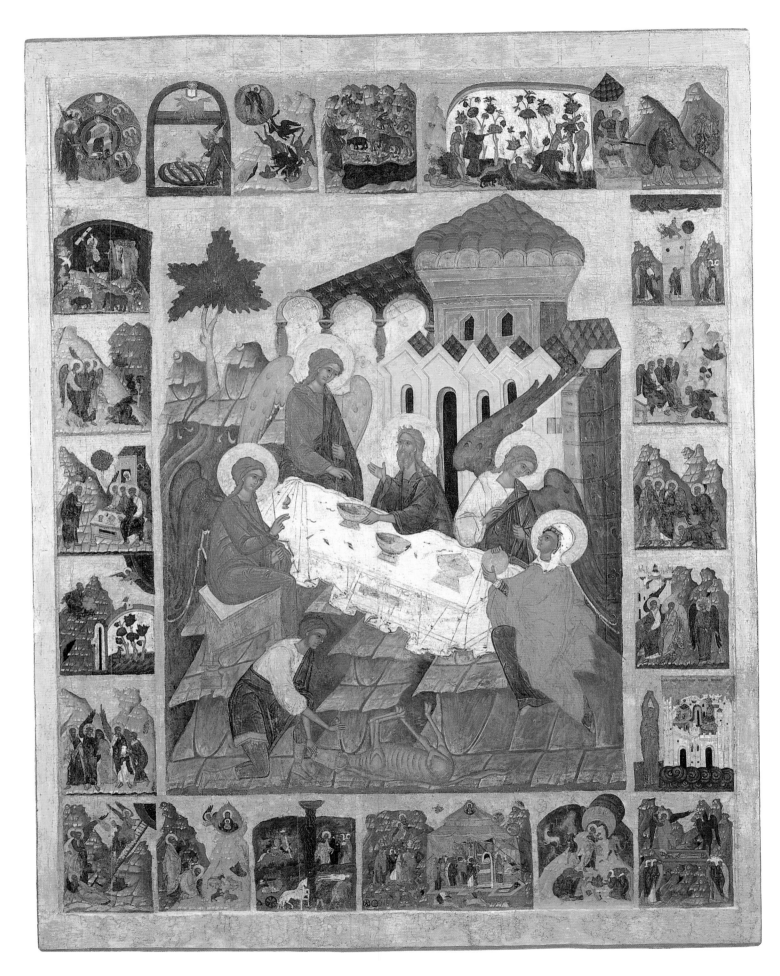

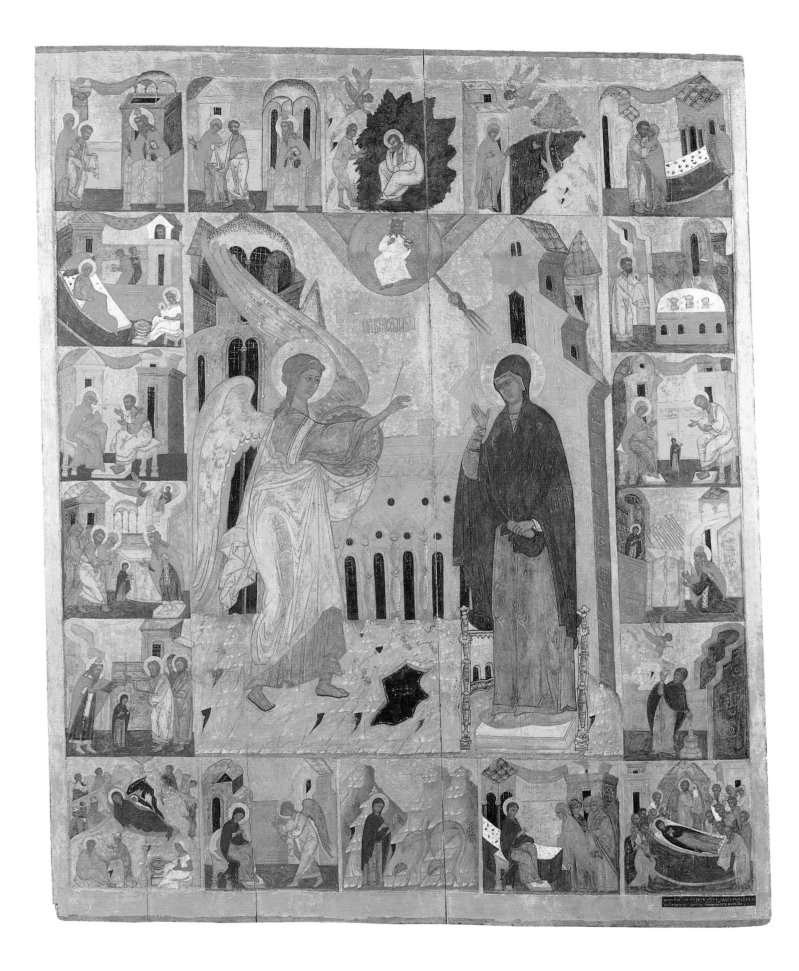

This arched panel, called a canopy (cat. no. 1), occupied the space above the royal doors at the center of a Solvychegodsk iconostasis. At the lower corners are the figures of Saint Nikita and Saint Eupraxia, patron saints of Nikita Stroganoff and his wife.

embodiment in Andrei Rublev's *Trinity.* Won over by the perfection of Rublev's icon, many icon painters addressing this same theme simply varied the solution he had created. The images produced by Muscovite icon painters in the fifteenth century look toward the bright world of the human spirit, embodying man's dream of a high moral ideal.

At this time the tall, multitiered iconostasis—a form peculiar to Russian religious culture, with no analogies in the Byzantine world—achieved its most perfect form. The composition of the iconostasis exerted considerable influence on church decoration, especially on wall frescoes, which were an important element in the synthesis of the arts brought about in the church. The iconostasis of the Stroganoff cathedral was typical for Old Russia at the beginning of the fifteenth century: a high wall made up of icons separated the altar from the rest of the church. The icons were mounted in multiple tiers intended to reveal the spiritual essence of what takes place in the sanctuary. The structure of the iconostasis, whose purpose is to bring people closer to God and reveal to them the path to salvation, is based on an elegant system expressing the breadth of religious dogma. The upper tiers represent images of the patriarchs and prophets of the Old Testament above and depictions of the principal events in the New Testament below. This second tier follows the church calendar of feast days and consists of icons devoted to the lives of Christ and the Virgin. Below that is the principal tier of the iconostasis, the *deisus,* in the center of which is Christ the Almighty. On either side of him, arranged in strict hierarchical order, are images of the Virgin, John the Baptist, the archangels, the apostles, the fathers of the church, and the martyrs. This ranking illustrates the prayer of the saints before Christ on the Day of Judgment. In the center of the lower, or "local," tier are double doors, called the Royal Doors, a symbolic passageway for Jesus Christ during Holy Communion. Flanking the doors are icons of Christ, the Virgin, and locally revered saints and feast days.

In accordance with the Stroganoffs' tastes, the iconostasis of Annunciation Cathedral was richly adorned. Its icons were overlaid with sheets of embossed silver, often studded with precious stones; examples of this silverwork can be seen in the icons *The Virgin of Vladimir with Scenes of Major Church Feasts* and *Saint Dmitry the Tsarevich* (cat. nos. 4, 9). Later the iconostasis was redone, but many of the original icons were preserved. Among the most

important examples that survive from the original iconostasis are the large *Trinity with Scenes from the Old Testament* and the *Annunciation with Scenes from the Life of the Virgin* (cat. nos. 2, 3), which date from the 1580s and 1590s. These two icons were significant elements in the decoration of Solvychegodsk's Annunciation Cathedral; both were placed in the local tier of the iconostasis, but their iconography and artistic conception are linked to paintings throughout the entire cathedral. Fresco depictions of the Trinity and the Annunciation on each side of the portal greet all who enter the cathedral from the porch. The walls inside the cathedral are painted with scenes from Biblical history, many of them similar to the border compositions on the icons, which are thought to have been painted in Moscow because of their complex iconography. The iconographic program of the *Trinity* icon is similar to an icon of the same subject in the Cathedral of the Annunciation in Moscow, painted shortly after a disastrous Kremlin fire in 1547.

The icons that adorned the Church of the Annunciation included several images of the Virgin of Vladimir—echoes of the famous Byzantine icon kept in Moscow's Kremlin. Originally the icon had been taken from Constantinople to Kiev and in the twelfth century to Vladimir, where it became the city's principal sacred object and acquired the name Virgin of Vladimir. In 1395, when Moscow was threatened with devastation by Tatar forces, the icon, famed for its miracle-working powers, was transported from Kiev to Moscow, and the advancing Tatars turned back. Moscow's salvation was ascribed to the miraculous intercession of the Virgin, and the icon's fame grew even greater. For a while, the icon was to have been returned to Vladimir, but in 1480 the decision was made to keep it in Moscow. By this time, it had become a sacred object for all of Russia, relieving all manner of disaster and illness and defending against enemy attacks. Innumerable copies found their way to every part of Old Russia. The sixteenth-century master who painted this Stroganoff example (cat. no. 4) surrounded the central image with depictions of the major church feast days arranged according to the iconostasis sequence, and embellished them with embossed silver mounts.

Saint Nicholas of Myra with Twenty Scenes from His Life (cat. no. 5), which stood in the local tier of intercessor saints in the iconostasis, was one of the most popular icons in Solvychegodsk. Reverence for Saint Nicholas was widespread throughout Old Russia. He was called the Russian God, and there was not a church that did not have his icon. A side chapel in Annunciation Cathedral was dedicated to him.

The exact provenance of the Royal Doors in the exhibition (cat. no. 10) is not known, but it is clear that they were originally from an iconostasis in one of the Solvychegodsk churches. The style of the painting suggests that they may have come from one of the side chapels of Annunciation Cathedral.

In the image of Saint Nikita (cat. no. 8), which is also connected with the cathedral, the saint is represented not as a warrior, as was customary, but as a martyr meekly praying to the Virgin and the Christ Child. The name of this saint was given to Nikita Grigorievich Stroganoff (1560–1616), who commissioned several icons of his heavenly protector. One often encounters icons like this among the Stroganoff commissions; saints who share names with the family are usually represented in prayer to the Savior or Virgin, as if to intercede on behalf of their wards. Nikita Grigorievich was primarily responsible for the decoration of the family cathedral, being the principal donor of most of the icons, and many of his icons are recorded in the cathedral inventories.

Nikita Stroganoff was the principal patron of Annunciation Cathedral in Solvychegodsk and had a special interest in icon painting. For this depiction of Saint Nikita (cat. no. 8) he altered the traditional iconography of the saint as a warrior to that of a wealthy man in prayer, which closely resembles the representation of the saint at the lower left corner of the canopy reproduced opposite.

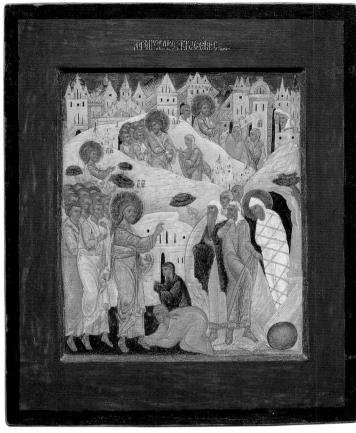

Nikita Grigorievich Stroganoff was not only a great connoisseur and collector of icons, but he also painted icons himself. His cousin Maxim Yakovlevich emulated him in this activity, and it is to the influence of these two men that we must attribute the great upsurge in icon painting that took place under the aegis of the Stroganoff family in the late sixteenth century and during the first quarter of the seventeenth. The 1580s saw the start of the Stroganoff icon workshops, with the largest and most important one built at Solvychegodsk, followed by others on new lands as they were acquired by the family. The need for them was great, and their activity quite intensive. However, recent research enables us to conclude that there are no substantial grounds for definitively connecting the icons of Annunciation Cathedral with the activities of these workshops, and no written evidence as to the authors of these icons has survived. They could have been talented local artists or icon painters invited from elsewhere. Stylistically, they correspond to the principal trends in icon painting of the second half of the sixteenth and the early seventeenth centuries. If monumentality, intensity of color, and a dynamism of forms that connect them with the traditions of the classical fifteenth century are present in the *Trinity* and *Annunciation* icons, then the fine graphic resolution and miniature quality of forms in the *Saint Dmitry the Tsarevich* icon are characteristic of the so-called Stroganoff school.

THE STROGANOFF SCHOOL OF ICON PAINTING What is the so-called Stroganoff school of icon painting? In the history of art, the term has been used to denote a particular trend in Russian icon painting of the end of the sixteenth century and the first quarter of the seventeenth. These icons are distinguished by their virtuoso technique, the beauty of their pure, lumi-

The author of these four small icons of the Baptism, the Raising of Lazarus, the Entry into Jerusalem, and the Descent into Limbo (cat. nos. 11–14) is known to be Mikhail, a master of the Stroganoff school, because he signed the reverse of each one. They are believed to have come from a single tier on a Solvychegodsk iconostasis and were brought together again when Count Sergei Stroganoff set about collecting dispersed icons of the Stroganoff school in the 1840s.

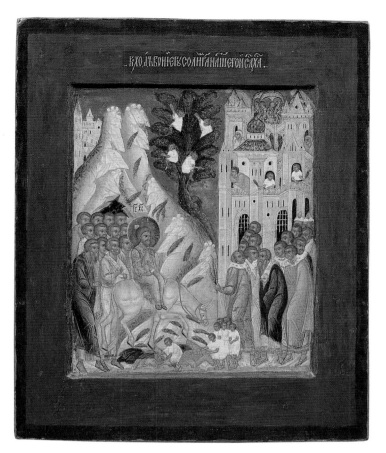
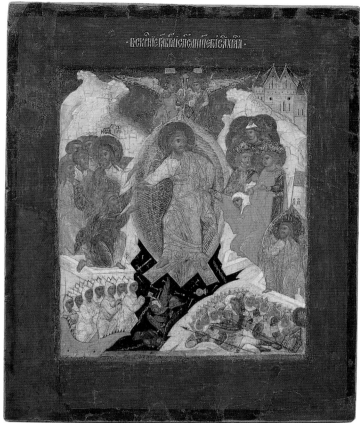

nous paints, and the diversity of subjects conveyed in myriad, painstaking detail, usually on a small wooden panel. We can still read on many of them inscriptions identifying the artist or the patron who paid for the work, and, once again, among those patrons we see the names of Stroganoffs—Nikita, Maxim, and Dmitry—who were among the first to appreciate and collect these icons. It was from these individuals that the trend took its name and became known as the Stroganoff school, although the artists were primarily from Moscow or were trained by Muscovites in the Stroganoff workshops. The Stroganoffs filled the chapels of their houses with these icons, and many, of course, were placed in Annunciation Cathedral.

In the middle of the seventeenth century a religious movement, known as the Old Belief (or Schism), arose in Russia in which those who held to traditional beliefs resisted political changes that were steering the country onto a new, European path of development. In icon painting, the Old Believers rejected attempts to introduce new forms and subject matter borrowed from Western culture. They extolled the art that had existed before the second half of the seventeenth century as the exemplar of true icon painting and recognized Stroganoff as the standard for true depiction, the model to be followed and emulated.

Beginning in the second half of the seventeenth century, when the center of the Stroganoffs' business activity moved to the Urals and the city of Nizhny Novgorod, Solvychegodsk went into a gradual decline. The first historian of Solvychegodsk, Alexei Soskin (1761–1822), reported that in his day there remained only one of the thirty salt pans that had been in operation in the sixteenth century and that it scarcely functioned. The fur trade had also come to a virtual standstill. A ruinous fire in 1819 damaged Annunciation Cathedral, and it was decided to collect money for its repair through the private sale of icons. More

than thirteen hundred icons from the cathedral were sold to the merchant N. Papulin, who placed them in Old Believers' chapels. Other miniature icons were scattered throughout Russia. "In our day, Stroganoff icons, so excellent for their drawing, enjoyed great renown," wrote a contemporary historian, K. Kalaidovich, in 1823. By order of the government, innumerable images had been confiscated from small monasteries and Old Believer homes and taken to the storehouse in Moscow. By the middle of the nineteenth century, the icons of the Stroganoff masters were concentrated in large numbers in private collections, mostly in Moscow. In 1849 the renowned icon scholar Ivan Sakharov counted more than one hundred private icon collections, including that of Sergei Grigorievich Stroganoff, a well-known connoisseur of Russian antiquities.

In the 1840s, Sergei was trustee of the Moscow Educational District, where he assembled his collection, which consisted mostly of icons obtained from the storehouse of one of the Moscow monasteries. Sergei Stroganoff requested and received permission to salvage icons for his own collection from this confiscated hoard. He chose primarily examples that had inscriptions on the back indicating that they had belonged to the Stroganoff family. After completing his service as warden, Sergei Stroganoff left Moscow and settled in St. Petersburg, and his icon collections took their place in the Stroganoff Palace on Nevsky Prospect. And so the family's sacred objects from Annunciation Cathedral were returned to their original owners.

Nikodim Kondakov, one of the foremost scholars of ancient Russian art, has written that no other collection could provide as much for the study of the Stroganoff school as Sergei's. To this day, the inscriptions on those icons remain our chief source of information about the masters of the Stroganoff school, including Semeika Borozdin, Yemelion Moskvitin, Mikhail (or Mikhaila), Pervusha, Nikifor Istomin Savin, and Semion Khromy. Although these artists all display general features of the style linking them in a single artistic movement, each one expresses a vivid individuality.

The artist represented by the greatest number of icons in Sergei Stroganoff's collection is Mikhail. We do not know his dates, and we know his name thanks only to the inscriptions on his icons, in all of which we encounter solid, dark olive backgrounds that emphasize the luminosity of the pure, bright colors and heighten the drama of the events depicted. Originally the Mikhail icons were all part of the feast tier of a single iconostasis and only later were they separated. The subjects are the Baptism of Christ, the Raising of Lazarus, the Entry into Jerusalem, and the Descent into Limbo (cat. nos. 11–14). In many ways, Mikhail takes a traditional approach to his stylistic devices; his figures do not have the lightness and fragility that distinguish most of the works of the other Stroganoff masters. Despite the small dimensions, the icons retain the impression of the monumental form, thanks to the enlargement of the figures relative to the total space of the icon plane and to their somewhat heavy proportions. While the main subject always occupies the central place in the icon, Mikhail shares with other Stroganoff icon painters the desire to show a sequence of events unfolding over time. Thus, in *The Raising of Lazarus* he combines four episodes connected with this evangelical event, and the composition seems to function on several planes. The culminating scene—the resurrection by Christ of his dead friend and follower Lazarus—is depicted on a larger scale than the others and placed in the foreground. The events leading up to it—the

Nikifor Istomin Savin was an outstanding master of the Stroganoff school who could transform a standard subject such as Saint George (cat. no. 17) into a composition of fairy-tale enchantment, giving as much attention to the richly clad princess and the amusing dragon as to the saint himself.

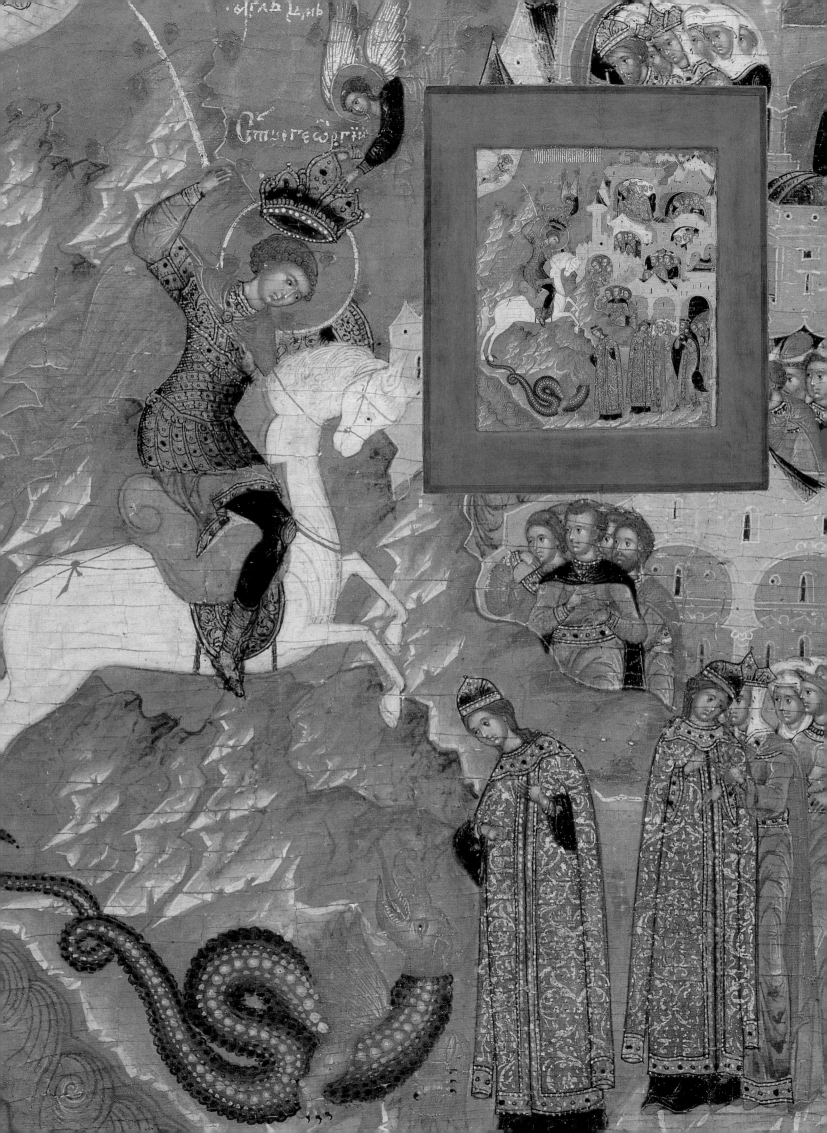

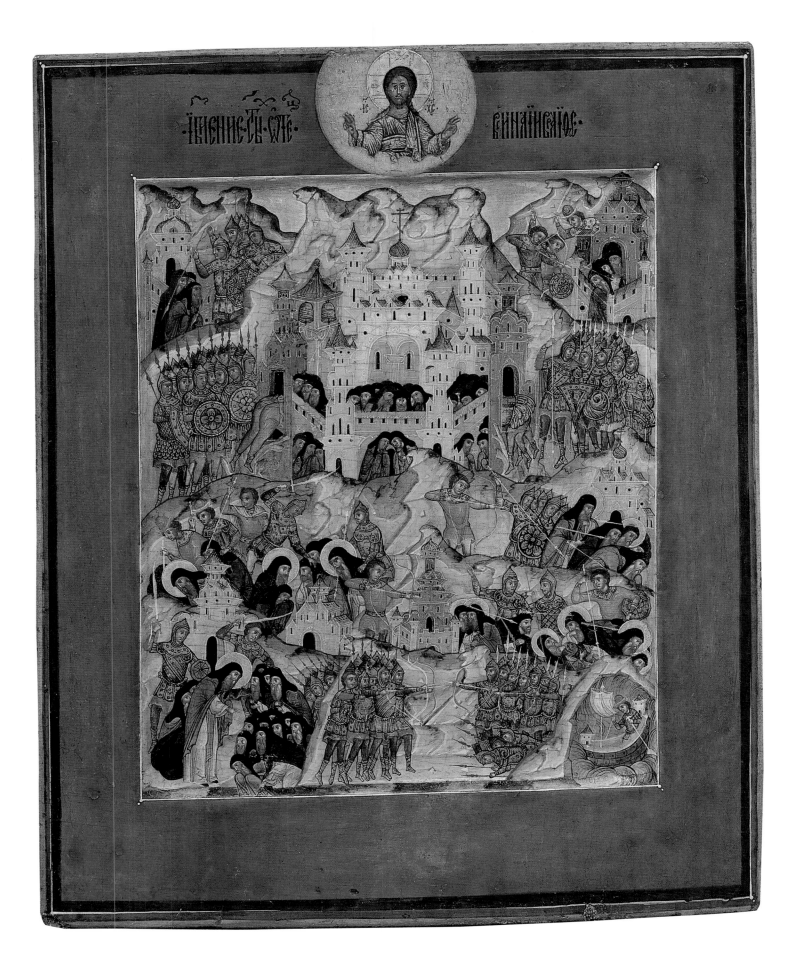

ABOVE: *Nikifor Savin's imagination triumphs in this early-17th-century icon (cat. no. 16), in which an elegant angel banishes the devil of dreams.*

OPPOSITE: *In a remarkable feat of illustration, the Stroganoff master known as Pervusha compresses on a single 14-inch panel (cat. no. 19) the dramatic tale of early Christian monks slaughtered by Arab nomads in their monastery at Mount Sinai (shown at the top in radiant pastel colors to signify spiritual light). The attackers of the martyred monks (depicted with halos) were subsequently routed by troops dispatched from the city of Pharan in a battle that is depicted below, in the lower register.*

meeting of Christ and his pupils, first with Martha, and later with both sisters—are depicted on the ledges of cliffs and in reduced size to create the illusion of a distant expanse, a device also found in sixteenth-century manuscript illumination. Additional episodes that are brought into the composition develop and clarify the idea of resurrection that is set forth in the principal scene.

Elegance and refinement characterize the images of the Stroganoff master Nikifor Istomin Savin. The bodies seem to have lost their flesh; the hands are very fine; the tiny feet barely touch the ground with their toes. The icon painter has drawn intricate patterns with a fine brush on the clothing and architectural forms over a multilayered painting in tempera, to which gold, silver, and colored varnishes have been applied. The colored layer under the gold ground and the fine black drawing over it are what create the icon's glittering, painterly surface. These icons are also distinguished by their bright but subtly varied colors. The artist has stripped the epic quality from the subject of Saint George slaying the dragon (cat. no. 17), which is usually portrayed as a lone hero in action, and has allowed many spectators to participate in Saint George's victory. The city is filled with people, but the tsar and tsaritza, with a colorful crowd of courtiers, occupy most of the surface of the icon. An angel has flown down from heaven to set a crown on the head of the victor, who has been crowded out of the center and is distinguished only by his size.

The text of a bedtime prayer is the theme of another of Nikifor's icons, *An Angel Protecting a Sleeping Man's Soul and Body* (cat. no. 16). The symbolic meaning of the guardian angel can be seen in funeral records that contain meditations on life and death: the guardian angel drives out the demon during sleep and protects man from all misfortunes while he is awake. In the icon, the angel is depicted standing at the head of the sleeping man's bed holding up a cross, the force of which chases away the devil. A deisus with Christ, Mary, and John the Baptist appears above the bed like the embodiment of the evening prayer and a reminder of the Day of Judgment.

The extreme refinement of these works, which brings to mind the Late Gothic art of western Europe filtered through the post-Byzantine imagery of Greek icon painters, is shared by Nikifor Istomin Savin and another Stroganoff master, Pervusha, a pupil of the famous Stroganoff icon painter Prokopy Chirin. Pervusha's *Massacre of the Holy Fathers at Mount Sinai and in the Rhaithou Desert* (cat. no. 19) depicts an early Christian event of the fourth century, marked by the church on January 14. As described by the Egyptian monk Ammonius, several monks living in the caves of Mount Sinai and in the desert of Rhaithou near the Red Sea, "two days journey from Sinai," were attacked by barbarians, nomadic Arab tribes who had arrived in ships. Troops were sent from the town of Pharan to help the righteous men, and the heathens were vanquished. Pervusha has combined a number of episodes in a single, complex composition. Mount Sinai rises in the background behind the brightly lit monastery,

LEFT: *Nikita Ivanov Pavlovets's* Old Testament Trinity *icon (cat. no. 21) was one of the few collected by Count Sergei Stroganoff that is not an example of the Stroganoff school but rather of its influence in the miniaturist virtuosity of a later Moscow artist.*

OPPOSITE: *This unidentified master of the Stroganoff school employed its typical device of illustrating an entire narrative in a single composition (cat. no. 18). The anecdotal story of Jonah is used to convey a political message as God looks down with favor on the repentant population of Nineveh. Repentance and forgiveness were popular themes offered as a moral resolution of the civil strife that occurred during the period in the 17th century known as the Time of Troubles.*

and the monks are shown hiding behind its walls dressed in black, hooded robes. In keeping with the tradition of ancient Russian painting, the artist has contrasted the asceticism of the monks' outward appearance and the illumination of the spiritual world as embodied in the image of the monastery. In the lower part of the icon are scenes showing the massacre of the holy fathers (shown with halos to signify their martyrdom) and the battle between the Arab nomads and the warriors from Pharan. In the middle of the upper portion, Christ is shown blessing the righteous who have died for their faith. A ship broken up against the cliffs conveys the idea of the inevitability of the enemies' death. This subject is rare in ancient Russian art, but compositions reproducing the topography of Mount Sinai and the monastery of Saint Catherine became widespread in Greek icon painting beginning in the sixteenth century, and such examples undoubtedly reached Old Russia as well. Pervusha's icon is clearly an early Russian adaptation of the sacred mountain.

Heightened interest in the lives of the holy fathers is a typical feature of the era. Among the saints canonized in church assemblies of the mid-sixteenth century we find many monks and founders of monasteries, whose lives are compared with the zealots of the first centuries

of Christianity. Their images appear in icons, illuminated manuscripts, wall paintings, and literary sources as well.

Another Stroganoff master close to Pervusha in his creative principles was the anonymous painter of *The Story of the Prophet Jonah* (cat. no. 18). As in other examples from the Stroganoff school, the plane of the ark is divided into two parts along the diagonal, which in this case is formed by the shoreline on which Jonah's ship has run aground. Jonah is shown in three episodes: being thrown into the sea, being swallowed by the whale, and sitting under a tree after having been spit back onto land. Most of the right half of the icon is filled with the inhabitants of Nineveh, who are contrite over their lack of faith and who have led even their cattle to repentance. They are all praying to Christ, who blesses them and draws their attention to the Gospels.

Inscriptions identifying three generations of Stroganoffs as donors of this basin for holy water (cat. no. 54) to Solvychegodsk's Annunciation Cathedral in 1633 have been worked into the decoration by a masterful local goldsmith.

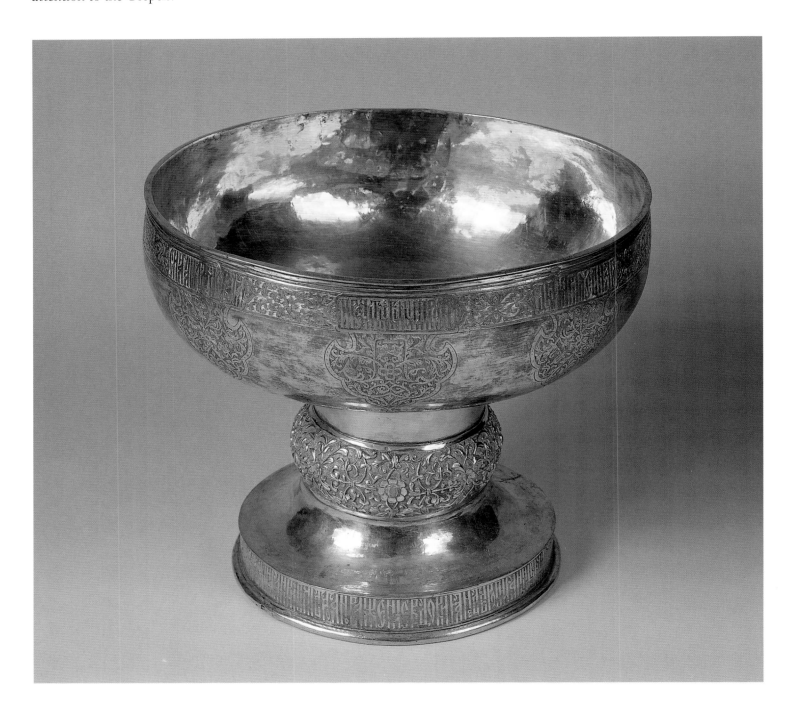

This reliquary cross (cat. no. 51), one of three donated to the cathedral by Nikita Stroganoff, was carved from fragments of the wooden coffins of the saintly princes Vasily and Konstantin of Yaroslavi, who are depicted in carved medallions below the figure of Christ.

The icon advances a moral theme rooted in the history of the era of Ivan the Terrible (1533–84). At the top Christ is shown reigning over all. He has turned away from Jonah, who is suffering misfortune and toward the repentant Ninevans, who rejoice. The call for repentance, so impassioned here, was a typical image in this chaotic period, called the Time of Troubles by Russian historians, as the wars and other problems were understood by the people to be a punishment for sin. The prophet's story was also reproduced in detail in the wall paintings of Annunciation Cathedral in Solvychegodsk, and the composition in this icon may well be directly connected to those murals.

The works of the artists of the Stroganoff school make up the largest and most important part of Sergei Stroganoff's collection. The remaining icons in the collection date from the seventeenth through nineteenth century, among them an interesting icon made by a famous painter from the Armory in Moscow, a storehouse for weapons that was transformed in the mid-seventeenth century into a large art studio that functioned as a kind of Academy of Fine Arts and attracted the best icon painters from towns all over Old Russia. Here worked Nikita Ivanov Erofeev's son, known as Pavlovets, because he was born in the village of Pavlovskoe in the region of Nizhny Novgorod. His art is noted for its virtuoso technique and fine miniature drawing inherited from the masters of the Stroganoff school. These characteristics of his style are clearly visible in the round icon *Old Testament Trinity* (cat. no. 21), dated 1670–71, demonstrating that the traditions of the Stroganoff school persisted in Russian icon painting for a very long time, even into the modern era.

Apart from icon painters, many other kinds of masters worked for the Stroganoffs, especially silversmiths. Like the painters, they did an extraordinary amount to make Annunciation Cathedral in Solvychegodsk a center for artistic interests throughout the northern region. Workshops set up by the family and staffed with serfs and artisans invited from other towns

manufactured icon covers, carved icons, and made crosses, religious utensils, and lamps, as well as domestic items. Their productions are unusual for the diversity of their techniques and their high artistic level. A brilliant example of such an item is the reliquary cross presented to Annunciation Cathedral in 1610 by Nikita Grigorievich Stroganoff (cat. no. 51).

In the late seventeenth century, the Solvychegodsk masters were becoming proficient in a new enamel-painting technique, known as Usolye enamel (Solvychegodsk was also called Usolye Vychegodsk), in which an image in vivid, translucent colors was imposed on a white opaque enamel. The technique was used to decorate the inner and outer surfaces of vessels, usually intended for domestic use, and icon covers were also executed in this technique. In the exhibition is a corner piece of a bible cover (cat. no. 61) with an image executed by a Usolye icon painter, who has added an inscription, an extremely rare feature, and a fortunate one for scholars.

THE STROGANOFF LIBRARY OF THE SIXTEENTH AND SEVENTEENTH CENTURIES

Tradition has it that the first Stroganoff library of manuscripts and rare books was the largest private library in Old Russia. Anika Stroganoff was its founder, although there is reason to believe that he inherited some of his books from his father. After Anika's death, the library was divided up among his heirs—Nikita Grigorievich, Maxim Yakovlevich, and Andrei Semionovich—all of whom were renowned bibliophiles. The library of Maxim Yakovlevich, for instance, numbered more than three hundred manuscripts and books. After the passing of

This illustrated irmologion, or songbook (cat. no. 109), is the product of the Stroganoff scriptorium, founded in the 1580s to supplement the works of literature that could be purchased or commissioned for the Stroganoff libraries, an essential part of the family culture. The book employs a method of transcription especially devised for the unique form of church singing that developed by the family chorus and eventually entered the mainstream of Russian song tradition.

OPPOSITE: *This 17th-century enamel plaque (cat. no. 61) depicts Saint Luke writing the gospel that would have been contained within the elaborate bible cover of which this corner piece is a fragment. The discreet inscription in the floor tiles, indicating that this is the work of an icon painter from Usolye, the region around Solvychegodsk, provides rare documentation of the production of silverwork enlivened with colorful painted enamels that flourished under Stroganoff patronage.*

this generation, the volumes were inherited by other members of the family, although there were exceptions, such as the library of the childless Nikita Grigorievich, which was sold in Moscow in 1616. What made the Stroganoff book collections special was that many volumes were collected with the intention of eventual donation to churches and monasteries on the Stroganoff estates, as well as other churches, for use in services and for private prayer. In the early seventeenth century, there were approximately two hundred books in Solvychegodsk's Annunciation Cathedral alone, including psalters, gospels, apostles, hours, services, lives of saints, and other manuscripts, as well as some early printed works. The subject of most Stroganoff books was religion and spiritual benefit, with morally edifying collections such as the *Bee* and the *Teachings of John Chrysostom*. Of a secular nature were chronicles and annals of Russian and world history, legal codes, and translations of classical Greek authors such as Menander, as well as basic educational textbooks on the alphabet, arithmetic, and grammar.

Although the Stroganoffs bought or commissioned many books, most were created in the family's scriptorium, which was founded in the 1580s and where fine manuscripts were executed and often illustrated with great artistry. Among the masterpieces that have been preserved is a primer in which each letter of the alphabet is written on a separate sheet in several variations, along with various examples of illuminations and initials, which served as models for scribes and artists. The primer has enabled present-day scholars to identify which of the surviving manuscripts of the period are the product of the Stroganoffs' scriptorium.

We should mention in closing another important feature of the Stroganoffs—their enthusiasm for church singing, a tradition that was passed down through the generations. At Annunciation Cathedral the family formed its own chorus, which later became the core of a school for singing to which they contributed songbooks, many of them transcribed in Stroganoff workshops (cat. no. 109). The earliest records of Usolye singing appear in collections from the 1580s and 1590s, which came out of the Stroganoffs' transcription workshop at Usolye Vychegodsk. The songs of the Usolye masters have become generally recognized and have entered the mainstream of the Russian song tradition, and the Usolye school of singing has played a significant role in the history of Russian culture.

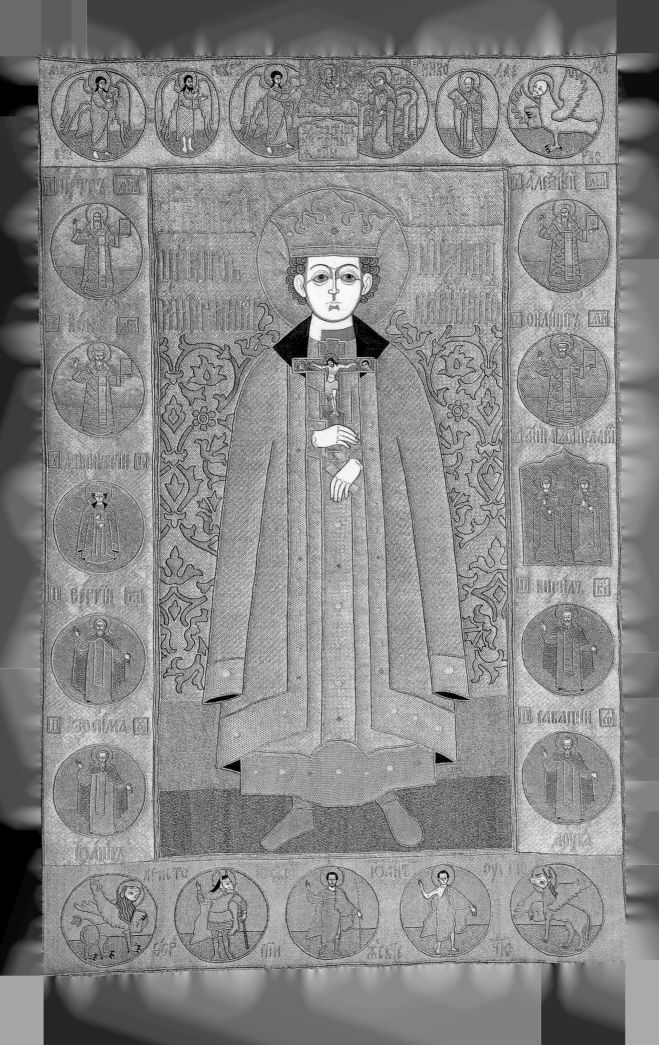

STROGANOff EMBROIDERY

Liudmila Likhachova

This life-size embroidered shroud (cat. no. 44) of Saint Dmitry the Tsarevich, her husband's patron saint, was made by Anna Stroganoff and her assistants. Her personal participation is believed to have gone beyond the intricacies of needlework to actually drawing the design on the fabric, normally the responsibility of icon painters. The figure from the border below represents Khristofor, the founder of a monastery near Solvychegodsk. He is shown as having a dog's head because official iconography had not yet been established. Such details must have had enormous appeal for the people of the region.

MANY EXAMPLES OF THE ECCLESIASTICAL EMBROIDERY MADE IN SOLVYCHEGODSK in the late sixteenth and seventeenth centuries by the Stroganoff wives and daughters figure among the treasures of the State Russian Museum. Some of them include inscriptions, occasionally with exact dates; others represent the saints who were particularly revered by the Stroganoff family. A few pieces can be definitively classified as Stroganoff items, while others are attributed to them on the basis of the style, drawing, and stitching technique.

Embroidery was one of the obligatory occupations for women of privilege in Old Russia. The Stroganoff wives not only did embroidery themselves, but they also taught this art to their daughters and employed expert embroiderers in their homes to work under their supervision. In addition, the family established large embroidery workshops.

Stroganoff embroidery is noted for its unusually refined technique. In the mid-seventeenth century a specific Stroganoff style of embroidery evolved featuring needlework made of couched gold thread, a technique in which threads are laid on top of the background fabric and anchored with silk threads to form geometric patterns. Faces were worked in a grayish silk with fine, precisely drawn shadings solidly stitched in a satin thread, and the contours of the figures and the folds of the clothing were denoted by raised silver lines. The

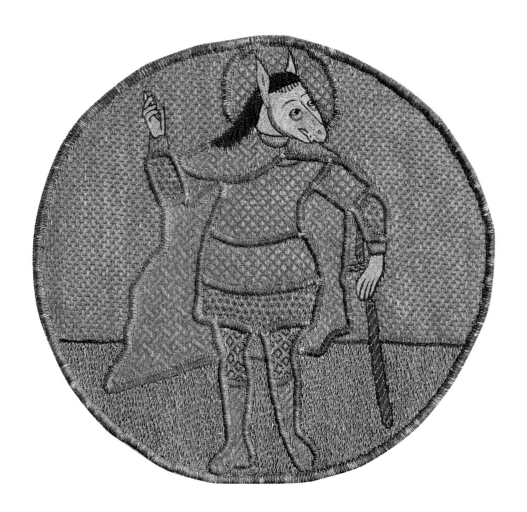

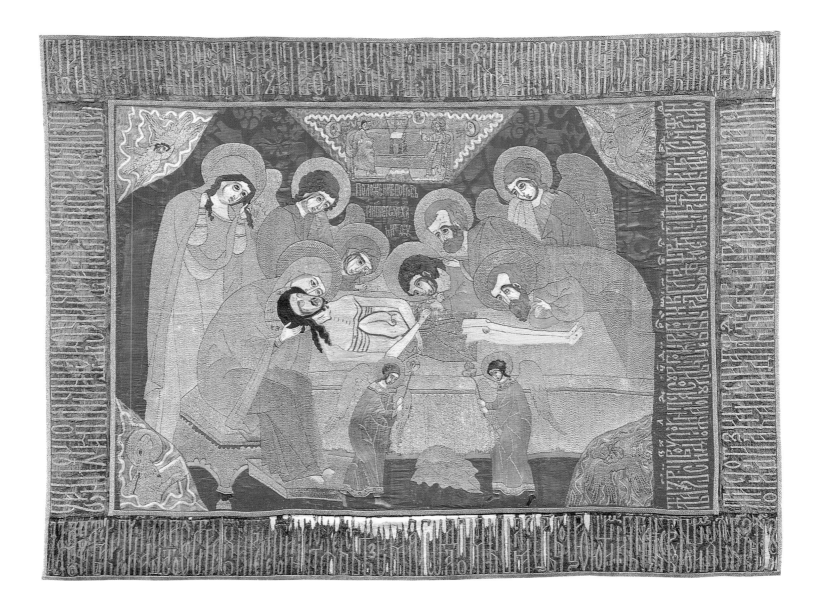

cross-shaped fragments that were originally applied to a priest's vestments (cat. nos. 48, 49) and the two small icon cloths (cat. nos. 45, 46), which were hung below painted icons, are excellent examples of this Stroganoff style.

The Russian Museum has in its collection the oldest of the dated works by Stroganoff master embroiderers—a shroud of the Entombment dating to 1592 (cat. no. 43). Executed under the supervision of Eupraxia Feodorovna, the wife of Nikita Grigorievich Stroganoff, the shroud was the family's contribution, as an important liturgical object, to Annunciation Cathedral at Solvychegodsk. The emotive power of the work can be appreciated in the head of a grieving woman who bends low over the corpse (see pages 44–45). The shroud survives in a remarkable state of preservation, retaining the original canvas backing and the damask ground, whose vivid red can be seen through worn areas of embroidery. This condition is all the more surprising because the piece served for centuries as an object of devotion, having been presented on a table every Easter for the faithful to approach and kiss.

It was in the 1650s and 1660s, under the aegis of Anna Ivanovna, the second wife of Dmitry Andreievich Stroganoff, that embroidery achieved its highest level. One of the best

Inscriptions in the borders of this needlework masterpiece depicting the Entombment (cat. no. 43) date the 6-foot-long shroud to 1592 and identify it as having been made in the workshop of Eupraxia, the wife of Nikita Stroganoff. It was one of the family's many donations to Annunciation Cathedral in Solvychegodsk.

works in the Russian Museum collection of ecclesiastical embroidery is the *Saint Dmitry the Tsarevich with Saints* shroud of 1656 (cat. no. 44) dedicated to the patron saint of Dmitry Andreievich Stroganoff. The shroud is typical of Stroganoff embroidery in that the saints especially revered by the Stroganoffs are depicted along the border. These include Zosima and Savvaty Solovetsky, the northern saints Ioann and Prokopy Ustiuzhsky, and Khristofor, as well as metropolitans, both venerable and sainted, who shared the same names as members of the Stroganoff family. Saint Khristofor, who was the patron and founder of a monastery not far from Solvychegodsk, is shown with a dog's head, a curious means of indicating that his actual appearance was unknown. The shroud was carried during peasant processions, which is why Tsarevich Dmitry is depicted upright, at full height. The skill with which his jewel-adorned raiment was embroidered is stunning, as is the painstaking execution of the faces.

The venerable saints Zosima and Savvaty Solovetsky, who founded the Orthodox Solovetsky Monastery on the islands of the White Sea, far to the north, are depicted together on an icon cloth (cat. no. 47), holding between them a model of their large monastery. On the border Anna Ivanovna embroidered the name of her son, Grigory Dmitrievich Stroganoff, personalizing this gift to the Solovetsky Monastery by dedicating it to him.

Although the tsaritza's workshops in Moscow employed leading artists to execute the drawings on fabric for the embroiderers to stitch, the workshops supervised by the Stroganoff wives and daughters in the seventeenth century were their equal in execution and virtuosity.

In this fragment from a vestment (cat. no. 48) Anna Stroganoff's mastery of technique is demonstrated in imagery created out of gold thread of subtly different shades in a variety of couched patterns.

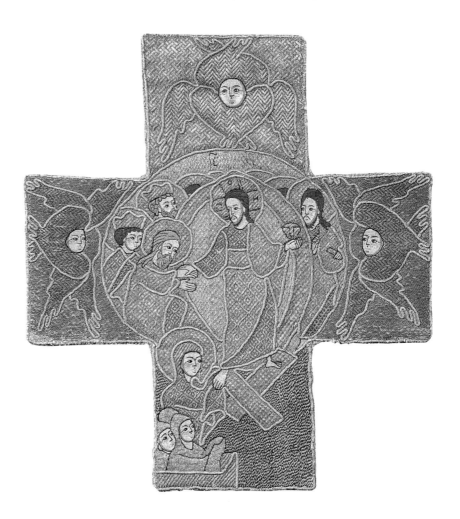

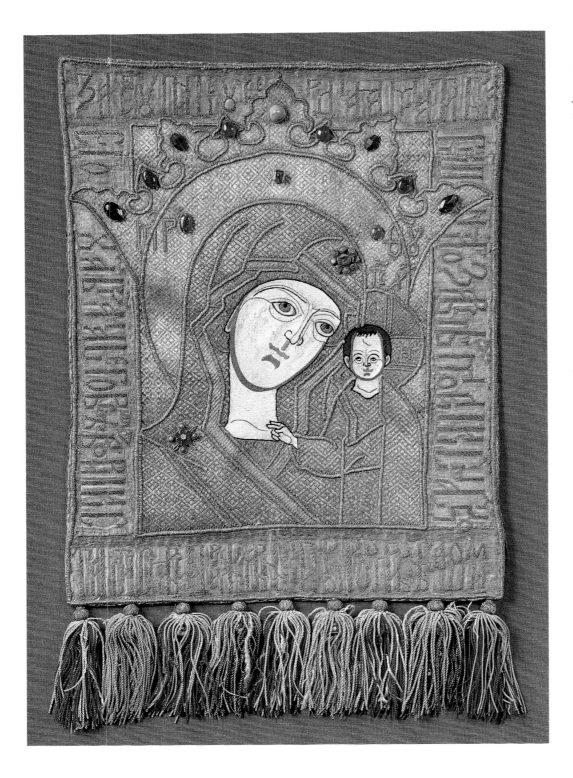

In this jewel-studded textile (cat. no. 45) depicting Our Lady of Kazan made to hang beneath an icon, we see the Stroganoffs' taste for panoply in the service of religion. Anna Stroganoff introduced a humanizing element into her embroideries by depicting facial types more sweetly expressive than those of conventional painted images.

OPPOSITE: *Vasily Istomin,* The Transfer of the Icon of the Virgin of Tikhvin, *1801 (cat. no. 31). The religious orthodoxy that remained central to Russian life and at the core of imperial and Stroganoff family traditions can be seen in this painted record of an event that took place in 1798, when a miraculous icon was transferred from one church to another in the small town of Tikhvin. In this view of the ceremonial procession Emperor Paul I himself (shown to the left accompanied by Empress Maria Feodorovna in a stylish black hat) and his heir, Alexander (shown to the right), carry the icon between them. Alexander Stroganoff follows directly behind them. The artist, an untrained local talent, looks out at the viewer from the foreground as if to proclaim his credibility as an eyewitness.*

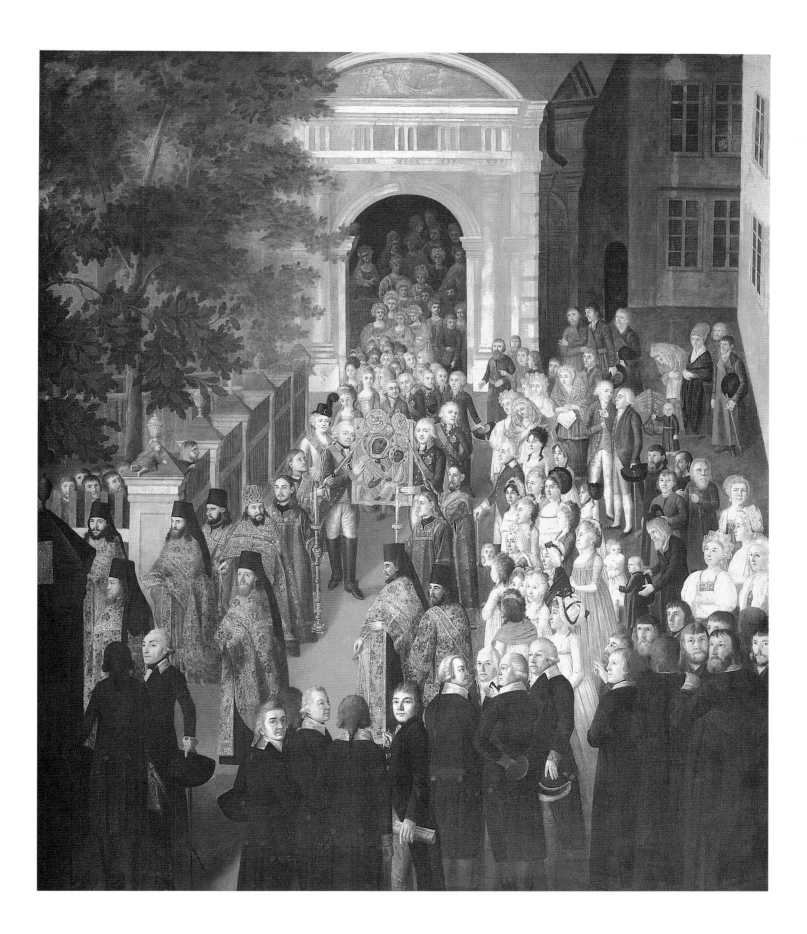

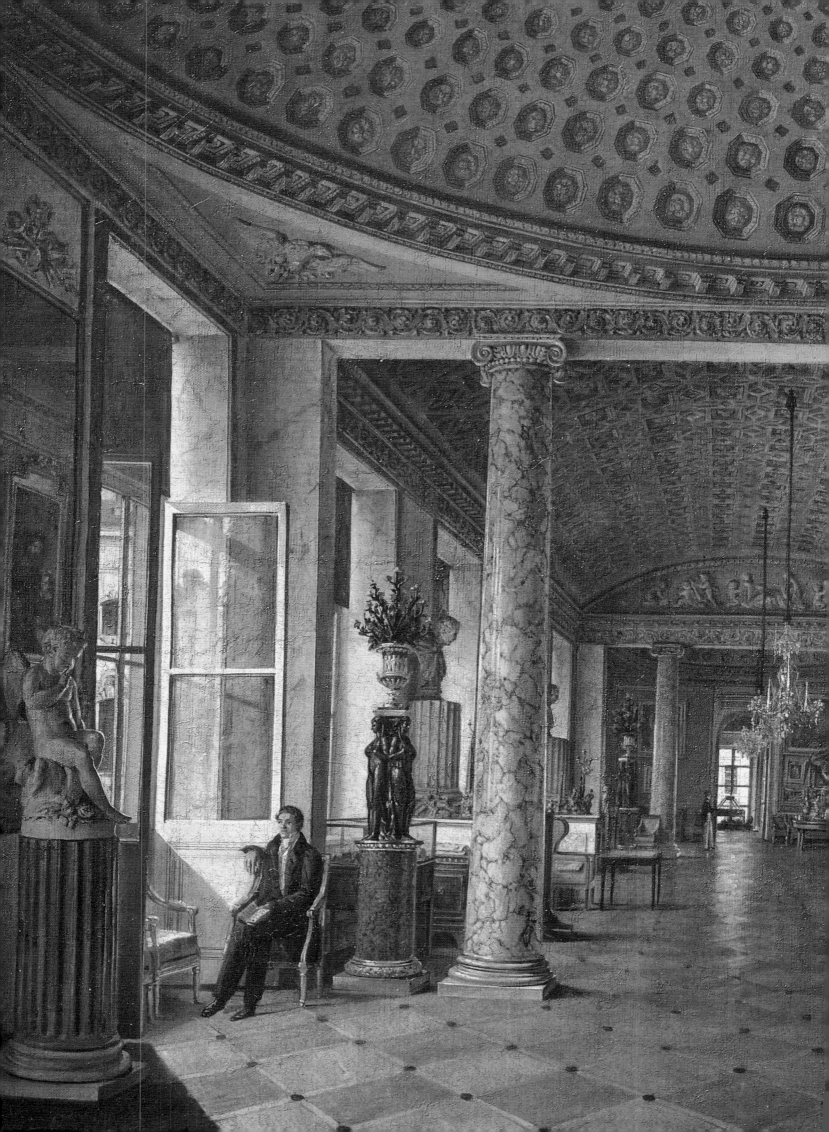

THE STROGANOff
COLLECTIONS

THE STROGANOff COLLECTORS

Militsa Korshunova

HE MOST VALUABLE OF ALL THE IMPORTANT ART COLLECTIONS OWNED by the Russian aristocracy, in terms of both quality and quantity, was that of Count Alexander Sergeievich Stroganoff (1733–1811). His Picture Gallery in the Stroganoff Palace on Nevsky Prospect in St. Petersburg was especially renowned, even in western Europe, thanks to the publication of catalogues prepared by the collector himself.[1] The painting collection had been given its start, however, by his father, Baron Sergei Grigorievich Stroganoff (1707–1756), the founder of this branch of the large Stroganoff family, which over the course of nearly two centuries did such an extraordinary amount for the cultural enlightenment of Russia. Possessing incalculable wealth, Sergei wished to use art to enhance his own daily life, and his choices reflected not only current fashion but also the inner needs of a man who had discovered for himself a world of new values. It is no coincidence that in 1726 the baron commissioned his portrait from the best Russian painter of the day, Ivan Nikitin (d. 1741),[2] who had perfected his craft in Italy. Later, in 1754, Sergei commissioned the talented architect Francesco Bartolomeo Rastrelli (1700–1771), who was building a palace for Empress Elizabeth Petrovna in the capital at the same time, to renovate his residence on Nevsky Prospect. The Baroque renovation transformed the building into a unique jewel that became a true ornament for the city's main thoroughfare.

Sergei entrusted to a Frenchman the education of his only son, Alexander, who had lost his mother at an early age (in 1737). As it soon became clear that Stroganoff the younger had no inclination for the military service that was expected of all Russian noblemen, his father sent him to complete his education in Europe. In May 1752, Alexander left St. Petersburg furnished with letters of recommendation and accompanied by his tutor and two servants. He visited Narva, Riga, and Danzig but stayed longest in Berlin, where he was drawn to all the attractions of the Prussian capital. He examined the picture gallery, the cabinet of curiosities, and the library, and he spent time in both Potsdam and Sans Souci. Then Alexander stayed two years in Geneva, the center of European scholarly life at the time, studying history, military fortifications, architecture, logic, Latin, and Italian (he had already learned French and German at home).

In September 1754 Stroganoff moved to Turin, where he visited the palace, picture gallery, and library. On October 8 he wrote his father from Milan: "There are many fine pictures here, and if I find anything for sale, I will certainly buy it."[3] This note testifies without doubt to the fact that Stroganoff the elder had instructed his son to purchase works of art and that Alexander was sufficiently prepared to make such acquisitions. The young man next visited Venice, where he disdained the noblemen he saw carousing, going bankrupt, and selling off their valuables. Here, in 1755, he made an important purchase, a painting by Correggio. He later visited many other towns in Italy, getting to know the artistic treasures of this country he had come to love.

From Italy Stroganoff's path led to Paris, where he not only viewed monuments and attended lectures but also toured workshops and factories, familiarizing himself with modern means of production. Here, in 1756, he made yet another acquisition, a picture by Domenico Fetti, *Rural Life,* which would become part of his basic collection (now in the

OVERLEAF: *Nikolai Stepanovich Nikitin,* **The Picture Gallery of the Stroganoff Palace,** *1832 (cat. no. 35)*

OPPOSITE: *In this detail of Andrei Voronikhin's* **Picture Gallery of Count Alexander Stroganoff** *(cat. no. 82), Alexander can be seen informally seated, with his dog Barrel at his feet, in the gallery space Voronikhin had just completed for the display of the paintings collection that would continue to grow in size and renown.*

Tula Museum of Art). Then young Alexander set out for Holland, learning en route about the untimely death of his father, on September 30, 1756. At the insistence of Empress Elizabeth Petrovna, who took the most active interest in his destiny, Alexander returned to St. Petersburg in July 1757.

On his second tour of Europe, from 1771 to 1778, during which he lived in Paris for an extended time, Alexander, now Count Stroganoff, got to know several of the famous French masters and gave commissions to Jean-Baptiste Greuze, Claude-Joseph Vernet, Hubert Robert, and Jean-Antoine Houdon. Once he saw the sculptor G. P. Tassaert carving an allegorical group entitled *Minerva Restoring the Arts on the Ruins of Antiquity* out of a magnificent piece of marble, and he prevailed upon the artist to give the goddess features like those of Catherine the Great. Alexander purchased the carved image, which eventually joined his collection in St. Petersburg (now Hermitage, 1653).

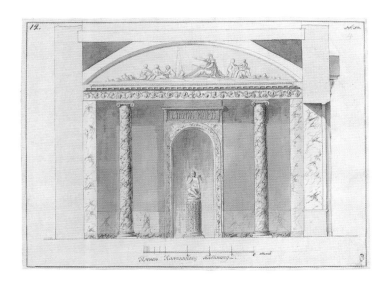

Cross section of the far end of the Picture Gallery in the Stroganoff Palace (cat. no. 79) showing the marble sculpture of Amour *by Falconet (now in the Hermitage) at the axis of the gallery. After the malachite coupe (cat. no. 72) was completed, Alexander moved the Falconet aside to give the place of honor to this new keystone of his collection (see Nikitin's painting of the gallery on pages 74–75).*

Stroganoff attended sales and acquired objects by well-known artists that belonged to such major collectors as the duc de Choiseul (1772), Blondel de Gagni (1776), the prince de Conti and Randon de Boisset (1777), and Charles-Alexandre de Calonne. Somewhat later his collection would be augmented by pictures purchased at the Poulaine (1780) and Richelieu (1788) auctions.[4] Upon receiving auction catalogues, Alexander Stroganoff often acted through intermediaries, usually agents specializing in art sales. During the end of the eighteenth century, the old-master paintings market had come to life in St. Petersburg, and it too served as a source for his collection. Some objects ended up in the Stroganoff Palace after passing through other Russian collections.[5]

The catalogue Stroganoff published on his Picture Gallery in 1793 summed up the owner's collecting activity to date and established exactly what was in his collection, which at the time numbered eighty-seven pictures by fifty-five western European artists. By 1800, when Stroganoff issued his second catalogue, the gallery would have one hundred and sixteen works by seventy-two painters. The 1807 edition (cat. no. 113) included engravings after what Stroganoff evidently felt were the best canvases in his collection,[6] including recent acquisitions, among them *Painting Allegory*, a picture executed in 1725 by the Russian artist Andrei Matveiev. In the future, paintings by many other Russian masters would find their way into the collection.

The catalogues that Alexander Stroganoff prepared were the first ever published of a private collection in Russia. He modeled them on the French auction catalogues compiled by professional antiquarians and on eighteenth-century books about art,[7] from which Stroganoff quoted extensively. His own commentary demonstrated considerable knowledge of art history and his fine taste, which was in line with the Neoclassical aesthetic fashionable at the time all over Europe.

Stroganoff divided the collection into two sections for the purposes of the catalogue. The first section consisted of the Italian schools of painting, to which he attached the Spanish. The second section brought together the Northern masters, and the French school held an intermediate position. Stroganoff's preference was obviously for the Italian painters, primarily

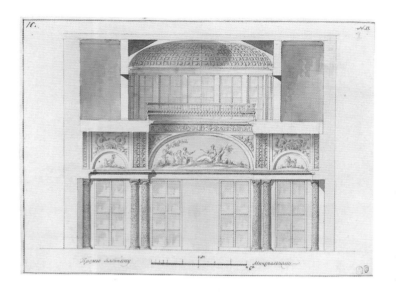

Cross section of Alexander Stroganoff's Mineral Cabinet (cat. no. 80) showing the room and its mezzanine lined with glazed cabinets for mineral specimens and books on mineralogy

artists of the Renaissance and academicians of the seventeenth century, who predominated in terms of quantity, although the Dutch and Flemish schools were also well represented.

Stroganoff's gallery included some first-rate pictures. Among the Italian artists represented we must cite, above all, Andrea del Sarto, Agnolo Bronzino, Benvenuto da Garofalo, Correggio, Procaccini, Tintoretto, Luca Giordano, Guido Reni, Francesco Solimena, and Gianpaolo Pannini. Spanish painting was represented by Velázquez, Ribera, and Murillo. Occupying a place of honor in his gallery were portraits executed by the Flemish painters Rubens and Van Dyck. There were many pictures by Dutch masters as well: Aelbert Cuyp, Gerrit von Honthorst, Jan Miel, Jan Asselyn, Jan Wynants, Jan van Goyen, David Teniers the Younger, Nicolaes Berchem, Adriaen van de Velde, Caspar Netscher, Jacob van Ruisdael, Gerard de Lairesse, and Aert van der Neer.

The German section included the contemporaries Querfurt, Füger, and Mettenleiter, and French painting was represented by Poussin, Dughet, Valentin, Bourdon, Mignard, De La Fosse, and De Troy, as well as artists whom Alexander Stroganoff knew personally, including Greuze, Fragonard, Vernet, and Robert. And this is only a partial list.

In the early 1790s, Stroganoff added at the back of his palace on Nevsky Prospect, facing east, a Picture Gallery designed by A. N. Voronikhin (1759–1814). In 1793, at the same time the catalogue was published, Voronikhin completed a watercolor, *The Picture Gallery of Count Alexander Stroganoff* (cat. no. 82). His detailed knowledge of architecture and his skill at miniature painting enabled Voronikhin to achieve a precise perspective and to re-create the interior and its many pictures, whose subjects are almost always recognizable and correspond accurately to the catalogue. Voronikhin also managed to convey the atmosphere of a late-eighteenth-century manor and to provide portraits of Count Alexander Stroganoff sitting at a small round table in the left-hand portion of the picture, his servants, members of his family, and even the artist himself behind the bureau in the right-hand portion of the page. The many well-drawn details—furniture, chandeliers, birdcages, and flowers in the windows—lend the interior a convincing authenticity. For this watercolor, the council of the Imperial Academy of Fine Arts awarded Voronikhin the title academician of perspective and miniature painting. Voronikhin's picture provides an extremely rare view of an eighteenth-century picture gallery. The pictures are hung rather closely, in three tiers, on the walls of the hall, obviously observing the principle of symmetry. Paintings and other art objects were placed in adjoining galleries and living quarters as well.

Of special interest in the Stroganoff Palace was the Mineral Cabinet (cat. no. 80), where minerals found on Russian territory and in various European countries were brought together, along with many fossils of corals, mollusks, fish, skulls, and plants. These objects were collected and displayed systematically, along with volumes containing the latest scientific scholarship.

Count Stroganoff's Picture Gallery and his magnificent library were made accessible to all experts, admirers, and foreign guests of the imperial court. After he was appointed president of the Academy of Fine Arts in 1800, his home became a place of study for many Russian artists who would one day be famous and whom he invariably patronized.

Andrei Voronikhin, The Picture Gallery of Count Alexander Stroganoff, *1793 (cat. no. 82). Many of the Stroganoff paintings can be identified in this watercolor, as can the artist himself (seated at a desk on the right), Alexander (at the left), Paul and Sophia Stroganoff, and various servants. Paul, in a blue jacket, is closely examining a painting in the gallery, while his wife stands in the distant archway, looking at two small pictures placed on a settee.*

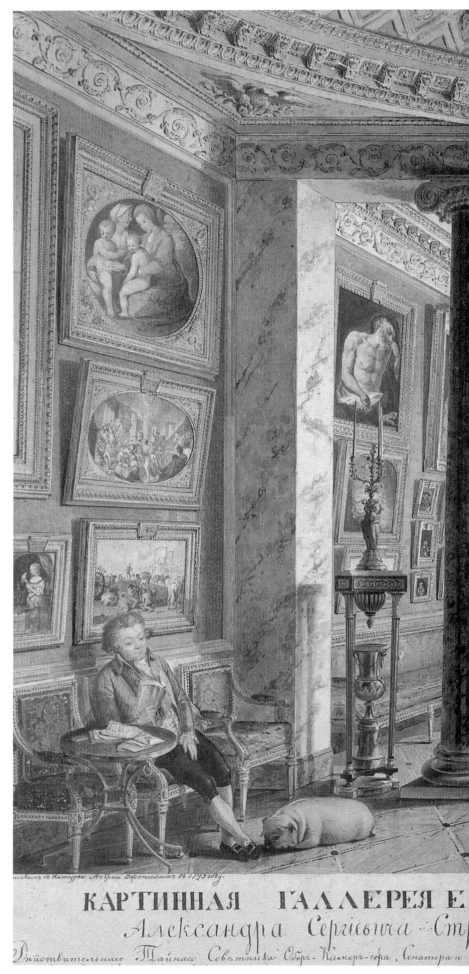

КАРТИННАЯ ГАЛЛЕРЕЯ Е

Александра Сергѣевича Ст

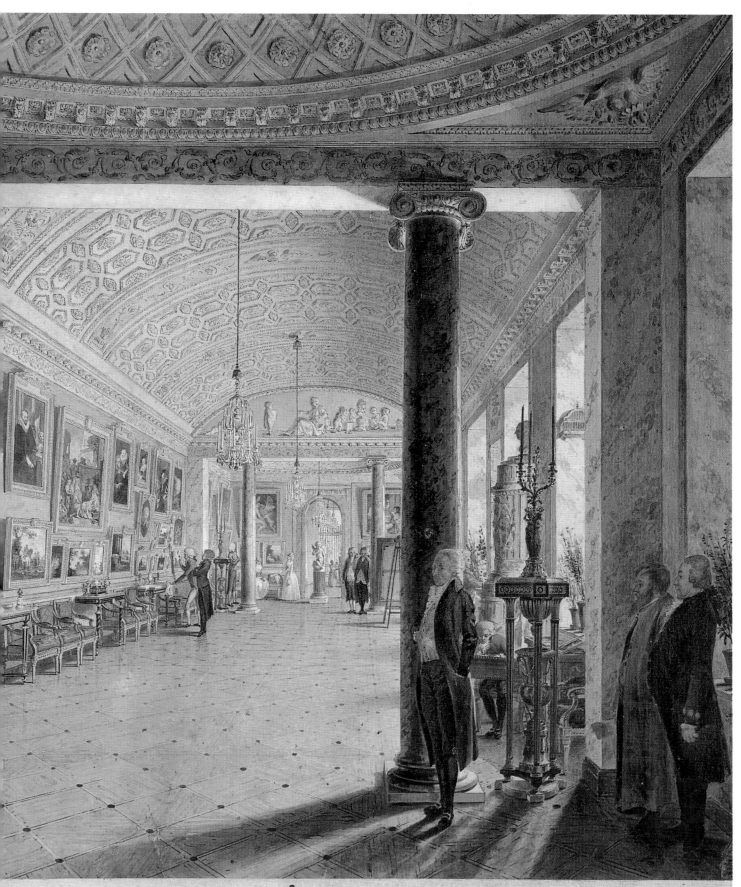

ΡΑΦΑ

а

GALLERIE DES TABLEAUX de S. E.

Monsieur le Comte de Stroganoff

Андрея Лор, с́ б.	Conseiller privé Act d Gr Chambellan de S. M. I., Senateur et Chevalier des Ordres: de St André de S.

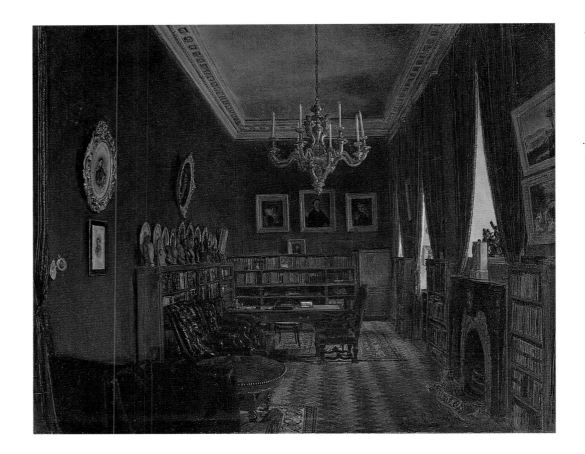

Alberto Colucci, The Study of Count Sergei Grigorievich Stroganoff, *1882 (cat. no. 38). The inner sanctum of the conservative and scholarly Sergei Stroganoff was a room lined with books, family portraits, and a selection of his favorite antiquities. The Mosnier portraits of Paul Alexandrovich Stroganoff and his wife, Sophia (cat. nos. 140, 141), are visible on the far wall.*

Alexander Stroganoff's direct male line ended tragically. His son, Paul, died in 1817, three years after his own son, Alexander's only grandson, Alexander Pavlovich (1794–1814), was killed in battle in the final stages of the Franco-Russian military campaign of 1812–14. By a special decree, handed down on August 11, 1817, the right of primogeniture was established for Paul Alexandrovich's widow, Sophia Vladimirovna. Later, their elder daughter, Natalia Pavlovna (1796–1872), and her husband, Count Sergei Grigorievich Stroganoff (1794–1882), who belonged to another branch of the family, would inherit the title, along with the estate, including Alexander's Picture Gallery.

Thanks to his excellent education and a desire to serve his country, Sergei Grigorievich, who was more a military man than a cultural figure, made many useful contributions in the sphere of education, becoming a trustee of the Moscow Educational District and rector of the university (1835–47). By way of encouraging the arts, he founded in Moscow the School for the Arts and Trades (later the Stroganoff Institute for Technical Design), which offered free drawing classes. His interest in icons from his native region of Perm and in its early archaeological monuments, as well as other archaeological finds, led to the creation in the Stroganoff Palace of one of the first collections of icon paintings in Russia and a section consisting entirely of antiquities.

Under Sergei Grigorievich, this collection achieved the status of a true museum. Not only were Italian primitives and other extremely valuable paintings added, but the numismatic section was significantly enlarged, in part through the addition of the collection of his oldest son, Alexander, who predeceased his father. Objects of a decorative nature were put on display, including valuable pieces of furniture and many small objects arranged on tables, shelves, and étagères—snuff boxes, vases of colored stone and bronze, candlesticks and can-

delabra, and small bronzes. About one hundred exquisite painted miniatures, mainly portraits of Stroganoff family members and outdoor scenes, were displayed in three large map cases in the gallery. Of immense value was the extensive library, to which all of the Stroganoffs added over time.[8]

After Sergei Grigorievich's death, the right of primogeniture passed to his grandson, Sergei Alexandrovich (1852–1923), the last count Stroganoff in the family. In 1884 he had an inventory made of the ancestral home listing all the valuables held there at the time.[9] On October 24, 1905, he left Russia for Paris, taking with him twelve paintings by Dutch artists, including the only work by Rembrandt—*Jeremiah Lamenting Over the Destruction of Jerusalem* (now in the Rijksmuseum, Amsterdam).[10]

In true family tradition, Sergei Grigorievich's second son, Paul Sergeievich Stroganoff (1823–1911), put together his own superb art collection. Paul was born in Moscow and graduated from the university's law school. In 1847 the young count entered the Ministry of Foreign Affairs, and as an embassy secretary, he spent many years in Italy and Vienna and later was often in Paris, Belgium, and Holland. He was a passionate collector, undoubtedly the result of his family's influence and the special atmosphere of the Stroganoff Palace and its treasures accumulated by many generations.

As he toured small towns and stopped at antique shops, Paul Sergeievich displayed a refined taste in his selection of fine works of art. Like his father, he acquired works by early Italian masters of the fifteenth and early sixteenth centuries, including small wooden objects, ceramics, and pieces of furniture. In Italy Paul was advised by Ernst von Liphart Sr., a connoisseur of Italian Renaissance painting, and Dutch and Flemish paintings also made up a large part of the collection, which was later augmented with paintings by contemporary European and Russian masters. The collection's artistic importance and the attribution of many pictures were established in 1864 in a report from G. F. Waagen, the director of the picture gallery at the Berlin Museum and Europe's foremost art historian at that time.[11] Waagen had been invited to consult at the Hermitage, but while he was in St. Petersburg he also took time to acquaint himself with several private collections.

Paul Sergeievich housed his treasures at Znamenskoye-Koriyan, his estate in Tambov Province, and in 1857 he began construction on a home in St. Petersburg at 11 Sergievskaia Street. The five pages from the Jules Mayblum album in the exhibition (cat. nos. 101–5) allow us to reconstruct the appearance of this house and to view its interior spaces. The house was built by the architect Ippolito Monighetti (1819–1878) between 1857 and 1859,[12] by which time Monighetti had already executed several commissions for the imperial court and built several private residences. Monighetti created a private house that was characteristic of the time, with exterior and interior decoration incorporating motifs and devices drawn from earlier periods. Despite this eclecticism in artistic ornament, the result was an effective though not astonishingly luxurious house of impeccable proportions. The exquisite interiors were an appropriate setting for Paul Sergeievich's large and diverse collection, and the construction of the house apparently stimulated the count's collecting activity.

The watercolors in the exhibition painted by Jules Mayblum between 1863 and 1865 reveal that the placement of works of art in the house differed from the customary practice for displaying eighteenth-century collections. Art treasures were usually concentrated in a special part of the house, often in galleries built especially for them, but here they have been incor-

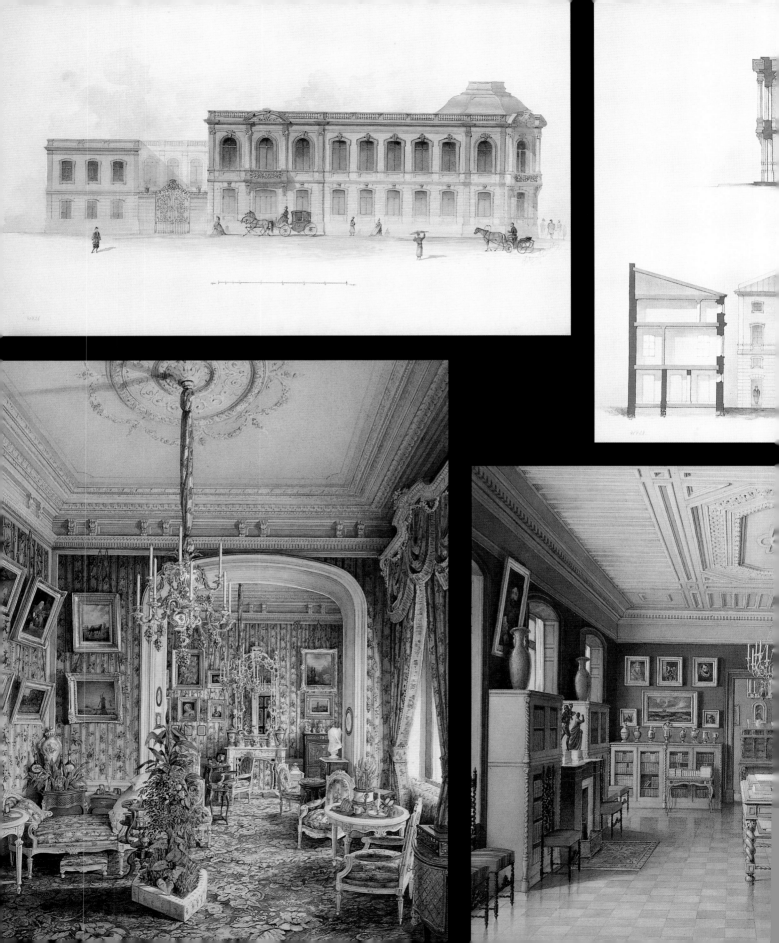

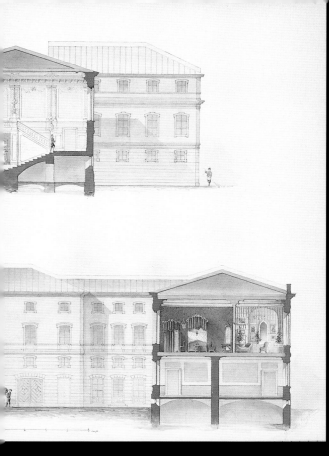

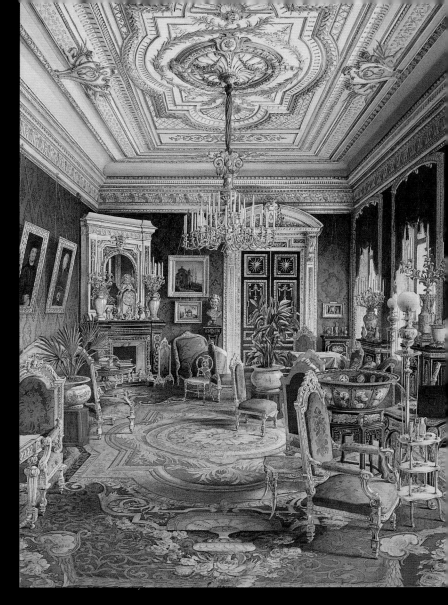

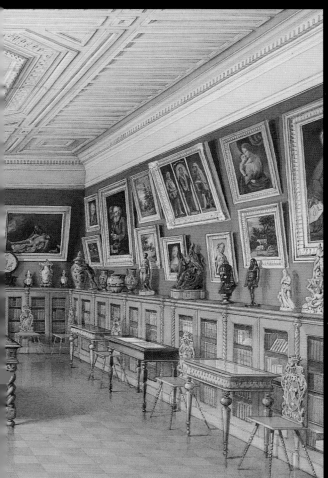

These watercolors by Jules Mayblum are from an album documenting Paul Sergeievich Stroganoff's St. Petersburg residence. A widely traveled and passionate collector, Paul worked with the architect Monighetti between 1857 and 1859 to build a mansion where his art would be incorporated into the living spaces rather than set apart in a designated gallery. Above, left to right: the facade facing Sergievskaya Street (cat. no. 101), an elevation showing interiors of the mansion (cat. no. 102), and the Green Drawing Room (cat. no. 103); below, left to right, the Boudoir (cat. no. 104) and the Library (cat. no. 105)

porated organically into the furnishing of the interiors, often complementing the rather heavy 1850s furniture and becoming an integral part of the daily life of the inhabitants.

Paul Sergeievich made his last acquisitions during the 1870s. Soon after his death, on December 17, 1911, his heirs transferred several works to the Hermitage in accordance with his will.[13] The museum's painting curator, Ernst von Liphart Jr., wrote in 1912: "The Hermitage has been given an opportunity to fill those disgraceful gaps that might have remained unfilled since competition with American millionaires in the markets of Europe has become impossible of late."[14] The bequest to the Hermitage included *Descent from the Cross* by Cima da Conegliano, *Adoration of the Christ Child* by Filippino Lippi, *The Apostle Andrew* by Domenichino, *Christ Bearing the Cross* by Gian Francesco Maineri (cat. no. 149), *A Dutch Interior* by Pieter Janssens Elinga (cat. no. 127), at the time attributed to Pieter de Hooch, *Portrait of a Senator* (Justinian?) by Giovanni Carboni (then attributed to Guido Reni), as well as a marble head, *The Faun,* considered to be the work of Michelangelo but later attributed to Baccio Bandinelli.

Paul Sergeievich had left instructions for several beautiful pieces, including Antoine Watteau's *La Boudeuse* (cat. no. 133), to be given to his brother, Grigory Sergeievich Stroganoff,[15] but since Grigory died before the will could be executed, this small French masterpiece ended up in the Stroganoff Palace and later went to the Hermitage with many other valuable works of art after the 1917 Revolution. Paul Sergeievich's primary heir was a minor, Prince Georgi Alexandrovich Shcherbatov (1897–1953). His collection at the country house Znamenskoye-Koriyan went (after 1917) to the Tambov Picture Gallery, where sixty-seven of the works are still kept, including a portrait of Paul Sergeievich by Karl Briullov.

Paul's brother, Count Grigory Sergeievich Stroganoff (1829–1911), who spent the second half of his life in Rome, had also inherited a love for the fine arts; he was a prominent expert on painting and put together his own collection. The core of that collection, however, was formed by the pictures he brought from his ancestral home in St. Petersburg, including two landscapes by Fragonard and the portrait of Erasmus of Rotterdam by Quentin Massys.[16] While living in Italy, Grigory Sergeievich remained in contact with the Hermitage and knew of the difficulties it was experiencing in acquiring works of art. For this reason, he too decided to give the Hermitage several works of art at the end of his life. In 1911 and 1912, the count's heirs, Prince Vladimir Alexeievich and Princess Alexandra Alexeievna Shcherbatov, presented the museum with sixteen objects from his collection.[17] In addition to Sasanian silver objects (see page 101), there were also such masterpieces as Simone Martini's *Virgin,* Fra Angelico's

Books from the Stroganoff family libraries (cat. nos., from left to right: 112, 110, 114)

Reliquary, a fragment of *The Virgin's Adoration of the Infant Jesus* by Jacopo Sellaio, and *The Ascension* by Bartolo di Fredi (the attribution of the last two is in dispute).[18] A few years after Grigory Sergeievich's death, the rest of his collection was sold in Paris.

After the Revolution, the connection between the Stroganoff Palace and its owners was severed. A house-museum was opened in the palace in 1919, and in it were placed many objects from the Stroganoff residence on Sergievskaia Street. By June 1925, the museum had become part of the Hermitage, and in 1930 the Stroganoff Palace was closed. That same year the Stroganoffs' extremely rich library was divided up between the public library, the Academy of Sciences Library, and the Hermitage.

In 1931 a number of Stroganoff masterpieces of art—paintings, furniture, sculptures, bronzes, objects made of colored stone, and so on—were auctioned off by Rudolf Lepke in Berlin.[19] Some of the unsold items went to the Hermitage, and some ended up, through the State Museum Fund, in other national museums, for example, Fetti's *Rural Life* (Tula Art Museum) and Bronzino's *Holy Family* (State Pushkin Museum of Fine Arts).

The story of the Stroganoff collections is a two-century chapter in the history of a family whose best representatives felt tied by ancestral heritage to their homeland. They were patriots eager not only to multiply their own wealth but also to help Russia flourish.

NOTES

1. *Catalogue raisonné des tableaux qui composent la collection du Comte A. de Stroganoff* (St. Petersburg, 1793); *Catalogue raisonné des tableaux qui composent la collection du Comte A. de Stroganoff* (St. Petersburg, 1800).
2. GRM Zh-4908. S. O. Androsov, *Zhivopisets Ivan Nikitin* [The Painter Ivan Nikitin] (St. Petersburg, 1998).
3. N. M. Kolmakov, "Dom i familiia grafov Stroganovykh, 1752–1887 [The house and family of the Counts Stroganoff]," *Russkaia starina* (April 1887), p. 92.
4. James Schmidt, *Die Sammlung Stroganoff* (Leningrad, 1931).
5. A. A. Artsikhovskaia-Kusnetsova, "A. S. Stroganov kak tip russkogo kollektsionera" [A. S. Stroganoff as a Type of Russian Collector], *Panorama iskusstv*, no. 11 (Moscow. 1988), p. 283.
6. A. Stroganoff, *Collection d'après quelques tableaux de la galerie de m-r Stroganoff. Gravées au trait par des jeunes artistes de l'Académie des Beaux Arts à St. Pétersbourg. Les explications sont tirées du catalogue raisonné fait le propriétaire lui-même* (St. Petersburg, 1807).
7. [Roger de Piles], *Abrégé de la vie des peintres, avec des reflexions sur leurs ouvrages et un traité du peintre parfait, de la connaissance des dessins et de l'utilité des estampes* (Paris, 1699).
8. Arkhiv Gosudarstvennogo Ermitazha, f. 1, op. X, 1878, d. 48. Catalogue of the S. G. Stroganoff library.
9. Arkhiv Gosudarstvennogo Ermitazha, f. 1, op. X, 1884, d. 55. Inventory of the S. G. Stroganoff gallery.
10. Kuznetsov, *Dvortsy Stroganovykh,* pp. 152, 153.
11. Arkhiv Gosudarstvennogo Ermitazha, f. 1, op. V, 1912, d. 31(33). File on the pictures bequeathed to the Hermitage by Count P. S. Stroganoff. On ll. 26–29 ob. there is an inventory of the pictures with their appraisal and a history of their provenance compiled in July 1864 at the Znamenskoe-Koriyen estate by Professor G. F. Waagen and M. Meffre.
12. The house of Count Paul Sergeievich Stroganoff was located at the corner of Sergievskaia Street (no. 11) and Mokhovaia Street (no. 2). The plot had been acquired in 1848 by Count Grigory Alexandrovich Stroganoff (1770–1857). After his death, the land belonged to his three sons, Alexander, Sergei, and Alexei. Somewhat later Paul Sergeievich became its owner. After the latter's death in 1911, the house passed to his heir, the young Prince Georgi Alexandrovich Shcherbatov (1897–1953). His father, Alexander Grigorievich Shcherbatov, the husband of Paul Sergeievich Stroganoff's niece, enjoyed guardianship rights over the house.
13. Arkhiv Gosudarstvennogo Ermitazha, f. 1, op. V, 1912, d. 31 (33). File on the pictures bequeathed to the Hermitage by Count P. S. Stroganoff.
14. E. von Lipgart Jr., "Dar grafa P. A. Stroganova Imperatorskomu Ermitazhu" [P. A. Stroganoff to the Imperial Hermitage], *Starye gody* (April 1912): 35.
15. Arkhiv Gosudarstvennogo Ermitazha, f. 1, op. V, 1912, d. 31(33). File on the pictures bequeathed to the Hermitage by Count P. S. Stroganoff. Original will (fragment), II, pp. 7, 8.
16. Schmidt, *Sammlung Stroganoff,* p. 2.
17. Arkhiv Gosudarstvennogo Ermitazha, f. 1, op. V, 1911, d. 36. On the gift of art objects to the Hermitage by the heirs of Count G. S. Stroganoff.
18. *The Virgin's Adoration of the Infant Jesus* (Hermitage, 289) is now attributed to the school of Sandro Botticelli, *The Ascension* (Hermitage, 290) to Andrea di Vanni.
19. Schmidt, *Die Sammlung Stroganoff.*

CLASSICAL ANTIQUITIES

Anna Trofimova

THE STROGANOFFS BEGAN PUTTING TOGETHER THEIR COLLECTIONS AT A TIME when the fashion for classical antiquity had reached its height in Europe and Russia. Changes in taste, spurred by a dramatic increase in archaeological activity that took place after the discovery of Herculaneum and Pompeii in the 1730s and 1740s, led to a general interest in collecting Greek and Roman antiquities, and collectors descended on Italy from Germany, France, England, and Russia. The largest and most important collections of antique art were formed over the course of the eighteenth century. In Russia these included the imperial collections of Catherine the Great and Paul I, as well as private museums belonging to the Russian aristocracy, such as those of the Yusupov, Shuvalov, and Golitsyn families.

For the Stroganoffs antique art was never a passion, because the main focus of their attention was the Picture Gallery in the palace on Nevsky Prospect. It is not surprising, however, that even Alexander Sergeievich Stroganoff had a small but well-chosen collection of antiquities and sculptures after the antique, as an interest in ancient art was obligatory for the true connoisseur during this period. By the 1770s, the Stroganoff Palace had become a marvelous Neoclassical ensemble, and classical sculptures had been acquired to adorn its interiors. Artistic treasures and interior decoration were intended to form an organic part of the overall complex, and objects were selected largely for their compatibility with the noble and sublime tone of Neoclassicism; questions of authenticity were of only secondary importance. In the Stroganoff Palace Neoclassical imitations, or works in the classical style, stood side by side with authentic pieces, copies, and casts. For the classicist Alexander Stroganoff, priority was always given to an ideal image of the antique, one that represented, in eighteenth-century terms, the essence of majestic simplicity and harmony of form.

The first antique marbles in the Stroganoff collection seem to have been purchased in Italy by Alexander Stroganoff during his travels abroad from the 1750s to the 1770s. As was often the case, he also acquired copies and excellent contemporary imitations along with antique originals. Acquisitions from this time include a pair of marble vases imitating the antique, of which

These two marble busts (cat. nos. 175 left, 174) were collected as classical antiquities by Alexander Stroganoff on his travels in Italy and entered the Hermitage collections in 1930 as such. They are here reassessed as the work of a well-known restorer and supplier to the European collectors who were trendsetters in the Neoclassical style in the late 18th century.

Stroganoff appears to have been particularly proud. The French traveler Fortia de Piles, who visited the palace at the end of the eighteenth century, relates that after being shown the paintings of Hubert Robert he was invited to admire "two antique vases" in the little hall before the Mineral Cabinet.[1] An engraved image of one of the vases was published by Alexander Stroganoff in the 1807 catalogue of the Picture Gallery; later, in the updated catalogue of 1835,[2] the reliefs were described as showing a scene of sacrifice, with two nude, winged Nike figures spearing bulls before a candelabra. Undoubtedly, it was this strange and exotic subject that drew the attention of Stroganoff, who was renowned as a "hunter after curiosities" (as he humorously described himself). One hundred years later, the Neoclassical grace of the reliefs charmed Alexander Benois, connoisseur and keeper of the Hermitage picture gallery. In describing the Stroganoff collection in the early twentieth century, Benois drew attention to the "marvelous marble vase" with an image of a sacrifice to Mithras.[3] In fact, this scene is a fantastical tangle of neo-Attic motifs, and both marble kraters were made in the mid-eighteenth century by an Italian Neoclassical sculptor.

Two female busts (cat. nos. 174, 175), probably acquired by Alexander Stroganoff in Italy, are known to have come from the same restoration workshop in Rome. One is an excellent imitation of an antique piece, while the second is an elegant work by an Italian sculptor of the second half of the eighteenth century. Characteristically, both busts are variations of one and the same sculptural type of Aphrodite, derived from an antique original and known to have been in the studio of Bartolomeo Cavaceppi, who was the most famous restorer of antique pieces in Rome during the second half of the eighteenth century. A talented and sensitive sculptor, Cavaceppi had all the great eighteenth-century Roman collectors among his clients. Thousands of antique sculptures were restored in his studio, and it was there also that copies, imitations, and fakes were produced.

A friend of Anton Raphael Mengs and Johann Winckelmann, Cavaceppi associated closely with connoisseurs and antiquarians—and collectors from Russia. We know, for instance, that his clients included Ivan Shuvalov, a close friend of Alexander Stroganoff who beginning in the 1750s was engaged in putting together in Rome a collection of antiquities. By the middle of the eighteenth century, Cavaceppi's studio was the most fashionable antiquarian salon in Rome, visited by the likes of Cardinal Alessandro Albani, the British artists and dealers Gavin Hamilton and Thomas Jenkins, the famous engraver Giovanni Battista

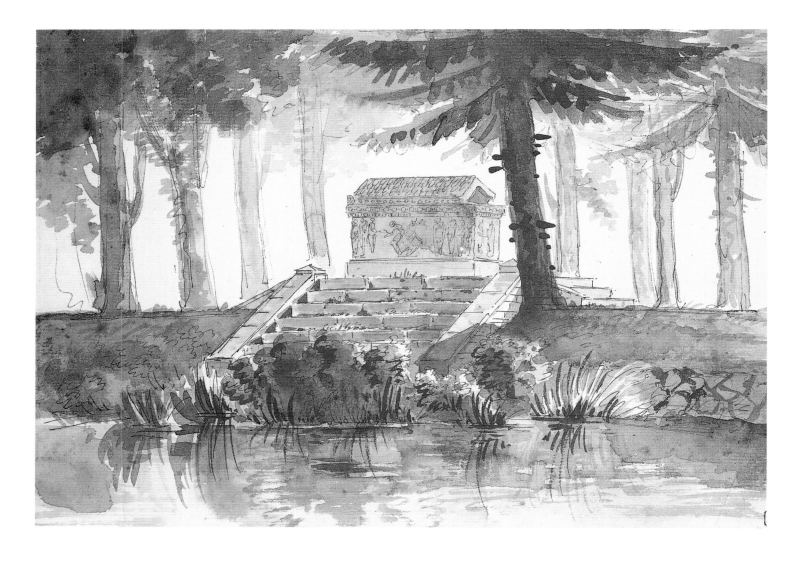

Piranesi, and Catherine the Great's art agent Johann Reifenstein.[4] It is likely that Alexander Stroganoff himself visited the Italian maestro's shop, where he would have acquired "antique" busts on the advice of his friends.

Although Alexander Stroganoff's antique acquisitions were not of a systematic nature, his rare taste enabled him to see the merits of some excellent pieces. In the 1780s, collectors' interests moved from ancient Rome to authentic Greek antiquity, but highly desirable ancient pieces were rarely allowed to be removed from Turkish lands. Having successfully acquired an antique sarcophagus found on an island in the Aegean Sea, Stroganoff described it emotionally as follows in his 1807 catalogue: "During the first Turkish war of 1770, when Russian arms were victorious on the seas, Domashnev, a Russian officer in command of our attack on one of the islands in the Archipelago, brought this sarcophagus to Russia and presented it to me. At the sight of this monument, I could not but cry: is this not the monument to Homer? The phrase was passed from mouth to mouth and totally without foundation everyone concluded that I was the owner of Homer's tomb."[5] The reliefs on this marvelous sarcophagus show scenes from the life of Achilles, and it was also thought to have been the tomb of Achilles. Many legends surround the work (according to one, it was used as a tomb for Stroganoff's favorite dog), which was turned by its owner into a romantic monument on the grounds of his country house on the Chernaya Rechka riverbank (now within the city of St. Petersburg).[6] It was thus, on the hill near the Round Pond, that the architect Andrei

This rendering by Andrei Voronikhin (cat. no. 85) shows his Romantic installation of a Greek sarcophagus on the grounds of the Stroganoff dacha. The huge stone sarcophagus is now a prominent feature of the antiquities galleries in the Hermitage.

Voronikhin depicted it in a watercolor in the 1790s (cat. no. 85). Not surprisingly, this unusual antique piece is mentioned in all the important descriptions of the city sights by such travel writers as Johann Georghi,[7] Mikhail Pyliayev,[8] and Vladimir Kurbatov.[9] The piece was moved to the courtyard of the Stroganoff Palace in St. Petersburg after 1910 on the orders of Sergei Alexandrovich Stroganoff, and it remained there until 1930. It now forms part of the holdings of the Department of Antiquities in the Hermitage.

In addition to antique sculptures—which were obligatory for any eighteenth-century collector—Alexander Stroganoff acquired archaeological pieces, as we learn from Heinrich von Reimers, who visited the palace in the early nineteenth century: "In the center of the last room (the Physics Room) a stove has been erected for the purpose of chemical experiments, decorated with certain Egyptian figures, and standing along the walls are cabinets in which are kept various notable Russian relics, so respected in northern Russia, and particularly Greek and Roman antiquities."[10] The greater part of the archaeological collection, however, was put together much later, in the middle of the nineteenth century, through the efforts of Sergei Grigorievich and Paul Grigorievich Stroganoff.

Historicism, the love for and imitation of a variety of different historical styles, came to the fore during the second half of the nineteenth century, and antique sculptures enjoyed an aesthetic reassessment. With the discovery of Greek Archaicism, thanks to excavations in southern Italy and at Troy, art lovers and collectors gained a new understanding of the artistic perfection of monuments produced during the early stages of Greek civilization. At the same time, there was a growing interest in archaeological objects for the precious evidence they provided of days long gone.

Sergei Stroganoff's study, photographed in 1865, with some of his favorite antiquities arranged on the bookcases

Sergei Grigorievich Stroganoff (1794–1882) had a passion for archaeology, which is clearly reflected in his collection. His passion was not merely a reflection of contemporary tastes: in 1859 he founded the Imperial Archaeological Commission, of which he remained chairman to the end of his life, and he did much to facilitate excavations in the northern Black Sea area. Throughout his life he excavated his own lands in Siberia near Perm in a very professional manner, and he never stopped adding to his family collection by acquiring antique objects both in Russia and abroad. The most notable pieces in artistic terms were eagerly published in the *Reports of the Imperial Archaeological Commission* by the keeper of the Hermitage's Department of Antiquities, Ludolf Stefani, who also provided valuable information regarding their origin. Thus, the reports for 1874–77 include reproductions of two red-figured Attic vases found in Italy near Capua and Nola and a marble bust of Zeus on an eagle, supposedly found at Sevastopol and acquired by Stroganoff from General Menkov.[11] Of all Sergei Stroganoff's acquisitions, however, of greatest importance was a group of Etruscan pieces, marvelous bronzes and votive heads (early Etruscan portraits), terra-cotta reliefs, and antefixes. It is known that in the selection and acquisition of these pieces he was assisted by the German archaeologist H. Helbig. Over several decades, Helbig was scientific secretary to the German Archaeological Institute in Rome. Responsible for overseeing excavations, he also acted as an agent or broker, purchasing finds from landowners and sending them to foreign collectors. It was thanks to Helbig that the collection of antique vases in the

ABOVE LEFT: *Etruscan terra-cotta votive head, first half 5th century* B.C. *(cat. no. 179)*

ABOVE RIGHT: *Etruscan terra-cotta canopic vase cover, second half 6th century* B.C. *(cat. no. 177)*

OPPOSITE: *Etruscan terra-cotta antefix, late 6th–early 5th century* B.C. *(cat. no. 178)*

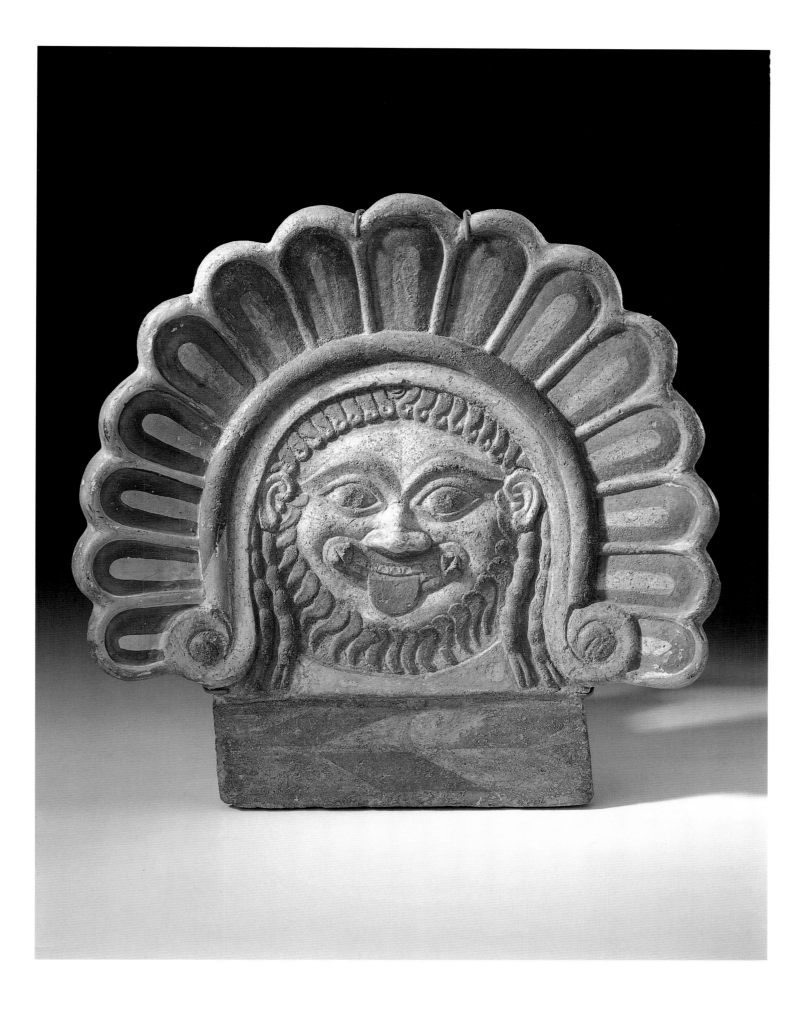

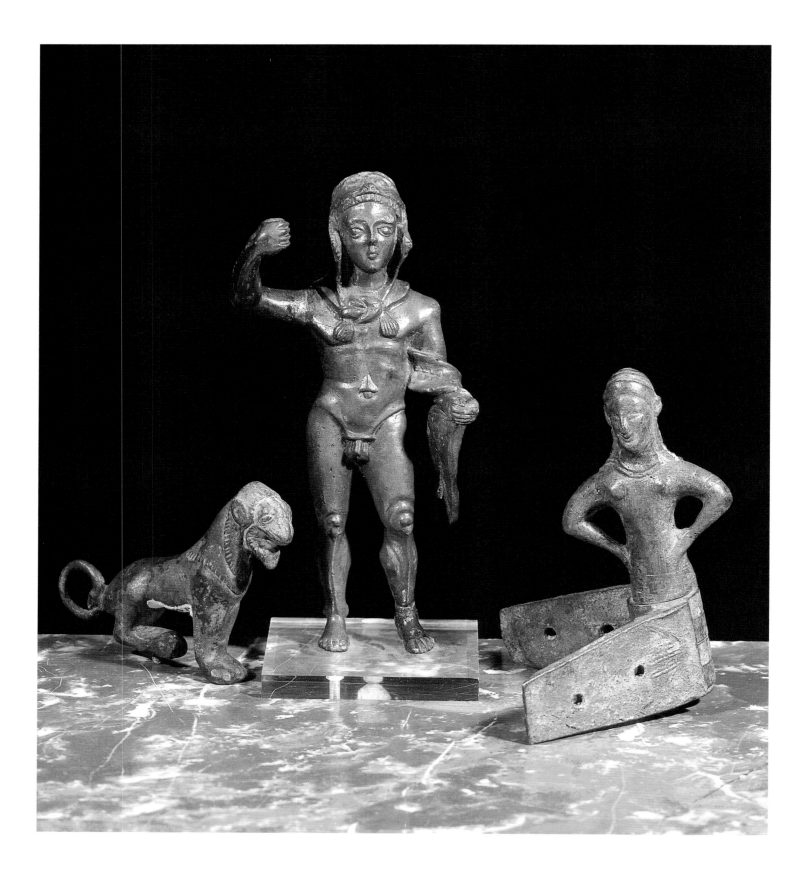

Etruscan bronzes collected by the Stroganoffs (cat. nos. 188, 190, 187)

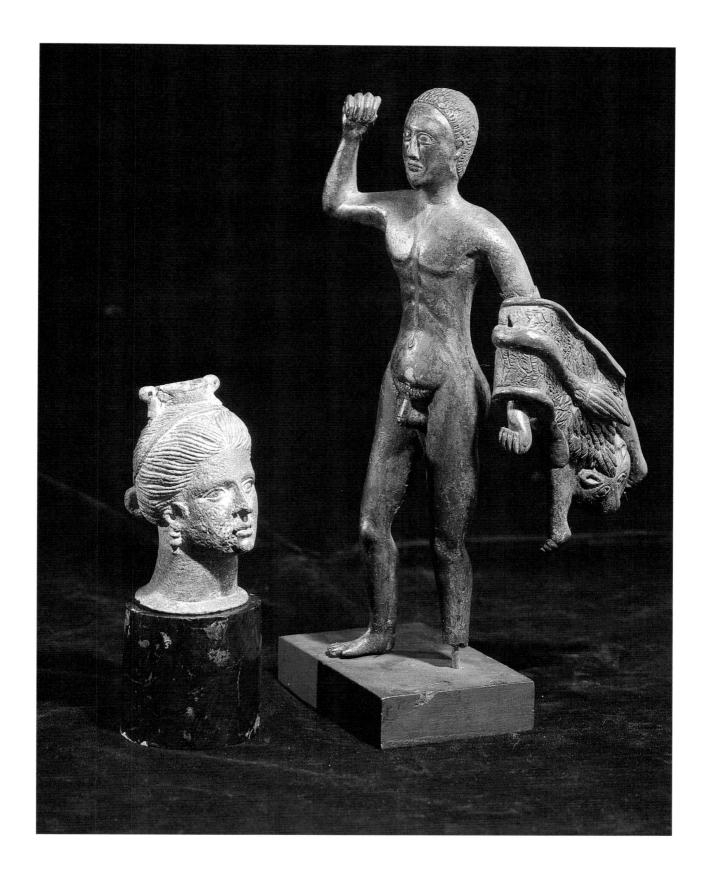

Etruscan bronzes (cat. nos. 191, 189)

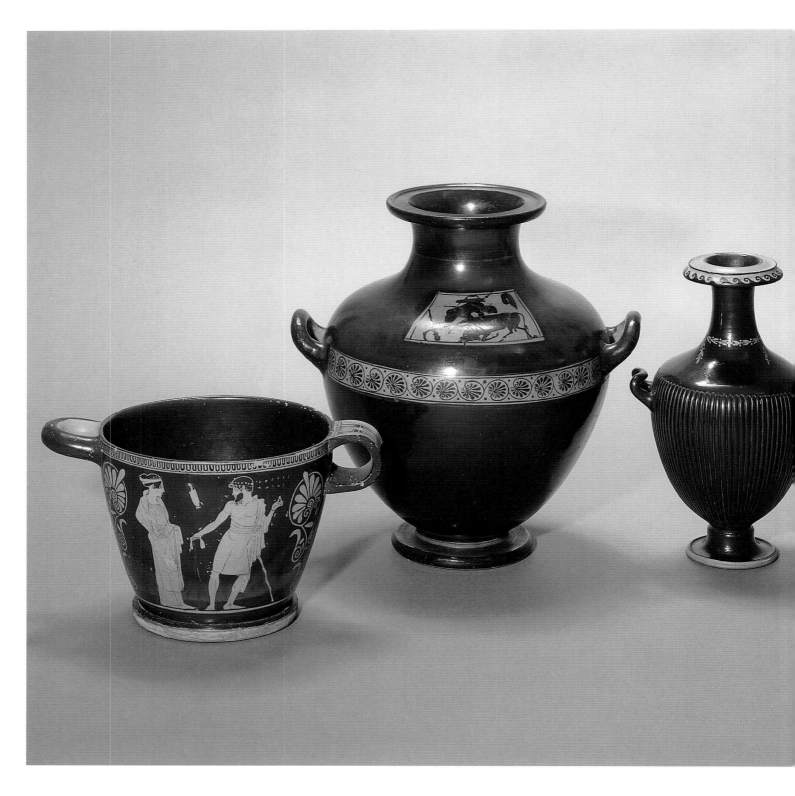

museum of the Stroganoff drawing school was formed. There is some reason to suggest that excavations at necropolises in Etruria and Campania, undertaken in the 1860s and 1870s with Helbig's involvement, were an important source of additions to Sergei Stroganoff's private collections.[12]

Various archaeological collections occupied an important place in the Stroganoff Palace. Judging by the inventory of 1884, compiled soon after the death of Sergei Stroganoff, archaeological objects were exhibited in several rooms. In the "Great [Picture] Gallery" were

A selection of Greek vases from the Stroganoff Collection (cat. nos. 180–83)

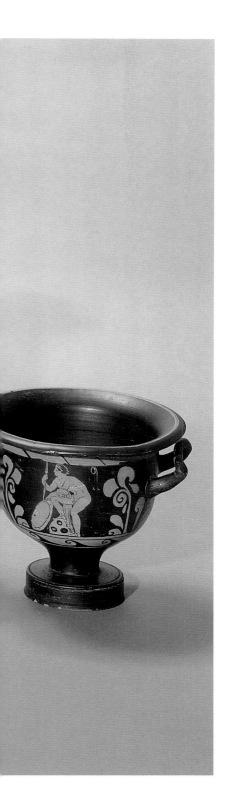

five "tables with antiquities" from Mexico, China, Egypt, and Etruria, and early Christian pieces from Rome, all complemented by antique painted vases set on marble pedestals. Set out on shelves and in cases in the two libraries were bronze and terra-cotta statuettes, small marble heads, and clay vessels. Etruscan helmets and swords were displayed on stands with weapons beside Turkish *yatagans* (swords) and the *shashki* (sabers) of the Don cossacks. Smaller objects—precious carved stones, gold plaques, and glass vessels—were kept in a special glass showcase.[13] One would like to think that Sergei Stroganoff himself personally selected his favorite antiquities to be displayed in his famous study. We know that the bust of Zeus on an eagle (see cat. no. 38) stood here, as well as the "ancient hollow heads of clay" —those rare Etruscan portraits. In a photograph of the room taken in 1865 (page 91) we can recognize a fine bronze statuette of an actor, a marble head of Scipio, and the "celebrated Apollo Boedromios."[14]

The latter, a large bronze statuette, was acquired by Sergei Stroganoff in 1874 from Prince Yuri Dolgoruky, who had received it from Count Grigory Orlov (a favorite of Catherine the Great).[15] After its publication by Stefani, the statuette was included in all fundamental works on the history of art published during the late nineteenth and early twentieth century. For thirty years there were endless heated discussions as to whether the Stroganoff Apollo was a reduced copy of the Vatican's Apollo Belvedere or merely an elegant nineteenth-century imitation. Despite the consistent faith of Russian scholars in its authenticity, the piece was exposed as an imitation by two German specialists in the antique, Kekulle von Stradonitz[16] and Adolf Furtwängler.[17] The passions surrounding the work can be explained by the undying fame of the Vatican statue and a certain nostalgia for the beauty of the age of Russian Neoclassicism.

Sergei Stroganoff passed on his love for classical antiquities to his sons Grigory and Paul, who also went on to become leading collectors of their time. In Paul's rich collections at his house on Sergievskaya Street (now Ulitsa Tchaikovskogo) in St. Petersburg there were Etruscan and Attic painted vases, bronze and terra-cotta statuettes, and clay lamps. Paul presented some pieces to the Museum of the Society for the Encouragement of Artists during his lifetime, and in the 1920s this collection was moved to the Stroganoff Palace Museum, which had become a branch of the Hermitage Museum in the post-Revolutionary restructuring.

How several pieces from Grigory Stroganoff's Roman palazzo—small Etruscan masks of demons, published in the catalogue of his collection in 1912—arrived at the St. Petersburg palace remains unexplained.[18] Judging by the overall makeup of his collection, Grigory himself preferred traditional Italian marbles, which were to be found in abundance on the Rome art market during the late nineteenth and early twentieth centuries.

The Stroganoff antiquities were kept at the palace and moved to the Department of Antiquities in the Hermitage after 1926. Fifteen marble sculptures, one hundred thirty-five bronzes, and fifty terra cottas, works in glass, and engraved gems—such a rich collection could have competed with any of St. Petersburg's famous eighteenth- and nineteenth-century aristocratic museums of antiquities. In the history of its formation we can clearly feel the personalities of the collectors, men who embodied the aesthetic tastes of two eras—the brilliant century of Neoclassicism and the age of historical styles.

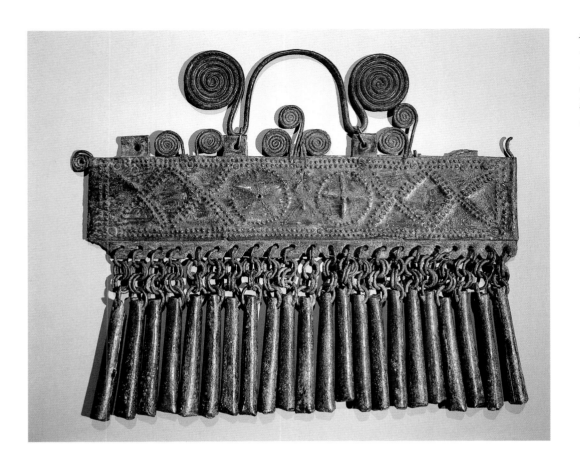

Ancient Italian bronze pectoral,
7th–6th century B.C. *(cat. no.*
185)

OPPOSITE: *Fragment of a double-sided*
Roman marble relief, second half
1st century A.D. *(cat. no. 176)*

NOTES

1. Fortia de Piles, *Voyage de deux français dans le Nord de l'Europe. 1790–1792* (Paris, 1796), IV, pp. 41–44.
2. *Collection d'Estampes d'après quelques tableaux de la galerie du comte A. de Stroganoff* (St. Petersburg, 1807); *Collection d'Estampes d'après quelques tableaux de la galerie du comte A. de Stroganoff* (St. Petersburg, 1835).
3. A. N. Benois: "Stroganovsky dvorets v Sankt-Peterburge" [The Stroganoff Palace in St. Petersburg], *Khudozhestvennye sokrovishcha Rossii* [Art Treasures of Russia], no. 9 (1901), pp. 165–80; with French translation ("Palais Stroganof à St. Pétersbourg," *Les Trésors d'art en Russie*).
4. S. Howard, *Antiquity Restored* (Vienna, 1990).
5. *Collection d'Estampes* (1807).
6. V. Kurbatov, "Sarkofag Stroganovskogo sada" [The Sarcophagus in the Stroganoff Garden], *Starye gody* [Days of Yore], 1912, pp. 41–43; G. Geld, "Stroganovsky sarkofag" [The Stroganoff Sarcophagus], *Germes* [Hermes], vol. 19 (1916), pp. 298–300; G. Trey, *Ukazatel skulpturnogo muzeya Imperatorskoi Akademii khudozhestv. Skulptura drevnikh narodov* [List of the Museum of Sculpture of the Imperial Academy of Fine Arts: Sculpture of Ancient Peoples] (St. Petersburg, 1871), p. 52, no. 191; p. 79, no. 330; p. 89, no. 377.
7. I. G. Georghi, *Opisaniye Rossiysko-Imperatorskogo stolichnogo goroda Sankt-Peterburga i dostopamiatnostei v okrestnostiakh onogo* [Description of the Russian Imperial Capital City of St. Petersburg and the Sights in Its Environs] (St. Petersburg, 1794; reprint: St. Petersburg, 1996); originally published as *Versuch einer Beschreibung der Russisch Kayserlichen Residenzstadt St. Petersburg under Merkwurdigkeiten der Gegend*, 2 vols. (St. Petersburg, 1790); with French translation (*Description de la ville de St Pétersbourg et ses environs* [St. Petersburg, 1793]).
8. M. Pyliayev, *Zabytoye proshloye okrestnostei Peterburga* [The Forgotten Past of the Environs of St. Petersburg] (St. Petersburg, 1889), p. 126.
9. V. Ya. Kurbatov, *Petersburg* (St. Petersburg, 1912), p. 480.
10. H. von Reimers, *St. Petersburg am Ende seines ersten Jahrhunderts* (St. Petersburg, 1805), II, p. 350.
11. *Otchety Imperatorskoi Arkheologicheskoi Komissii* [Reports of the Imperial Archaeological Commission] (St. Petersburg, 1874), p. 204, table 7, no. 3; 1875, p. 200, table 6, no. 3; 1878–79, p. 161.
12. N. A. Sidorova, O. V. Tugusheva, V. S. Zabelina, *Antichnaya raspisnaya keramika iz sobraniya Gosudarstvennogo muzeya izobrazitelnykh iskusstv im. A. S. Pushkina* [Antique Painted Ceramics from the Collection of the Pushkin State Museum of Fine Arts] (Moscow, 1985), nos. 7, 9, 17, 19, 20, 30, 31, 32, 34, 37, 40, 41, 42, 47, 50, 53, 54, 55, 57, 62, 64, 68, 71, 73, 74.
13. Hermitage Archives, fund 1, inv. X, files 6, 19a, 32, 33, 49, 51, 53, 55.
14. *Fotoalbom. Dvorets Stroganovykh* [Album of Photographs: The Stroganoff Palace], *Italian Portrait Photography by the Artist I. Bianchi on Mikhailovskaya Square in the Bodischo House, area 15* (St. Petersburg, 1865).
15. L. Stefani, *Apollon Boedromios. Bronze-statue im Besitz Seiner Erlaucht des Grafen Sergei Stroganoff* (St. Petersburg, 1860).
16. G. Kiserizky, *Der Apollo Stroganoff*, in the series *Mitteilungen des K. Deutschen Arch. Instituts* (Athens, 1899), XXIV, pp. 468 ff.
17. A. Furtwängler, *Meisterwerke der griechischen Plastik* (Munich, 1895), pp. 659–62.
18. A. Muñoz, *La Collezione Stroganoff* (Rome, 1910), 2 vols.

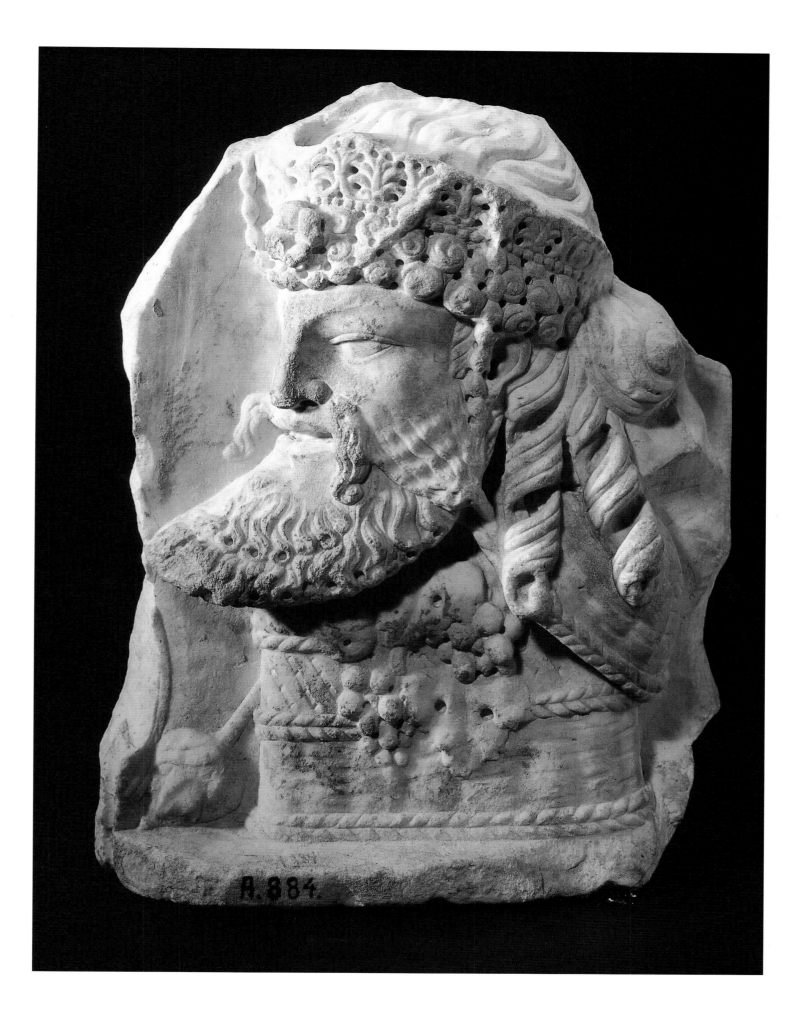

A.884.

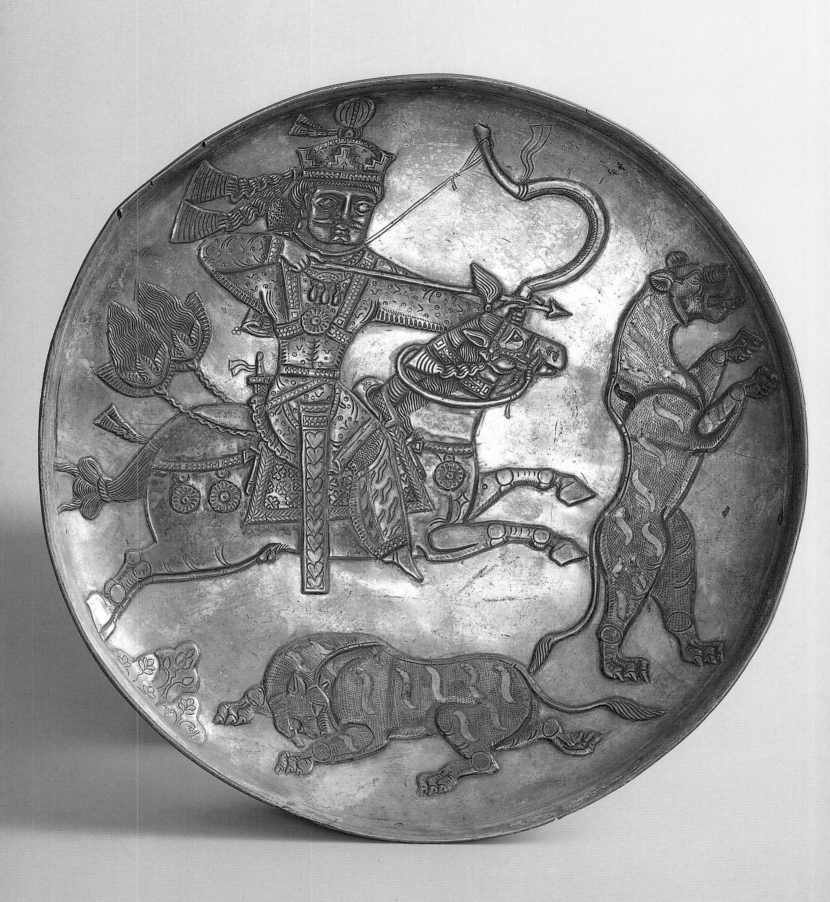

LATE-ANTIQUE SILVER

Boris Marshak

THE STROGANOFFS OPENED THE WAY FOR A NEW CHAPTER IN THE HISTORY OF art by forming the first modern collection of late-antique silver vessels, the subject of the earliest scholarly publications on what would later become known as Sasanian metalwork.[1] This collection of twenty-nine silver masterpieces, found mostly by chance on the family's enormous estates in the Kama River basin, was one of the richest in the world at the time it was transferred to the Hermitage in 1925.

The silver objects collected by the Stroganoffs were found in hoards that had been hidden in the dense Kama forest from the sixth through the fourteenth century by Finno-Ugrian natives, hunters and trappers who had traded their furs to Middle Eastern merchants in exchange for silver vessels and steel swords originating in several centers throughout Europe and Asia. The hunters used the silver dishes for sacrificial meat and occasionally as faces for their pagan idols. Medieval Russian princes exacted tribute from the people of this region in the form of silver from these hoarded treasures, as there were no silver mines or commercial centers in the region, and thus many priceless objects must have been been destroyed for the sake of their valuable metal content.

In the mid-eighteenth century, however, when Alexander Stroganoff was still a student in Paris, he learned of a silver find on family lands.[2] Thanks to his interest, a fine silver ewer with repoussé decoration depicting Anahita, an Iranian goddess who was the divine patroness of the Sasanian dynasty (A.D. 224–651), was brought for study to Paris, where it was published in 1755.[3] Unfortunately, this masterpiece of Sasanian art disappeared during the French Revolution. Another silver hoard was found at about the time Alexander returned to Russia in 1778 after an extended sojourn abroad, and from then on all accidental findings from the Stroganoff estates were carefully saved and added to the family's holdings.

Count Sergei Grigorievich Stroganoff made additional acquisitions in the 1870s, purchasing objects from those who had found them or from the art market. As founder of the Imperial Archaeological Commission in 1859 and its president until his death in 1882, Sergei Stroganoff oversaw the publication of its report (the first archaeological periodical published in Russia) and its policy of directing new finds to the Hermitage, a policy that continued until 1917. Although the commission organized many archaeological expeditions, silver vessels came only from hoards discovered by chance.

In 1909 Yakov I. Smirnov published his famous corpus of Near Eastern silver,[4] dedicated to the fiftieth anniversary of the Imperial Archaeological Commission, and in it he reproduced all of the Stroganoff vessels and provided concise but important commentaries. In 1911 the Stroganoff pieces that had been taken to Rome by Grigory Sergeievich were donated by his heirs to the Hermitage, where they were joined by the rest of the collection when it was transferred from the Stroganoff Palace in 1925. Only one Sasanian plate, depicting Shapur II hunting wild boar, never reached the Hermitage. It found its way from St. Petersburg to Washington, D.C., where it was acquired by the Freer Gallery of Art in 1934.

The core of the Stroganoff collection of Middle Eastern silver consisted of eight or nine objects produced under the Sasanian dynasty, which ruled over a vast area in the Middle

Sasanian silver dish, 7th century (cat. no. 195)

East that includes modern-day Iran. Among them are three superb Sasanian royal plates dating from the fourth through the seventh century (cat. nos. 194, 195). The Stroganoff collection also included a number of pieces identified by current scholarship as originating beyond the time and territory of the Sasanian dynasty and categorized now as Bactrian, Byzantine (cat. no. 193), Chorasmian, Islamic Iranian, and Volga Bulgarian, with dates ranging from the fourth through the twelfth century. This group includes unsurpassed examples of Sogdian and early Islamic (Abbasid) silver.

NOTES:

1. M. le Président de Brosses, "Description d'un vase," *Mémoires de littérature tiré des registres de l'Académie Royal des inscriptions et belles-lettres,* XXX (Paris, 1764), pp. 777–84; H. K. E. Köhler, Über die Denkmäler des Altertums aus Silber in der Sammlung Stroganow (Göttingen Anzeiger, 1803), pp. 41 ff.
2. See the account of Alexander's 1753 letter to his father requesting details on page 32 of this book.
3. *Comtes rendus de l'Académie des inscriptions et belles-lettres,* vol. 30 (Paris, 1755).
4. Yakov I. Smirnov, *Argenterie Orientale* (St. Petersburg, 1909).

Eastern Iranian silver dish, early 9th century (cat. no. 194)

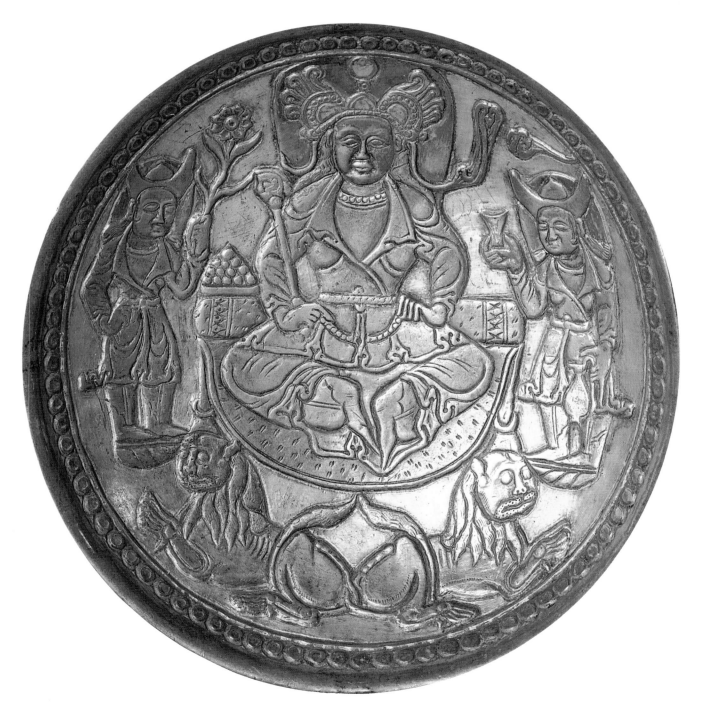

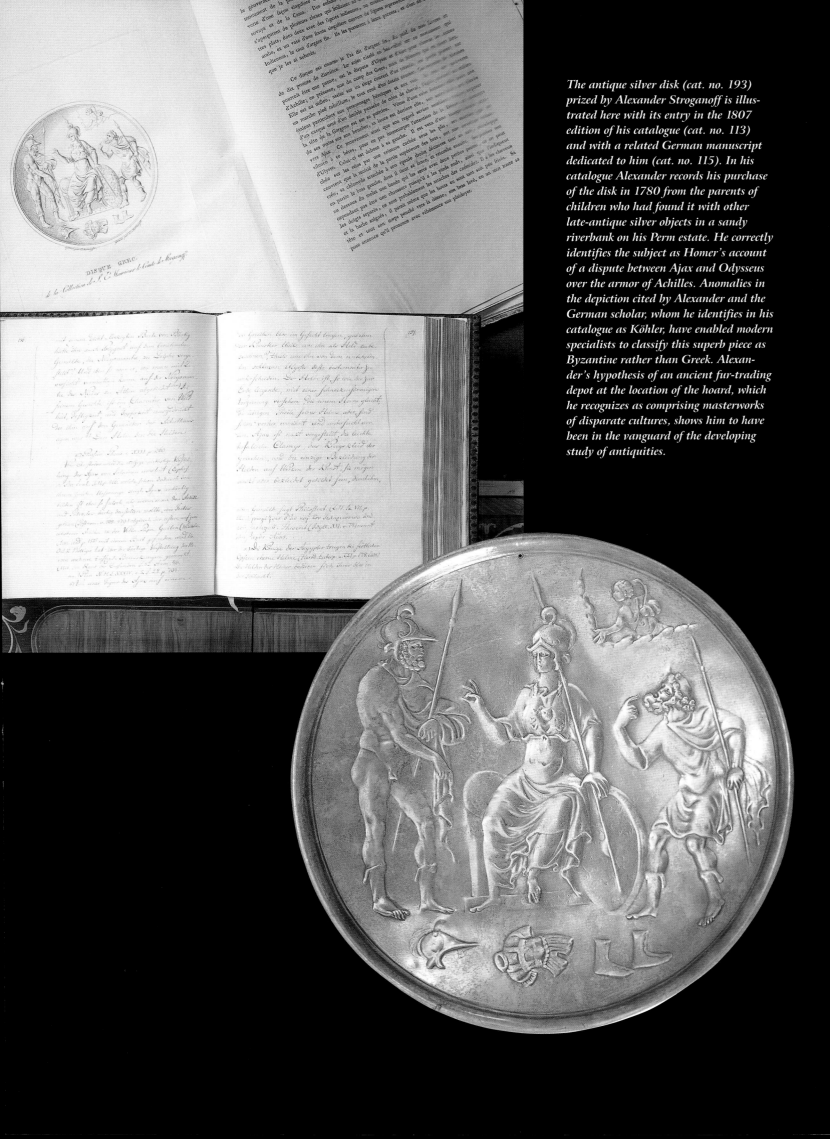

The antique silver disk (cat. no. 193) prized by Alexander Stroganoff is illustrated here with its entry in the 1807 edition of his catalogue (cat. no. 113) and with a related German manuscript dedicated to him (cat. no. 115). In his catalogue Alexander records his purchase of the disk in 1780 from the parents of children who had found it with other late-antique silver objects in a sandy riverbank on his Perm estate. He correctly identifies the subject as Homer's account of a dispute between Ajax and Odysseus over the armor of Achilles. Anomalies in the depiction cited by Alexander and the German scholar, whom he identifies in his catalogue as Köhler, have enabled modern specialists to classify this superb piece as Byzantine rather than Greek. Alexander's hypothesis of an ancient fur-trading depot at the location of the hoard, which he recognizes as comprising masterworks of disparate cultures, shows him to have been in the vanguard of the developing study of antiquities.

MEDIEVAL ART

Marta Kryzhanovskaya

THE ACQUISITION OF MEDIEVAL WORKS OF ART BY MEMBERS OF THE STROGANOFF family reflected the intellectual climate of historicism in the nineteenth century and the Stroganoff proclivity for rare and beautiful pieces. Following the fashion for the Gothic Revival style launched by Europe's literary elite in the 1820s, the Stroganoffs created a special room at their Maryino estate. Whether it contained any actual antiquities is unclear, but we know that it was filled with Neo-Gothic furniture made in the St. Petersburg workshop of Heinrich Gambs (1765–1831). The ensemble is now displayed at the Hermitage in an installation re-creating the Stroganoff "Gothic Cabinet."

Interest in antiquities dating from the Middle Ages was demonstrated first by Count Sergei Grigorievich Stroganoff, and it became a collecting enthusiasm with his son Grigory. In 1870 Sergei donated three medieval works (including the Limoges enamel plaque, cat. no. 200) to a museum then being organized by the Society for the Encouragement of Artists. After the Revolution in 1917 the museum was closed, and works from its collections were transferred to the Hermitage. The Society for the Encouragement of Artists had been organized in 1820 with the active participation of Sergei's mother-in-law, Sophia Vladimirovna, and by the middle of the century had taken over the management of the School for the Arts and Trades (later the Stroganoff Institute for Technical Design) in Moscow and the Stroganoff drawing school, both founded by Sergei Grigorievich. These schools were among the first expressions of the society's mission to provide broader training for artisans. In 1870 a spe-

Limoges enamel reliquary chasses, late 12th–early 13th century (cat. nos. 198 left, 197)

ABOVE: *Italian ivory crozier top, 13th century (cat. no. 201)*

RIGHT: *Italian rock-crystal and copper-gilt processional cross, 15th century (cat. no. 205)*

cialized museum was founded under the direction of the society with the aim of "furnishing the means for graphic familiarization with all types and forms of art in their immediate application to fine artisanal production." The preface to the museum's first exhibition catalogue read: "The examples from the new museum, which have awakened the tastes of student artisans and shown them various adaptations relevant to their work, will serve, undoubtedly, both their development and the elevation of their artistic sense as well. . . . From this point of view, the pieces exhibited might be beneficial in exactly the same way to gentlemen artists and in general to individuals involved in art."

The Stroganoff family took an active part in the creation of the museum and could be considered its principal donors. The founder, Grand Duchess Maria Nikolaievna, gave the museum only about fifty items, whereas the Stroganoffs collectively donated nearly four hundred works, including Russian, Western European, and ancient works of art executed in a wide range of mediums. Sergei Grigorievich himself donated about one hundred seventy pieces, three of which dated from the medieval period. Among the two hundred objects donated by his son, Grigory Sergeievich, forty were medieval. Unlike another major collector, A. P. Basilievsky, who donated only electroplate replicas he did not need, Grigory Sergeievich found it in his heart to give the new museum rare and valuable items.

Father and son had a different approach to collecting. As one contemporary said about Sergei, "the art objects in his collection pleased him even more if they could facilitate the successful resolution of a given scientific problem," whereas Grigory Sergeievich's obituary noted that his collection "had always been known for its beautiful works of art, all of them first rate and always interesting for their artistic virtues." This assessment applies to his medieval objects as well, especially the champlevé enamels, including such outstanding, rare pieces as the twelfth-century plaques depicting Temperance and Justice, two Limoges reliquary chasses from the late twelfth century (cat. nos. 197, 198), carved wooden objects such as the very rare fifteenth-century needlecase depicting an amorous couple holding a heart, and carved ivory objects. In addition to the Stroganoff donations to the Society, which subsequently went to the Hermitage, medieval objects in the collections were transferred from the Stroganoff Palace. These fifty works from the Stroganoffs' collection, many of them of exceptional quality, constitute a sizable proportion of the total of eight hundred in the medieval section in the State Hermitage Museum today.

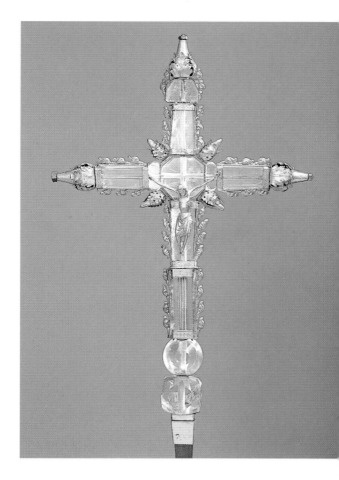

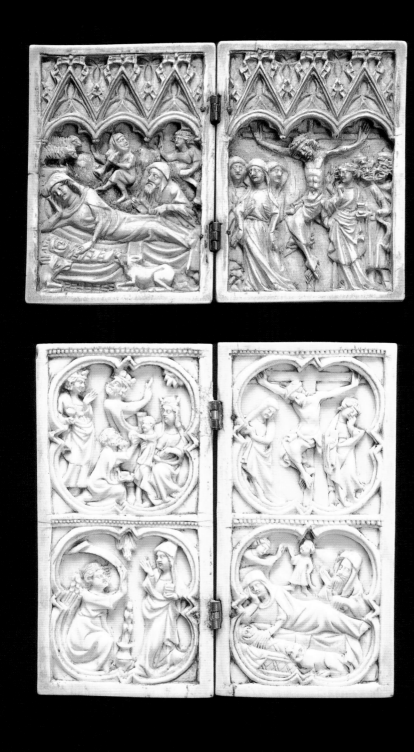

OPPOSITE: *Medieval ivories, from top: Flemish 14th-century diptych with the Nativity and the Crucifixion (cat. no. 204), French 14th-century diptych with the Adoration of the Magi, the Crucifixion, the Nativity, and the Annunciation (cat. no. 203), and three German 12th-century plaques with Christ between Saints Peter and Paul and two apostles (cat. no. 196)*

14th-century ivory triptych with the Virgin and Child and angels, probably from northern France, with a mid-19th-century wood frame (cat. no. 202)

ANCIENT AMERICAN ART

Miriam Dandamayeva

THE HERMITAGE OWNS EIGHT EXAMPLES OF THE STONE-CUTTING ART OF ANCIENT Mexico that originally came from the Stroganoff collection. All of these objects were transferred to the museum in the late 1920s. The circumstances of their acquisition by the Stroganoffs are not documented but, as other scholars suggest, may have been associated with the emergence of Precolumbian artifacts on the international art market during Maximilian's reign as emperor of Mexico from 1864 to 1867.

The 1884 inventory of the Stroganoff Palace records objects from Mexico included among the antiquities displayed on tables in the Picture Gallery. A stellar example from the Stroganoff collection is the Aztec pendant bell in the form of a warrior-eagle that was featured in the 1990 Metropolitan Museum of Art exhibition of Mexican art and is now on permanent exhibition in the Hermitage's Treasury Room.

The Stroganoff objects date from various periods in Precolumbian America. Because of the superb quality of their workmanship, they are the most valuable pieces in the Hermitage's small collection of ancient American art.

OPPOSITE: *Mexican jade mask with obsidian eyes from Teotihuacan, 5th–8th century (cat. no. 208)*

BELOW LEFT: *Aztec alabaster mask, 14–15th century (cat. no. 209)*

BELOW RIGHT: *Mexican figure of a seated goddess, 14th–15th century (cat. no. 210)*

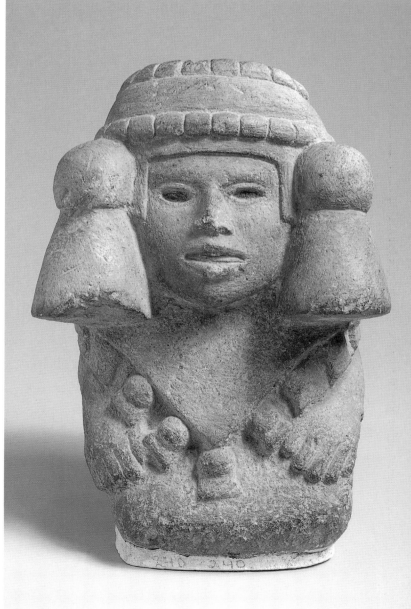

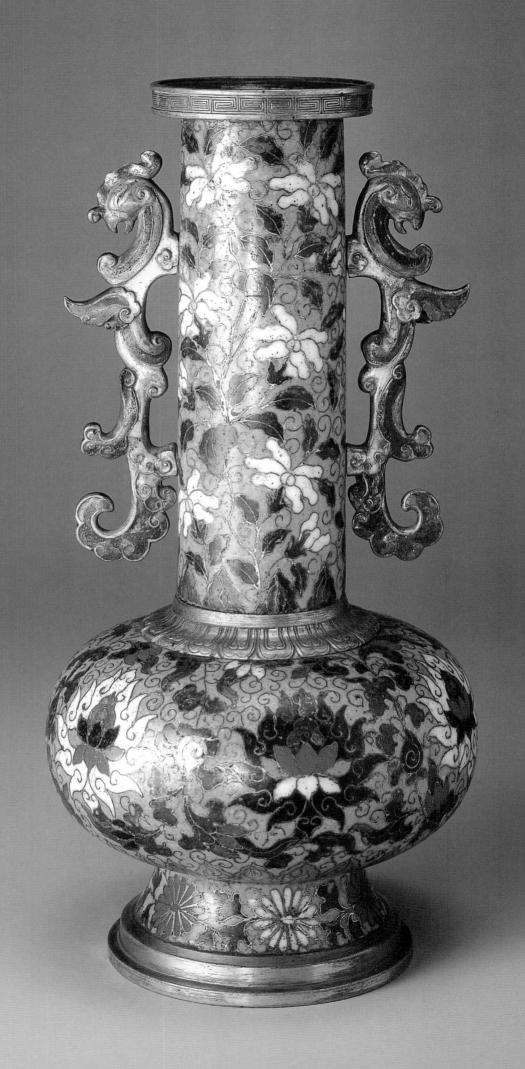

CHINESE ART

Maria Menshikova

THE COMPREHENSIVE APPROACH TO COLLECTING WORKS OF ART DEMONSTRATED by the Stroganoff family explains the variety of objects housed in the St. Petersburg palace before the collections were removed in the late 1920s. A contributing factor to their extensive knowledge and to their taste for exotic pieces was their close connection to the court of the tsar and to the nobility of St. Petersburg. Chinese works of art first circulated in the Russian court as early as the seventeenth century, during the reign of Tsar Alexei Mikhailovich. It was only under his son, Peter the Great, however, when regular contact was made with embassies and trade caravans, that the popularity of Chinese art spread to wealthy Russians, who incorporated it into the decoration of their houses. During the eighteenth century, chinoiserie (Western objects made in the Chinese style and using Chinese motifs) became fashionable, especially in St. Petersburg. Although many original examples, such as the Chinese rooms in Peterhof Palace and the Chinese village and interiors at Tsarskoe Selo, were destroyed, the Chinese palace in Oranienbaum survives relatively intact.

In addition to the Chinese silks and silver that were considered necessities, Peter the Great also ordered the purchase of different types of Chinese "curiosities" for his new *Kunstkammer* (art gallery) and for display at the court. The empresses Anna Ivanovna, Elizabeth, and Catherine the Great continued to acquire Chinese objects of art, and special emissaries and caravans from China brought back gold, silver, porcelain, and silk, along with tea and other goods. The best pieces were selected for the court, and the rest were sold at auctions in St. Petersburg, where members of the nobility naturally made purchases reflecting the interests of their rulers. Catherine the Great constructed mezzanine galleries in the Hermitage and filled them with Chinese silver filigree, gold objects, toys, and carved stones, many of which are still in the Hermitage. The empress liked to play cards here, and she invited her friends to soirées held in these galleries. A frequent guest was Baron Alexander Sergeievich Stroganoff (1733–1811), who certainly must have seen the Chinese curiosities on these occasions. As many contemporary visitors noted, the spirit of connoisseurship in the galleries of the Stroganoff Palace was closely akin to that of the Hermitage.

The earliest documented Stroganoff acquisitions of Chinese art were made by Alexander Sergeievich, who about 1796 purchased in Spain, either personally or through agents, Chinese watercolors on rice paper with "fishes, plants, boats from the collection of Manuel Agot." In 1804 Alexander acquired "68 watercolors with plants and Spanish inscriptions on them by the professor of painting Manuel Palomino." Among the seventeen albums transferred from the Stroganoff Palace to the Hermitage in the 1920s, and later to the Institute of Oriental Studies, were renderings of Chinese coins, depictions of summer residences and ceremonial processions, and anatomical studies of men and women. (These pictures were not sold in 1931, because they were not thought to have any value in foreign currency, so they were mostly kept in the Hermitage and institute libraries.)

A hiatus in the Stroganoff collecting of Chinese material after the death of Alexander in 1811 ended a half century later, when political events stimulated European interest in Chinese art. In 1861 French and British troops suppressed the Taiping rebellion in China and looted the famous Summer Palace outside Beijing. Large numbers of imperial-quality pieces

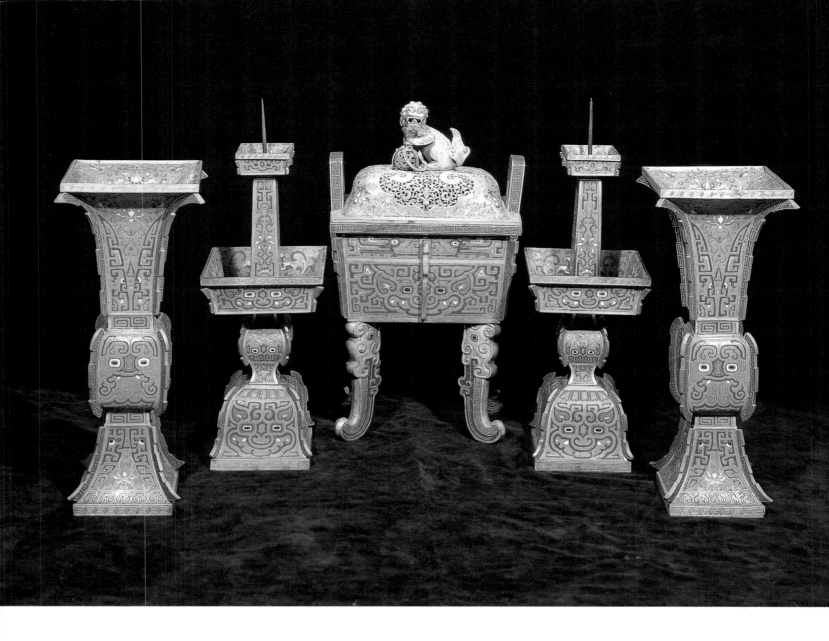

Chinese cloisonné-enamel altar set, second half 18th century (cat. no. 212)

appeared on the European market, and thus the Chinese collections at the Victoria and Albert Museum, the Musée des Arts Décoratifs, Fontainebleau Palace, and Buckingham Palace were built. Although Russia did not take part in that war, its nobility profited by acquiring Chinese art from auctions and art dealers in France and England. A. G. Vlangali, the representative of the Russian court in China in the 1860s, also brought a major collection to St. Petersburg and sold it in the capital.

The most important Russian collection of Chinese decorative art was amassed for the museum of the School of Industrial Art by the heirs of Baron Alexander Stieglitz, the benefactor of the school for whom the museum was named. The Palace of Anikiev was also filled with Chinese objects, especially cloisonné enamels, collected with great enthusiasm by Alexander III and his wife before they came to the throne. These were the social circles of Count Sergei Stroganoff, and there must have been an element of competition for the best newly available examples of Chinese art between highly placed private collectors and the imperial family.

Yet another wave of Chinese art collecting occurred after 1900, as a result of the Boxer Rebellion. This time the Russian army participated in the looting of Beijing along with the

European armed forces, and as a consequence many Chinese pieces eventually appeared in Russia. Although Sergei Alexandrovich Stroganoff, who was head of the family at the time, preferred to live in western Europe rather than Russia, it seems likely that some of the looted objects were sent to the Stroganoff Palace in St. Petersburg. Drawings and photographs of the interiors made at the beginning of the century show Chinese vases standing in the large Drawing Room, the small Sitting Room, the State Dining Room, and the small library. Exotic pieces, such as ancient bronzes and other objects unfamiliar to European eyes, decorated the palace's Arabesque Gallery. Porcelain and cloisonné vases, and even complete five-piece altar sets, were set on side tables and mantelpieces.

There was a particular interest in cloisonné enamels in Russia, as enamel was widely used in Russian decorative art. We know that Chinese enamels were displayed in Peter the Great's gallery, and that Russian craftsmen were sent to China in the eighteenth century to study enamel techniques. During the nineteenth century Chinese masters of porcelain and enamel worked in St. Petersburg factories alongside their Russian counterparts. The Stroganoffs could hardly have failed to share this national proclivity, and in fact enamels represent a major part of their holdings of Asian art. The Hermitage received eighteen Chinese cloisonné items from the Stroganoff collection.

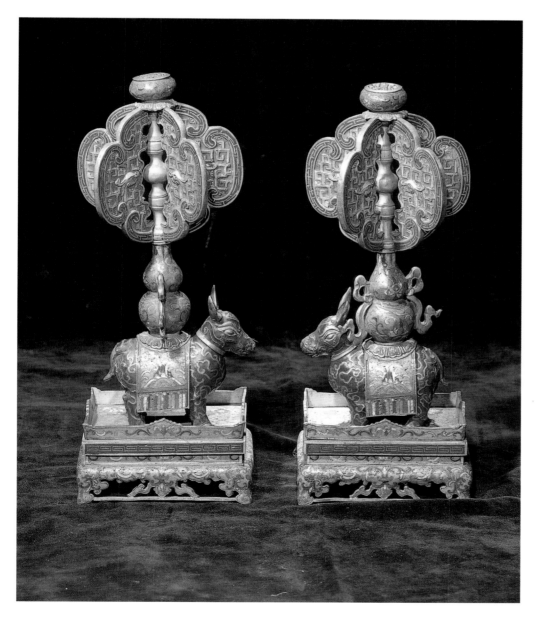

Pair of Chinese cloisonné-enamel hatstands, second half 18th century (cat. no. 213)

Not all of the Stroganoffs' extensive Asian collections went to the Hermitage, but there are about sixty Chinese works in the museum with Stroganoff provenance. Some of the most valuable pieces, in terms of hard currency, were sold in the 1931 Berlin auction or through the Antiquariat, an organization that traded works of art outside Russia for hard currency. Some objects, such as "two Chinese figures with nodding heads" listed in the Stroganoff inventory, have not yet been traced, but the examples that survive in the Hermitage today—Chinese enamels, porcelains, carved and painted lacquer, bronzes, silver, and even a silk robe—are of a quality that demonstrates the superb taste and understanding the Stroganoffs had for a foreign culture.

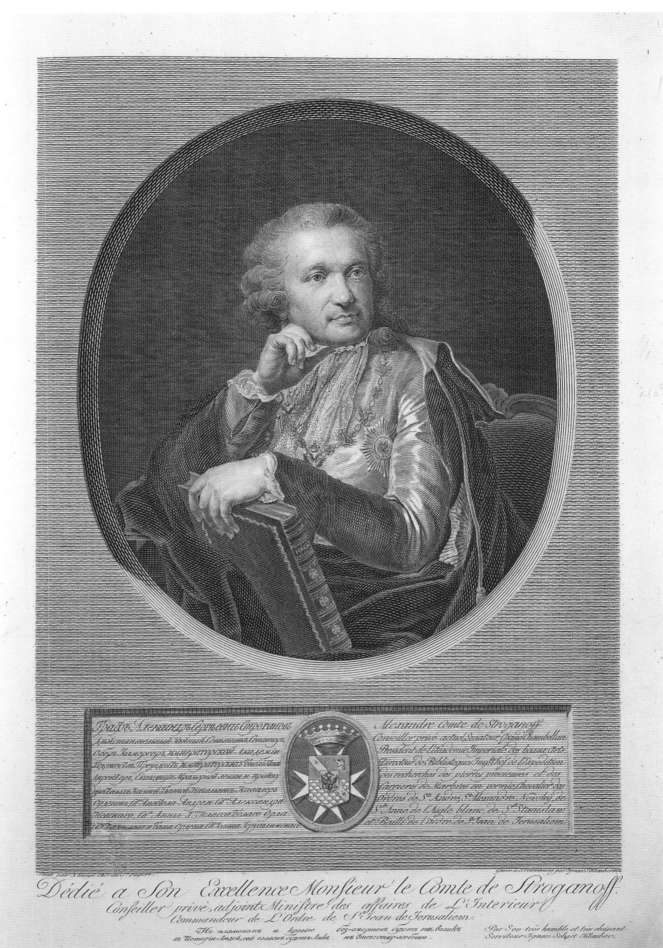

Dédié a Son Excellence Monsieur le Comte de Stroganoff.
Conseiller privé, adjoint Ministre des affaires de L'Interieur
Commandeur de L'Ordre de St Jean de Jerusalem.

AN ALBUM OF STROGANOFF PAINTINGS

Penelope Hunter-Stiebel

In his preface to the 1793 catalogue of his paintings collection, Alexander Stroganoff eloquently expressed the emotion shared by great art collectors through the centuries:

> I wrote this catalogue for myself, to come to grips with the riches that I have been assembling over the past twenty-seven years, and the sensations that their ownership has made me experience. I also write for true art lovers, who are defined by their passion, in whom that passion was born with their earliest ideas and developed increasingly as they were exposed to beauty; who have, in a word, a sincere love for the arts and who try to acquire the information indispensable to the full enjoyment and proper appreciation of the products of talent. . . .
>
> Deliver us, great God!, from art lovers without love and from connoisseurs without connoisseurship, for they, more than all others, contribute to the corruption of taste and do real harm to progress in the arts.

Alexander's catalogue consisted of entries for eighty-seven paintings, written to the highest standards of Enlightenment scholarship, comprising information about the artists and a description of each work, along with a discussion of its iconography and a personal evaluation of its merit. In 1800 he published a revised edition of the catalogue, which included new acquisitions, and in 1807 he enlisted students at the Academy of Fine Arts to produce engravings for an illustrated edition. The entries in the catalogue of the present exhibition (see pages 221–29) were written by specialists in the European paintings department of the Hermitage. Although there have been a few changes of attribution over the course of years, in a surprising number of cases current experts concur with Alexander Stroganoff's critical assessments. Certainly, none would deny the connoisseurship behind the purchase of Poussin's *Flight into Egypt* and Van Dyck's *Portrait of Nicolaas Rockox,* which are recognized as supreme achievements of two of art history's most respected masters.

In his selection of imposing religious and mythological compositions, Alexander expressed the prevailing aesthetic standards by which such history painting was ranked as the most important form of art. But his acquisitions also demonstrate a personal affinity for the animated realism of Dutch landscapes and an appreciation of portraiture for its artistic rather than documentary value. Alexander's great grandson Paul Sergeievich, along with his brother Grigory, brought a renewed passion for paintings into the family collecting tradition in the middle of the nineteenth century and enriched a predominantly late Renaissance and Baroque collection with the works of earlier masters.

The viewer's direct response to beauty was Alexander's motivating concern from his first art purchase as a student to his dying day. For this reason, reproductions of paintings from the Stroganoff collections are presented here in album form for purely visual delectation. In the pages that follow we can share to some extent the pleasure that Alexander experienced in the final hours of his life, which he chose to spend in a chair in the Picture Gallery of the Stroganoff Palace, ill and exhausted after the completion of Kazan Cathedral but surrounded by the paintings he held so dear.

Engraved portrait of Count Alexander Stroganoff by Ignace Sebastian Klauber after a painting by Johann Baptist Lampi, pasted in as a frontispiece to the 1807 catalogue of the Stroganoff collection (cat. no. 113)

ANTHONY VAN DYCK, ***Portrait of a Young Man.***
Purchased by Paul Sergeievich Stroganoff (cat. no. 123)

ANTHONY VAN DYCK, *Portrait of Nicolaas Rockox.*
Purchased by Alexander Stroganoff (cat. no. 122)

BARTHOLOMEUS VAN DER HELST, *Portrait of a Woman.*
Purchased by Paul Sergeievich Stroganoff (cat. no. 125)

GOVAERT FLINCK, *Portrait of Cornelia Haring.*
Purchased by Paul Sergeievich Stroganoff (cat. no. 126)

SCHOOL OF PETER PAUL RUBENS, *Portrait of Rubens and His Son Albert.*
Purchased by Alexander Stroganoff (cat. no. 121)

PIETER JANSSENS ELINGA,
A Dutch Interior.
Purchased by Paul Sergeievich
Stroganoff (cat. no. 127)

ADRIAEN VAN OSTADE, ***The Smoker.***
Purchased by Paul Sergeievich Stroganoff (cat. no. 124)

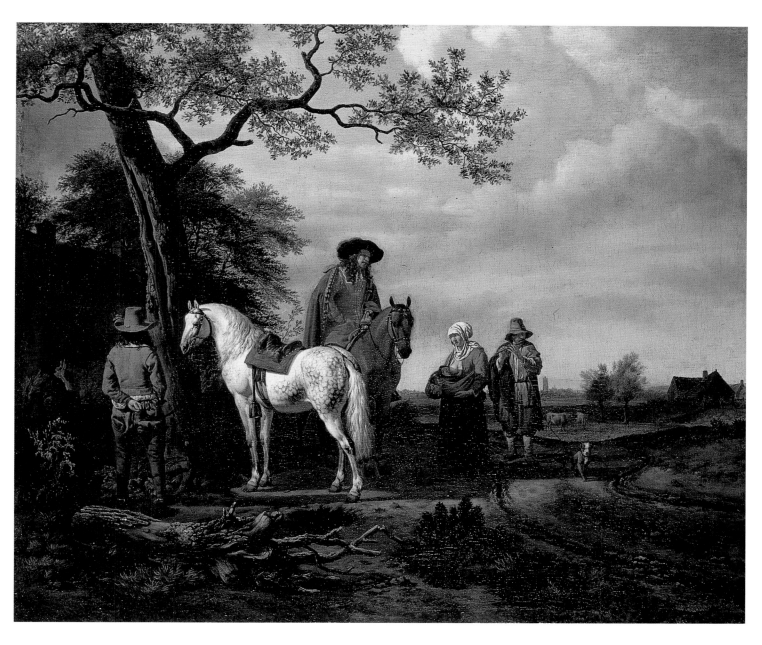

ADRIAEN VAN DE VELDE, ***A Halt.***
Purchased by Alexander Stroganoff (cat. no. 128)

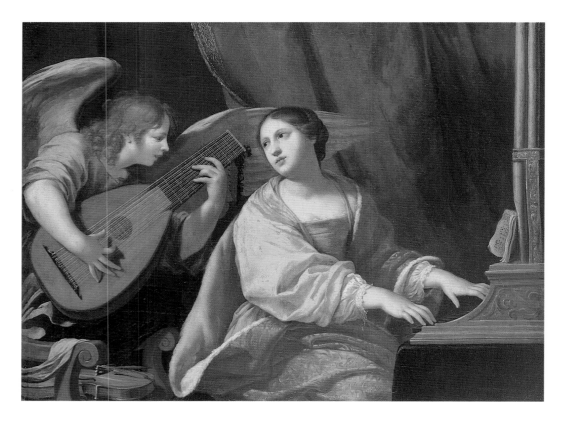

Attributed to JACQUES BLANCHARD, *Saint Cecilia.*
Purchased by Alexander Stroganoff (cat. no. 130)

CLAUDE LORRAIN, *Landscape with Dancers.*
Purchased by Alexander Stroganoff (cat. no. 131)

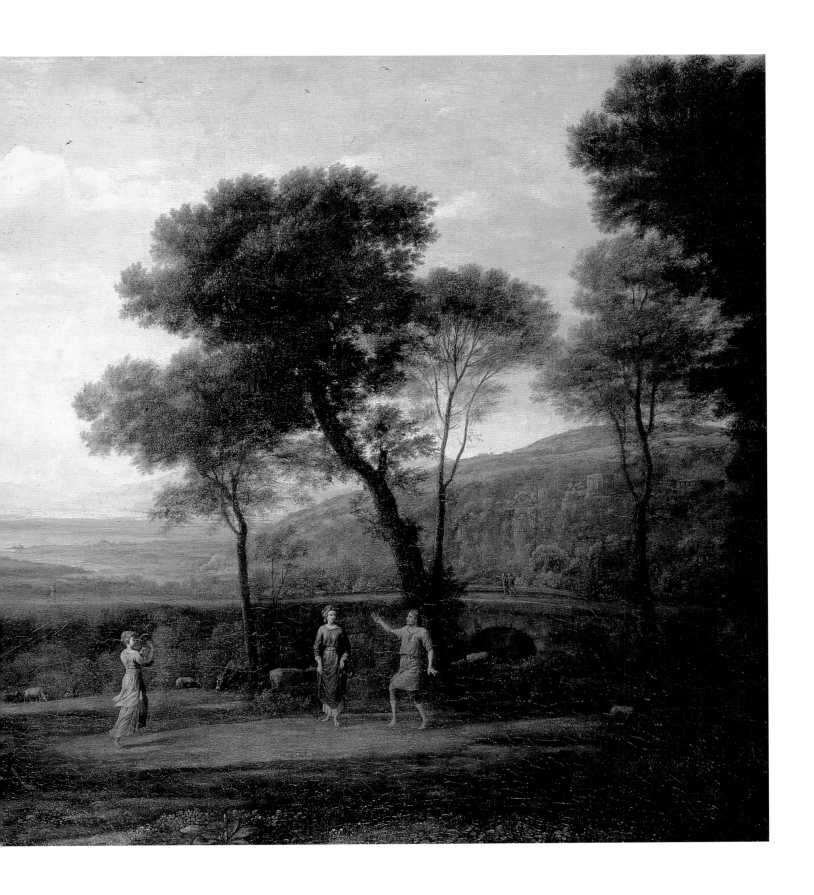

NICOLAS POUSSIN, *Rest on the Flight into Egypt.*
Purchased by Alexander Stroganoff (cat. no. 129)

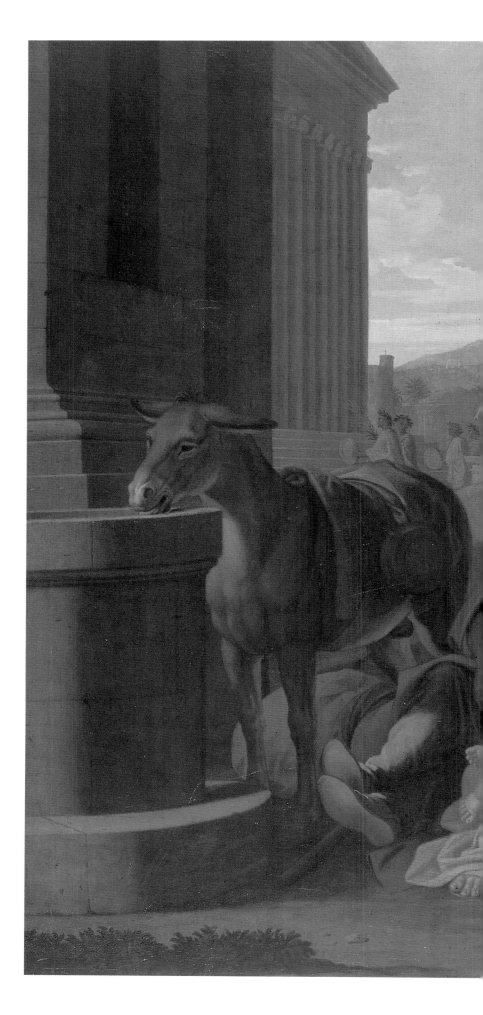

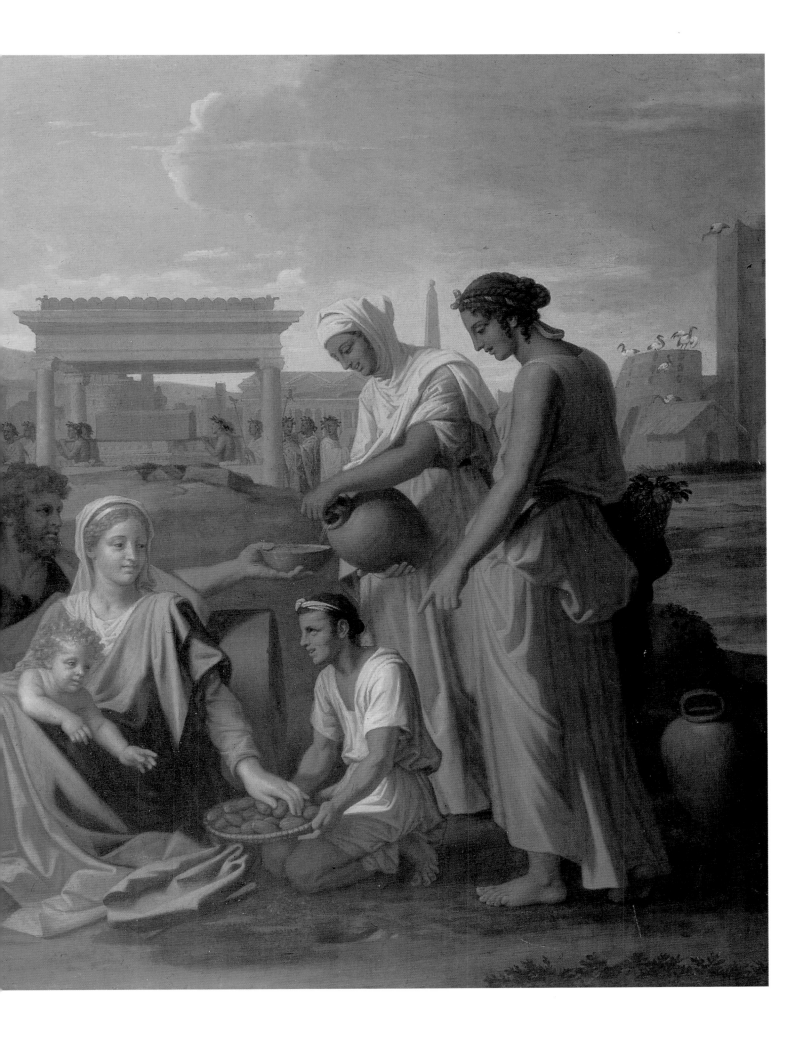

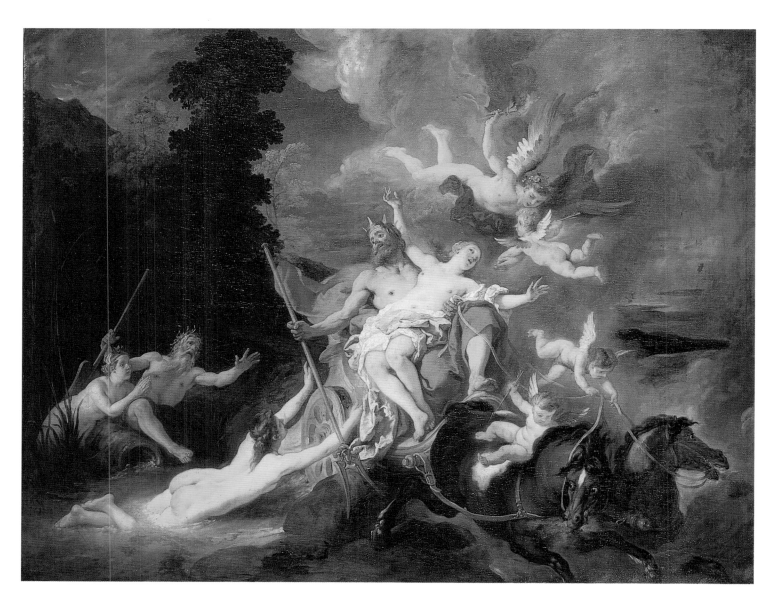

JEAN-FRANÇOIS DE TROY, ***The Rape of Proserpine.***
Purchased by Alexander Stroganoff (cat. no. 132)

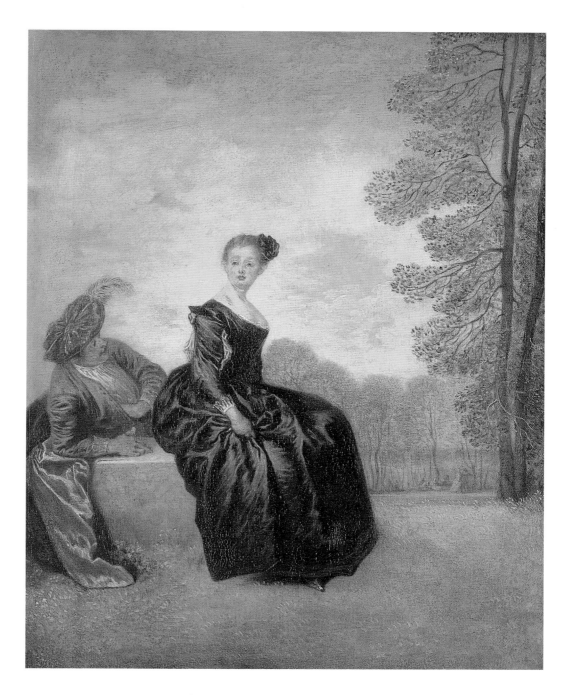

ANTOINE WATTEAU, *La Boudeuse.*
Purchased by Paul Sergeievich Stroganoff (cat. no. 133)

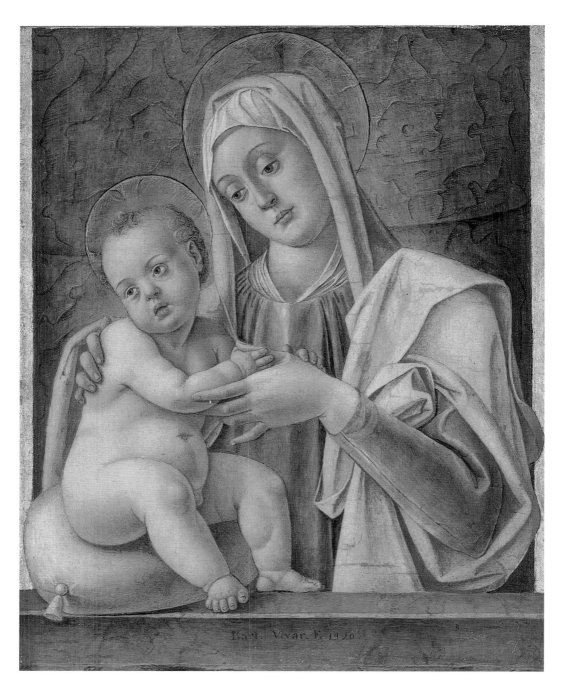

BARTOLOMEO VIVARINI, *Virgin and Child*.
Purchased by Paul Sergeievich Stroganoff (cat. no. 146)

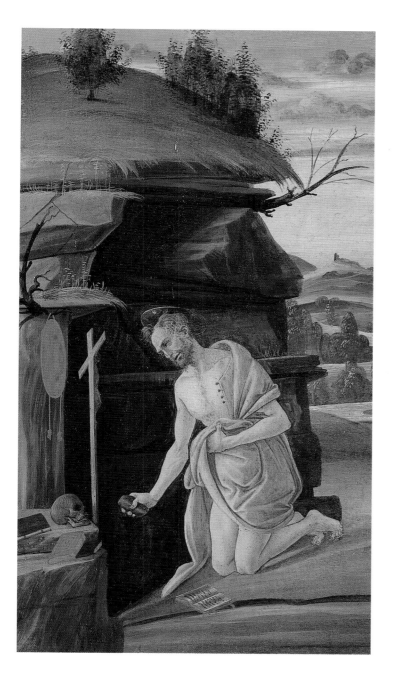

SANDRO BOTTICELLI, **Saint Jerome.**
Purchased by Paul Sergeievich Stroganoff (cat. no. 147)

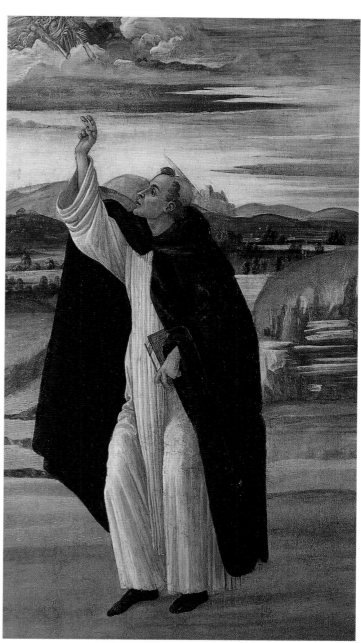

SANDRO BOTTICELLI, **Saint Dominic.**
Purchased by Paul Sergeievich Stroganoff (cat. no. 148)

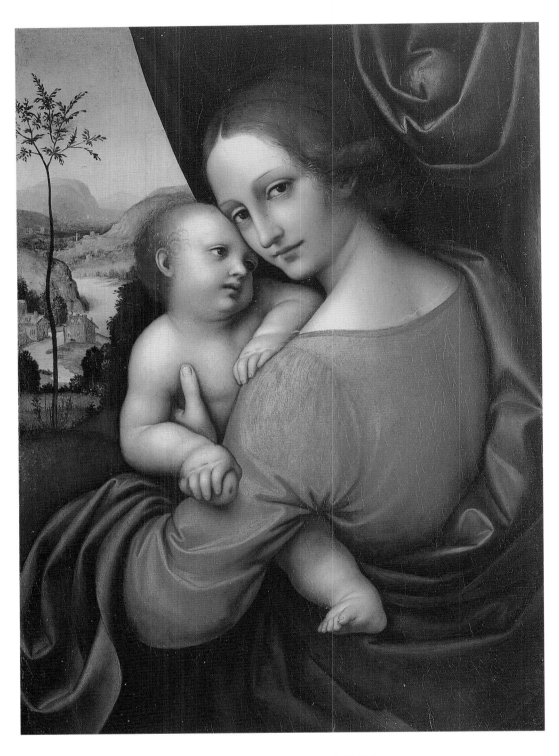

GIAMPETRINO, *Virgin and Child.*
Purchased by Paul Sergeievich Stroganoff (cat. no. 150)

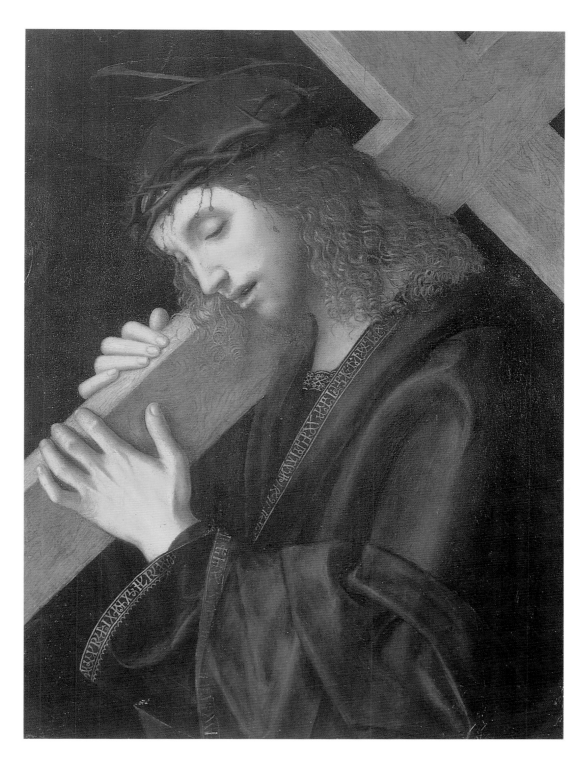

GIAN FRANCESCO MAINERI, ***Christ Bearing the Cross.***
Purchased by Paul Sergeievich Stroganoff (cat. no. 149)

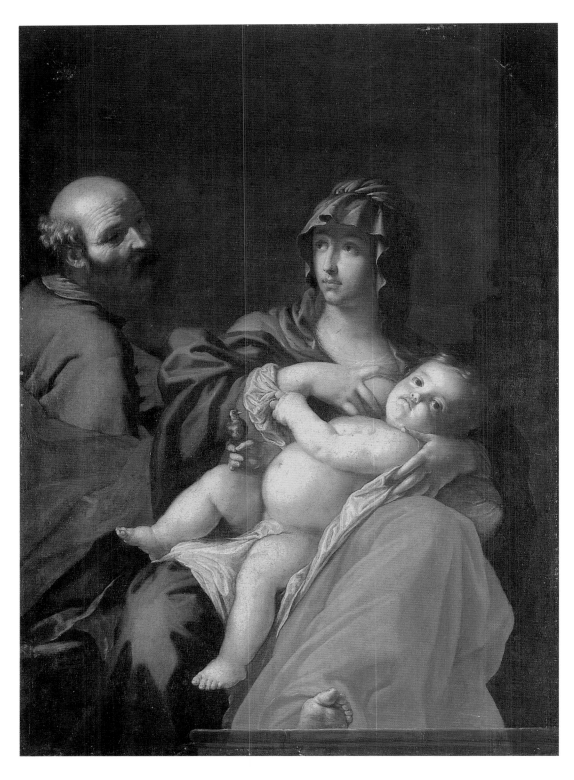

CESARE DANDINI, *The Holy Family.*
Purchased by Alexander Stroganoff (cat. no. 153)

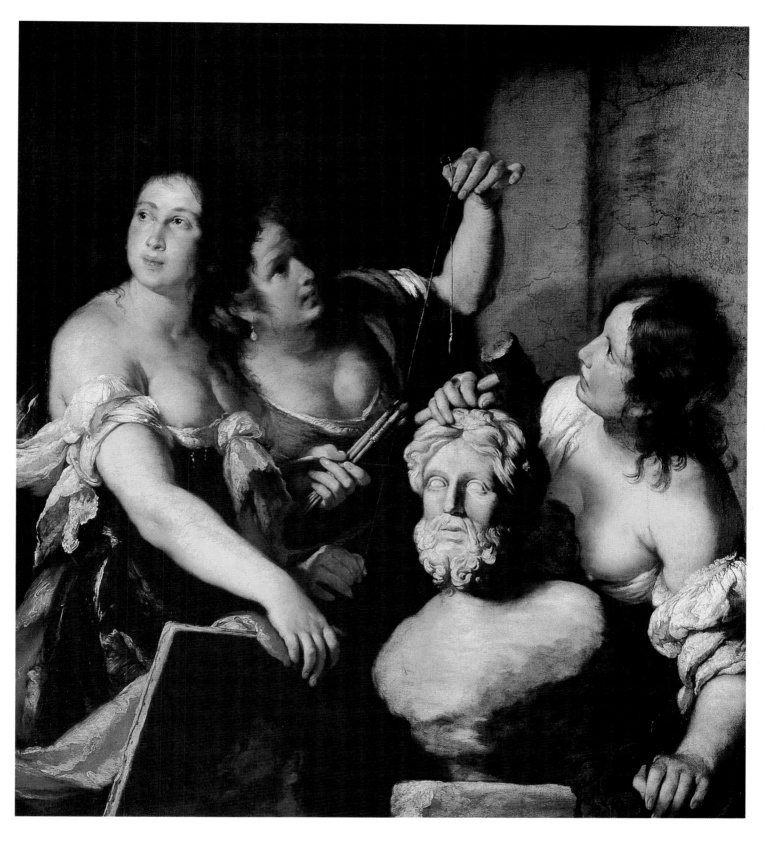

BERNARDO STROZZI, *Allegory of the Arts.*
Purchased by Alexander Stroganoff (cat. no. 152)

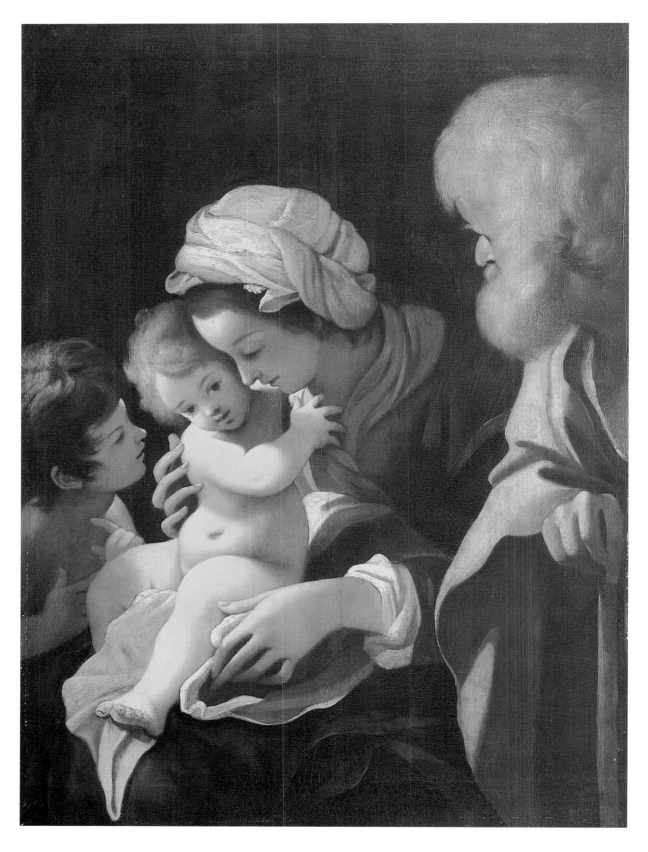

BARTOLOMEO SCHIDONE, ***The Holy Family.***
Purchased by Alexander Stroganoff (cat. no. 151)

OPPOSITE: FRANCESCO SOLIMENA, ***Allegory of the Reign.***
Purchased by Alexander Stroganoff (cat. no. 155)

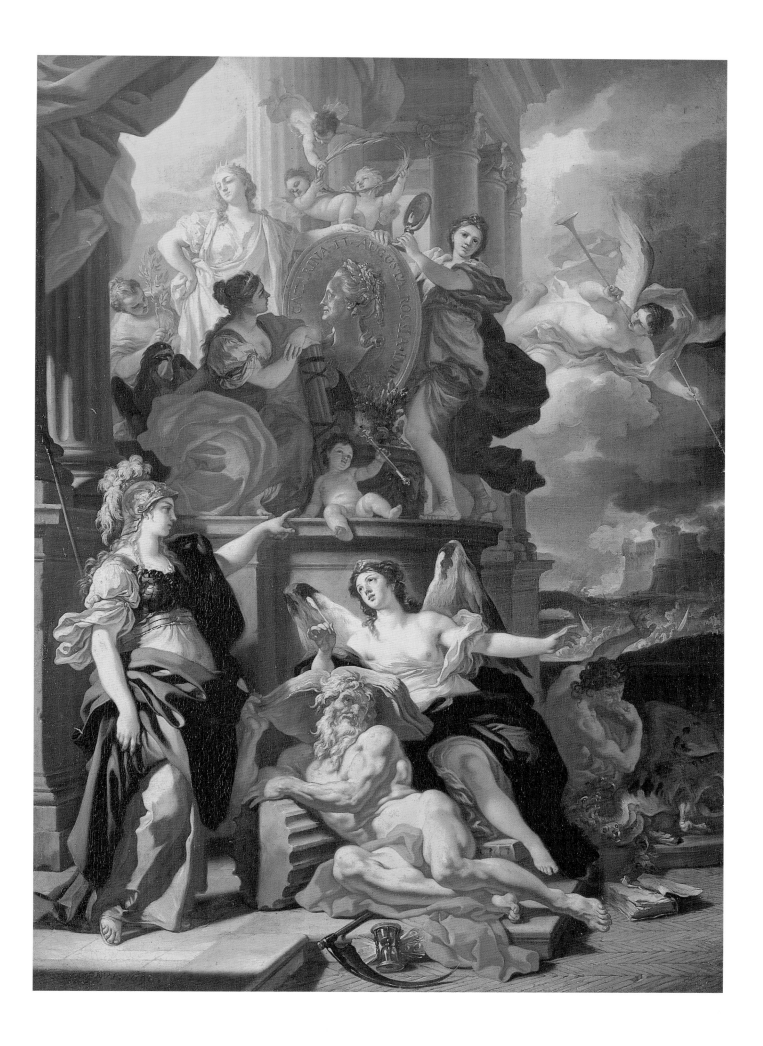

LUCA GIORDANO, *The Battle of Lapiths and Centaurs*. Purchased by Alexander Stroganoff (cat. no. 154)

ALESSANDRO MARCHESINI, *The Sacrifice of a Vestal*.
Purchased by Alexander Stroganoff (cat. no. 156)

Stroganoff Coat of Arms
(detail of cat. no. 110)

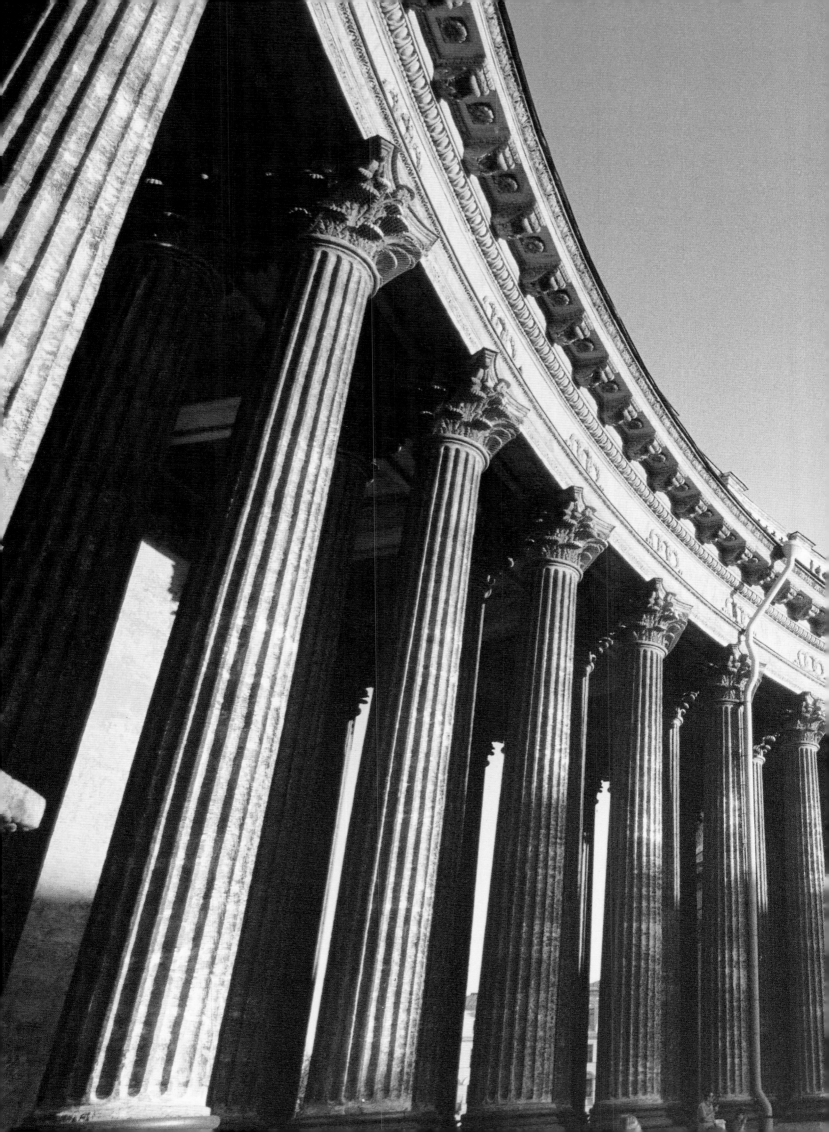

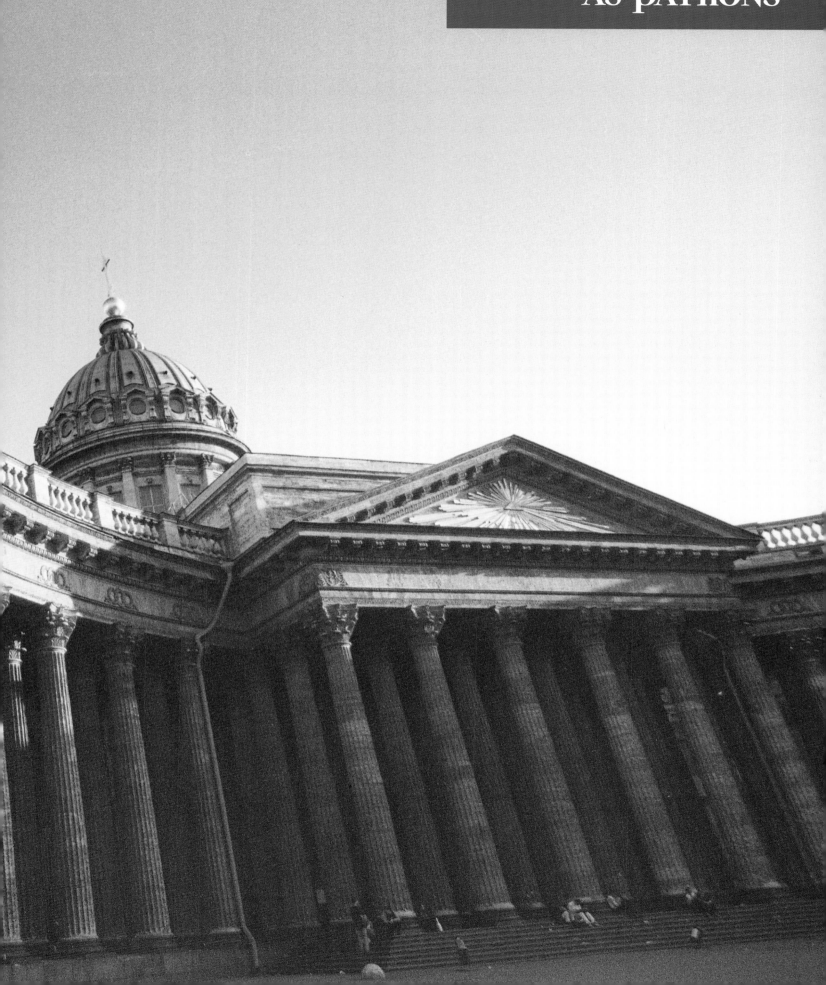

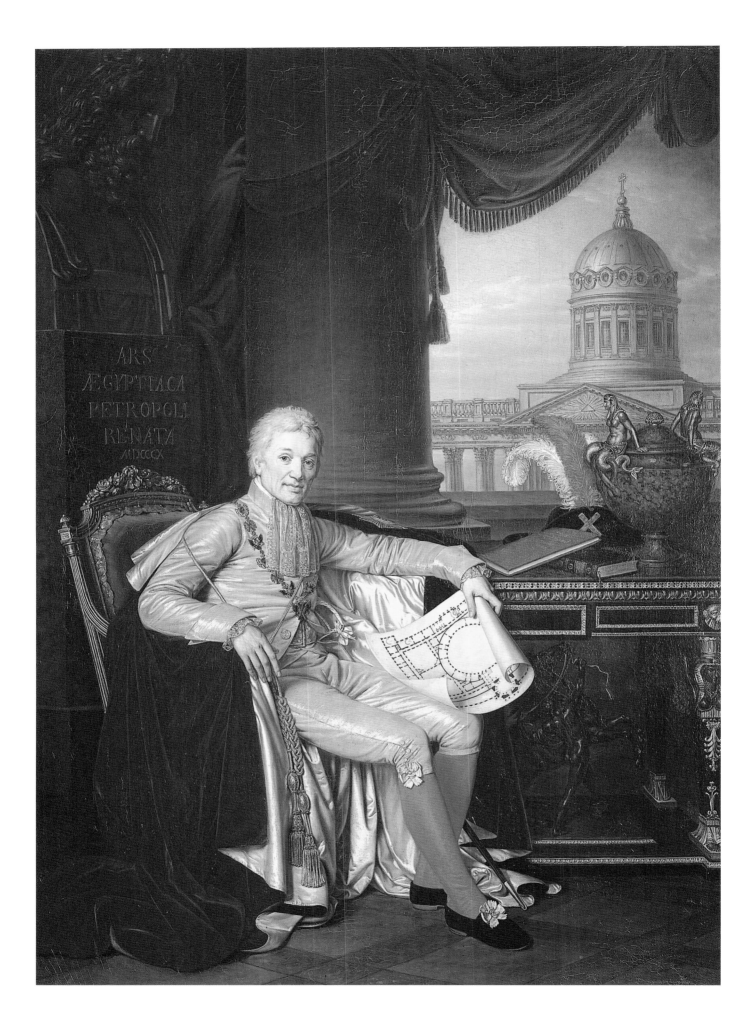

ARS
ÆGYPTIACA
PETROPOLI
RENATA
MDCCCX

PATRONAGE

PENELOPE HUNTER-STIEBEL

PATRONS ARE MORE THAN COLLECTORS OF ART AND MORE THAN SUPPORTERS of artists. Fundamentally, it is the patron's vision that the artist is selected and challenged to fulfill. This was the role assumed by generations of Stroganoffs from the sixteenth century, when Anika envisioned the first great stone church in the remote reaches of Russia's north. In an age when art was the direct visual expression of religion, his children and grandchildren sponsored church architecture, icon painting, and embroidery as an act of piety that extended to personal participation.

Even as eighteenth-century philosophy imposed a distinction between secular and religious art, the Stroganoffs continued their patronage with moral vigor. Baron Sergei Grigorievich took up the patriotic campaign of Peter the Great to make St. Petersburg into an international showplace. Sergei engaged the Italian architect Rastrelli to transform two bourgeois town houses into a Baroque palace and to decorate it in the style of European courts, creating one of the enduring jewels of Russian architecture. Moreover, the baron consciously set the course of future Stroganoff patronage by sending Alexander, his only son and heir, for an intellectual and artistic education abroad.

It became Alexander Stroganoff's personal mission to transplant the art of the European Enlightenment to Russian soil. He promoted the work of contemporary French artists and installed, exhibited, and published his collection of important European old masters with the intent of bringing the best of Western art to his compatriots. Once he became president of the Academy of Fine Arts, he used the post to obtain major commissions for Russian artists. As director of the imperial stone-cutting manufactories, he raised the exploitation of Russia's minerals to the level of an art form that remains highly prized on the international market. Returning to the piety of his ancestors, Alexander devoted the last decade of his life, and most of his fortune, to the building of Kazan Cathedral, which dominates the main thoroughfare of St. Petersburg to this day. His protégé and artistic collaborator on the project was Andrei Voronikhin, generally believed to have been Alexander's natural son, a talented architect who put a distinctly Russian stamp on Neoclassicism.

The nineteenth-century fascination with historicism found a patron in Count Sergei Stroganoff, who developed the science of archaeology in Russia and established the Imperial Archaeological Society, directing its work from the Stroganoff Palace and channeling its finds to public institutions. Sergei also played a vital part in the revival of interest in the art of Old Russia and encouraged its adaptation to contemporary design through his school of applied arts.

In every era from the sixteenth through the nineteenth century, there were Stroganoff patrons, and the legacy of their vision was as important to their homeland as were the treasures of their collections.

OVERLEAF: *Kazan Cathedral*

OPPOSITE: *In homage to the recently deceased patron of the Academy of Fine Arts, Alexander Grigorievich Varnek, an Academy painter, portrayed Alexander Sergeievich Stroganoff (cat. no. 32) resplendent in the uniform of the Order of Saint Andrew and surrounded by emblems of his interests: in his hand the plans of the Academy, beside him a gilt-bronze mounted vase, in the shadows the sculpture of Zeus that presided over the antiquity-filled rooms in the Stroganoff Palace where he held Masonic meetings, and, in the distance, Kazan Cathedral.*

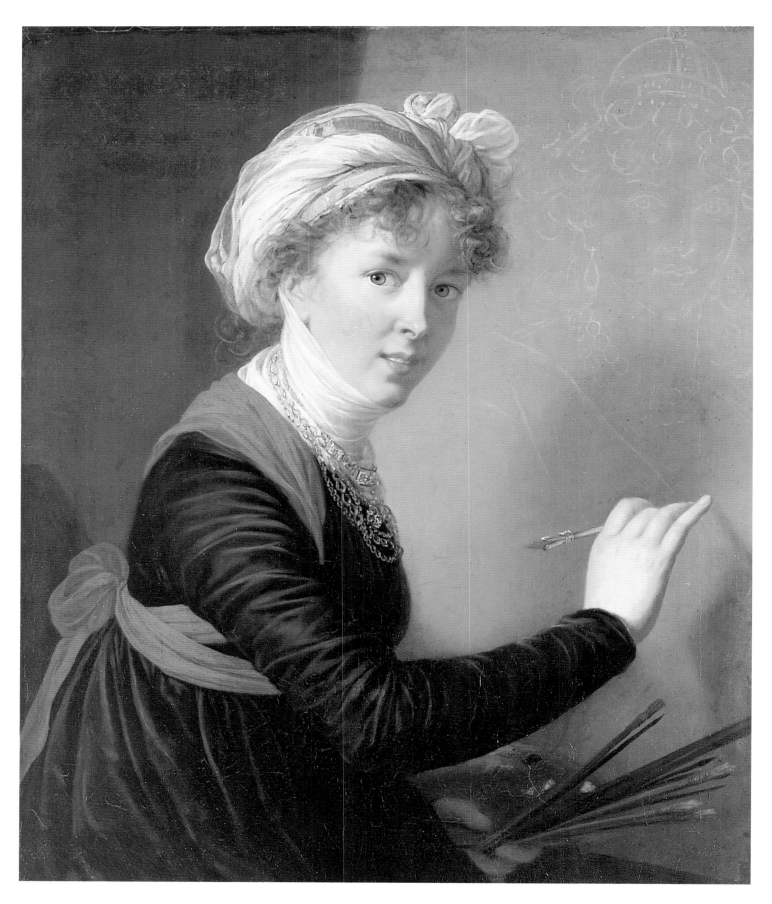

Marie-Louise-Élisabeth Vigée-Lebrun, Self-Portrait, 1800 (cat. no. 142). Immediately after Alexander became president of the Academy of Fine Arts, he made the French painter an honorary member in a ceremony she found so moving that she painted this self-portrait to present to the institution.

ARTIST AND PATRON

Yekaterina Deriabina

Count Alexander Sergeievich Stroganoff (1733–1811) invested many years of passion and broad erudition in the acquisition of paintings "in order that this collection," as he wrote to his son, "might remain in perpetuity as a monument to my zeal for you and my filial devotion to our fatherland." Stroganoff had begun purchasing paintings in the mid-1750s in Italy, but he became particularly active as a collector in France, where he spent the years 1771 to 1779. A fine connoisseur of art, he compiled and published two catalogues of his Picture Gallery (1793 and 1800), the equal of catalogues of the best-known European collections. Distinguished visitors to the Stroganoff Palace remarked on the count's cordial hospitality. "With charming courtesy and friendliness, the owner himself sometimes takes a stranger around and explains the curiosities exhibited here with admirable, expert knowledge," wrote Heinrich von Reimers in his extensive 1805 study of contemporary St. Petersburg and its artistic life.

It is important to realize that Stroganoff was interested not only in paintings of an earlier era, primarily Italian, Dutch, and Flemish, but also in the art of his own time, and that he commissioned works from artists, many of whom he knew personally, and had a reputation as a generous patron. In Paris Alexander Stroganoff knew Jean-Baptiste Greuze, from whom he commissioned a portrait of his son, Paul (cat. no. 135). He also made the acquaintance of the young Marie-Louise Élisabeth Vigée-Lebrun, who painted his portrait, according to her own account, and later made portraits of other members of the Stroganoff family (cat. nos. 143, 144). During the years Vigée-Lebrun spent in St. Petersburg, Alexander Stroganoff maintained a friendly relationship with her and helped her obtain commissions, and on June 16, 1800, just after he had been appointed director of the Imperial Academy of Fine Arts, he personally awarded the artist a diploma in the name of Emperor Alexander I, making her an honorary member of the Academy.

Alexander Stroganoff's closest and longest artistic friendship was with Hubert Robert, the famous French painter of ruins and landscapes and master of decorative ensembles. They first met probably in 1754 or 1755 in Rome, where the young artist's patrons were French diplomats, the comte de Stainville, the future duc de Choiseul, and Bailli de Breteuil. However, they did not become close friends until about a decade and a half later in Paris. Testimony to their relationship was the exhibition at the Paris Salon of 1773 of five small ovals, which Robert had painted for Count Stroganoff and which received critical acclaim. (It

Jean-Baptiste Greuze, Portrait of Count Paul Stroganoff as a Child, *1778 (cat. no. 135). Alexander Stroganoff termed "charming and infinitely lovable" this depiction of his six-year-old son painted while the family was living in Paris, but he commissioned no further works from the artist.*

should be mentioned that a portrait of the count from the brush of Alexander Roslin and two drawings by Pierre-Antoine de Machy also belonging to Stroganoff were exhibited at the same salon.) Stroganoff presented two of these oval compositions (see page 148), *The Pantheon and St. Peter's Square in Rome* (now in the Novosibirsk Picture Gallery) and *The Villa Borghese in Rome* (now in the Belarus State Museum, Minsk), to Catherine the Great, evidently the first paintings the Russian capital had seen by this French master. The other three pictures remained in Paris and were probably sold in 1780.

The year 1773 marked an important milestone in Hubert Robert's artistic life, for it brought yet another commission from Count Stroganoff, one in which, for the first time, the artist showed himself to be a true master of the decorative ensemble, which was just coming into European fashion at the time and which combined in an integral way with

Alexander Stroganoff may well have recommended the talents of Marie-Louise-Élisabeth Vigée-Lebrun to his handsome cousin Grigory, who was on diplomatic duty in Vienna when she arrived, fleeing the French Revolution. Her portrait of Grigory (right, cat. no. 143) projects the winning personality of a Stroganoff who, the artist wrote in her memoirs, "had an unsurpassed gift to charm and animate those around him." Vigée-Lebrun painted the portrait of Grigory's wife and son (opposite, cat. no. 144) soon after arriving in St. Petersburg in 1795.

Neoclassical interiors. Attuned to the spirit of the times, Stroganoff commissioned Robert to create a painting ensemble of six canvases for one of the halls of the St. Petersburg palace (cat. no. 136). It would be difficult to overstate the importance for the artist's career of a commission from someone as influential as Stroganoff was in French aristocratic and cultural circles.

It was not business alone, however, that connected the two men, who represented not only different countries but also different social classes. The count could not have failed to appreciate Robert's extensive knowledge and the classical education he had received at the privileged Collège de Navarre. But their membership in two Masonic lodges, which they joined simultaneously and most likely at Stroganoff's initiative, speaks to a profound spiritual kinship. Stroganoff and Robert were members of Les Neuf Soeurs, a Masonic lodge founded in 1776 by the astronomer J. J. François de LaLande, who was succeeded as leader

Hubert Robert, **Villa Borghese in Rome** *(left) and* **The Pantheon and St. Peter's Square in Rome**

by Benjamin Franklin. Right up to the beginning of the French Revolution, this was one of the most famous Masonic organizations in France, bringing together men mostly of art and literature. The second lodge joined by the Russian patron and his French artist was Les Amis Réunis, on whose council Stroganoff served for a time.

Two of Robert's paintings suggest that the artist and his patron took trips together. Until the twentieth century there was at Maryino, the Stroganoff-Golitsyn estate near Novgorod, a small painting that depicts two figures, probably Stroganoff and Robert, viewing the interior of a Gothic church. The picture left Russia after the Revolution in 1917, and its whereabouts were not known until it was auctioned at Versailles on November 27, 1977. Meanwhile, in 1920, the Hermitage obtained a panel detained at customs in which Robert has depicted two men gazing upon an old church (see page 149). The two compositions, both painted on wood, reveal a striking similarity in both dimensions and subject matter and were likely a pair, kept together at the Maryino estate. The Hermitage painting may depict a moment during a trip in which Stroganoff and Robert viewed monuments of French architecture. The ladies participating in this contemplation of antiquity could well be their spouses.

The arrival in 1780 of the Dutch ship *L'Expédition* bringing the count's art collection for installation in his St. Petersburg palace marked the introduction of the French master to a Russian audience. It is possible that the Robert pictures also inspired the grand duke, Paul Petrovich, and his wife, Maria Feodorovna, to visit the artist's studio at the Louvre during their tour of Europe in 1782. The result was a commission in Paul's name, through Prince N. B. Yusupov, for a series of paintings for Paul's palace on Kamenny Island in St. Petersburg (now in the palace at Pavlovsk).

As the ideas of Jean-Jacques Rousseau began to penetrate Russian culture, accompanied by a fashionable interest in landscaped parks, antiquity, and French art, Hubert Robert enjoyed increasing success in Russia. He was invited to visit Russia by Catherine the Great on two occasions, in 1782 and 1791, but he did not make either trip. In 1782 he was enjoying a plethora of profitable commissions in France and he anticipated obtaining the presti-

LEFT: *Hubert Robert,* **Visit to a Medieval Church**

ABOVE: *Hubert Robert,* **Tower-Ruin at Tsarksoe Selo**, *painted after a drawing by Alexander Stroganoff*

gious position of curator of the Royal Museum in the Louvre. It may well have been in connection with Catherine's first invitation that Count Stroganoff conveyed to him her commission of an unusual landscape, *Tower-Ruin at Tsarskoe Selo* (Catherine Palace, Pushkin Museum). He sent to the artist as an example his own drawing of the park structure, an artificial ruin built in the form of a tower in 1771–73 by the architect Yuri Velten. The drawing was provided with a caption in Russian, and this is painstakingly reproduced in the final painting. For unknown reasons, the dispatch of the resulting painting to Russia was delayed, and then the events of the French Revolution intervened, so Catherine did not receive her *Tower-Ruin* until 1791. In a letter dated May 1 of that year, an old correspondent of the empress's, the encyclopedist Melchior Grimm, informed her: "Robert assures me that this picture was ordered on behalf of Your Imperial Majesty by Count Stroganoff. Its price is 50 louis or 1,200 French livres." Evidently, Robert again expressed no desire to travel to St. Petersburg, inasmuch as Grimm noted further, not without malice: "One must imagine that Robert, whose primary talent is painting ruins, must find himself in clover in his homeland. Everywhere he turns he finds his genre laid out for him with the most beautiful and the freshest ruins in the world." In a response dated June 6, 1791, the empress expressed her satisfaction with the landscape she had received: "I have the highest opinion of Robert's painting," and she went on to write in the same ironic vein as her correspondent: "If this Robert were neither a demagogue nor a hothead, and if he came here, he would find some views to paint, because all Tsarskoe Selo is an immense collection of the most picturesque views that

one could find. . . . Since this artist prefers to paint ruins, and he has so many before his eyes, he has good reason not to leave his country of ruins."

There is no way to know whether Robert regretted his refusal to leave France when he was arrested in October 1793, but he did avoid the tragic lot of other supporters of the ancien régime when he was freed a week after the coup of 9 Thermidor. Upon regaining his freedom, however, Robert discovered that most of his clients had not been as lucky: some had perished, others had emigrated, and still others had been ruined. Stroganoff's collection catalogues indicate that between 1793 and 1800 he had acquired two more small landscapes by Robert. One of them was probably sold during the 1920s, and the other we believe can be identified as *Laundresses in the Ruins* (cat no. 137). Inasmuch as these are early works by the artist, painted while he was still at the French Academy in Rome, it can be assumed with some confidence that Stroganoff purchased them from Robert's own collection during a difficult period in the artist's life, in order to prop up his friend's badly shaken affairs.

Alexander Stroganoff quite likely had something to do with Paul I's acquisition of two beautiful paired paintings by Robert now in the Hermitage collection: *Arch on a Bridge over a Stream* and *Ancient Building Serving as a Public Bath,* which was exhibited at the Salon of 1798, the last in which Robert participated. In the Hermitage's manuscript catalogue of that period we find: "These two pictures were painted in 1798 for the president of the Academy of Fine Arts, Count Stroganoff, and purchased in 1802 by the Sovereign Emperor Alexander I." Throughout the eleven years of Stroganoff's tenure as president of the Academy of Fine Arts in St. Petersburg (1800–1811), he took an active part in the acquisition of works for the imperial family and the Hermitage. In a letter dated August 15, 1802, he addressed the court minister Count Guriev: "For the two pictures from the painter Robert that I ordered from Paris, his Imperial Majesty has seen fit to order the issue from his cabinet of six thousand livres." The pictures acquired by the emperor were immediately used for the decoration of his dining room—along with the two ovals Stroganoff had previously presented to Catherine the Great—indicating that he liked them.

Hubert Robert's admission to the Academy of Fine Arts soon followed, undoubtedly with the support of its president, Count Stroganoff. On December 11, 1802, the Academy announced this decision: "In accordance with the general agreement of the assembly, Mr. Robert, a member of the former Royal Academy in Paris, has been elected an honorary free associate of this society." This title, of which the artist was very proud, was included in the inscription on his tombstone in the Auteuil cemetery outside Paris: "Hubert Robert, painter, councilor of the Royal Academy of Painting, and honorary associate of the Academies of Petersburg."

Alexander Stroganoff never forgot his French friend. Realizing that the aging artist, who had lost the greater part of his former clients as a result of the Revolution, was in need of moral and material support, Stroganoff rendered him all manner of assistance. Capitalizing on the same favorable disposition toward Robert in the young emperor, Alexander I, that he had seen on the part of Catherine and Paul, the count used his influence at court in 1803 to bring about another major acquisition, eight pictures that the artist had sent to Stroganoff with a request to offer them to the emperor. These works—currently in the collections of the Hermitage, the Pushkin Museum in Moscow, the Louvre, and the Bishkek Museum of Art—

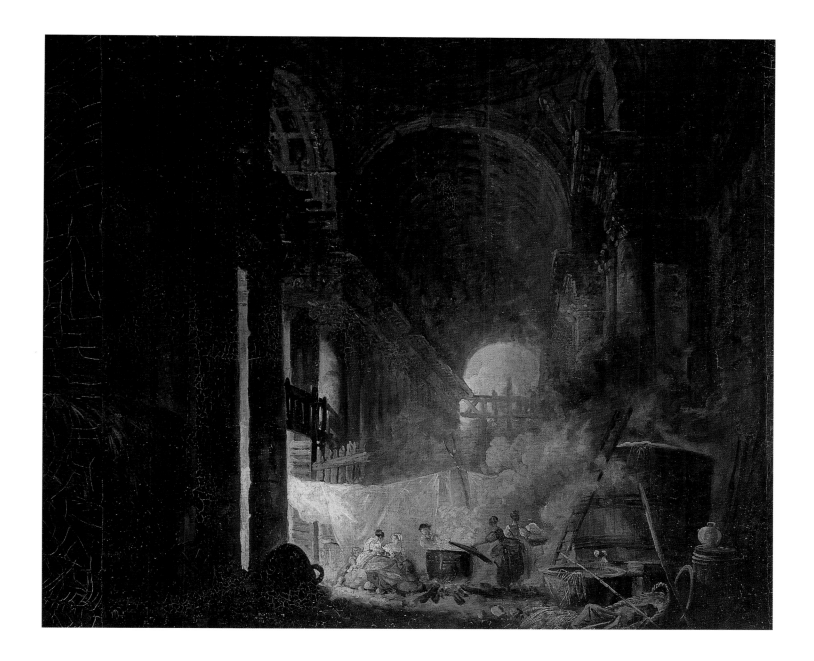

Hubert Robert, **Laundresses in the Ruins** *of 1760 (cat. no. 137) was an unsold early work that Alexander Stroganoff bought from the impoverished artist late in his career.*

OVERLEAF: *Hubert Robert's decorative ensemble of six architectural landscapes, which soar to a height of nearly 10 feet, was commissioned in 1773 by Alexander Stroganoff for his St. Petersburg palace (cat. no. 136).*

have been erroneously considered a series with the date of 1803, but in fact the artist had chosen for the emperor paintings made at different times during the 1770s, 1780s, and 1790s. Judging from the selection, one can see that Robert was trying to present the diversity of his work: architectural views, landscapes, an interior, a genre scene. The monarch's generosity was long remembered by Robert. Three years later, he would write to his friend, the architect Pierre-Adrien Pâris: "The Emperor of Russia for whom I have just completed several paintings, which he paid me for in quite a different manner than they pay here, added in a extra expression of generosity and satisfaction with my dispatch, a very beautiful and valuable diamond and the diploma of my acceptance as an honorary member of his Academy in St. Petersburg."

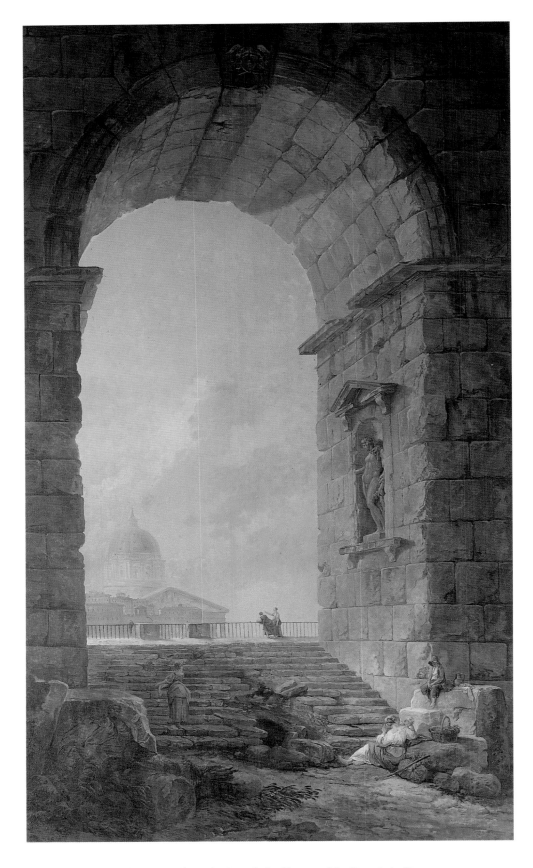

Landscape with an Arch and the Dome of St. Peter's in Rome

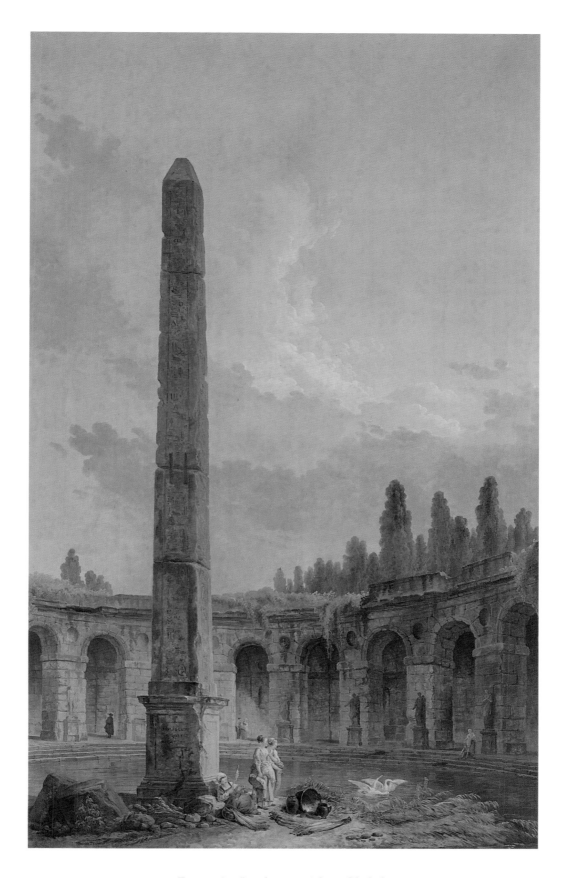

Decorative Landscape with an Obelisk

Cypresses

Landscape with Rocks

Landscape with a Waterfall

Landscape with a
Triumphal Column

The Latin inscription in Karl Leberecht's 1803 wax portrait of Alexander Stroganoff, made to commemorate his presidency of the Academy (cat. no. 41), reads: "Count Alexander Stroganoff, Great Lover of the Arts of His Country." On either side tiny coins spill out of cornucopias to become emblematic works of art in an ingenious representation of patronage. In Alexander's first year as president he enlisted this master of miniaturized sculpture to teach medal making.

THE IMPERIAL ACADEMY OF FINE ARTS

VERONICA IRINA BOGDAN

THE IMPERIAL ACADEMY OF FINE ARTS WAS FOUNDED IN ST. PETERSBURG IN 1757. Fate linked Alexander Sergeievich Stroganoff with the school in 1768, when he was named an "honorary lover of the arts." He took over active stewardship in January 1800, when Tsar Paul I appointed him president. Stroganoff used his considerable influence at court for the benefit of the Academy, whose mission, beginning in 1802, was "to study designs for the adornment of the capital and cities." Thereafter, all "monuments to the glory of the fatherland" were to be erected only after the Academy had given its approval. At this time, Academy artists began to be shown preference in the distribution of commissions for the construction of public buildings.

Appointed chairman of the Committee for the Construction of Kazan Cathedral in St. Petersburg, Stroganoff saw to it that this hugely important commission went to his young Russian protégé Andrei Voronikhin rather than to Paul I's favorite architect, the Italian Vincenzo Brenna. Students in the Academy's architecture class had the opportunity twice weekly, and at times even daily, to learn practical disciplines directly on site. When the time came for the cathedral's sculptural ornamentation, the Academy took that responsibility upon itself as well. Attached to the Academy was a sculpture foundry, where the casting of large sculptures was often attended by spectators seated in armchairs arranged so that they could observe the impressive lost-wax process by which a bronze statue was cast in a single piece. Thus, Kazan Cathedral became a place where both pupils and teachers from the architecture, sculpture, and painting departments could apply their skills.

During the period of Stroganoff's presidency (1800–1811), some of the most beautiful buildings in St. Petersburg were erected with the direct participation of the Academy and its artists, specifically the Admiralty (Adrian Zakharov, architect, and Fedos Shchedrin, sculptor) and the Stock Exchange (Thomas de Thomon, architect). In 1800–1801, Mikhail Kozlovsky executed a monument to the great Russian commander Alexander Suvorov, which was cast at the Academy's foundry. Before that monument could be completed, a new sculpture program for the Grand Cascade at Peterhof was launched, in which the sculptors Fedot Shubin, Fedos Shchedrin, Ivan Prokofiev, and Jean-Dominique Rachette completed a series of ornamental statues and groupings. For the center of the ensemble Kozlovsky created his *Samson Tearing Open the Lion's Jaws.* (When this talented artist passed away in 1802, Stroganoff instituted a gold medal in his honor for the

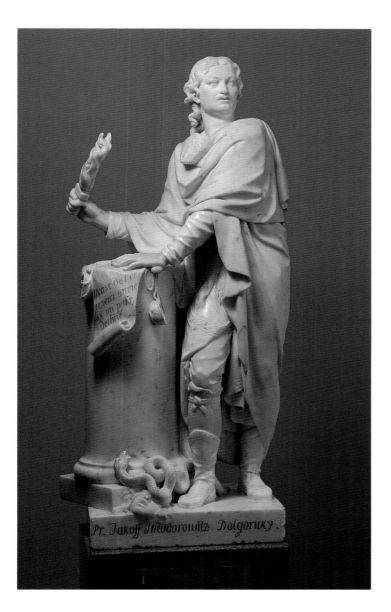

Mikhail Kozlovsky represents the first generation of artists trained at the Academy. Alexander Stroganoff so admired this sculpture celebrating the Russian hero Yakov Dolgoruky (cat. no. 40) that he commissioned a version for his own collection. When Kozlovsky died in 1802, Alexander instituted an Academy award for monument design in his honor.

best monument drawing and awarded it to Kozlovsky's pupil Vasily Demuth-Malinovsky.) A colonnade and fountain arches were erected there as well, under Voronikhin's supervision and based on his design.

With the energetic participation of the president, two new classes were opened at the Academy: one in medal making, which was put in the charge of the German artist Karl Leberecht (cat. nos. 41, 56), who was simultaneously teaching heraldry; and one in painting restoration. The latter was first taught in 1801, when Stroganoff instructed the Academy to hire the painter Ivan Hoff to teach students the "correction and repair of pictures." Stroganoff brought about an impressive increase in staff at the Academy and introduced several supplemental articles to the old charter. Now students were first accepted at eight or nine years of age, not at five or six, as under the previous president Ivan Betsky, and as a consequence the term of instruction was cut from fifteen to twelve years. The program of general-education subjects was expanded, so that starting in the third form pupils (fourteen to seventeen years old) began studying perspective, optics, aesthetics, and fine-arts theory. The "theory of allegories and emblems" and the history of the fine arts and artists were introduced in the fourth form. Students selected to go abroad were required to learn Italian in the year before their departure, so that they would derive maximum benefit from their foreign study. Future architects were required to observe at construction sites and to submit their notes and drawings to the council at the end of the projects.

From its treasury the Academy of Fine Arts had paid out annually ten thousand rubles apiece to artists who completed projects on the topic of the nation's history. Stroganoff continued the tradition, according to which the president of the Academy provided subsidies for pupils out of his own personal funds and allocated money to those students completing their study abroad. By way of extending his patronage to engravers, the count commissioned an edition of engravings of his collection (cat. no. 113), which included reproductions of objects in the Picture Gallery, whose catalogue Stroganoff had compiled in French. In 1805, at his initiative, *Works of the Students of the Imperial Academy of Fine Arts* was published with engravings that would familiarize the broad public with the works of young artists.

Stroganoff was closely involved in the selection of professors and endeavored to hire the very best. Thus, in 1803, one of the foremost architects of Alexander I's day, Thomas de Thomon, was chosen to teach a course in perspective in the architecture department alongside Adrian Zakharov and Andrei Voronikhin. Stroganoff was worried by what he saw as "a deficiency in the proper use of color" among his students, and so the French portraitist Jean-Laurent Mosnier (cat. nos. 138–41) was invited to join the faculty. In the years 1806 to 1808, he and Stepan Shchukin (cat. nos. 29, 30) taught the portrait-painting class together, and

This intaglio by Alexei Yesakov (cat. no. 42) belonged to Sophia Stroganoff. Its author was a headstrong young artist who wanted to submit a subject of his own invention for acceptance to the Academy rather than the image of Herakles throwing Lichas into the sea required by the unyielding council. Despite his reluctance, Yesakov qualified so brilliantly that he was immediately appointed to assist Leberecht in teaching the class in gem cutting.

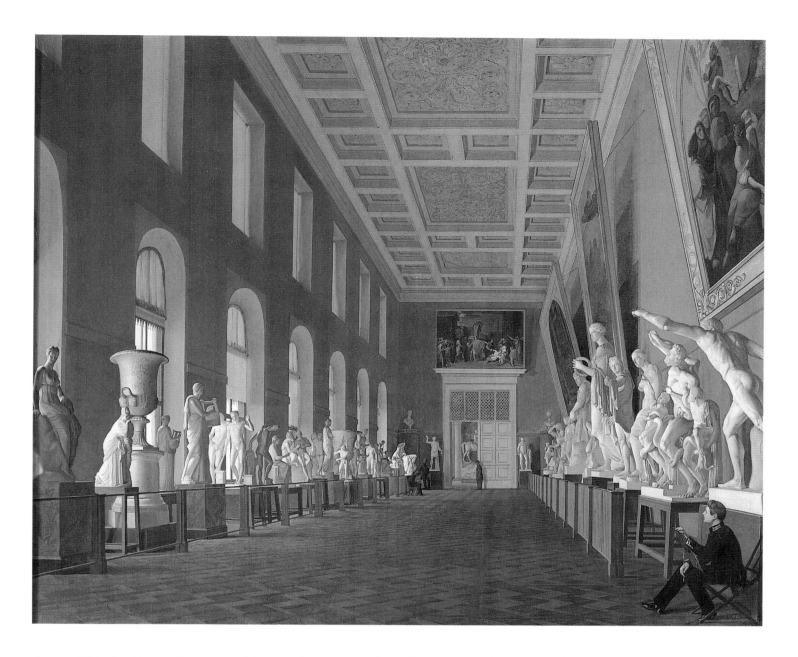

Grigory Mikhailov, Second Classical Gallery in the Academy of Fine Arts in St. Petersburg, 1836 (cat. no. 36). An essential part of the curriculum was the study of great works of the past, which were assembled at the Academy, both in original and reproduction. The artist has depicted himself here in the Academy uniform studying plaster casts of antiquities.

Mosnier also supervised pupils copying at the Stroganoff Palace on Nevsky Prospect.

In 1807, at Stroganoff's suggestion, a granite column from the construction site of Kazan Cathedral was erected in the Academy's circular courtyard. He intended it to serve as a symbol of the school's gratitude to the "generosity of the monarchs," especially Elizabeth I as its founder, Catherine II as the empress under whom the Academy's stone building was begun, and Alexander I, under whom its formation was completed. Installation of the column was assigned to the architect A. Mikhailov, who worked under the supervision of Voronikhin, and the bronze ornamentation was executed with funds from Stroganoff.

The Academy of Fine Arts continued its tradition of taking into its ranks talented and famous artists, including foreigners. In 1800 the French painter Élisabeth Vigée-Lebrun was inducted and described the ceremony in detail in her memoirs. She made a gift to the Academy of her self-portrait (cat. no. 142), now in the Hermitage. In 1802 Hubert Robert was named an honorary associate. A graduate of the Academy, Alexander Stupin, opened a drawing school with his own funds in Arzamas in 1805, the first private art institute in Russia. The Academy took the school under its wing four years later, and Stupin received the title

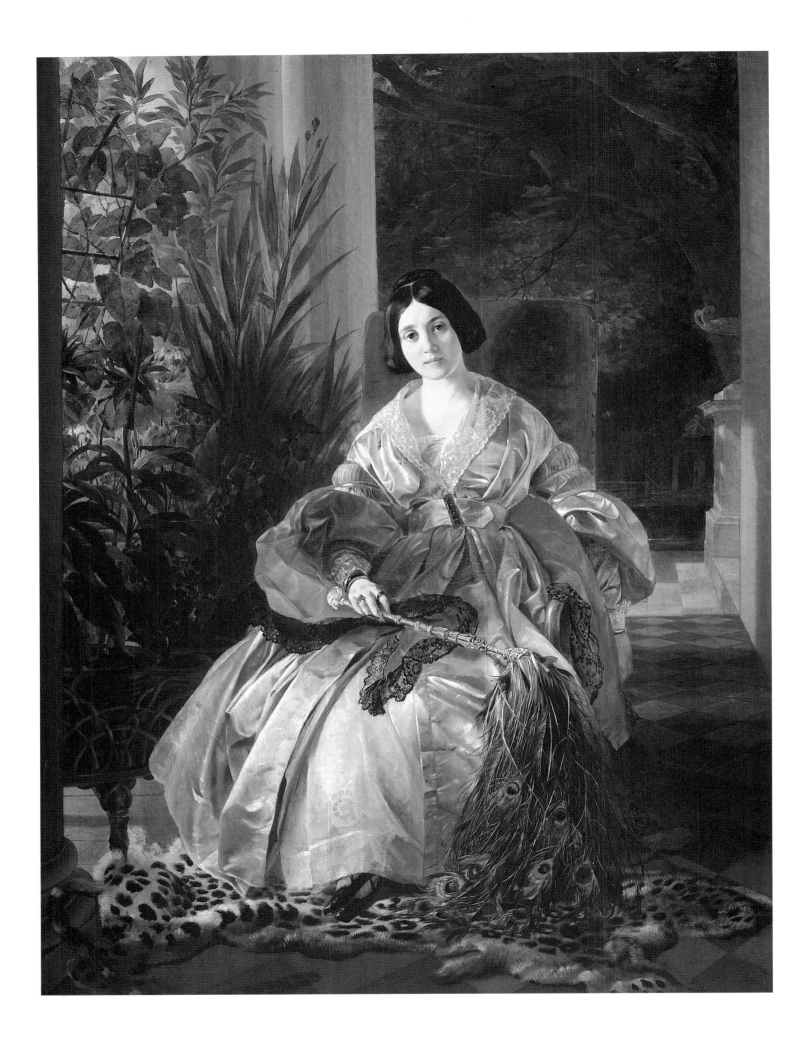

Karl Pavlovich Briullov, Portrait of Her Highness Elizabeta Saltykova, *c. 1841 (cat. no. 33). A stellar figure in 19th-century Russian painting, Briullov was a product of the Academy and one of its professors. Elizabeta Saltykova, a daughter of Sophia and Paul Stroganoff, was widowed soon after her marriage and moved back to an apartment created for her in the Stroganoff Palace, where she hung this masterpiece of portraiture.*

of academician without being officially appointed and without completing a program ("as the first initiator of an enterprise most exceptional").

Stroganoff was eager to add to the art collection of the Academy, which was very rich in those days. Outstanding among its many first-class acquisitions was a marble sculpture by Michelangelo Buonarotti, *Crouching Boy,* the only authentic work by the sculptor in Russia. (When the Academy's museum was dismantled during the 1920s and 1930s, the sculpture was taken by the Hermitage.) Stroganoff himself donated to the Academy's library 150 drawings of ceilings at Versailles painted by Charles Le Brun that had been brought back from France by Voronikhin.

In 1801 the Venetian *cavaliere* Antonio Francisco Farsetti, who was a commander of the Order of Saint John of Jerusalem (as was Stroganoff himself), sent his collection of sculptures to the Academy as a gift, dedicating it to the Russian throne. While the terra cottas were subsequently transferred to the Hermitage, part of the collection is still housed in the Academy's museum. A 1998 exhibition, "From the Sculptor's Hand," organized by the Art Institute of Chicago, was devoted to Farsetti's Italian Baroque terra cottas. Farsetti, in flight from his creditors in 1804, arrived in St. Petersburg hoping to collect money for the transport of the collection, and Stroganoff intervened on his behalf at court to secure a pension for the destitute nobleman.

With Alexander Stroganoff at the head of the Academy of Fine Arts from 1800 to 1811, the institution was blessed with a marvelously educated, truly cultured man whose status at court secured for it the greatest possible protection and valuable commissions. Because Stroganoff understood and loved art, he could devote himself to the Academy's problems from an informed vantage and find understanding among the members of the Academy's council. The strong complement of instructors, some of whom had been selected by the count himself, ensured a high level of training for the students. Graduates during this period included the painters Orest Kiprensky, Vasily Shebuev, Silvester Shchedrin, Alexander Varnek (cat. no. 32), and Piotr Sokolov, the engraver Nikolai Utkin, and the sculptor Vasily Demuth-Malinovsky. In 1807 a gold medal by Karl Leberecht, after a drawing personally approved by Alexander I, was struck in honor of Alexander Stroganoff with the dedication: "In recognition of the benefit received under his leadership from a grateful Academy of Fine Arts." It was presented to him in a formal ceremony at the Academy on December 20, 1807. Alexander Stroganoff's tenure as president was truly a golden age for this important Russian institution.

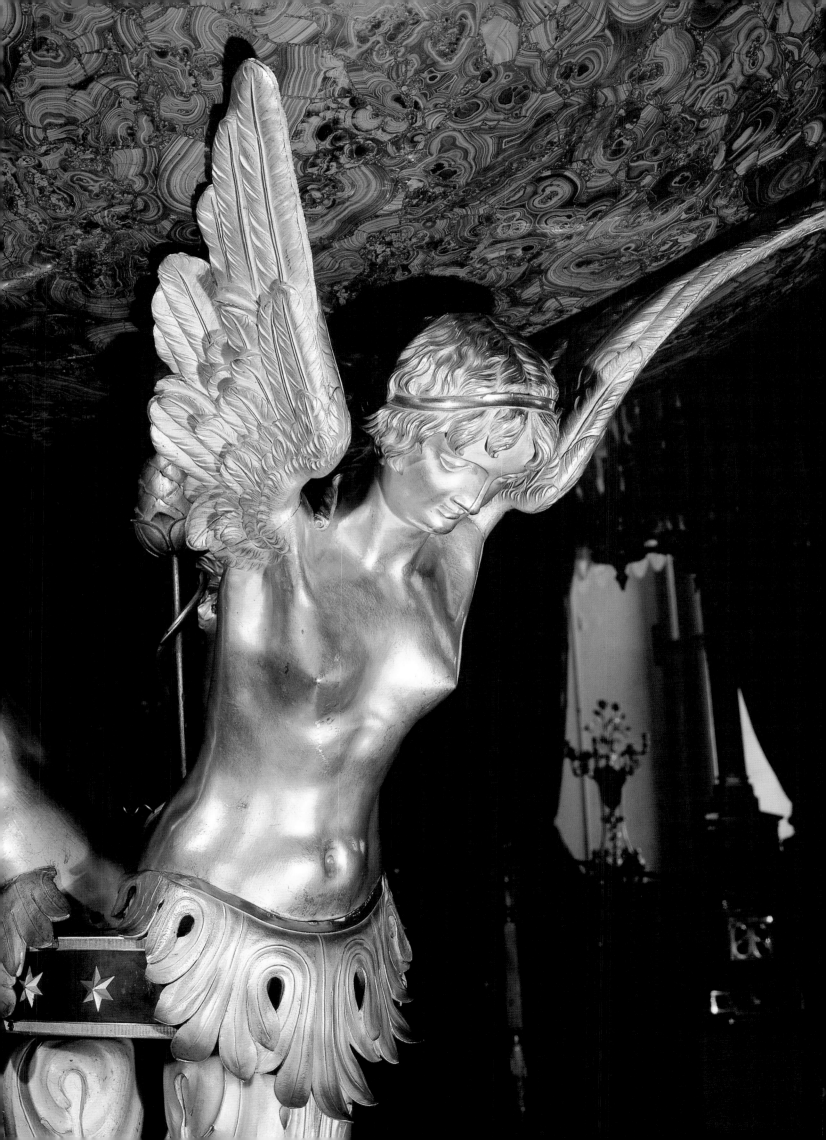

DECORATIVE STONEWORK

Natalia Mavrodina

DURING THE SECOND HALF OF THE EIGHTEENTH CENTURY, INTEREST IN MINERALOGY had become, as Catherine the Great put it, "a common disease," but for Alexander Stroganoff collecting the best and most beautiful objects was hardly a whim or a simple reflection of current taste. When he renovated the Stroganoff Palace on Nevsky Prospect in 1791, this enlightened collector added a Mineral Cabinet. As one scholar wrote: "Now Stroganoff can brilliantly accommodate his extremely rich collection of ores and minerals, and also his rare collection of books on geology and mineralogy, in no way inferior in its completeness to similar ones belonging to European collectors."[1] Clearly, his scientific interest in minerals carried over into his appreciation for decorative objects fashioned from them.

Alexander Stroganoff became director of the Imperial Lapidary Works in 1800 and made many changes before his death in September 1811. Thanks to his powerful influence at court, he helped raise the level of stone carving to new heights, personally presenting finished products to Emperor Alexander I. He also acquired for his personal collection a group of extremely fine carved stone objects.

The Imperial Lapidary Works, or Peterhof Lapidary and Grinding Mill, was the first Russian stone-cutting factory. It was founded in 1721 near St. Petersburg by an edict of Peter the Great, at the time his park and palace at Peterhof were being constructed. The mill specialized in relatively small pieces, working only with raw material brought from the Urals and the Altai, more than six hundred miles away. The Altai offers probably the richest sources in the world for decorative colored stones. One particular feature of Altai stones is that they are mined in large monolithic blocks, rather than as small fragments. In 1786 the Kolyvan Lapidary Works developed out of a small workshop set up in the area to work with the hard stones mined there. Larger pieces could be produced here, sometimes attaining huge proportions, such as the famous Kolyvan vase in the Hermitage, whose monolithic bowl measures nearly ten feet across and fifteen feet high. Kolyvan, as well as the original Peterhof and the Yekaterinburg Lapidary Works, founded in 1726, came under Alexander Stroganoff's administration.

A state bronze foundry, which manufactured gilt-bronze mounts for the products of the lapidary workshops, was set up in 1805 on Vasilievsky Island in St. Petersburg in a building belonging to the Imperial Academy of Fine Arts. Alexander Stroganoff, in his role as president of the Academy, was the initiator of the project, and there is good evidence to suggest that he was greatly interested in the manufactory and even concerned himself with the training of the staff: "We must teach our own masters, who might successfully produce bronzes, taking into account state interests," he wrote.[2] He suggested that five boys be selected from the Yekaterinburg works who "declare a desire for this and a taste for drawing," and that they be sent to St. Petersburg to be trained. The literature has so far not recorded the count's enthusiasm and generosity in establishing the new

OPPOSITE: *Detail of the malachite coupe (cat. no. 72)*

BELOW: *Cameo of Catherine II as Minerva, after 1789 (cat. no. 39)*

This porphyry vase (cat. no. 65), designed by Andrei Voronikhin and made at the Peterhof Lapidary Works, was photographed in a window of the Hermitage overlooking the Palace Square with the monolithic granite column of Alexander I.

works, but he seems to have been its major financial supporter. As he himself wrote, he "suggested to His Majesty the Emperor that the bronze works should be so conducted that payment not be required for work and other materials, to receive pay solely for the gilding, as work requiring a good deal of precious metal, which offer was merited with the Highest confirmation."[3]

It is likely that most of the decorative stone items transferred to the Hermitage from the Stroganoff Palace were acquired by Alexander Stroganoff at the end of the eighteenth century and during the early years of the nineteenth. It is interesting to note that some copies of objects in the Stroganoff collection were made late in the nineteenth century at the Imperial Lapidary Works, such as a jade (nephrite) vase in a silver setting with garnets in the Byzantine style, which was copied in 1884 from a piece "currently with Count Stroganoff" and presented to the Imperial Court.[4] The original vase can be seen in Voronikhin's 1793 watercolor view of the Stroganoff Picture Gallery (cat. no. 82), which offers a rare opportunity to provide a relatively precise date for such an early piece, which was probably made at Yekaterinburg.

The architect and designer Andrei Voronikhin, the protégé and probably also the natural son of Count Stroganoff, played an important role in the establishment and development of Russian carving in colored stone. Paying close attention to all details of the palace interiors on which he worked, Voronikhin designed decorative pieces for particular settings in which colored stone was often featured. We know of a number of different pieces made to his designs or concepts at both the Yekaterinburg and the Kolyvan Lapidary Works (cat. no. 63), but Voronikhin's activities were concentrated at Peterhof. Judging from surviving correspondence, Voronikhin often traveled to the Peterhof mill on various errands for Count Alexander Stroganoff: to look at the structure of the buildings, to identify blocks of stone for particular objects, and to select finished pieces to be sent to the bronze manufactory. The architect's opinion bore great weight. In April 1801 the head of Count Stroganoff's chancellery wrote to the commander of the mill: "Do not reproach me that I did not visit you, for as you know, alone, without Andrei Nikiforovich, there is nothing for me to do there, and he has had no leisure to come all this time."[5]

This set of jasper tray and cups for drinking vodka (cat. no. 62), made at Peterhof in 1754, is a rare example of early Russian stone-cutting from the Stroganoff collection.

Voronikhin brought many new elements to the art of stone carving, in particular the introduction of new forms. It was largely thanks to him that the characteristically compact lines of eighteenth-century pieces became freer and more open. Gilded bronze ceased to be a subordinate part of the composition, merely intended to set off or contrast with the stone, and became important in its own right, sometimes even the dominant element, as in Voronikhin's Egyptian figure (cat. no. 68) for Count Stroganoff's *surtout de table,* or his large-scale coupe supported by a standing Egyptian figure for Pavlovsk (cat. no. 73).

1. Yu. V. Trubnikov, *Stroganovsky dvorets* [The Stroganoff Palace] (St. Petersburg, 1996), p. 74.
2. Yekaterinburg Archive, fund 770, inv. 1, file 584, f. 3.
3. History Archives, fund 468, inv. 38, file 348, f. 8.
4. History Archives, fund 504, inv. 1, file 1627, f. 6.3.
5. History Archives, fund 468, inv. 32, file 1126, f. 10; file 1131, f. 12

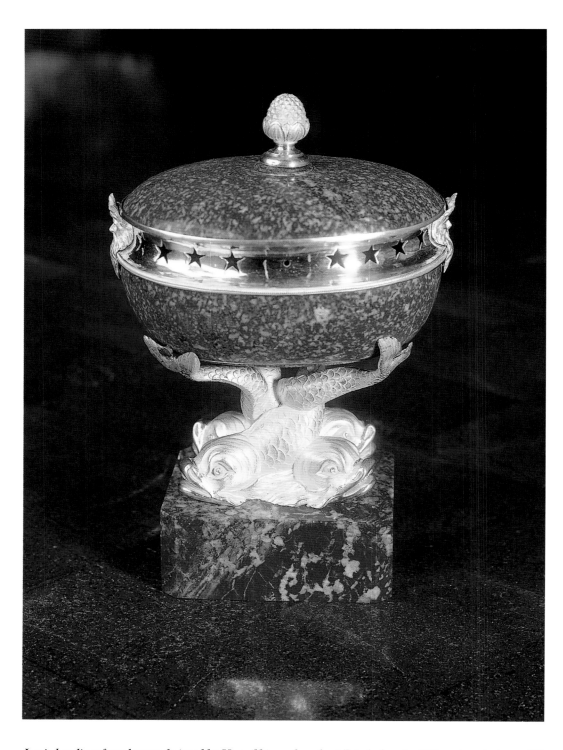

Lapis-lazuli perfume burner designed by Voronikhin and made at Peterhof, early 19th century (cat. no. 69)

OPPOSITE: **This group of Peterhof quartz coupes from the Stroganoff collection (cat. nos. 67, 70) are photographed in a gallery at the Hermitage on a lapis-topped table from Alexander Stroganoff's collection; another of his tables can be seen in the background.**

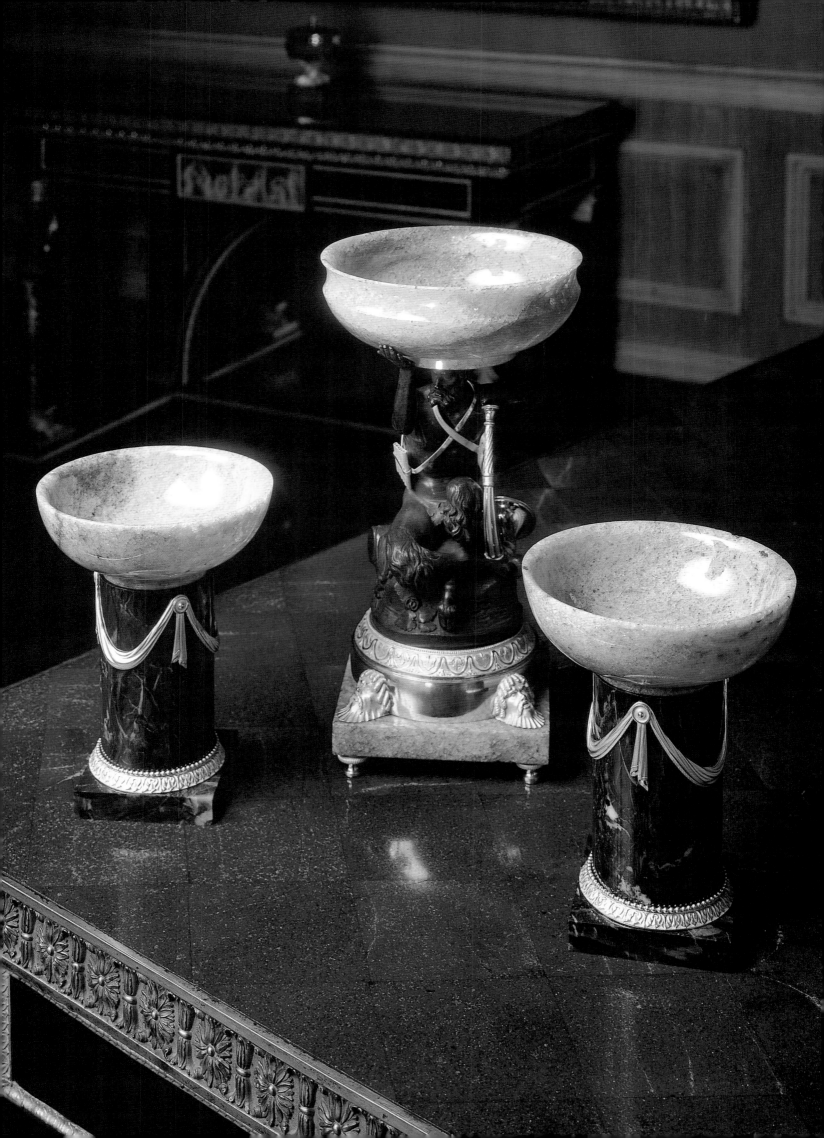

OPPOSITE: *In a bravura design attributed to Voronikhin, an oversized basin fashioned at Peterhof of malachite, Russia's most highly prized stone, is set in a stunningly original gilt-bronze stand. This coupe (cat. no. 72) was the crowning treasure of Alexander Stroganoff's collection, and he placed it at the axis of his Picture Gallery.*

The gilt-bronze mounts for this pair of obelisks (cat. no. 71), designed by Voronikhin and made of porphyry, agate, and jasper at Peterhof in 1804, were among the first products of the foundry established at the Academy by Alexander Stroganoff.

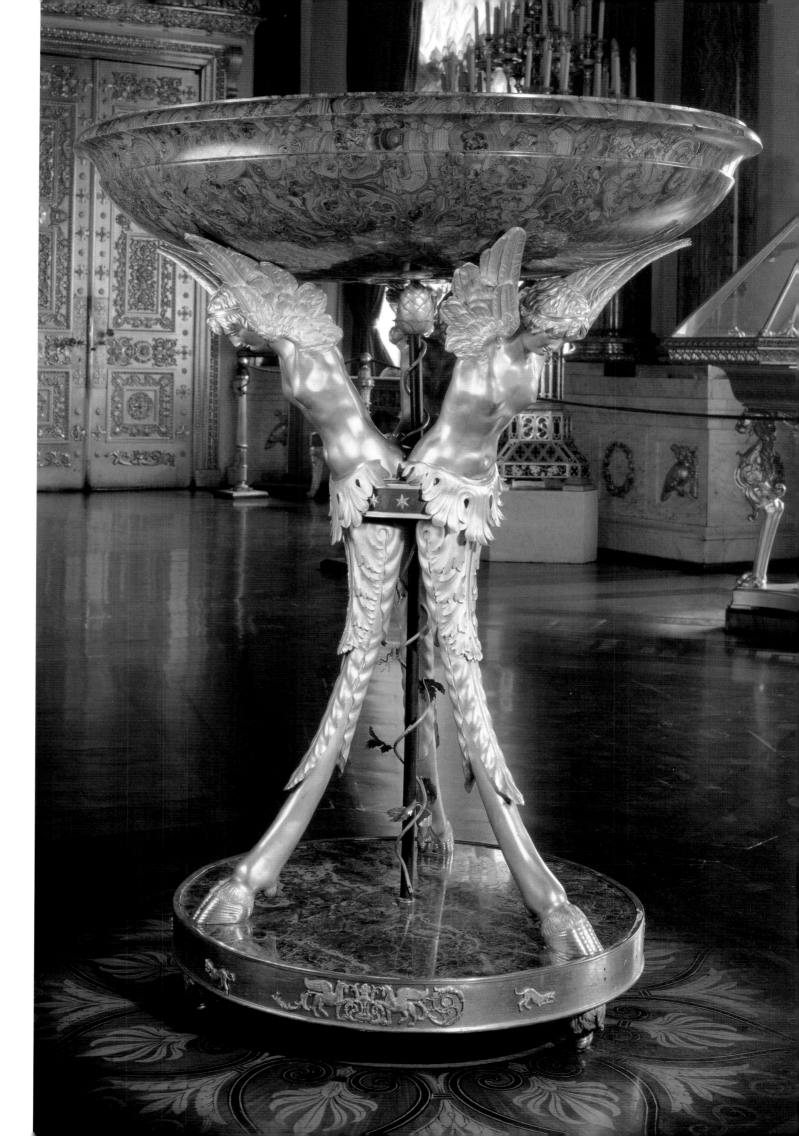

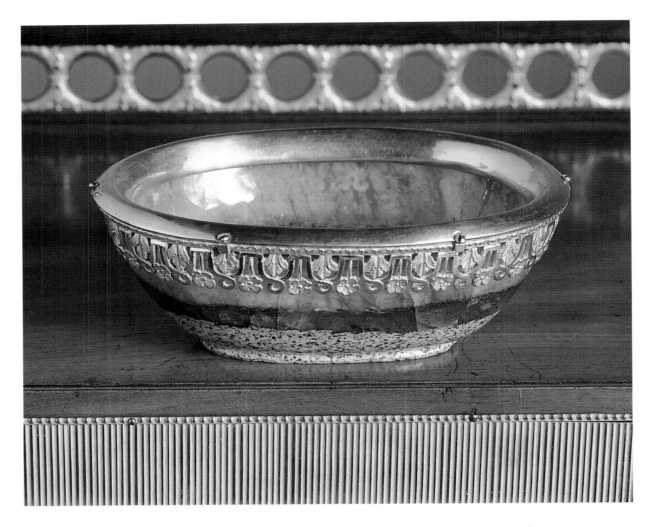

Alexander Stroganoff's enthusiasm for mineralogy predated his responsibilities at the imperial stone-cutting manufactories. In his Mineral Cabinet he displayed unusual specimens, such as the layered stone called pierre d'alliance, *which was used at Yekaterinburg Lapidary Works to create this bowl (cat. no. 64).*

OPPOSITE: *This Egyptian figure holding a tourmaline bowl (cat. no. 68) was part of a set of table ornaments designed by Voronikhin and made at Peterhof in 1801–6. The quartz columns (cat. no. 63), made at Kolyvan Lapidary Works in 1790, also decorated tables in the Stroganoff Palace.*

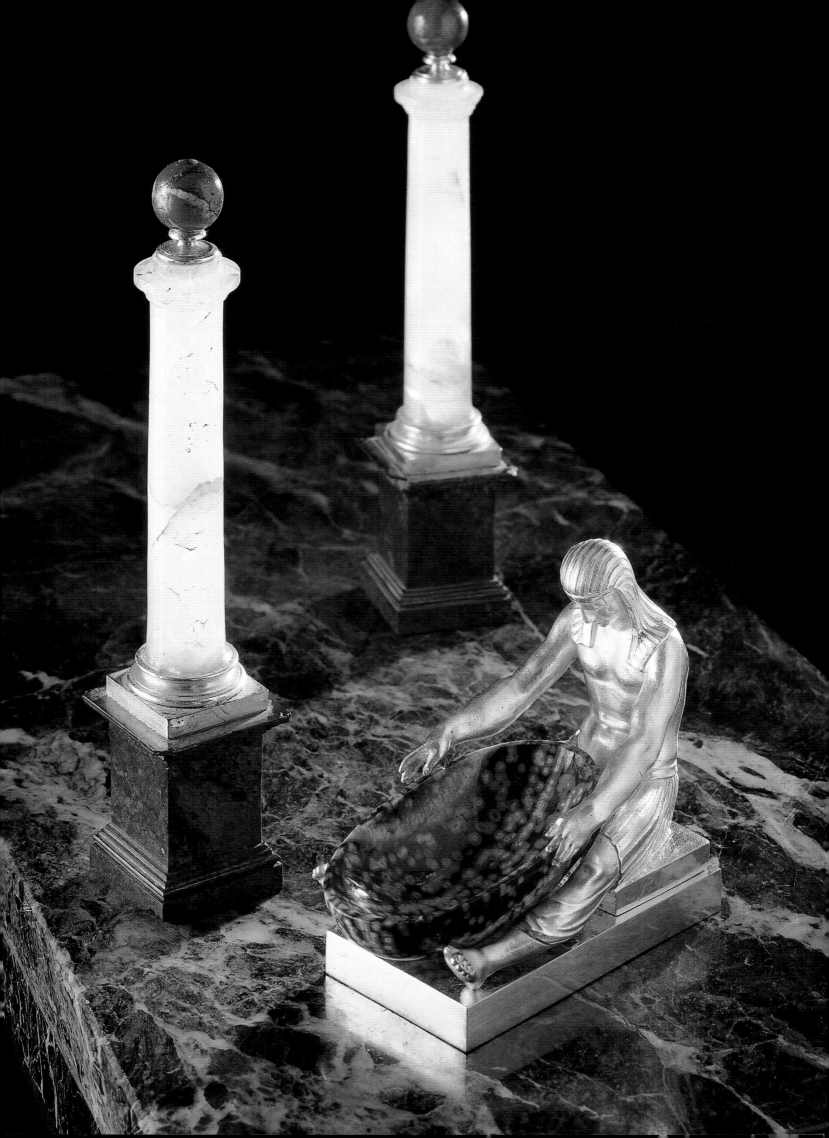

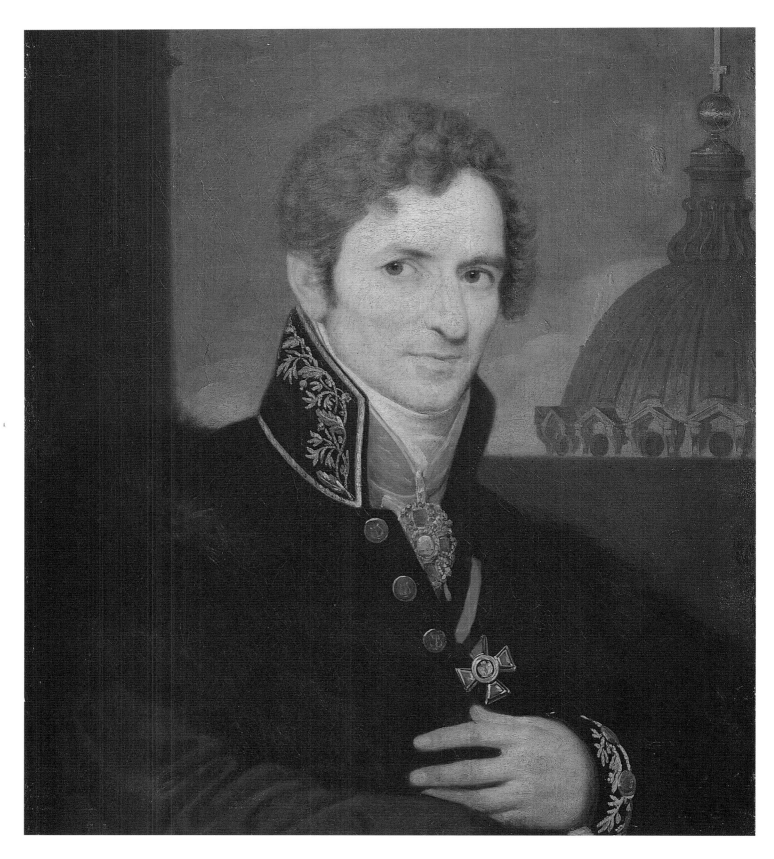

In this portrait of Andrei Voronikhin (cat. no. 28) the dome of Kazan Cathedral is included to signify his crowning accomplishment. Born a serf on Stroganoff land, he rose to an imperial appointment as architect for the dowager empress's palace at Pavlovsk, thanks to the support of Alexander Stroganoff, thought to be his natural father.

ANDREI VORONIKHIN

Alexei Guzanov

Andrei Nikiforovich Voronikhin (1759–1814) was one of the premier Russian architects of the late eighteenth and early nineteenth centuries, and he occupies an honored place at the opening of this new stage in Russian architecture. The buildings and architectural ensembles he created, his work with interiors, and his designs for decorative objects were tremendously important to the overall evolution of Russian art and architecture, and they retain their significance as unsurpassed achievements to this day.

Voronikhin's career is closely tied to Count Alexander Sergeievich Stroganoff and his family, thanks to whom the architect's talent was brought to light and developed. The facts of his life have been difficult to document. Even the matter of the architect's date and place of birth is complicated. There are several contradictory accounts, each based on different historical legends, reports, and occasional documents. The official version is that Voronikhin was born a serf on October 17, 1759, in the Perm Province in the Ural Mountains, in the village of Novoe Usolye, and that his parents were serfs of Alexander Sergeievich Stroganoff. More convincing, however, is the story, which is supported by quite a bit of circumstantial evidence, that Voronikhin was the count's illegitimate son. Voronikhin was given his freedom at the age of twenty-six, but we have very little information about his life before that time. We do know that he received his first artistic training in his native region, where he worked as an apprentice to the famous eighteenth-century Russian master Gavrila Yushkov at the Stroganoff icon workshop. Later, in 1777, Voronikhin was sent to Moscow to study architecture, perspective, and miniature painting with the most capable and talented students of the highly respected architects V. I. Bazhenov and M. F. Kazakov. According to Voronikhin's obituary, it was in Moscow that "his architectural abilities and inclinations developed, here that he laid the cornerstone for his knowledge of this important art, taking to heart the admonitions of the then-renowned Russian architect Bazhenov and, through his works, attracting the attention of the well-known architect Kazakov, who foretold Voronikhin's talents and future fame in the building art."[1]

The young Voronikhin recorded his travels in sketches, including this view of the Château de Gléné in Switzerland (cat. no. 81), which was preserved in an album by Alexander Stroganoff.

In 1779 Alexander Stroganoff sent Voronikhin to St. Petersburg, where initially he carried out his master's instructions and completed minor architectural projects for buildings and structures owned by the Stroganoffs, who addressed the young man in simple familial fashion as Andrei. Voronikhin was appointed serf artist to Alexander's son, Paul Stroganoff, the sole heir to his father's vast fortune. Paul's tutor and mentor was the Frenchman Gilbert Romme, who would become a prominent figure in the French Revolution. He had been invited to Russia to work with Paul at the recommendation of the renowned philosopher Denis Diderot, and Voronikhin also took part in the lessons. Romme's instructional system covered various disciplines, including mathematics and the natural sciences. The program of study for Paul, who was given most of the attention, emphasized

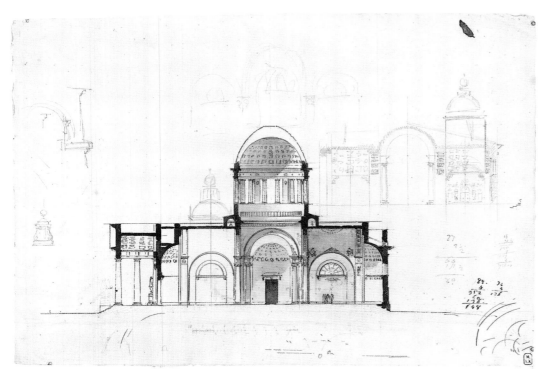

Voronikhin's cross section of Kazan Cathedral (cat. no. 95) was a preliminary working drawing kept by Alexander Stroganoff. As head of the supervising committee for the construction of Kazan Cathedral, he worked closely with his protégé from the project's conception to the details of its decoration.

BELOW: *In this formal presentation drawing for Kazan Cathedral, 1810 (cat. no. 96), Voronikhin laid out the great curved colonnade, whose evocation of St. Peter's in Rome had won him the commission.*

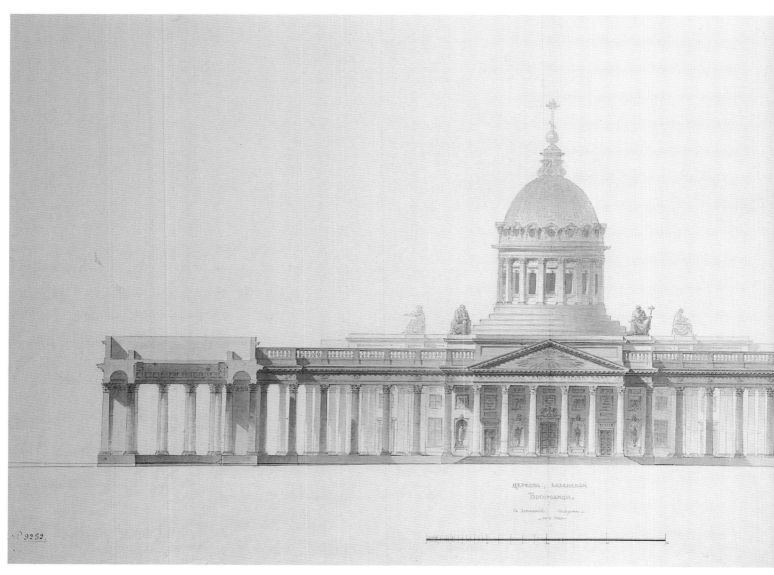

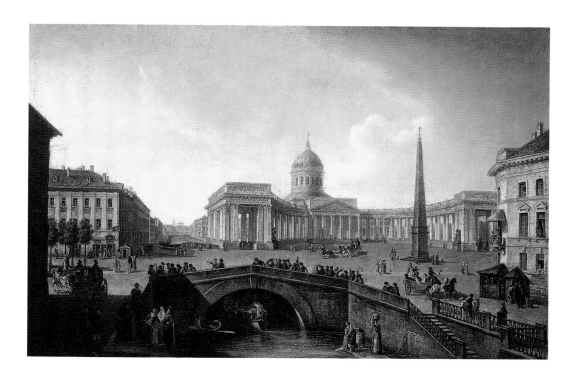

Feodor Yakovlevich Alexeiev,
**View of Kazan Cathedral in
St. Petersburg,** *1810s (cat. no. 26)*

travels through his native land as well as abroad, so that he would become familiar with the ways of the world, and Voronikhin joined them on these trips, which were, of course, extraordinarily beneficial for the young architect. Visiting different cities, studying the most varied structures and important monuments, and sketching them helped round out his creative arsenal. They visited many famous Russian cities, including Kiev, and spent time in the Crimea, which gave them an opportunity to learn about Islamic architecture. Voronikhin completed an album of drawings and watercolors that he later entitled *A Painter Traveling through Russia.*

After Voronikhin was given his freedom in 1786, he accompanied Paul Stroganoff and Romme on another European tour, which included, of course, a visit to France. In Paris Voronikhin "continued his study of ancient and recent architecture,"[2] and he may have attended classes at the Academy of Architecture there. Romme reported regularly to Count Stroganoff about the journey and Paul's successes and lessons, but in a letter from Paris dated February 12, 1789, he wrote: "I am trying to curb Voronikhin's rather excessive passion for painting, since I am endeavoring to make him into someone truly useful to your son. I am sending him to study architecture, mechanics, and everything that will make him knowledgeable on matters of production. He studies everything with such amazing zeal, it would please you no end to see it."[3] The great many drawings Voronikhin made on this trip were excellent practice for the artist and stood him in good stead in his later work.

When he returned to Russia in late 1790, Voronikhin worked primarily on commissions from the Stroganoff family. One of his first works was for the Stroganoff Palace on Nevsky Prospect in St. Petersburg, where he reconstructed the palace interiors, and he eventually created unique interiors for the Mineral Cabinet and the Picture Gallery. In 1794 he was awarded an appointment to the Imperial Academy of Fine Arts for his rendering of the interior of the Picture Gallery (see page 80, cat. no. 82). This beautifully executed watercolor is of special interest, because it painstakingly records virtually every aspect of the interior's architectural detailing and furnishings.

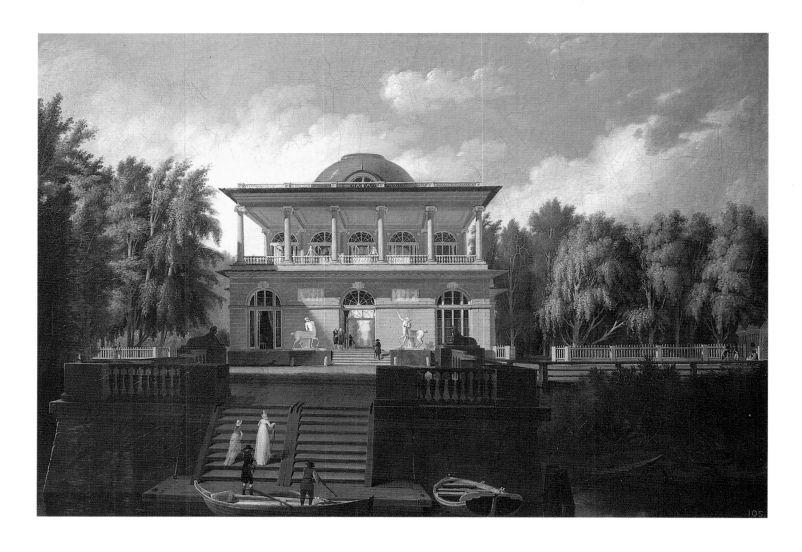

After this project, Voronikhin worked on the renovation of the Stroganoff dacha on the Greater Neva River in St. Petersburg. For his 1797 oil rendering of the dacha (cat. no. 27) he was awarded the title academician of perspective and miniature painting. Early in 1800, Alexander Stroganoff was appointed president of the Academy of Fine Arts, and in that same year Voronikhin began to teach there, first as an assistant to the architect Adrian Zakharov; by 1811 he was a senior professor of architecture.

In 1800 Voronikhin's design for Kazan Cathedral on Nevsky Prospect was accepted over other entries submitted to the competition by such venerable master architects as Charles Cameron and Thomas de Thomon. The fact that Alexander Stroganoff was Voronikhin's patron unquestionably played a crucial role in his winning the competition. In creating his design, the architect had to keep in mind Paul I's requirement that the cathedral have a colonnade like that of St. Peter's in Rome. This desire of the emperor's was evidently of long standing and dated to his European tour in 1782, when he was grand duke. He and his wife, Maria Feodorovna, traveling as the comte and comtesse du Nord, spent nearly thirteen months visiting various countries and surveying interesting sites. In a letter from Rome to Platon, the archbishop of Moscow, Paul wrote: "We have already viewed the remains of the works of great men with much admiration and feel an incentive to adopt them for our own purposes, an incentive that stems from the conclusion that we too are men like them, so why should we not have the same as others? The Church of St. Peter is such

ABOVE: *Voronikhin's 1797 painting (cat. no. 27) of the Stroganoff dacha recorded the renovation he had just completed of Rinaldi's building.*

OPPOSITE BELOW: *Johann Baptist Lampi the Elder,* Portrait of Maria Feodorovna *(cat. no. 145). Alexander Stroganoff owned this portrait of Maria Feodorovna, which was painted when she was grand duchess, before her husband became Emperor Paul I. When her palace at Pavlovsk was damaged by fire in 1803, Alexander recommended Voronikhin to the widowed empress as the architect for the restoration.*

The palace at Pavlovsk, resurrected from the ashes for a second time, after World War II

that I would like to see my friend the Archbishop of Moscow hold services in a similar church in Moscow."[4] And so Kazan Cathedral in St. Petersburg became the pinnacle of early-nineteenth-century monumental Russian architecture.

Voronikhin also did a great deal of work on the imperial country residences of Peterhof, Gatchina, and Strelna, and he rebuilt the Mining Institute in St. Petersburg on the Neva embankment. In 1802 he worked on the interiors of Dowager Empress Maria Feodorovna's half of the Winter Palace in St. Petersburg, and in 1803 he began a major restoration of her palace at Pavlovsk, near Tsarskoe Selo. A fire, caused by inadequate repairs to the flues, had destroyed the ceiling beams and caused severe damage to the central section of the palace, although it did not reach the building's wings because preventive measures had been taken. Thanks to energetic work and meticulous organization, some pieces of furniture, porcelains, bronzes, tapestries and rugs, and sculptural mountings, as well as decorated fireplaces, mirrors, doors, and other architectural ornaments, were saved, but three days of burning had taken their toll. The fire was a terrible blow for the mistress of the palace, who favored this particular residence; she wrote to Count S. R. Vorontsov, a Russian diplomat in London, to tell him about the fire: "Although my dear Pavlovsk has lost its beauty, seeing as my beautiful home was reduced to ashes eight days hence, nonetheless I cherish the hope that you will come to commiserate with the poor woman who has lost everything to this fire. The event took place last Saturday. A beam close to the chimney was the reason for the fire, which was so powerful that only the walls remain from the main block; the wings and much of the furniture were saved. . . . We have been through a tremendous amount of trouble, count, and a great deal of unpleasantness, but actually it is easy to endure this kind of grief, if one compares it with the sufferings my heart has experienced."[5] Indeed, Maria Feodorovna had suffered the loss of many loved ones, including her husband, the emperor, in 1801; her two daughters, who were very dear to her (Alexandra, the wife of Archduke Joseph of Austria, in 1801; and Helen, the wife of Friedrich-Ludwig, duke of Mecklenburg-Schwerin, in 1803). Maria Feodorovna may have found some solace, however, in restoring the palace to its former appearance.

Voronikhin was invited to Pavlovsk at the recommendation of Alexander Stroganoff. He was made chief architect of the Pavlovsk Municipal Administration and given the task of restoring the palace to its pre-conflagration appearance. While aware of the enormous complexity and practical

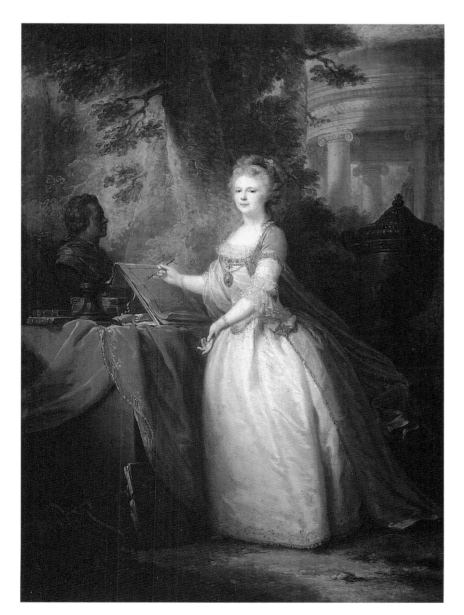

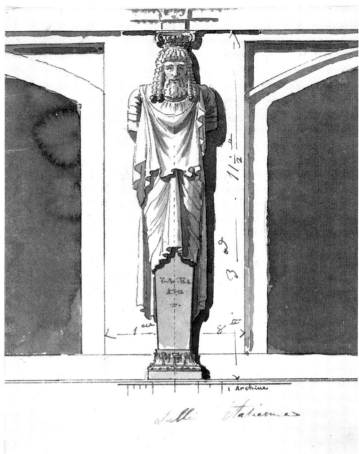

impossibility of fulfilling the dowager empress's desires, Voronikhin did everything in his power to reproduce the destroyed detailing as precisely as possible without violating the overall architectural ensemble. Unfortunately, only a very few of Voronikhin's drawings for his restoration work on the Pavlovsk Palace have survived (cat. nos. 88, 89). During the restoration process, he had occasion to argue with the palace's mistress more than once, and he was obliged to defend his position when it came to making certain alterations. Nonetheless, he managed to restore the palace in a relatively short period of time.

It was in Pavlovsk that Voronikhin revealed himself to be unsurpassed at designing interiors. Although he introduced completely new ideas and motifs, he nevertheless treated everything that had been done by his predecessors in Pavlovsk with the utmost care and respect. He possessed a fine sense of proportion and color relationships. Maria Feodorovna personally followed the progress of the renovation very closely. Her desire had been to restore the palace to its former appearance, but several changes were made in the decoration of the interiors that were in line with the fashion and spirit of the times, either at the advice of Voronikhin or at her own personal request. He made hundreds of drawings for the furniture, bronzes, porcelain items, and lighting fixtures, more than 480 pages of which have been documented. Furniture was made from his drawings, much of it in the workshop of the court furniture maker, Heinrich Gambs. Voronikhin's artistry and talent in the decorative arts became widely recognized; it was his design that was used to produce an important diplomatic gift—a Psyche mirror—for the Prussian king, Frederick William III, and his wife, Louise of Mecklenburg-Strelitz, which until 1945 was on view in the Royal Palace in Berlin.

The dowager empress was not an easy client and always had the last word, as evidenced by the transformation of the forbidding male herms designed by Voronikhin for the Italian Hall at Pavlosk (right, cat. no. 88) into the buxom female caryatids that were actually executed.

Andrei Voronikhin's design for the
upper vestibule of Pavlovsk Palace,
c. 1803 (cat. no. 89)

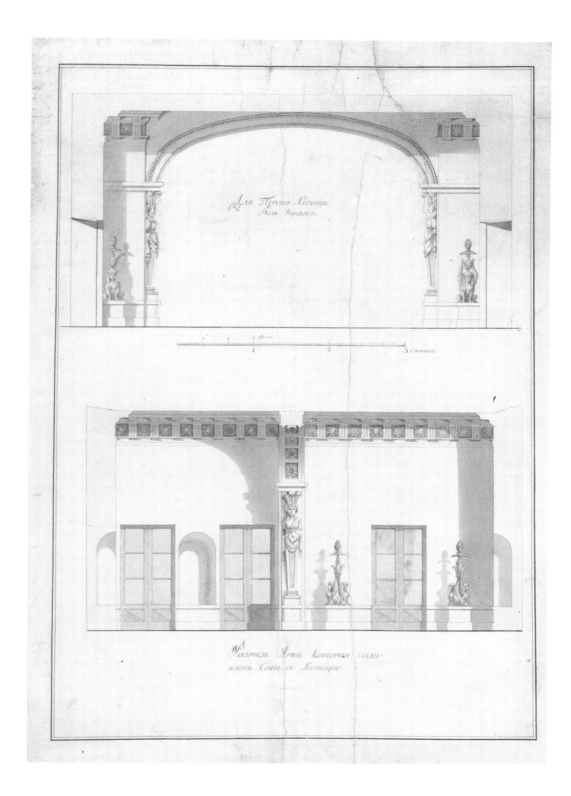

Voronikhin's designs for the furnishings of the Pavlovsk Palace were perfectly suited to the building's architecture and use, reflecting classical motifs in the European fashion of the period. In the furniture he made extensive use of colors that imitated the antique, including dark green, bronze, and gold. In upholstery fabrics he used embroidery with antique ornament, as can be seen in the examples of furniture made for the Aviary (volière) Park Pavilion (cat. no. 77) in the St. Petersburg furniture workshop of K. Scheibe in 1807. The suite made expressly for this pavilion consisted of four sofas, two couches, eight armchairs, four chairs, and four tables, of which only two armchairs and a sofa remain at Pavlovsk. This

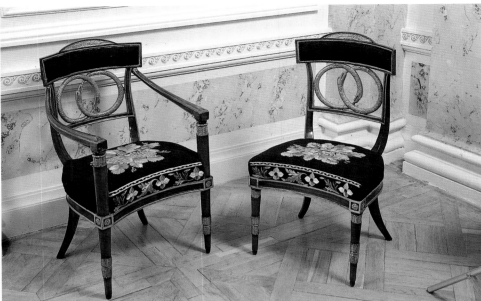

Voronikhin's incorporation of snakes into
the design of the seat backs for this set of
Stroganoff furniture (cat. no. 78) can be
attributed to Alexander's involvement
in Freemasonry, which used snakes as a
recurrent device.

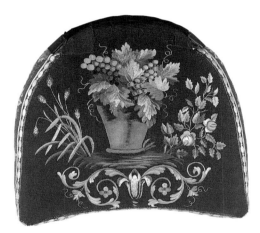

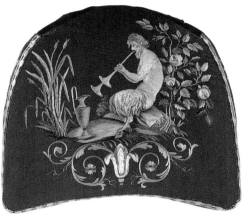

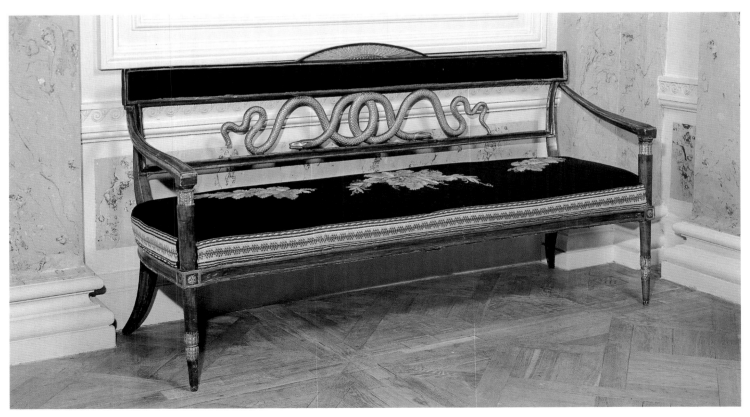

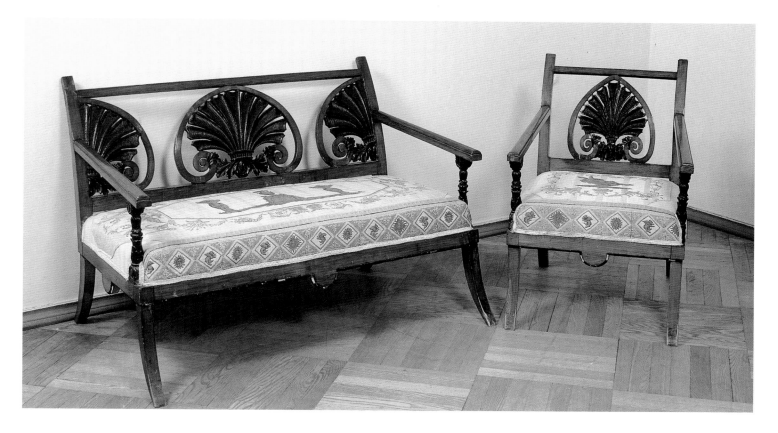

Voronikhin used a more formal palmette design for the suite (cat. no. 77) designed for the Volière Pavilion in the park at Pavlovsk. The architect believed that the upholstery of his furniture was so important that he made his own embroidery designs.

furniture was fashioned from traditional Russian birch stained to look like mahogany, with the decorative elements stained to look like ebony. The pieces still retain the original upholstery, in silk cross-stitch on canvas with antique motifs, designed by Voronikhin. Although simple in form, the palmetto design of the back splats is delightful. This suite of furniture was not highly refined in detail, but it was comfortable and practical.

Another suite of Voronikhin furniture now in Pavlovsk comes from the Stroganoff collection (cat. no. 78). The design employs one of the architect's favorite motifs, the snake. The pieces are upholstered in green fabric embroidered in silk-satin stitching, and the quality of execution and state of preservation are stunning. In his designs for Pavlovsk Voronikhin

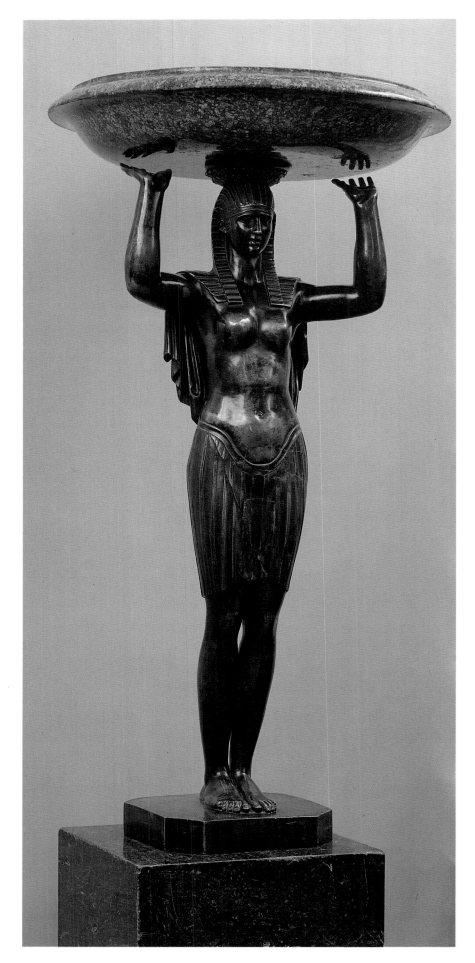

Immediately after taking charge of the imperial stone-cutting manufactories, Alexander Stroganoff involved Voronikhin in the selection of materials as well as in the design. This Egyptian figure (cat. nos. 73, 91), completed in 1809 for the anteroom to Maria Feodorovna's private apartments at Pavlovsk, was a site-specific work. The architect was involved at every stage, from the design to the cutting of the granite coupe to the casting of the bronze figure at the Academy foundry.

invented a series of highly original jardinière models, in which a desk, a wardrobe, and even an armchair are equipped with holders for fresh flowers.

In the many initiatives and projects that Alexander Sergeievich Stroganoff undertook as president of the Academy of Fine Arts, he involved Voronikhin not only as a protégé but also as a talented master and artist in his own right. For example, when Count Stroganoff was put in charge of the Yekaterinburg and Peterhof Lapidary Works, he paid great attention to the quality and artistic merit of the objects produced there. In order to make the highest-quality bronze ornaments for mounting the precious stone objects fashioned in these factories, Stroganoff acquired instruments, molds, and drawings from the workshop of the French bronze sculptor Pierre-Louis Agy, who had returned to his homeland after working in St. Petersburg for more than twenty years. The acquisition enabled the Official Bronze Manufactory of the Academy of Fine Arts, headed by Count Stroganoff, to begin operations in 1805. Among its first assignments were gilt-bronze mounts for two obelisks designed by Voronikhin and produced at the Peterhof Lapidary Works in 1804 (cat. no. 71). The obelisks themselves were executed in gray porphyry, deep red agate, and polished Kalkan jasper, and the mounts were so meticulously chased that they recall lapidary technique. In them we can see Voronikhin's characteristic approach to decorative objects, such as his use of stone of various types, colors, and textures to underscore the decorative lyricism of a particular form. Voronikhin went on to design monumental vases for various palace interiors. At Pavlovsk, there is a drawing and the vase itself (cat. nos. 91, 73), executed in 1809, in the form of a standing bronze figure of an Egyptian with upraised arms holding a large thick cup made of red granite. Voronikhin called upon masters from the Peterhof factory to survey Pavlovsk to determine the placement of a projected vase, and he himself was often on hand in the foundry to inspect objects while they were being made or after they were finished.

As president of the Academy, Alexander Stroganoff oversaw all stone-cutting production in Russia, including the activities of an official expedition to quarry marble and precious stones and those of the Peterhof lapidary and bronze factories. He also encouraged architects to participate actively in the stone-cutting production, which occasionally enabled them to modify and improve their original plans. The direct collaboration between designers and artisans that occurred during this period under Count Stroganoff yielded significantly improved results.

Voronikhin created three interiors in the empress's living quarters on the second floor in the south wing of the Pavlovsk Palace, as he worked on the restoration after the 1803 fire. These were the Lantern Study, the bedchamber, and the small Tent Study. In the first study he designed an amazingly well-integrated and unusually expressive ensemble, where he sought to unify the interior's architectural elements and decorative furnishings. The Lantern Study was one of Maria Feodorovna's favorite rooms, and one of the most stunning interiors in the palace, and it was here that she hung her most beloved paintings by such masters as Bronzino, Guido Reni, and José Ribera. The design of this interior is considered the finest in the history of the Russian Empire style. It is characteristic of Voronikhin that in creating the interior he painstakingly thought through all the details in order to combine them into a single harmonious whole. This interior represented one of the most complex moments in his architectural career, and, as his work at the palace demonstrates, Voronikhin mastered the art of interior design to perfection. Not only did he create the architectural elements, but he also designed the room's furnishings—the furniture, hangings, lighting fixtures, and decorative vases made of

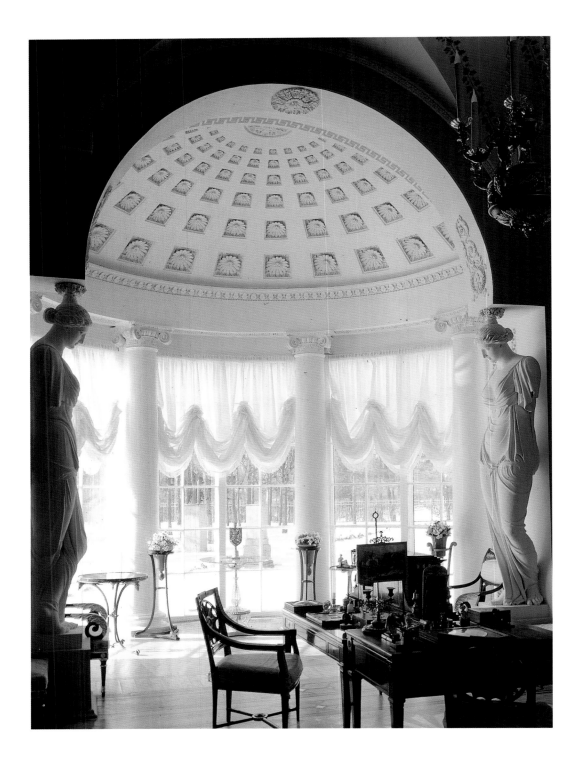

colored glass, porcelain, stone, and bronze—conceiving of them as organic components of the overall design.

After Voronikhin's restoration of the Pavlovsk Palace, its interiors took on a greater severity and at the same time a heightened elegance. Certain early Neoclassical elements were not reproduced but eliminated in favor of new designs; for example, the original parquet floors in the Lantern Study were not restored but were replaced with a parquet designed by Voronikhin. In the Greek Hall, he replaced the original crystal chandeliers between the columns with new marble and bronze hanging lights fashioned in the manner of antique oil lamps, giving the room a strong Empire accent. Despite the difficulties that arose between them, the interests of the architect and the dowager empress were focused on a single goal—

the creation of an artistic setting in harmony with the personality of the client and worthy of her social status, yet at the same time reflecting the latest artistic and aesthetic trends. Each change made by the succession of architects who worked at Pavlovsk bore evidence of individual creativity, but all kept to the context of an integrated Neoclassical ensemble: thus, Cameron's contribution demonstrates antique stylization permeated with the most refined lyricism; Brenna's is a Baroque stylization within the framework of classicism; Quarenghi's is a powerful formal resolution even in the private living quarters; and Voronikhin's is an antique stylization within an Empire framework. In 1811 Voronikhin redesigned the dacha of Prince Bagration in the Pavlovsk park, which had been purchased by Maria Feodorovna. It was called the Pavillon des Roses because it was surrounded by magnificent beds of roses. This pavilion became one of the empress's favorite structures at Pavlovsk. Here she held her salons, which brought together many famous writers, artists, and musicians. In 1814 a large ballroom was built onto the pavilion on the occasion of the return of Maria Feodorovna's son, Emperor Alexander I, from Paris after his victory over Napoleon. The park also includes several other structures designed by Voronikhin.

Little is known about the architect's personal life. In 1801 he married an Englishwoman, Maria Lond, and the union produced six children, two of whom died at an early age. The architect himself died in 1814 and was buried in the Saint Lazarus Cemetery of the Alexander Nevsky Monastery in St. Petersburg. His headstone was executed in 1814 in the form of a column engraved with a depiction of Kazan Cathedral, the architect's most important building. Antoine Chenevière, the author of *Russian Furniture: The Golden Age, 1780–1840,* suggests that Voronikhin committed suicide, but this seems unlikely, if only because, according to the canon of the Orthodox Church, suicides are usually buried outside the boundaries of the cemetery.

The architect's nephew, Alexei Voronikhin, the son of his brother Ilya, was a well-known artist who began his studies at the Imperial Academy of Fine Arts in 1801 and won a gold medal. In 1815 he began working at the St. Petersburg Porcelain Manufactory, first as an assistant and then as a model master, designing porcelain groupings and decorations for tea services.

Andrei Voronikhin's career in the history of Russian art, beyond his remarkable architectural designs, is most closely connected with decorative art because of his mastery of the harmonious interior ensemble. The range and depth of his works were remarkably broad, and he was an important influence on artistic production in Russia in the early nineteenth century.

Voronikhin continued his renovations of the Stroganoff Palace even while he was working on Kazan Cathedral and at Pavlovsk. The lion mounts at the center of the majestic doors to Paul's apartment (cat. no. 76) show the influence of Quarenghi's original doors for Pavlovsk's Italian Hall, but they are distinguished by a personalized, soulful countenance.

NOTES

1. "Nekrologiia Voronikhina" [Voronikhin's Obituary], *Syn Otechestva* [Son of the Fatherland], no. 12 (1814), pp. 231–36.
2. Ibid.
3. Letters of G. Romme to A. S. Stroganoff: Appendix to A.V. Chudinov, "G. Romme and P. Stroganov in revolutionary Paris (1789–1790)," *Rossiia i Frantsiia XVIII–XX veka* [Russia and France, 18th–20th century], II (Moscow, 1998).
4. Letter from Grand Duke Paul Petrovich to his religious instructor, Platon, Russian Archive (St. Petersburg, 1887), p. 20.
5. Archive of Prince Vorontsov (Moscow, 1876), vol. 10, p. 45.

Design for a bridge at Pavlovsk (cat. no. 90)

Design for a wood bridge (cat. no. 92)

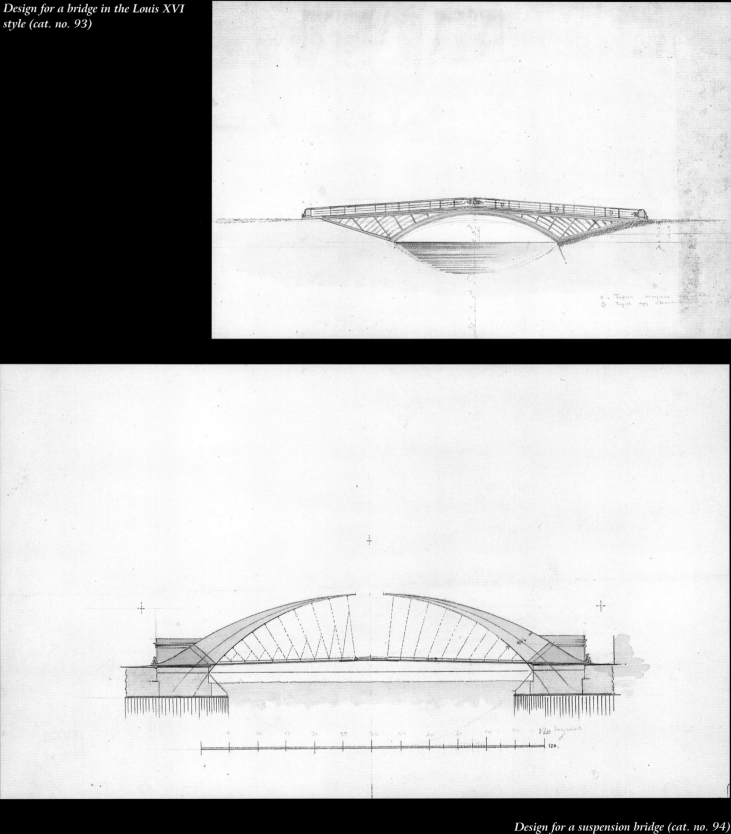

Design for a bridge in the Louis XVI style (cat. no. 93)

Design for a suspension bridge (cat. no. 94)

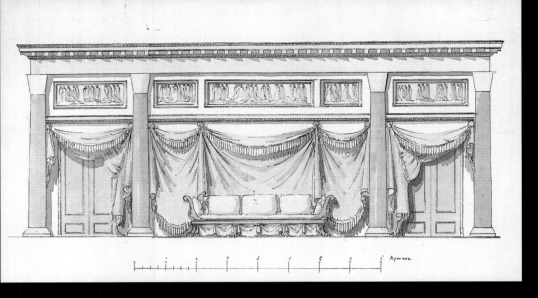

LEFT: *Drawing for the State Dining Room in Paul and Sophia's apartment in the Stroganoff Palace (cat. no. 84)*

BELOW: *Voronikin maximized the potential of the Stroganoff Palace corner room that had windows on both Nevsky Prospect and the Moika River by lining one wall with mirrors between half columns. This device reflected light from the windows and gave the illusion of a room double its actual size. The contribution of Sophia Stroganoff to this successful resolution is indicated by Voronikhin's inscription dedicating to her this watercolor of the room (cat. no. 83) and by his inclusion of the figure of a gentleman bowing to a lady.*

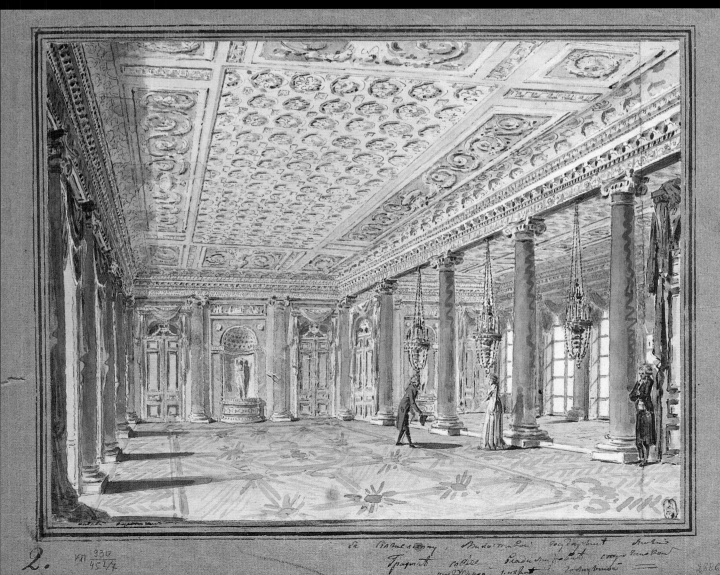

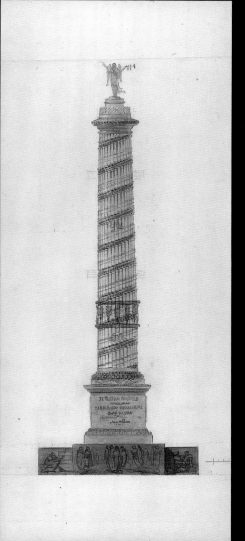

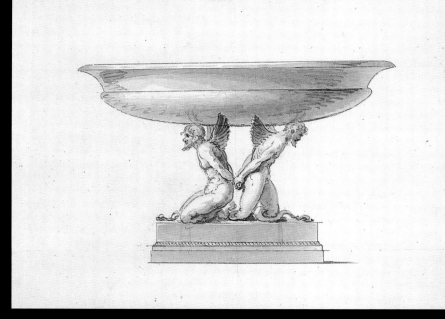

ABOVE: *Design for a bowl supported by tritons (cat. no. 87)*
LEFT: *Design for a memorial column made of captured French guns (cat. no. 98)*

Innovative design for a fireproof ceiling, in which metal was to be used with a thin layer of brick to replace heavy masonry vaults (cat. no. 97)

An imaginative sketch for a bed (cat. no. 86)

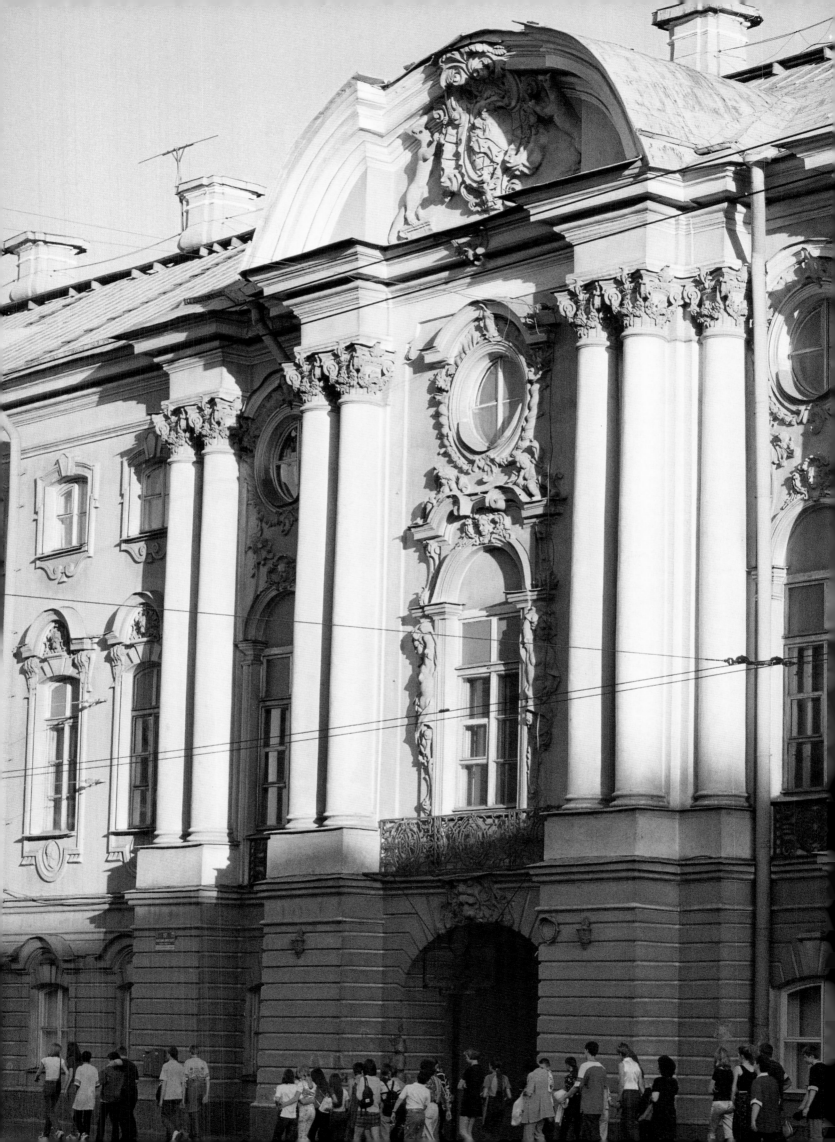

THE PALACE ON NEVSKY PROSPECT

SERGEI LIUBIMTSEV

THE STROGANOFF PALACE STANDS IN THE HEART OF ST. PETERSBURG ON NEVSKY Prospect, not far from the imperial Winter Palace. The prominent location of this impressive Baroque palace testifies to the lofty status of the Stroganoffs in the social hierarchy of the Russian state. Beginning in the eighteenth century, this extremely wealthy family of industrialists from the Urals contributed vast sums of money to Russian cultural and educational institutions, built churches, founded art schools, created unique collections of painting, sculpture, and other objects, and supported young artistic talent materially as well as morally. Because of the unflagging efforts of several generations of Stroganoffs, the family's principal palace in St. Petersburg became famous not only to their compatriots but also to enlightened Europeans.

Construction of the palace was begun in 1753 from a design by the court architect Francesco Bartolomeo Rastrelli, who was a personal friend of Sergei Grigorievich Stroganoff and who had designed the Winter Palace for the imperial family. The magnificent Baroque facade of the Stroganoff Palace, with its many relief ornaments and sculptures, has survived to the present day almost unaltered. The Grand Ballroom, with its magnificent ceiling by Giuseppe Valeriani, has also been preserved in memory of the Rastrelli era. The empress herself, Elizabeth Petrovna, daughter of Peter I, attended a birthday ball given in her honor by Sergei Stroganoff in the Grand Ballroom on December 15, 1753, and this was probably the

OPPOSITE: *The Stroganoff Palace*

BELOW: *A view of the developing Nevsky Prospect (cat. no. 106) showing the 1756 Rastrelli facade of the Stroganoff Palace at the right*

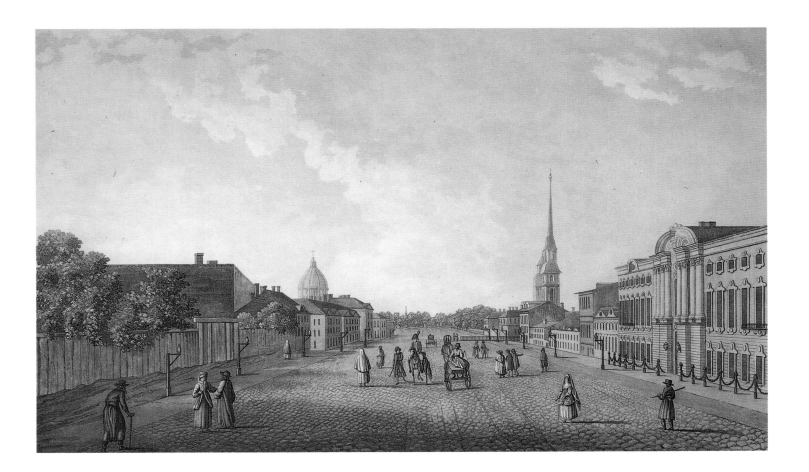

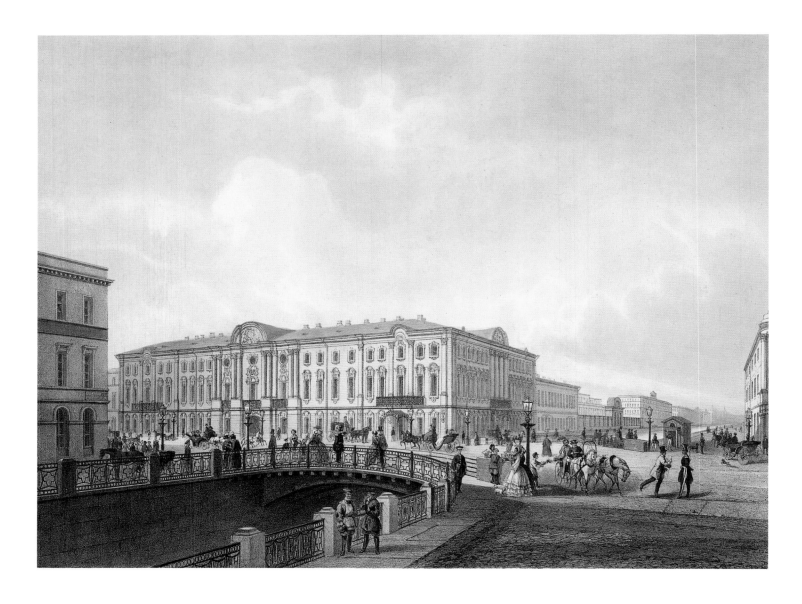

occasion when Italian musicians and singers gave their famous Russian premiere of Pergolesi's *Stabat Mater.*

Over the years, however, the building behind the facades was remodeled several times; the decoration and plan of the interiors were altered, and new wings were built at the back of the property to make Rastrelli's original L-shaped structure into a square enclosing a court-yard with a small fountain.

Beginning in the late 1780s, several architects—Feodor Demertsov, Andrei Voronikhin, and Piotr Sadovnikov—undertook successive renovations updating the interiors to Neo-classicism. This is the period when the ravishing and architecturally daring formal Dining Room appeared, along with the perfectly proportioned Mineral Cabinet and, most famous of all, the Picture Gallery, which embodied the enlightened tastes of the Stroganoffs. Pupils at the Imperial Academy of Fine Arts, whose president was Alexander Sergeievich Stroganoff, copied masterpieces by Rubens and Van Dyck, Bronzino and Guido Reni, Hubert Robert, Nicolas Poussin, and Claude Lorrain, recorded in the catalogue compiled by Count Stroganoff himself.

The Russian Revolution in 1917 brought dramatic changes in the destiny of the Stroganoff Palace. One of the first decrees of the Soviet government nationalized the palace

A view from the 1840s of the Police Bridge and the Stroganoff Palace beyond (cat. no. 108)

Detail from stuccowork in the Ballroom
before restoration

The restored Rastrelli Ballroom

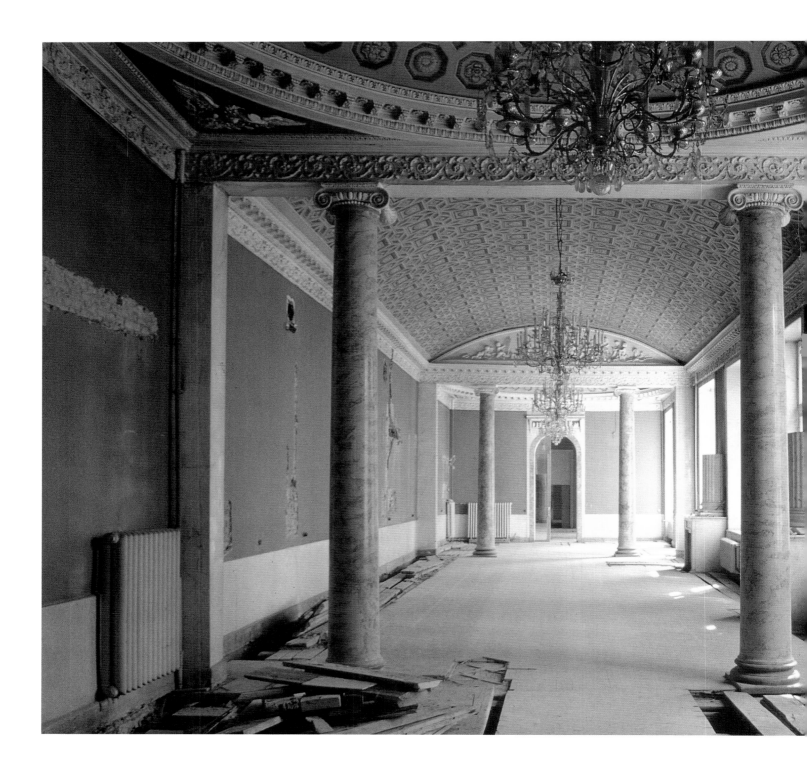

and stripped its former owners of all property rights. The unique collections also fell entirely under the control of a new class of bureaucrats, which declared the Stroganoff Palace from 1918 to 1930 a branch of the Hermitage and on whose whim and will the future of the palace would depend. Most tragic for the palace was the government's decision in 1929 to disperse all the Stroganoff collections, so that these extremely rich groupings of art and minerals, as well as the library, were scattered among other museums; parts of the collections were lost without a trace. Sadly famous was the auction that took place in 1931 at the Lepke Gallery in Berlin, where many of the paintings from Sergei Stroganoff's Picture Gallery, as well as the finest of the French decorative arts, were sold. This auction was only one in a series of

ABOVE AND OPPOSITE: *The Stroganoff Picture Gallery*

disasters that almost ruined the palace, which in 1930 was reassigned to the Academy of Agricultural Sciences. Seven years later a military organization took occupancy, and the palace shut its doors firmly, not just to visitors but also to professional historians.

The first glimmer of hope for the palace's restoration appeared when the authorities in Leningrad decided to transfer ownership of the building to the State Russian Museum. Starting in 1975 and for fifteen years thereafter, the museum struggled to oust the military department, which had no desire to move out of the palace. Only in 1991 was the building completely vacated by its tenants and was the museum able to get down to the work of renovation. The museum's administrators faced a complicated task. They eliminated the numerous cubicle dividers in the formal halls, pulled out miles of cables that encumbered the entire palace, and removed tons of dirt to bring the ground floor back to its original level. The entire heating system had to be replaced after several accidents damaged some of the formal rooms. At the same time, the staff wanted to restore several halls to their original condition and open them to the public before too much more time elapsed. As this difficult and major undertaking got under way, the project suffered from a chronic shortage of financing, as Russia had lost its once-powerful tradition of state patronage and sponsorship. The first sign of hope appeared with an initiative by Baroness Hélène de Ludinghausen, née Stroganoff, to

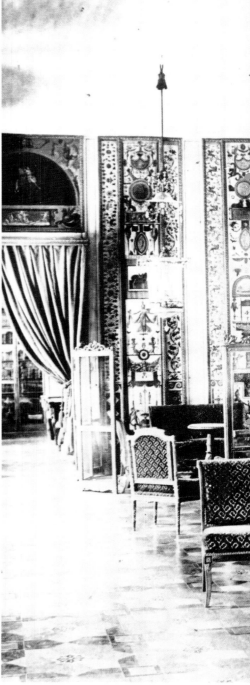

This restored arabesque panel is part of a series painted for the Mikhailovsky Palace in 1800 and later installed in the Arabesque Hall of the Stroganoff Palace, photographed here in 1913.

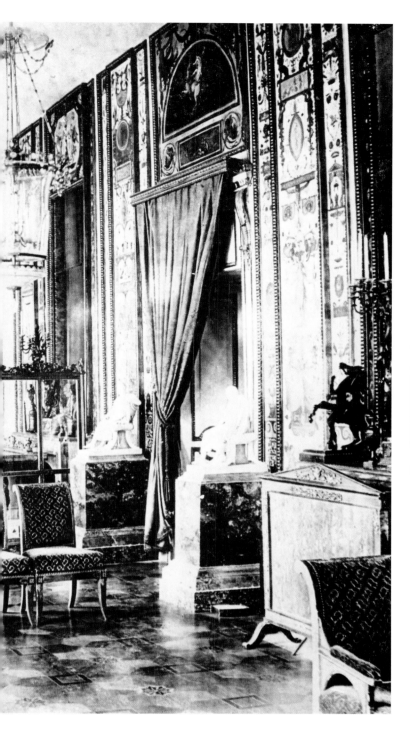

ABOVE: *A room in the palace, 1999*

create a special fund for the restoration of the palaces of St. Petersburg, starting with the Stroganoff Palace. The first funds transferred to the State Russian Museum by the Stroganoff Foundation were used to install a new heating system in the palace.

In the few years that have passed since the foundation was established, the Russian Museum and the Stroganoff Palace have opened their doors to hundreds of visitors, but much more remains to be done. All the utilities need modernizing, and the building must be completely rewired before restoration of the interiors can be completed. The sooner these repairs can be made, the sooner this pearl of Russian architecture can be returned to St. Petersburg and, indeed, to the rest of the world.

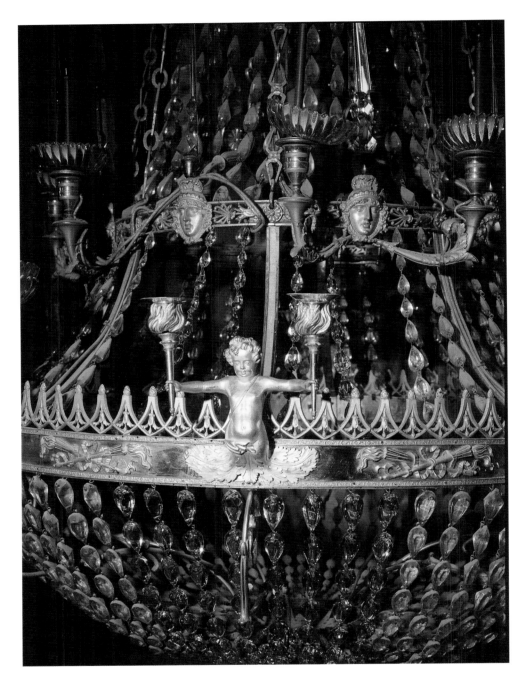

The chandelier photographed in the Mineral Cabinet (cat. no. 75) before restoration

OPPOSITE: *The Mineral Cabinet*

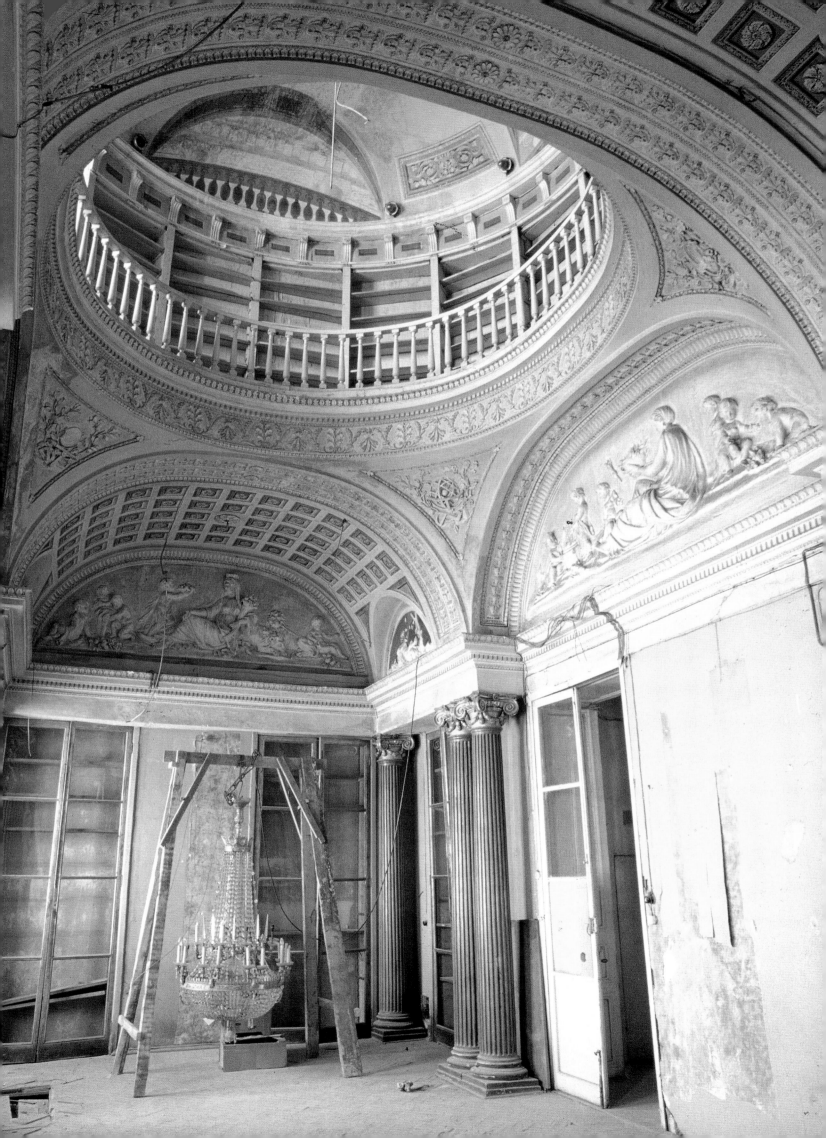

RUSSIAN ART

ICONS

1. *Canopy*
Russian, 1580s
Tempera on wood; 34¾ x 43⅜" (89 x 111.3 cm)

Provenance: Probably Annunciation Cathedral, Solvychegodsk

Paintings on this canopy were closely related to the symbols and images of the saints depicted on the Royal Doors above which the canopy was placed. The Holy Trinity in the center symbolizes the liturgy, in which angels in white albs holding *rhipidia,* the liturgical fans, take part. To the right and left of the Trinity are the scenes of the Eucharist, the main sacrament of the Christian Church, in which Christ offers bread and wine to the apostles.

The most distinctive feature of this canopy is the representation of the praying figures of Saint Nikita (Nicetas) and Saint Eupraxia, patron saints of Nikita Stroganoff and his wife. Both saints are painted in the lower corners of the canopy and participate in the sacrament by interceding before God on behalf of their living namesakes. **TV**

The Solvychegodsk History and Art Museum (SM 252)

2. *Icon: The Trinity with Scenes from the Old Testament*
Russian, 1580s–90s
Tempera on wood; 76⅞ x 60⅝" (197 x 155.5 cm)

Provenance: Annunciation Cathedral, Solvychegodsk (donated by Nikita Stroganoff)

Border scenes: 1. The Creation of the Angels. 2. The Creation of the Heavens, the Earth, and the Waters. 3. The Fall of the Rebel Angels. 4. The Creation of the Animals. 5. The Creation of Adam and Eve and the Fall. 6. The Expulsion from Paradise of Adam and Eve. 7. Noah's Ark. 8. The Construction of the Tower of Babel. 9. The Appearance of the Trinity to Abraham. 10. Abraham Washes the Angels' Feet. 11. Abraham Brings Food to the Angels. 12. The Angels Leaving Abraham's House. 13. The Sacrifice of Isaac. 14. Angels Going to Sodom and Gomorrah. 15. Angels Taking Away Lot and His Two Daughters. 16. The Destruction of Sodom and Gomorrah and the Transformation of Lot's Wife into a Pillar of Salt. 17. Jacob's Ladder. 18. Moses' Vision of the Burning Bush. 19. The Israelites Crossing the Red Sea. 20. The Tabernacle Is Set Up. 21. Moses Communicating with God. 22. The Archangel Michael Arguing with Satan over the Body of Moses

The border scenes illustrate events described in the Pentateuch, beginning with the Creation of the World and ending with Moses' death. In the center of the icon is the Old Testament Trinity, which embodies the main dogma of the Orthodox Church. The scene is based on the story of Abraham entertaining three angels, which here symbolize the triune nature of God (Genesis 18:1–2). The anonymous icon painter chose for his subject an uncommon diagonal variant of the composition by placing the table for a meal in an oblique position. Among the figures grouped around the table are, in addition to the three angels, Abraham and his wife, Sarah. The Tabernacle itself is depicted in the lower row of border scenes (20). According to the theological doctrine, Abraham's house is a prefiguration of a New Testament temple, and the similarity of these structures emphasizes the idea of the close link between the Old and New Testament churches. The long rectangle of the table covered with a white cloth brings to one's mind the tomb of Christ and at the same time is an altar for the eucharistic sacrifice. The killing of the calf is therefore a symbol of Christ (the Lamb of God). Thus, the scene of the hospitality of Abraham can be interpreted as a symbol of the divine liturgy. **TV**

The Solvychegodsk History and Art Museum (SM 344)

3. *Icon: The Annunciation with Scenes from the Life of the Virgin*
Russian, 1580s–90s
Tempera on wood; 76⅜ x 62½" (196.5 x 160.3 cm)

Provenance: Annunciation Cathedral, Solvychegodsk

Border scenes: 1. Joachim and Anne Make an Offering. 2. The High Priest Refuses Their Offering. 3. The Annunciation to Joachim in the Desert. 4. The Annunciation to Anne in the Garden. 5. The Kiss of Joachim and Anne (the Conception of the Virgin). 6. The Birth of the Virgin. 7. Priests Blessing the Infant Mary. 8. Caressing the Infant Mary. 9. First Steps of the Virgin. 10. The Presentation in the Temple. 11. Prayers for Wands. 12. The Betrothal of Mary to Joseph. 13. The Annunciation at the Well. 14. The Nativity of Christ. 15. Archangel Gabriel Appears to the Virgin to Announce Her Death. 16. The Virgin on the Mount of Olives. 17. The Virgin Bidding Farewell to the Women of Jerusalem. 18. The Dormition of the Virgin

The subject of this icon, as well as the subject of the Old Testament Trinity icon (cat. no. 2), is narrated in the complex language of symbols and allusions characteristic of the art of the mid- and late sixteenth century. Moreover, it develops the theme of the Trinity. The close relationship of these icons is further confirmed by the similarity of their measurements. A canticle performed in the church on the eve of the Annunciation interprets the house of Abraham as the Virgin's womb. The icon is a variant of the iconographic type called the Annunciation of Ustiug, which presents the Christ Child on the breast of the Virgin—a visual variant of Christ's Incarnation in the Virgin's womb. This composition is based on Luke 1:26–38, the apocryphal *Protevangelium of James,* and praising hymns, first of all the *Acathistus to the Virgin.* In the latter the Virgin is called "the receptacle of God uncontainable." Above, on the clouds of Heaven, within a fiery circle, robed in white, is God the Father. His image is in full accord with the text of the Book of Daniel (7:9): "The Ancient of days did sit, whose garment was white as snow, and the hair of his head like the pure wool: his throne was like the fiery flame. . . ." God the Father, from whom the Holy Ghost proceeds, together with the Christ Child, epitomizes a revelation of the Trinity. A rocky mountain and a cave seen between the Virgin and the Archangel Gabriel are depicted in reference to the setting of the Nativity. Other details of the picture are also associated with the Acathistus. For instance, the Acathistus compares the Virgin to the impregnable wall, and the scene in the icon is represented against a background of the wall. The throne by which the Virgin stands illustrates the following words in the Acathistus: "Rejoice, for thou art the throne in which the King sits." **TV**

The Solvychegodsk History and Art Museum (SM 345)

4. *Icon: The Virgin of Vladimir with Scenes of Major Church Feasts*
Russian, late 16th century
Tempera on wood; 40½ x 27½" (104 x 70.5 cm)

Provenance: Annunciation Cathedral, Solvychegodsk

Border scenes: 1. The Trinity. 2. The Nativity of the Virgin. 3. The Presentation in the Temple. 4. The Annunciation. 5. The Nativity. 6. The Visitation. 7. The Baptism. 8. The Transfiguration. 9. The Raising of Lazarus. 10. The Entry into Jerusalem. 11. The Crucifixion. 12. The Entombment. 13. The Descent into Limbo. 14. The Ascension. 15. The Descent of the Holy Ghost. 16. The Dormition. 17. The Raising of the Cross. 18. The Intercession **TV**

The Solvychegodsk History and Art Museum (SM 547)

5. *Icon: Saint Nicholas of Myra with Twenty Scenes from His Life*
Russian, late 16th century (central part); early 17th century (border scenes)
Tempera on wood; 49½ x 38⅞" (127 x 99.5 cm)

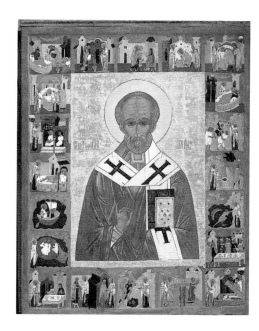

Provenance: Local tier of iconostasis, Annunciation Cathedral, Solvychegodsk (donated by Nikita Stroganoff)

Border scenes: 1. The Birth of Saint Nicholas. 2. The Baptism of Saint Nicholas. 3. The Initiation to Learning. 4. Saint Nicholas Is Ordained Deacon. 5. Saint Nicholas Is Ordained Priest. 6. Saint Nicholas Is Ordained Bishop. 7. Saint Nicholas Appears to King Constantine in a Dream. 8. Saint Nicholas Appears to Three Condemned Men in Prison. 9. The Deliverance of Three Innocent Men from Death. 10. The Healing of a Sick Man. 11. The Cutting of a Tree. 12. The Saving of a Ship Sailing from Egypt to Libya. 13. Saint Nicholas Saves Demetrius from Drowning. 14. Saint Nicholas Saves Sailors. 15. Three Merchants Return to the Banquet. 16. Saint Nicholas Returns Basil to His Parents. 17. Saint Nicholas Buys a Carpet from the Old Man and Gives It Back to His Wife. 18. Saint Nicholas Strikes Water from a Rock. 19. The Translation of Saint Nicholas's Relics from Myra in Lycia to Bari in Italy. 20. The Entombment of Saint Nicholas **TV**

The Solvychegodsk History and Art Museum (SM 342)

6. Icon: The Virgin Hodegetria of Smolensk
Russian, second half 16th century
Tempera on wood; 46⅞ x 34¾" (120 x 89 cm)

Provenance: Solvychegodsk, possibly Annunciation Cathedral

This icon is of the so-called Hodegetria type (Greek, meaning "showing the way"). The Virgin gestures toward the Christ Child, who raises his right hand in blessing and holds a scroll in his left hand, indicating that he is the way of salvation.

The origin of this icon type, which was later called the Virgin of Smolensk, is linked with

Byzantium, whence it had been brought to Kiev by the Kievan prince's wife. In 1077 Vladimir Monomachus transferred it to Smolensk, and in the early fifteenth century the icon was brought to Moscow and placed in Annunciation Cathedral in the Kremlin. However, in 1456 Grand Prince Vasily II Temny (the Dark) of Moscow, in response to the appeal of the people of Smolensk, returned the icon to them, leaving its exact copy in Moscow. *The Virgin of Smolensk* was treated with great veneration and revered almost as much as the *Virgin of Vladimir*. Many copies were made throughout Russia, especially in Moscow. In 1525 Grand Prince Vasily III built a cathedral dedicated to the icon in the New Maiden Monastery. July 28 was appointed the icon's feast day.

The Virgin's image here seems monumental and austere. In contrast with the glittering gold of the background and of Christ's robe, the sober color of the Virgin's cloak (chiton) appears even darker. Her face with its sharp, prominent features is shadowy, gloomy, and mournful. This image type of the Virgin is often found in the icon painting of the mid- and late sixteenth century, continuing a tradition epitomized by early Russian icons painted before the Tatar invasion. By the sixteenth century the icons are markedly darker, which is considered a characteristic trait of the archaizing trend in sixteenth-century painting.

Several icons of the same type as this were kept in Annunciation Cathedral in Solvychegodsk. **TV**

The Solvychegodsk History and Art Museum (SM 250)

7. Icon: Saint Basil the Blessed
Russian, late 16th century
Tempera on wood; 41⅞ x 10⅜" (107.5 x 27.3 cm)

Provenance: Probably Annunciation Cathedral, Solvychegodsk

The Muscovite Saint Basil (Vasily) was canonized in 1588. According to his hagiography, Basil had been born in 1469 in a settlement outside Moscow and possessed the gift of prophecy from childhood. At the age of sixteen he left his apprenticeship and devoted himself to the life of a holy fool, subjecting himself to every type of deprivation, wearing heavy chains on his body, and going without clothing or shelter in all kinds of weather. Basil exposed falsehood and evil and thereby won the people's love. Holy fools had always played an important role in Russian spiritual life and enjoyed deep respect in Russian society "as seers into men's hearts and minds." Thus it was with Basil the Blessed, whom even Tsar Ivan the Terrible revered and feared. After Basil's death, in 1552, a cathedral was erected in what is now Moscow's Red Square on the spot where Basil's body was buried, to commemorate

the capture of Kazan by Ivan the Terrible. In the late sixteenth century, on the instruction of Tsar Feodor Ivanovich, a silver shrine was created for Basil's relics, and the side chapel where the shrine was put was named after him. Ever since that time, the church on Moscow's Red Square has been called the Cathedral of Saint Basil the Blessed. The Solvychegodsk icon is one of the earliest depictions of this saint. **TV**

The Solvychegodsk History and Art Museum (SM 246)

8. Icon: Saint Nikita
Russian, early 17th century
Tempera on wood; 55⅜ x 15⅜" (142 x 39.5 cm)

Provenance: Annunciation Cathedral, Solvychegodsk

Saint Nikita, or Nicetas, was regarded as the spiritual patron of Nikita Stroganoff, who probably commissioned this icon. **TV**

The Solvychegodsk History and Art Museum (SM 425)

NAZARY ISTOMIN SAVIN
Russian, 17th century
9. Icon: Saint Dmitry the Tsarevich, 1621 or 1622
Tempera on wood, with embossed silver gilt; 59⅝ x 30⅜" (153 x 77.8 cm)

Provenance: Annunciation Cathedral, Solvychegodsk

An inscription on the reverse of this icon indicates that it was painted by Nazary Istomin Savin by the order of Andrei Stroganoff.

According to tradition, Tsarevich Dmitry, the son of Ivan the Terrible, was killed in Uglich in 1591 at the age of ten. In 1606 Dmitry was canonized as a martyr and his body was transferred from Uglich to Archangel Cathedral in Moscow's Kremlin, where members of the royal family were traditionally buried. Like the icon of Saint Basil the Blessed, the Solvychegodsk depiction of Saint Dmitry is among the earliest known images of the saint. **TV**

The Solvychegodsk History and Art Museum (SM 535)

10. Royal Doors
Russian, 17th century
Tempera on wood; left leaf: 63 x 12⅞" (161.5 x 33 cm); right leaf: 62⅜ x 12¼" (160 x 31.5 cm)

Provenance: Possibly Annunciation Cathedral, Solvychegodsk

The doors located in the center of the iconostasis in the Russian Orthodox Church represent the entrance to the sanctuary and are called the Royal Doors in honor of Christ, whose spirit mysteriously passes through them dur-

ing the sacrament of Holy Communion. Representations on the Royal Doors and the canopy above them are rich in symbolic meaning. In the upper part of this set of Royal Doors is the scene of the Annunciation; in the lower part, on the door leaves, are images and symbols of the Evangelists. **TV**

The Solvychegodsk History and Art Museum (SM 431, 432)

MIKHAIL or **MIKHAILA**
Russian (Stroganoff School), late 16th–early 17th century
11. *Icon: The Baptism*
Tempera on wood; 13⅞ x 11¾" (35.6 x 30 cm)
On the reverse: the Stroganoff mark and an inscription with the master's name

Provenance: Annunciation Cathedral, Solvychegodsk; Sergei Stroganoff collection, St. Petersburg, 19th century

The State Russian Museum (AP 1020)

MIKHAIL or **MIKHAILA**
Russian (Stroganoff School), late 16th–early 17th century
12. *Icon: The Raising of Lazarus*
Tempera on wood; 13⅞ x 11¾" (35.8 x 30.2 cm)
On the reverse: the Stroganoff mark and an inscription with the master's name

Provenance: Annunciation Cathedral, Solvychegodsk; Sergei Stroganoff collection, St. Petersburg, 19th century

The State Russian Museum (AP 1012)

MIKHAIL or **MIKHAILA**
Russian (Stroganoff School), late 16th–early 17th century
13. *Icon: The Entry into Jerusalem*
Tempera on wood; 14 x 11¾" (35.8 x 30.2 cm)
On the reverse: the Stroganoff mark and an inscription with the master's name

Provenance: Annunciation Cathedral, Solvychegodsk; Sergei Stroganoff collection, St. Petersburg, 19th century

The State Russian Museum (AP 1014)

MIKHAIL or **MIKHAILA**
Russian (Stroganoff School), late 16th–early 17th century
14. *Icon: The Descent into Limbo*
Tempera on wood; 13⅞ x 11⅜" (35.4 x 29.7 cm)
On the reverse: the Stroganoff mark and a partly effaced inscription with the first letters of the master's name

Provenance: Annunciation Cathedral, Solvychegodsk; Sergei Stroganoff collection, St. Petersburg, 19th century

The State Russian Museum (AP 1038)

YEMELYAN MOSKVITIN
Russian (Stroganoff School), first half 17th century
15. *Icon: The Three Young Men in the Fiery Furnace*

Tempera on wood; 14 x 12¼" (35.8 x 31.5 cm)
On the reverse: the Stroganoff mark and an inscription with the master's name

Provenance: Annunciation Cathedral, Solvychegodsk; Sergei Stroganoff collection, St. Petersburg, 19th century

The State Russian Museum (AP 1022)

NIKIFOR ISTOMIN SAVIN
Russian (Stroganoff School), first half 17th century
16. *Icon: An Angel Protecting a Sleeping Man's Soul and Body*
Tempera on wood; 14 x 12⅛" (36 x 31 cm)
On the reverse: two inscriptions made at different times with the master's name

Provenance: Sergei Stroganoff collection, St. Petersburg, 19th century

The State Russian Museum (AP 1035)

NIKIFOR ISTOMIN SAVIN
Russian (Stroganoff School), first half 17th century
17. *Icon: Saint George Slaying the Dragon*
Tempera on wood; 13¾ x 11⅝" (35.2 x 29.8 cm)
On the reverse: inscription attributing the icon to Prokopy Chirin added in the 19th century

Provenance: Sergei Stroganoff collection, St. Petersburg, 19th century

The State Russian Museum (AP 1039)

18. *Icon: The Story of the Prophet Jonah*
Russian (Stroganoff School), first half 17th century
Tempera on wood; 13⅞ x 11⅜" (35.4 x 29 cm)

Provenance: Apparently from Annunciation Cathedral, Solvychegodsk; Sergei Stroganoff collection, St. Petersburg, 19th century

The State Russian Museum (AP 2054)

PERVUSHA
Russian (Stroganoff School), first half 17th century
19. *Icon: Massacre of the Holy Fathers at Mount Sinai and in the Rhaithou Desert*
Tempera on wood; 13⅞ x 11⅜" (35.7 x 29.8 cm)
On the reverse: the Stroganoff mark and an inscription with the master's name

Provenance: Annunciation Cathedral, Solvychegodsk; Sergei Stroganoff collection, St. Petersburg, 19th century

The State Russian Museum (AP 2144)

20. *Icon: The Descent of the Holy Spirit*
Russian, second half 17th century
Tempera on wood; 43¼ x 33⅜" (111 x 85.5 cm)

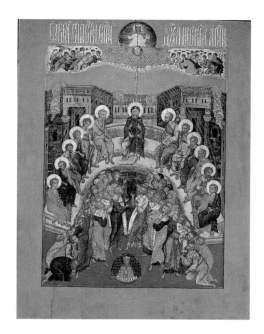

Provenance: Sergei Stroganoff collection, St. Petersburg, 19th century

The State Russian Museum (AP 1298)

NIKITA IVANOV PAVLOVETS
Russian (Moscow Kremlin Armory School), 17th century
21. *Icon: The Old Testament Trinity,* 1670–71
Tempera on wood; diam. 4⅝" (11.8 cm)
Dated and inscribed below the representation (in Cyrillic): "Painted by a humble servant Nikita Pavlovets"

Provenance: Sergei Stroganoff collection, St. Petersburg, 19th century

The State Russian Museum (AP 2560)

22. *Icon Shrine: Miracle of Saint George and the Dragon*

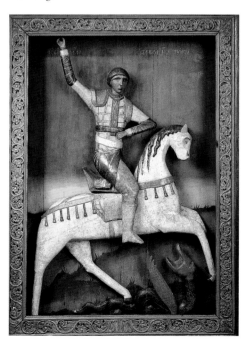

Russian, first half 17th century; frame, 19th century
Tempera on carved wood; 54½ x 39⅜" (139.8 x 101 cm)

Provenance: North chapel of Annunciation Cathedral, Solvychegodsk

The Solvychegodsk History and Art Museum (SM 68)

PAINTINGS

UNKNOWN ARTIST
Russian, 18th century
23. *View of Nevsky Prospect near the Police Bridge,* before 1753
Oil on canvas; 28⅛ x 47⅜" (72 x 121.5 cm)

Provenance: Transferred from the Ethnographic Museum, St. Petersburg, in 1941

This painting provides a view of the two Stroganoff houses (seen to the right of Nevsky Prospect) as they looked before they were combined into a single structure by Francesco Bartolomeo Rastrelli. The architect of the larger house facing Nevsky Prospect was the well-known Russian Mikhail Zemtsov, who had not completed the construction at the time Sergei Stroganoff purchased the property. Stroganoff subsequently commissioned Rastrelli to rebuild and join the mansions. The work was carried out from 1753 to 1756 and resulted in one of the finest buildings in St. Petersburg, the Stroganoff Palace.
IK

The State Hermitage Museum (1864)

DMITRY LEVITSKY
Russian, 1735–1822
24. *Portrait of Catherine the Great,* 1782
Oil on canvas; 64⅜ x 51½" (165 x 132 cm)

Provenance: Museum, Imperial Academy of Fine Arts, St. Petersburg; transferred to the State Russian Museum

Catherine the Great is depicted here wearing the Order of Saint Andrew the First Called (ribbon, star, and cross). Vigilius Eriksen's *Portrait of Catherine the Great Before a Mirror* served as a model for Levitsky's figure of the empress; a close iconographic parallel for the turn of the head and the facial expression can be found in the portrait of Catherine (now in the Hermitage) by Pierre-Étienne Falconet, the son of the sculptor Étienne-Maurice Falconet.

One of the most brilliant Russian painters of the latter half of the nineteenth century, Levitsky was nominated for membership in the Imperial Academy of Fine Arts in 1769, academician in 1770, and member of the Academy of Fine Arts council in 1780. He painted a great number of portraits of high-ranking nobility, members of the imperial family, cultural figures, and artists. The empress's cabinet paid Levitsky 500 rubles for this portrait in 1782.

Catherine the Great was a daughter of Prince Christian August of Anhalt-Zerbst and Princess Johanna Elizabeth of Holstein-Gottorp. Her name, before she was crowned Empress Catherine II, was Sophia Augusta Frederica of Anhalt-Zerbst. In 1744 Empress Elizabeth Petrovna chose her to be the bride of Grand Duke Peter Feodorovich (later Emperor Peter III), whom she had appointed heir to the Russian throne, and the couple was married in 1745. Catherine seized the throne after a coup d'état on June 28, 1762.
YeS

The State Russian Museum (40)

CARL FRIEDRICH KNAPPE
Russian (born Germany), 1745–1808
25. *Pair of Fire Screens,* 1805
Mahogany, brass, oil on canvas; screens: 57⅜ x 15½" (147 x 131 cm); painted panels: 34⅜ x 47⅜" (88 x 122 cm)

Provenance: Stroganoff Palace, St. Petersburg; transferred to the Hermitage; transferred to the Pavlovsk Palace Museum in 1959

These two fire screens were on view in the Pavlovsk Palace Museum for many years with mauve silk panels replacing the original canvas panels, which were only recently discovered and restored for the present exhibition. The canvas panels represent dogs—a poodle and a spaniel—that were apparently Stroganoff favorites. According to the 1922 inventory of the Stroganoff Palace, the frames of these screens originally had brass plaques with inscriptions in Russian: "Moustapha, favorite dog of Count Sophia V. Stroganoff" (on the poodle portrait) and "Mouton, favorite dog of Count Alexander S. Stroganoff. 1780" (on the spaniel portrait). The former is signed by Carl Friedrich Knappe and dated 1805.
NSt, AA

Pavlovsk Palace Museum (1160-V, 1161-V)

FEODOR YAKOVLEVICH ALEXEIEV
Russian, 1753?–1824
26. *View of Kazan Cathedral in St. Petersburg,* 1810s
Oil on canvas; 27⅜ x 43⅞" (71 x 112.5 cm)

Provenance: Acquired from V. K. Kusterskaya in 1910

Kazan Cathedral was built to the design of Andrei Voronikhin between 1801 and 1811. Count Alex-ander Stroganoff, who headed the Committee for the Construction of the Cathedral, solemnly presented keys to the emperor on September 15, 1811, the day the cathedral was consecrated. Stroganoff contributed liturgical vessels (such as a paten and chalice) made of platinum and precious stones from the Urals to the cathedral.

The square in front of the cathedral is painted as it looked at the time when the cathedral's construction was completed. At either end

of the colonnade stand figures of the kneeling archangels, Saint Michael and Saint Gabriel, executed in temporary materials after the model of Ivan Martos (they lasted as long as thirteen years). A wooden obelisk surmounted with a cross is seen in the center of the square; it was demolished in 1826. The foreground shows the Yekaterininsky (now Griboyedov) Canal. **YeS**

The State Russian Museum (5049)

ANDREI NIKIFOROVICH VORONIKHIN
Russian, 1759–1814
27. *View of the Stroganoff Dacha in St. Petersburg,* 1797
Oil on canvas; 26⅜ x 39⅛" (67.5 x 100.5 cm)

Provenance: Imperial Academy of Fine Arts, St. Petersburg; transferred to the State Russian Museum in 1897

The dacha was remodeled in 1795–96 to Voronikhin's design for Count Alexander Stroganoff at the place where the Chernaya Rechka flows into the Bolshaya Nevka. On December 19, 1797, Voronikhin was awarded the title of academician of perspective painting for this painting, then entitled *The Suburban House of His Excellency Count A. S. Stroganoff.* In the architecture of the building, which is reminiscent of a Palladian suburban villa, the heavily rusticated first story is contrasted with the light arcade of the second-story gallery. A large park extended behind the dacha, and a landing stage for pleasure boats decorated with sphinxes descended into the Bolshaya Nevka.

In 1908–9 the dilapidated dacha was radically renovated again; in 1970 it was finally demolished and only a part of the park still remains. The site, which was on the outskirts of St. Petersburg in the eighteenth century, is now almost in the center of the city. **YeS**

The State Russian Museum (5034)

ANDREI NIKIFOROVICH VORONIKHIN?
Russian, 1759–1814
28. *Self-Portrait,* 1811–14
Oil on canvas; 26½ x 22⅜" (68 x 57.5 cm)

Provenance: Artist's family until 1872; Imperial Academy of Fine Arts, St. Petersburg; transferred to the State Russian Museum in 1923

When this painting was in the possession of Voronikhin's family and in the Imperial Academy of Fine Arts, it was believed to be a self-portrait. There was even an inscription (in Russian) on the back of the picture, "Painted by the artist himself." Today, however, researchers have expressed doubt as to whether this picture is indeed by Voronikhin. Nevertheless the subject remains undisputed, and it is the only existing likeness of the artist and architect.

Voronikhin is depicted in the dress uniform of the Imperial Academy of Fine Arts with lyres on the buttons. At his neck is the Order of Saint

Anne Third Class, on his chest the Order of Saint Vladimir Fourth Class. On the right is the dome of his Kazan Cathedral. **YeS**

The State Russian Museum (5035)

STEPAN SEMEONOVICH SHCHUKIN
Russian, 1762–1828
29. *Portrait of Emperor Paul I,* 1796–97
Oil on canvas, 60½ x 45¼" (154 x 116 cm)

Provenance: Yusupov collection, St. Petersburg; acquired by the State Museum of Ethnography, St. Petersburg; transferred to the Hermitage in 1941

Paul I (1754–1801) was the son of Peter III and Catherine the Great. He became emperor in 1796 after his mother's death and was killed during a palace revolution on March 11, 1801. He is depicted here in the uniform of colonel of the Preobrazhenskii Regiment, wearing the star and ribbon of the Order of Saint Andrew the First Called, the Order of Saint Alexander Nevsky, and the Order of Saint Anne. Paul I especially liked this portrait, of which the artist made several versions.

Paul I appointed Alexander Sergeivich Stroganoff president of the St. Petersburg Public Library in 1798 and president of the Imperial Academy of Fine Arts in 1800. He also made Stroganoff a member of the Order of Saint John of Jerusalem and appointed him chairman of the committee supervising the construction of Kazan Cathedral. **IK**

The State Hermitage Museum (1733)

STEPAN SEMEONOVICH SHCHUKIN
Russian, 1762–1828
30. *Portrait of Alexander I, Emperor of Russia,* no later than 1805
Oil on canvas, 30¼ x 24⅛" (77.5 x 62 cm)

Provenance: S. Polotsova collection, St. Petersburg; transferred to the Russian Museum in 1918

Portrait painter, miniaturist, icon painter, and teacher, Stepan Semeonovich Shchukin received his primary education in the Moscow Children's Home. In 1776 he entered the portrait class of Dmitry Levitsky at the Academy of Fine Arts in St. Petersburg and studied there under the name of Stepan Semeonov until 1782. In that year he was awarded the Great Gold Medal for his program painting *Portrait of a Teacher and Her Pupil.* From 1782 to 1786 he studied in Paris with A. Roslin and J.-B. Suvée. He was nominated for membership in the Academy of Fine Arts in 1786 and began teaching portrait painting that year; in 1788 he was appointed to the Academy Council and became an academician in 1797 after he had painted the portrait of Paul I (cat. no. 29). Among his pupils were the well-known Russian

artists Vasily Tropinin, Alexander Varnek (see cat. no. 32), and Mikhail Terebenev.

This portrait was painted before December 13, 1805, when Alexander (1777–1825) was awarded the Order of Saint George, Fourth Class. The emperor is shown wearing the uniform of the Preobrazhensky Regiment of the Life Guards with the star and ribbon of the Order of Saint Andrew the First Called and the embroidered star and Order of Saint John of Jerusalem. **SM**

The State Russian Museum (3230)

VASILY ISTOMIN
Russian, d. early 19th century
31. *The Transfer of the Icon of the Virgin of Tikhvin from the Church of the Nativity of the Virgin to the Dormition Cathedral in Tikhvin on June 9, 1798,* 1801
Oil on canvas; 110⅜ x 99" (283 x 254 cm)
Signed, dated, and inscribed (in Russian), bottom center, on the scroll: "This picture was painted by Vasily Istomin from May 20, finished Nov. 2, 1801"

Provenance: Imperial Academy of Fine Arts, St. Petersburg; transferred to the State Russian Museum in 1898

The artist has recorded here, with documentary precision, an event he witnessed in the ancient town of Tikhvin: a procession led by senior Orthodox clergy, in which Emperor Paul I, accompanied by Maria Feodorovna and his heir, Grand Duke Alexander, carried the miracle-working icon to the main church of the monastery founded in 1383 on the site where the icon first appeared. The actual icon is now in a Ukrainian church in the Chicago area.

The painter was not one of the professional artists of the academic school, but he conveyed likenesses fairly successfully. Alexander Stroganoff is shown walking directly behind the icon, and the surrounding crowd is made up of portraits of leaders of the community. The artist depicted himself in the center foreground looking straight out at the viewer. **YeS**

The State Russian Museum (5797)

ALEXANDER GRIGORIEVICH VARNEK
Russian, 1782–1843
32. *Portrait of Alexander Sergeievich Stroganoff,* 1814
Oil on canvas; 97⅞ x 71¾" (251 x 184 cm)
Signed, bottom left: A. Varnek. 1814

Provenance: Stroganoff collection, St. Petersburg; transferred to the State Russian Museum in 1930

This portrait was painted posthumously using as a source the portrait by Jean-Laurent Mosnier

(cat. no. 138). In 1814 it was displayed in an exhibition at the Imperial Academy of Fine Arts.

AS

The State Russian Museum (5497)

KARL PAVLOVICH BRIULLOV
Russian, 1799–1852
33. *Portrait of Her Highness Elizabeta Saltykova,* c. 1841
Oil on canvas, 78 x 55⅜" (200 x 142 cm)

Provenance: Stroganoff collection, St. Petersburg; transferred to the State Russian Museum in 1919

Karl Briullov was the leading and most gifted representative of the Russian academic artists whose work reflected both the romantic experiments and the realistic tendencies to be found in Russian art during the first half of the nineteenth century. Painter, watercolorist, and draftsman, the author of historical compositions, portraits, genre works, and monumental wall paintings, he was greatly admired by his contemporaries, among them Thorwaldsen, Walter Scott, Stendhal, and Liszt. Born in a family of artists, Karl Briullov studied at the Academy of Fine Arts from 1809 to 1822, when he was awarded a stipend by the Society for the Encouragement of the Arts for travel in Italy.

Princess Elizabeta Pavlovna Saltykova (1802–1865), née Stroganova, was the daughter of Paul Alexandrovich Stroganoff and the wife of Prince Ivan Dmitrievich Saltykov. She was acquainted with Briullov from the time of his stay in Italy, when he painted a marvelous watercolor portrait of her in Rome (1833–44). Apollon Mokritsky recalled a visit to the artist's studio in St. Petersburg by the poets Pushkin and Zhukovsky in 1837, two weeks before the duel in which Pushkin was killed. Mokritsky describes how Pushkin saw the watercolor *Arriving at a Ball Given by the Russian Envoy at Smyrna,* praised it loudly, and requested that "the great Karl" present it to him. Briullov refused, however, citing the fact that the watercolor had already been promised to Princess Saltykova.

This portrait would seem to have been begun in the 1830s and finally completed at the end of 1841, an assumption documented by the February 1841 issue of the St. Petersburg *Art Gazette.* It is one of the artist's few finished works, a carefully posed, official image that continues the tradition of formal portraiture that was seen in Russia in the eighteenth century. In such formal images artists often limited themselves to an unemotional record of the sitter's appearance and sufficient details to provide evidence of his or her high position in society. This approach was unthinkable to Briullov, who never repeated his own compositional solutions or relied on traditional iconography.

In the painting he has introduced daring decorative combinations of bright color contrasts (the blue dress and red shawl, the black lace, the

plants in the conservatory) and exotic elements in the attire and the setting (the peacock feather fan, the leopard skin). These freely rendered details, combined with the sitter's relaxed pose and the keen psychological characterization, give the portrait a unique lyrical tone. This portrait is one of the "great Karl's" greatest achievements.

GG

The State Russian Museum (5090)

YEFIM KOPYIN
Russian, active early 19th century
34. *Portrait of Yermak Timofeievich*
Oil on canvas; 38¼ x 29¼" (98 x 75 cm)
Signed and inscribed, bottom right (in Russian): "P. Yefim Kopyin, teacher at the School of the Don Forces, in 180 . . ."

Provenance: Collection of Emperor Alexander III; transferred from the Hermitage in the 1930s

In the 1980 paintings catalogue of the State Russian Museum this portrait was listed as by an unknown eighteenth-century artist. During restoration the signature was discovered on the front, making it possible to establish the authorship and refine the dating of the work. In iconographic type the portrait resembles late-eighteenth-century examples.

Yermak Timofeievich (c. 1540–1584/5?) was the cossack ataman (commander) who led the campaign in Siberia that marked the beginning of Russia's annexation and the opening up of that territory. The initiators of the campaign were the Stroganoffs, who owned the lands around Solvychegodsk on the River Kama. In 1558 the Stroganoffs were granted their first charter to "the abundant places of the Kama"; in 1574 they were given lands beyond the Urals and permission to build fortifications along the Ob and Irtysh Rivers. In 1579 Nikita Stroganoff and his cousin Maxim invited Yermak and other cossacks to enter their service. The cossacks accepted and arrived in the Stroganoffs' lands in the autumn of the same year to protect them against the attacks of the Siberian khan Kuchum. The army lived there for two years before setting off on a campaign to conquer Siberia, in the course of which Yermak was killed.

RD

The State Russian Museum (3971)

NIKOLAI STEPANOVICH NIKITIN
Russian, 1811–1881
35. *The Picture Gallery of the Stroganoff Palace,* 1832
Oil on canvas; 27⅜ x 38¼" (71 x 98 cm)

Provenance: Acquired from V. K. Kusterskaya in 1910

This is the Picture Gallery in the Stroganoff Palace on Nevsky Prospect, one of the finest private picture galleries in Europe. Nicolas Poussin's *Rest on the Flight into Egypt* (cat. no. 129), now one

of the masterpieces in the Hermitage, is visible in the foreground.

YeS

The State Russian Museum (5126)

GRIGORY MIKHAILOV
Russian, 1814–1867
36. *Second Classical Gallery in the Academy of Fine Arts in St. Petersburg,* 1836
Oil on canvas; 53⅞ x 66½" (138 x 170.5 cm)

Provenance: possibly Imperial Academy of Fine Arts, St. Petersburg

The Imperial Academy of Fine Arts was founded in St. Petersburg in 1757, and until the mid-nineteenth century, it was the only educational institution in Russia where professional artists were trained. Alexander Stroganoff served as its president from 1800 until his death in 1811. The halls and classrooms of the Academy contained many original works of art, as well as copies and plaster casts of famous masterpieces.

The picture shows the Second Classical Gallery (now the Raphael Hall). On the right wall one can see exact copies of Raphael's frescoes from the Vatican executed by the Academy's graduates, who received grants to study in Italy, and a copy of Titian's *Ascension.* Hanging over the door leading to the round conference hall is the *Death of Camilla, a Sister of the Horatii* by the Russian painter Feodor Bruni. Along the walls stand plaster casts of the most celebrated statues of antiquity—the Venus de Milo, Apollo Belvedere, Laocoon, and the Farnese Herakles.

In the lower right corner the artist depicted himself at work, dressed in the Academy student uniform, a blue coat with a high collar and brass buttons.

YeS

The State Russian Museum (6260)

KONSTANTIN YEGOROVICH MAKOVSKY
Russian, 1839–1915
37. *Portrait of Count Sergei Grigorievich Stroganoff,* 1882
Oil on canvas; 69⅞ x 48¾" (179 x 125 cm)
Signed and dated, bottom right: K. Makovsky. 1882

Provenance: Collection of N. Versen, St. Petersburg; State Museum Reserve, St. Petersburg; transferred to the State Russian Museum in 1920

Count Sergei Grigorievich Stroganoff (1794–1882) was a cavalry general, adjutant general, and member of the State Council. In 1831–34 he performed the duties of military governor in Riga and Minsk. In 1835–47 he was education administrator of the Moscow district and also chairman of the Moscow Society for Russian History and Antiquities. He organized the restoration of the Cathedral of Saint Dmitry in Vladimir and on the basis of the material gathered wrote the book *The Cathedral of Saint Dmitry in Vladimir-on-the-Kliazma, Built in 1194–97* (St.

Petersburg, 1849). In 1854–55 he participated in the Sevastopol campaign of the Crimean War. In 1859 he founded the Archaeological Commission, remaining its president for the rest of his life. In 1859–60 he served as governor general of Moscow, and in 1863–65 he was chairman of the Railways Committee. In the 1850s and 1860s he was the chief tutor of Alexander II's sons, Grand Dukes Nikolai, Alexander (the future Alexander III), Vladimir, and Alexei.

Sergei Stroganoff was one of the first in Russia to collect early Russian art and artifacts connected with the history of Russia before Peter the Great. With his own published works and the support he gave to noted researchers (Buslaiev, Granovsky, Solovyov, Kavelin) he made a significant contribution to the formation and development of Russian historical studies. He had a large numismatic collection. In Makovsky's portrait the count is shown in his study in the Stroganoff Palace, St. Petersburg. **PK**

The State Russian Museum (620)

ALBERTO COLUCCI
Italian, active second half 19th century
38. *The Study of Count Sergei Grigorievich Stroganoff,* 1882
Oil on canvas; 17½ x 21⅛" (45 x 55.5 cm)
Signed and dated, bottom right: *Alb. Colucci*

Provenance: Collection of N. Versen, St. Petersburg; State Museum Reserve, St. Petersburg; transferred to the State Russian Museum in 1920

The Study in the Stroganoff Palace adjoined the famous Picture Gallery. Besides books, the study contained family portraits and part of the count's collection of sculpture and paintings by Russian and western European artists. **PK**

The State Russian Museum (2739)

SCULPTURE

39. *Cameo: Portrait of Catherine II as Minerva*
Russian (St. Petersburg), after 1789
Porcelainlike paste on green agate, bronze; 3⅜ x 2⅛" (8.7 x 5.6 cm)

Provenance: Stroganoff collection, St. Petersburg; transferred to the Hermitage in 1925

Catherine II's passion for cameos was such that she described it, not without some self-deprecation, as an illness. The illness proved to be infectious to all around her: "Both the learned and the ignorant—all have become antiquarians," she wrote to Prince Yusupov in 1788. A favorite pastime at court was the making of papier-mâché casts from carved stones. Although Catherine herself went no further than this, she encouraged her family and close friends to take up the art of carving.

Grand Duchess Maria Feodorovna attained great skill in gem carving, which was one of her numerous artistic pastimes. In honor of Catherine II's name day she produced a portrait of the empress with a laurel wreath and a winged sphinx, carved in pink and gray jasper; the date on the cameo alongside the signature, is that of the name day (MARIA F. 21 APR. 1789). This cameo is a copy of that carved gem.

Contemporaries relate how Maria Feodorovna mastered this very difficult craft with the aid of the court engraver and medalist Karl Leberecht and went on to create her own cameos independently. According to the librarian and secretary G. Lafermier, who was often present while she worked, "The grand duchess first—sometimes from life or, as in the case of the empress, from a good portrait—makes a model in wax from which she then carves the cameo in hard stone, using for this the beautiful layered stones of Siberia. . . . In modeling the portrait, she listens to the advice of her teacher or those present and takes it into account if she finds the advice to be just, but when she works on the stone the teacher dares not put his own hand to it and he has no other duties but to pass her the tools."[1]

The cameo became famous, thanks to numerous repetitions in porcelain and glass made from a cast taken at the Imperial Porcelain and Glass Manufactories, as well as in colored pastes, smelt glass, gum, alabaster, and plaster in a laboratory within the Hermitage itself. Here, gems in the Hermitage collection were reproduced by Karl Leberecht, together with the court "chemist" and glassmaker G. König. Although Lafermier wrote that "she [M. F.] had nothing to do with the manipulation of the paste copies, which is the work of a laborer, and which consists only of taking a form from the original stone, a form that then serves to make the paste copies," it has been asserted in the literature that with the aid of König, Maria Feodorovna herself made copies of her cameos in glass paste, in order to use them in the decoration of furniture and other objects in the palace at Pavlovsk.

This example from the Stroganoff collection differs from the numerous other copies in that the portrait bas-relief had its own ground removed and was glued onto a polished convex plaque of natural agate (a similar approach can be seen in another early-nineteenth-century piece in the History Museum, Moscow, where a marble relief was placed on onyx) and then set into a massive classical-style frame. **JK**

1. Archive of Prince Vorontsov, St. Petersburg, 1833, book 29, pp. 291–92.

The State Hermitage Museum (K.6267)

MIKHAIL KOZLOVSKY
Russian, 1753–1802
40. *Yakov Dolgoruky Tearing the Tsar's Decree,* 1797
Marble; 35 x 16¾ x 12" (90 x 43 x 31 cm)

Inscribed left, on the base: *fecit Kaslowsky;* on the obverse: *Pr. Jakoff Theodorowitz Dolgoruky;* on the scroll: *Ukase de l'Empereur onereux au pais dechire.*

Provenance: Dolgoruky family collection, St. Petersburg; transferred to the State Russian Museum in 1918

Alexander S. Stroganoff often commissioned replicas of well-known works by eminent sculptors for his collection. In 1788 a marble bust of the great mathematician Leonhard Euler by Jean-Dominique Rachette, the original version of which was produced for the Imperial Academy of Sciences, appeared in his palace on the Moika River (corner of Nevsky Prospect), next to the busts of Voltaire and Diderot by Jean-Antoine Houdon. In 1793 Rachette made for Stroganoff a smaller marble model of a monument to the outstanding military figure Piotr Rumiantsev-Zadunaisky (the large bronze statue has not survived). Mikhail Kozlovsky, the most prominent Russian sculptor of the last decades of the eighteenth century, made for Stroganoff a replica of his famous marble of Yakov Dolgoruky (now the "Stroganoff" version is in the Tretyakov Gallery, Moscow). The fact that Kozlovsky turned to the image of a national hero was significant for the history of Russian art. As a participant in the Crimean War, Peter the Great's Azov campaign, and the Great Northern War with Sweden, Senator Yakov F. Dolgoruky (1639–1720) was said to have been one of the most honest and courageous men of his time. Legend has it that he once tore up the tsar's decree at the Senate, because it encroached upon the rights of peasants. Following classical precepts, the sculptor included a number of allegorical attributes—the scales of justice, the burning torch, and the symbols of evil and pretense defeated—placing them at the foot of the statue. **YeK**

The State Russian Museum (SC 328)

KARL LEBERECHT
Russian (born in Germany), 1755–1827
41. *Bas-relief: Portrait of Count Alexander Stroganoff, President of the Imperial Academy of Fine Arts,* 1803
Tinted wax on blackened glass plate; diam.4¼" (10.8 cm); 8⅜ x 7½" (22.1 x 19.3 cm with frame)
On reverse of frame: *fait par Charl de Leberecht, 1803*

Provenance: Stroganoff Palace, St. Petersburg; transferred to the Hermitage in 1921

Karl Leberecht, a medal maker and gem cutter, took his first art lessons in Germany, but from 1778 on he worked at the St. Petersburg mint, where he became its chief medalist in 1799. In 1794 he received the title of academician at the Imperial Academy of Fine Arts. Leberecht received an appointment at the Russian court to instruct Grand Duchess Maria Feodorovna in gem cutting, which was one of her numerous

artistic pastimes. He often met Count Alexander Stroganoff at various court gatherings, and on Stroganoff's initiative, he became in 1800 a supervisor of the medal-making class at the Academy of Fine Arts, a post that he held until his death. He was honorary member of the Berlin and Stockholm academies of art.

In the upper part of the bas-relief is a modeled vignette with cornucopias, attributes of the liberal arts, and a count's crown, under which is a bronze plate with an inscription: "Comiti Alexandro Stroganov Amantissimo Artium Patri 1803." Alexander Stroganoff is depicted in a gown with a chain of the Order of Saint Andrew the First Called.

The bas-relief served as the model for a medal commissioned by the Academy of Fine Arts from Ivan Shilov in 1807 to commemorate the fiftieth anniversary of Alexander Stroganoff's activity at the Academy. **ET**

The State Hermitage Museum (144)

ALEXEI AKIMOVICH YESAKOV
Russian, d. 1815
42. *Intaglio: Herakles Hurls Lichas into the Sea*, c. 1813
Sard; 1¾ x 1½" (4.6 x 3.9 cm)
Signed at the left: A. Yesakov

Provenance: Sophia Stroganoff collection, St. Petersburg, before 1845; transferred to the Hermitage in 1925

This is an enlarged copy by the artist of a carnelian intaglio depicting the same subject (Hermitage 4279) carved in 1813 by Alexei Yesakov, who taught carving in steel and hard stones to the medal-making class of the Imperial Academy of Fine Arts in St. Petersburg. The piece was submitted as part of his effort to become an academician.

The story behind both intaglios is of great interest. In January 1813 the council of the Academy expressed the hope that Yesakov would produce a work worthy of the title of academician[1] and on June 7 suggested that he "carve in stone Herakles throwing into the sea the youth who brought him a tunic dipped in poison from Deianeira."[2] On the same day the chief medalist, Karl Leberecht, informed the council that "former pensioner of the Academy Yesakov wishes to carve in stone his own composition, depicting Aeneas carrying his father Anchises from the burning of Troy."[3] The council, however, which strictly regulated life at the Academy, would not permit this free choice of subject and ordered Yesakov to present by September for their assessment a work on the theme they had suggested.

The engraver completed his task successfully. Untouched by the polishing tool, the group of figures contrasts with the shining, slightly convex surface of the stone. Freely arranged in space, the composition sits neatly in the oval form. Anatomically speaking, the figures of Herakles and Lichas, the latter depicted upside down so

that one of his hands is thrown behind his head and the second hangs to the ground, are fully in keeping with the classical canon. The harshness in the carving of the program intaglio has been avoided in the sard version, which was apparently produced at about the same time. After receiving the title of academician, Yesakov was appointed to fill the vacancy as Leberecht's assistant, but he occupied it for only two years, owing to his early death in 1815.

According to Alexei Olenin, president of the Academy, the intaglio belonged to Countess Sophia Vladimirovna Stroganoff, née Princess Golitsyna, the wife of Paul Stroganoff. In 1829 he wrote: "In the difficult field of the fine arts, the young artist Yesakov sparkled briefly in the sphere of carving on hard stones. Only two of his works survive. One of these, with an image of Herakles throwing Iole into the sea, is with Countess S. V. Stroganoff."[4] Despite a slight difference in the identification of the subject and the type of stone, the reference was undoubtedly to this work by the famous Russian engraver. **JK**

1. P. N. Petrov, *Sbornik materialov dlia istorii Imperatorskoi Akademii khudozhestv* [Anthology of Material on the History of the Imperial Academy of Fine Arts] (St. Petersburg, 1865), vol. II, p. 46.

2. History Archives, fund 789, inv. I, part I, no. 234.

3. Petrov, *Sbornik materialov*, p. 46.

4. *Kratkoye istoricheskoye svedeniye ob Imperatorskoi Akademii khudozhestv s 1764 po 1829 g.* [Brief Historical Information about the Imperial Academy of Fine Arts from 1764 to 1829] (St. Petersburg, 1829), p. 29.

The State Hermitage Museum (11530)

DECORATIVE ARTS

EMBROIDERY

43. *Shroud: The Entombment*
Russian (Solvychegodsk, workshop of Eupraxia F. Stroganoff), 1592
Gold and silver thread and silks on silk damask, with homespun lining; 53⅜ x 72⅛" (137.5 x 185 cm)

Provenance: Annunciation Cathedral, Solvychegodsk; Anichkov Palace chapel, St. Petersburg; Museum of the History of St. Petersburg; transferred to the State Russian Museum

An inscription giving the date and the donor's name is embroidered on the right side of the central panel, which is worked on crimson damask; the violet border bears the words of a prayer. This outstanding example of the embroiderer's art was worked with the participation and supervision of Eupraxia Stroganoff for the family church, Annunciation Cathedral of Solvychegodsk, founded by her husband, Nikita Grigorievich Stroganoff. It is the earliest dated piece of needlework produced in the Stroganoff workshops. **LL**

The State Russian Museum (287)

44. *Shroud: Saint Dmitry the Tsarevich with Saints*
Russian (Solvychegodsk, workshop of Anna I. Stroganoff), 1656
Gold and silver thread and silks on silk taffeta, with damask lining; 56⅜ x 36⅜" (144.6 x 93.3 cm)

Provenance: Annunciation Cathedral, Solvychegodsk; Museum of the Society for the Encouragement of the Arts, St. Petersburg; transferred to the State Russian Museum in 1918

The central panel features Saint Dmitry (Demetrius) the Tsarevich. In the corners are the symbols of the Evangelists, and on the upper border the Lord God Sabaoth is depicted in the center, flanked by the figures of the Virgin with the Christ Child on her breast and the archangel Gabriel of the Annunciation, with John the Baptist and Saint Nicholas on either side. The side and lower borders show Russian saints, metropolitans, holy fools, and the patrons of Dmitry Andreievich Stroganoff's family: Saint Dmitry the Tsarevich, Saint Anna the Prophetess, and Saint Pelagea the Martyr.

On the reverse of the shroud there is an embroidered depiction of the Cross of Golgotha, below which is an inscription giving the date and the names of the donors. The inscription tells us that the shroud was intended for use in religious processions during festivals devoted to the birth and martyrdom of Saint Dmitry the Tsarevich and the transfer of his relics from Uglich, where he was killed, to Moscow.

The shroud was made in the workshop of the wife of Dmitry Stroganoff, who had many objects made in honor of his patron saint. **LL**

The State Russian Museum (206)

45. *Icon Cloth: Our Lady of Kazan*
Russian (Solvychegodsk, workshop of Anna I. Stroganoff), mid-17th century
Gold and silver thread and silks on silk, with taffeta lining; 12⅞ x 10½" (33.2 x 27 cm)

Provenance: Transferred to the State Russian Museum from the Hermitage in 1938

The inscription embroidered in the margins presents the opening words of a prayer. The crown, the halo, and the *maphorion* (cloak) of the Virgin are decorated with colored glass and turquoise mounted on metal. The ground is worked all over in gold thread, the central panel on red silk, the borders on green silk. The cloth is decorated with tassels sewn onto the lower edge. **LL**

The State Russian Museum (370)

46. *Icon Cloth: The Vernicle*
Russia (Solvychegodsk, workshop of Anna I. Stroganoff), mid-17th century
Gold and silver thread and silks on satin, with silk lining; 14 x 12" (36 x 31 cm)

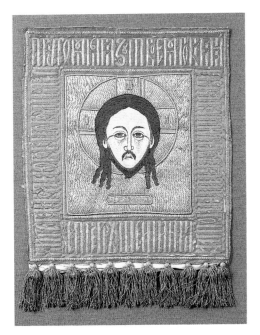

Provenance: Transferred to the State Russian Museum from the Hermitage in 1938

The image is identified in the inscription in Greek embroidered below it. The central panel is worked on light brown damask; the inscription, citing a prayer, is worked on red satin. The cloth is decorated with tassels sewn onto the lower edge.

According to legend, Saint Veronica came to Christ as he was carrying his cross to Calvary and with a linen cloth wiped the sweat from his face. The image of his features became miraculously imprinted on the cloth, called a vernicle or sudarium, which is supposedly preserved as a holy relic at Saint Peter's in Rome. The image of Christ's face impressed on the vernicle was very popular in Russian icon painting. **LL**

The State Russian Museum (372)

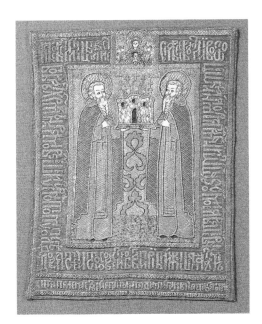

47. *Icon Cloth: Saints Zosimus and Sabbatius of the Solovetsky Monastery*
Russia (Solvychegodsk, workshop of Anna I. Stroganoff), mid-17th century
Gold and silver thread and silks on silk satin, with silk lining; 16 x 12" (41 x 30.8 cm)

Provenance: Transferred to the State Russian Museum from the Solovetsky Monastery in 1923

The inscription on the lower border, below the prayer in the margins, reads: "This icon cloth was made to the order of Grigory Dmitrievich Stroganoff." Grigory Dmitrievich Stroganoff (1656–1715) was the son of Dmitry and Anna Stroganoff. The Stroganoffs particularly revered the saints Zosimus and Sabbatius, who founded the Solovetsky Monastery on the White Sea in the fifteenth century. **LL**

The State Russian Museum (85)

48. *Vestment Fragment: The Descent into Limbo*
Russian (Solvychegodsk, workshop of Anna I. Stroganoff), 1660s
Gold and silver thread and silks on silk satin, with new taffeta lining; 12½ x 11⅛" (32 x 28.5 cm)

Provenance: Acquired by the State Russian Museum in 1925 from the N. L. Shabelskaya collection

The cruciform fragment has been taken from an omophorion, part of a bishop's vestment. The outlines of the figures and the folds of their clothing are marked by raised lines of stitching. **LL**

The State Russian Museum (70)

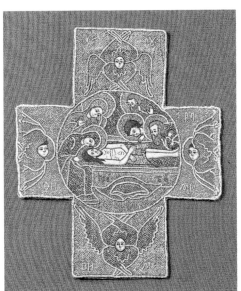

49. *Vestment Fragment: The Entombment*
Russian (Solvychegodsk, workshop of Anna I. Stroganoff), 1660s

Gold and silver thread and silks on silk taffeta, with new taffeta lining; 12⅜ x 10⅜" (32.5 x 26.5 cm)

Provenance: Transferred to the State Russian Museum from the Hermitage in 1938

The cruciform fragment has been taken from an omophorion part of a bishop's vestment. The contours and inscriptions are worked in silver thread. **LL**

The State Russian Museum (361)

METALWORK

50. *Shishák Helmet*
Russian (Moscow?), second half 16th century
Steel, iron, brass, and fabric; 19⅜ x 8¼" (50.4 x 21.2 cm)

Provenance: Collection of Augustus van Horne Ellis, Rye, New York, before 1896 and 1932–39; The Metropolitan Museum of Art, New York, 1896–1932; Clapp and Graham Company, New York

The Stroganoffs' immense wealth placed them on a high level in Russian society, which permitted them to maintain a private army for self-defense. Reforms enacted by Tsar Ivan IV regulated such private armies through a feudalistic payment system that was required to provide annual service to the tsar.

The Stroganoffs recognized that they could not hold and fully exploit their rich eastern lands against Tatar raids without additional troops. Therefore, the cossack ataman Yermak was dispatched at the head of a force of fewer than one thousand cossacks equipped with modern firearms and cannon. After initial victories, Yermak declared Siberia the property of the tsar and for this gesture received gifts that included a fine shirt of mail and a cuirass (probably a mail and plate defense called *zertsala*) bearing a gold, double-headed eagle. Mail shirts known as *pantsir* were preferred by Russian aristocrats such as the Stroganoffs and were worn with *zertsala*. Moscow mail was noted for its dense network of rings, which produced a nearly impenetrable but heavy defense. As a cossack, Yermak would not normally have worn armor, and he was said to have drowned from its weight when his force was ambushed at a river and virtually wiped out.

Yermak's campaign entered into Russian and Stroganoff legend, and he became a folk and family hero. Some two centuries later, a trophy of arms and armor allegedly belonging to him was mounted in the palace in St. Petersburg. The trophy included a helmet, quite possibly like this *shishák*, a type rarely found outside Russian national collections. The *shishák*, which probably originated in the lower Balkans, was popular throughout Europe, east into Persia (Iran), and among Russia's noble cavalry. *Shish* refers to the

tall spike, which in Russia was sometimes fitted with a small pennant. Russian *shisháks* were generally plain or embellished with light fluting or inscriptions, although some chronicles describe examples that are gilded or encrusted with precious stones and pearls. The piercing of the protective cheekpieces to facilitate hearing may represent the cross of Saint Andrew, patron saint of Russia. **WK**

The Higgins Armory Museum (2558)

51. *Reliquary Cross*
Russian (Solvychegodsk), 1610
Wood, silver; 10⅜ x 4½ x ⅜" (26.5 x 11.5 x 1 cm); case (*staurothèque*): wooden base covered with thin silver-gilt sheets; 14⅝ x 8⅜ x 1⅛" (37.5 x 21.5 x 2.7 cm)

Provenance: Annunciation Cathedral, Solvychegodsk

At the top of this carved crucifix the Lord God Sabaoth is depicted in an elaborate niche with the intercessors flanking the Crucifixion. Below it, Princes Vasily and Konstantin of Yaroslavl are represented. The crucifix was made of wooden boards from the coffins of these saintly princes. The silver endpieces of the cross are decorated with turquoise insets.

The lower silver endpiece of the cross bears an engraved inscription indicating that the cross was donated by Nikita G. Stroganoff. The cathedral's inventories show that two more reliquary crosses were donated by Nikita G. Stroganoff. **IP**

The State Russian Museum (BKK 3040)

in relief, produced in imitation of dishes from Moldavia. The boss on the bottom features two male heads, one in profile and the other in a three-quarter view. The boss is inscribed in a rosette surrounded by a narrow ring that contains a fine geometrical braiding pattern. The lobes of the rosette bear a carved inscription with the name of the cup's owner.

In 1605 Nikita G. Stroganoff donated similar pieces to the sacristies of Annunciation Cathedral and the Church of the Presentation in the Temple in Solvychegodsk. **IP**

The State Russian Museum (2987)

53. *Kovsh*
Russian, late 16th or early 17th century
Silver, partly gilded; h. 4¾" (12.5 cm), l. 11½" (20.5 cm)

Provenance: Maxim Y. Stroganoff, St. Petersburg; transferred from the Hermitage in 1939

This shallow, flat-bottomed scoop with a flat grip is decorated with an engraved inscription within gilded cartouches containing the name of the owner. **IP**

The State Russian Museum (2991)

54. *Basin for Holy Water*
Russian (Solvychegodsk), 1633
Silver; h. 9¾" (25 cm), diam. 11¾" (30 cm)

Provenance: Annunciation Cathedral, Solvychegodsk

This basin was used for the sanctification of water, which involves the immersion of a cross

taking monastic vows, assumed the name Euphrosene), and her sons, Andrei and Piotr, and her grandsons, Dmitry and Feodor. **TV**

The Solvychegodsk History and Art Museum (SM 873 S 23)

55. *Kovsh*
Russian (Solvychegodsk), third quarter 17th century
Wood burl, with silver mount; h. 3⅛" (8 cm) x l. 6¼" (16 cm)

Provenance: Dmitry A. Stroganoff, 1673; Grigory D. Stroganoff, 1716, A. L. Stieglitz collection, St. Petersburg; transferred from the Hermitage in 1939

The scoop is carved from a burl of wood. An engraved inscription containing the name of the kovsh's owner runs along the silver rim from the arrow-shaped end to the grip. **IP**

The State Russian Museum (2992)

56. *Tankard with Lid*
Russian (St. Petersburg), 1808
Silver; h. 10⅞" (27.7 cm)
Maker's mark: A. Yashinov; assay mark: St. Petersburg, 84

Provenance: Stroganoff collection, St. Petersburg

This tankard was presented to Count Alexander Stroganoff on the occasion of his seventy-fifth birthday. It is decorated with impressions of two medals by Karl Leberecht struck in his honor: one from the Academy of Fine Arts (1807) in honor of his presidency and the other to honor him as marshal of the St. Petersburg nobility (1808). **LZ**

The State Hermitage Museum (4872)

57. *Covered Cup*
Russian (St. Petersburg), 1832
Gold; h. 14¾" (37.7 cm)
Marks: Maker's mark (Karl Heine); assay mark St. Petersburg; engraved on the back: *Andrews Magasin Britanique St Petersb*

Provenance: Sergei Stroganoff collection, St. Petersburg; transferred to the Hermitage in 1925

The hexahedral body of this cup is applied with trophies of war and the attributes of science, art, abundance, and justice emblematic of the duties of Sergei G. Stroganoff (1794–1882), who served as military governor in Riga and Minsk from 1831 to 1834. The cup was evidently presented to him during one of his visits to Minsk, as documented by the Russian inscription on the shield applied on the front ("To Count Sergei Stroganoff from the citizens of Minsk Province") and the arms of the Stroganoff family under a count's crown on the back.

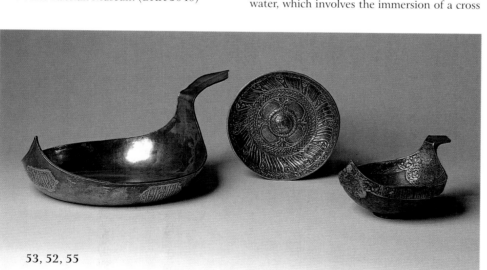

53, 52, 55

52. *Footed Dish*
Russian, late 16th or early 17th century
Silver, gilded; h. 1⅛" (3 cm), diam. 5½" (14 cm)

Provenance: Maxim Y. Stroganoff, St. Petersburg; transferred from the Hermitage in 1939

This forged silver dish is decorated with patterns

into water, a process that is repeated three times and accompanied by prayer and chanting. On the basin is the date, 1633, and an inscription in ligature script indicating that the basin was intended for Annunciation Cathedral and that it had been donated to the cathedral by the wife of Semeon Stroganoff, Eudoxia (who, after

This is the only example in the Hermitage of Heine's work in gold; the master was particularly popular for his silver pieces. The cup is executed in the characteristic manner of the 1830s, which is especially pronounced in the Gothic shapes of the chased decor. OK

The State Hermitage Museum (Z 9146)

Enamels

58. *Box*
Russian (Solvychegodsk), late 17th century
Painted enamel and silver; h. 1⅞" (4.8 cm); diam. of base 2⅛" (5.5 cm); diam. of lid 2⅜" (6.2 cm)

Provenance: A. L. Stieglitz collection, St. Petersburg; transferred from the Hermitage in 1938

This cylindrical box is enameled inside and out.

The sides are decorated with flowers worked in filigree, filled in with enamel, and painted. The faceted conic lid is decorated with painted heads of youths and young girls. The inside surface is covered with a minute pattern against a white-and-blue enamel ground. The bottom is coated with enamel on both sides and features a large flower.
 The box is an example of Usolye painted enamel. (Usolye is a name given to the city Solvychegodsk and vicinity.) In the last quarter of the seventeenth century the silversmiths of Solvychegodsk began producing Usolye enamels with filigree work, coating large surfaces with white and multicolored enamel and painting it with bright and highly original patterns. IP

The State Russian Museum (BK 3140)

59. *Bowl*
Russian, late 17th century
Painted enamel and silver, gilded with filigree; h. 1½" (4 cm), diam. 6⅛" (15.6 cm)

Provenance: Acquired from M. P. Botkin collection, St. Petersburg, in 1926

The interior of the bowl is painted with a stag at the center encircled by a garland of large flowers on a white enamel ground. The exterior and underside are similarly enameled with luxuriant flowers. IP

The State Russian Museum (BK 3142)

60. *Cup*
Russian (Solvychegodsk), late 17th century
Painted enamel and silver, gilded with filigree; h. 1" (2.4 cm), diam. 2⅞" (7.2 cm), l. 3¾" (9.7 cm)

Provenance: Acquired from the M. P. Botkin collection, St. Petersburg, in 1926

The cup rests on a low foot-ring. The edges of the boss, cup, and flat grip are outlined in filigree. The boss and the grip are enameled on both sides and painted with a floral pattern. The sides

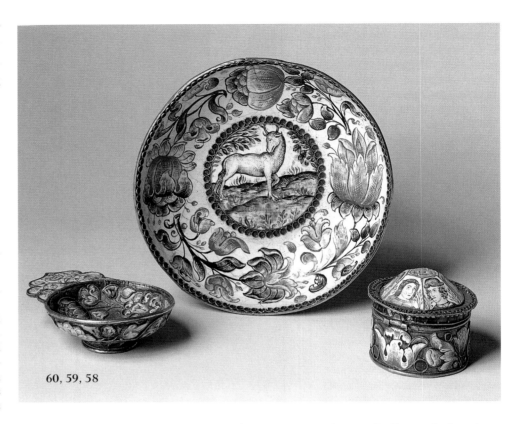

60, 59, 58

of the cup inside and out are decorated with filigreed stalks and flowers filled in with enamel and painted. IP

The State Russian Museum (BK 3144)

61. *Corner Piece of a Gospel Cover*
Russian (Solvychegodsk), late 17th century
Painted enamel and silver, gilded with filigree; 8 x 5⅞" (20.6 x 14.6 cm)

Provenance: Acquired from the M. P. Botkin collection, St. Petersburg, in 1926

Saint Luke is painted on a rectangle of white enamel on this corner piece from the lower left corner of a gospel cover. The rest of the surface is covered with coils of filigreed stalks, as well as with flowers and leaves painted on enamel. At the bottom of the image an inscription in semi-uncial script has survived, stating that the piece was painted by an icon painter from Usolye. IP

The State Russian Museum (BK 3141)

Decorative Stonework

62. *Drinking Set of Kalkan Jasper*
Russian (Peterhof Lapidary Works), 1754
Colored stone; tray: ½ x 6⅞ x 5½" (1.3 x 17.3 x 14.5 cm); each cup: 1 x 1⅜ x 1⅜" (2.7 x 3.7 x 3.7 cm)
Label with an inscription (in Russian) on one of the long sides of the tray: "a. 45–46. of grayish-green Jasper with black speckles and with it six *charki*"

Provenance: Stroganoff collection, St. Petersburg; transferred to the Hermitage in 1925

The Peterhof Lapidary and Grinding Mill (later the Imperial Lapidary Works) was the first Russian stonecutting factory, founded near St. Petersburg during the reign of Peter the Great, at the time of construction of his park and palace at Peterhof. The mill specialized in relatively small pieces, as it worked solely with raw material brought from more than a thousand kilometers away, from the Urals and the Altai.
 Archive documents relating to the Peterhof Lapidary Works mention the dispatch to the Cabinet of His Imperial Majesty on August 3, 1754, of a box with finished works. Among them were two trays of grayish jasper with black veins, six large *charki* (shot cups), and six small *charki* of the same stone.[1] The reference to the tray with small *charki* probably relates to this set, which enables us to give it such a precise date.
 In the middle of the eighteenth century, among the variety of pieces produced at the Peterhof mill, we often find utilitarian pieces such as teacups, sugar bowls, trays, vases (with and without lids), and saltcellars. The Hermitage set, which consists of a tray and six *charki* is an extremely rare surviving example of such works from this early period.
 Judging from these small objects, the stone carvers had already achieved a high level of skill in working with jasper, a hard and intractable stone. Only by hand can one achieve such fine walls in the vessels (just 1 mm thick) and finish the very complex profile of the rounded corners of the *charki*. Somewhat unusual for stone-carved pieces is the form of the *charki*, which

may have been borrowed from old Chinese gold drinking vessels of a kind then known in Russia and examples of which are now in the Hermitage collection. **NM**

1. History Archives, fund 468, inv. 32, file 916, f.35.

The State Hermitage Museum (ZI 9104–9110)

63. *Pair of Tigiretsky Quartz Columns*
Russian (Kolyvan Lapidary Works), 1790
Colored stone and bronze; h. 7" (18 cm)

Provenance: Stroganoff collection, St. Petersburg; transferred to the Hermitage in 1925

These small rose quartz columns, which are topped with spheres of Salair jasper and supported by bases of red jasper, are unusual products of the Kolyvan works.

The majority of Kolyvan products were listed in four albums now in the Hermitage. Inscriptions accompanying drawings of the objects in two albums indicate that on December 31, 1790, four identical columns were sent to St. Petersburg. The location of the second pair mentioned in the inscription is unknown.

In the 1790s two sets of table decorations were produced in the Altai and a third at the turn of the century. One of these, which consists of many vases, obelisks, columns, and arches, formerly belonged to Count Nikolai Sheremetev (1751–1809) and is now in the State Russian Museum, St. Petersburg (332). The columns from the Stroganoff collection probably formed part of one of the other two lost sets. **NM**

The State Hermitage Museum (ZI 9149, 9150)

64. *Vase of Pierre d'Alliance*
Russian (Yekaterinburg Lapidary Works), no later than 1793
Colored stone and gilt bronze; h. 2⅜ x w. 6½ x d. 4½" (6 x 16.5 x 11.5 cm)

Provenance: Stroganoff collection, St. Petersburg; transferred to the Hermitage in 1925

This kind of stone was known in the past as "union" or "two-faced" (*pierre d'alliance*), as it consists of stripes produced by alternating layers of different color or different kinds of rock grown into one another. In the eighteenth century such stones were much admired. In the Hermitage, for instance, we find two paired candlestick-vases (ZI 1414, 1415), also produced at Yekaterinburg in 1779 of a combination of gray granite and quartz, in which the layers go vertically, so that from one side the candlestick-vase seems to be made of granite and from the other of quartz. In the vase from the Stroganoff collection the layered effect of the same kind of stone is used differently, and the back is made from that part consisting of dense granite. Such a play on nature, enhanced by the skill of the carvers, would naturally be attractive for an admirer of stones and a specialist in minerals as

enthusiastic as Alexander Stroganoff. **NM**

The State Hermitage Museum (ZI 9147)

65. *Porphyry Vase*
Russian (Peterhof Lapidary Works), late 18th–early 19th century
Designed by Andrei Voronikhin

Colored stone; h. 15¾" x w. 6⅜" (52.5 x 16.5 cm)

Provenance: Entered the Winter Palace (now part of the Hermitage), St. Petersburg, in the early 19th century

The vase was designed by Andrei Voronikhin, as we see from a comparison with a drawing published by G. Grimm, a well-known authority on the architect's work,[1] which totally accords in form and outline. The sole difference lies in the bronze decoration in the drawing, which is not present in the finished object. A pair of similar vases (h. 71 cm) chiseled from gray-green reven jasper at the Kolyvan works in the early nineteenth century is now in the Museum of the St. Petersburg Mining Institute; they too are without decoration. **NM**

1. G. G. Grimm, *A. N. Voronikhin. Chertezhi i risunki* [A. N. Voronikhin. Plans and Drawings] (Leningrad/ Moscow, 1952), fig. 204 right.

The State Hermitage Museum (E 6366)

66. *Jasper Vase, with Lid*
Russian (Peterhof Lapidary Works), late 18th–early 19th century
Designed by Andrei Voronikhin
Colored stone; h. 15¾" x w. 9⅝" (40.5 x 24.8 cm)

Provenance: Entered the Winter Palace (now part of the Hermitage) in the early 19th century

The famous Russian mineralogist Alexander Fersman grouped this vase with works produced at the Yekaterinburg Lapidary Works at the end of the eighteenth century.[1] The lack of any information regarding it in the list of works produced in the Urals after 1790[2] makes it impossible, however, to agree with this attribution. In the Hermitage collection we find a similar but smaller vase (ZI 9101; h. 12 cm) of speckled jasper, which came from the Stroganoff collection. These vases can be identified with a drawing by Andrei Voronikhin, published by G. Grimm,[3] thus extending the range of early works made to designs by Voronikhin. We should note that the author's drawing includes bronze decoration, which was not applied to the finished object. Although in form the vase looks back to objects made in the late eighteenth century, a number of features suggest that it might have been produced at the very beginning of the nineteenth century. **NM**

1. A. Ye. *Fersman, Ocherki po istorii kamnia* [Essays on the History of Stone] (Moscow, 1961), vol. II, p. 281.

2. Yekaterinburg Archive, fund 86, inv. 1, file 62.

3. G. G. Grimm, *A. N. Voronikhin, Chertezhi i risunki* [A. N. Voronikhin: Plans and Drawings] (Leningrad/ Moscow, 1952), fig. 198.

The State Hermitage Museum (2558)

67. *Pair of Quartz Coupes*
Russian (Peterhof Lapidary Works), late 18th–early 19th century
Colored stone and gilt bronze; h. 7" (18 cm); diam. of bowl 5¼" (13.5 cm)

Provenance: Stroganoff collection, St. Petersburg; transferred to the Hermitage in 1925

Hard, colored stones were rarely employed for the sets of tabletop ornaments popular in the eighteenth and nineteenth centuries. Certainly, three hard-stone sets were produced at the Kolyvan Lapidary Works (see cat. no. 63; Hermitage ZI 9149, 9150). Such pieces were made also at Peterhof, as we learn from the French traveler Fortia de Piles, who visited the works at the end of the eighteenth century.[1] Archival sources document the work at Peterhof from 1786 to 1795 on a stand made of Russian precious stone mosaic that was to serve as the base for a table decoration ordered by Catherine II.[2] Other items for this set may have been undertaken simultaneously at both manufactories. Unfortunately, only one such table set has survived in full (Russian Museum 332), formerly the property of Count Nikolai Sheremetev (1751–1809). The pair in question here, in terms of form, decoration, and dimension, has analogies in the Sheremetev set, which differs only in the stone used. In the Hermitage case the vases are carved of yellow craquelure quartz, a mineral mined in the Urals rather than the Altai (where the Kolyvan works were located), and this enables us to attribute it to the Peterhof works. This attribution

is supported by the absence of reproductions of the vases in albums of items produced at the Kolyvan Grinding Works. **NM**

1. V. K. Makarov, *Tsvetnoi kamen v sobranii Ermitazha* [Colored Stones in the Hermitage Collection] (Leningrad, 1938), p. 18.

2. History Archives, fund 468, inv. 32, file 1075, f. 125; file 1086, f. 26.

The State Hermitage Museum (ZI 9142, 9143)

68. *Egyptian Figure Holding Tourmaline Bowl*
(one of a pair)
Russian (Peterhof Lapidary Works), 1801–6
Designed by Andrei Voronikhin
Colored stone and bronze; h. 3½" (9 cm);
base: 3⅜" x 1¾" (8.5 x 4.5 cm)

Provenance: Stroganoff collection, St. Petersburg; transferred to the Hermitage in 1925

In addition to the figure described here and its mate, the Hermitage also acquired from the Stroganoff Palace a pair of statuettes very similar in style and form, showing kneeling Egyptians in gilded bronze, each holding before him a bowl of raspberry tourmaline (ZI 9153, 9154). Grimm established that all these pieces were designed by Andrei Voronikhin.[1] Also from the Stroganoff collection is another object of raspberry tourmaline, now in the Hermitage (ZI 9159), a small obelisk in poor condition. Like the Egyptian figures, it can be identified with a drawing by Voronikhin.[2] Clearly, the whole of this miniature ensemble—the two bowls and obelisk, made of a mineral rarely used for such objects—formed an Egyptian set.

On the basis of archive sources,[3] which record the completion at the Peterhof mill in February 1801 of "an obelisk of red tourmaline with a labradorite pedestal" and its delivery to Count Stroganoff in 1806, we can date this set to 1801–6. **NM**

1. G. G. Grimm, *A. N. Voronikhin. Chertezhi i risunki* [A. N. Voronikhin: Plans and Drawings] (Leningrad/Moscow, 1952), fig. 73.

2. G. G. Grimm, *Arkhitektor Voronikhin* [The Architect Voronikhin] (Leningrad/Moscow, 1962), fig. 200.

3. History Archives, fund 468, inv. 32, file 1141, f. 16v; file 1156, f. 57.

The State Hermitage Museum (ZI 9151)

69. *Lapis-Lazuli Perfume Burner*
Russian (Peterhof Lapidary Works), early 19th century
Probably designed by Andrei Voronikhin
Colored stone and gilt bronze; h. 8 x w. 5⅝ x d. 4⅜" (20.5 x 14.4 x 11.2 cm)

Provenance: Stroganoff collection, St. Petersburg; transferred to the Hermitage in 1925

K. F. Asayevich and Ye. M. Yefimova grouped this vase censer with works designed by Andrei Voronikhin, finding similar motifs in a design for a fountain resting on four dolphins.[1] Fantasies

on the theme of the water—falling streams, fountains thrusting upward, naiads, tritons, swans, and dolphins—were favorite motifs in the designs of this architect, who from 1800 worked for the most part in and around Peterhof, the town and palace near St. Petersburg renowned for its fountains.

The vase, lid, and base under consideration here consist of whole pieces of lapis-lazuli—a rare example of such lavish use of this extremely expensive stone, generally used in a fine laminate to cover objects. The superb gilt bronze was probably produced at the State Bronze Manufactory of the Imperial Academy of Fine Arts. The manufactory was founded by Count Alexander Stroganoff, and the equipment, models, and drawings for it were purchased from the French bronze maker Pierre-Louis Agy (1752–1828). Over the short period of its existence (the manufactory closed in 1812, soon after the death of Alexander Stroganoff), it produced many works, some large and complex, demonstrating a high level of skill in casting, chasing, gilding, and the use of patinas.

Archive materials relating to the Yekaterinburg Lapidary Works[2] include a drawing of a deep bowl with a projecting lip resting on the tails of identical dolphins, who in turn rest on their tails on the base. The accompanying inscription to the design, dated January 19, 1823, states that the bowl was to be made in malachite, using the Russian mosaic technique. We do not know if the project was realized. **NM**

1. K. F. Asayevich, Ye. M. Yefimova, "Kamereznye izdeliya, sozdannye po proektam A. N. Voronikhina v Ermitazhe" [Carved Stone Objects in the Hermitage, Created to Designs by A. N. Voronikhin], *Samotsvety* [Semiprecious Stones] (Leningrad, 1961), no. 1, p. 76, app. 13, 14.

2. Yekaterinburg Archive, fund 86, inv. 1, file 864, f. 29.

The State Hermitage Museum (ZI 9141)

70. *Quartz Coupe Supported by Bronze Satyr*
Russian (Peterhof Lapidary Works), 1806–9
Colored stone and bronze; h. 11⅞" (30.4 cm);
diam. of bowl 6⅛" (15.5 cm)

Provenance: Stroganoff collection, St. Petersburg; transferred to the Hermitage in 1925

Objects of yellow craquelure quartz were often made at the Peterhof works, but only in one case do archive documents record the completion (in May 1806) of a "round vase with a square of yellow quartz."[1] This would seem to refer to the quartz vase under discussion here, which has a square plinth of the same kind of quartz. Five months later, on October 25, 1806, work began at Peterhof on four vases of agate and yellow quartz (documents do not specify the number of agate and quartz vases, but they were probably produced in pairs). These vases continue to figure in the manufactory reports of work for 1807 and 1808.[2] A pair of yellow quartz vases now in the Pavlovsk Palace Museum has an identical

bronze satyr and differs only in details of the stonework.

Kuchumov determined that the Pavlovsk pair was made to a design by the famous Russian sculptor Stepan Pimenov (1784–1833) in 1809, that the vases were made at Peterhof and the sculptural compositions at the bronze manufactory attached to the Academy of Fine Arts.[3] The basis for this was a list of objects set in bronze, which mentions the making of a pair of "seated Satyrs with vases, each at 150 roubles."[4] The Stroganoff bronze satyr was thus made at the same manufactory in the period between 1806—the date when the vase was completed—and 1809, when the sculptures of the Pavlovsk collection were produced. **NM**

1. History Archives, fund 468, inv. 32, file 1156, f. 55.

2. History Archives, fund 468, inv. 32, file 1156, ff. 46v, 47; file 1161, ff.54v, 55, 75v, 76; file 1164, ff.33v, 34.

3. A. M. Kuchumov, *Russkoye dekorativno-prikladnoye iskusstvo v sobranii Pavlovskogo dvortsa-muzeya* [Russian Decorative and Applied Art in the Collection of Pavlovsk Palace Museum] (Leningrad, 1981), pp. 155, 157, fig. 93.

4. History Archives, fund 468, inv. 32, file 1167, f. 15.

The State Hermitage Museum (ZI 9156)

71. *Pair of Obelisks*
Designed by Andrei Voronikhin
Russian (Peterhof Lapidary Works), 1804
Gilt bronze decorations produced at the State Bronze Manufactory of the Imperial Academy of Fine Arts, St. Petersburg
Kalkan jasper, gray porphyry, "meat-colored" agate (Urazovo jasper), ormolu; h. 22¼" (57 cm)

Provenance: Stroganoff Palace, St. Petersburg before 1930; transferred to the Hermitage in the 1930s; transferred to the Pavlovsk Palace Museum in 1956

The Pavlovsk Palace Museum (956-VIII, 957-VIII)

72. *Malachite Coupe*
Russian (Peterhof Lapidary Works), 1809–10?
Attributed to Andrei Voronikhin
Malachite and bronze; h. 52¼" (134 cm);
diam. of bowl: 41¾" (107 cm)

Provenance: Stroganoff collection, St. Petersburg; transferred to the Hermitage in 1925

This magnificent coupe was without doubt one of the outstanding pieces of the Stroganoff collection. It was allocated a place in the center of one of the stateliest rooms in the palace, the Picture Gallery, and can be seen in a painting of that interior by Nikolai Nikitin dated 1832 (cat. no. 35). Yet the Stroganoff vase remains something of a mystery. Some authors have suggested that the work came from the Peterhof works,[1] while others attributed it to masters working in the Urals.[2] Yet others did not suggest any origin at all.[3] Nor is there any common opinion in the literature regarding the date. The piece has been

dated to the late eighteenth or early nineteenth century (Saltykov), and the beginning of the nineteenth century (Makarov, Voronikhina), while many authors supported the date of 1809 put forward by Ye. M. Yefimova but without any documentary support. Another date has also been suggested of no earlier than 1815.[4] The majority of those who have written on this subject supported Yefimova's inclusion of the coupe with those designed by the architect Andrei Voronikhin. Only V. B. Semionov considered the vase to be an early-nineteenth-century western European work and did not recognize Voronikhin as the author.[5]

There are two analogies for the Stroganoff vase, an extremely rare object. One of these is now in the Malachite Salon of the Grand Trianon at Versailles. Along with a number of other large malachite works, it was a gift from Russian Emperor Alexander I to Napoleon after the conclusion of the Peace of Tilsit (July 1807) and was presented during a diplomatic reception on August 21, 1808. A gilded bronze tripod was ordered for the vase, once in France, executed to a design by Charles Percier and F. H. G. Jacob-Desmalter in the form of chimeras with heads of Herakles.[6]

The second coupe (poorly preserved) is now in the Hermitage reserve collection (E 7559). Of this we know the following: In 1803, through the mediation of Major General Khitrovo, a group of the Three Graces in dark bronze carrying on their heads a porphyry bowl was sent from Paris. Five years later, in 1808, the bowl was replaced with a malachite one that came from "the Russian merchant Sitnev, owner of a shop." At the end of this year the architect Giacomo Quarenghi provided a pedestal.[7] How such a luxurious malachite bowl could have come into the merchant's possession is so far impossible to explain. But all three bowls are of the same diameter.

The archives of the Yekaterinburg Lapidary Works have survived in good condition, but a search has produced no indication that the bowl was produced in the Urals. A very close study of documents from the Peterhof works covering the first decade of the nineteenth century (which have some gaps) does not provide a precise answer regarding the date the vases might have been made. We can only suggest that the Stroganoff bowl was made in 1809–10, because the registers of works produced in 1809 mention five bowls begun October 24, "prepared in mosaic on serpentine in malachite and lapis-lazuli." As is often the case, the documents[8] do not clarify the exact number of malachite and lapis-lazuli vases produced, nor do they provide the dimensions. In the monthly reports for the following year we find mention of only three bowls and are told that "the mosaic work on a malachite bowl is finished and it is being polished."[9]

Malachite was then still rare, and it was only

two decades later that the fashion for malachite objects appeared in Russia, but Count Alexander Stroganoff was certainly in a position to be able to commission such a luxurious work. As to the extremely elegant bronze tripod, which is remarkable both in artistic terms and for its high quality of execution, we unfortunately have no information as to where and when it was made. This piece is very different from the static, heavy, and grandiose objects in the Russian Empire style. It was probably commissioned by Stroganoff from one of the bronze workshops in St. Petersburg, but we cannot entirely exclude the possibility that it is of western European origin. **NM**

1. V. K. Makarov, *Tsvetnoi kamen v sobranii Ermitazha* [Colored Stones in the Hermitage Collection] (Leningrad, 1938), no. 135.

2. K. F. Asayevich, Ye. M. Yefimova, "Kamnereznye izdeliya, sozdannye po proektam A. N. Voronikhina v Ermitazhe" [Carved Stone Objects in the Hermitage, Created to Designs by A. N. Voronikhin], *Samotsvety* [Semiprecious Stones] (Leningrad, 1961), no. 1, p. 76; Ye. M. Yefimova, *Russky reznoi kamen v Ermitazhe* [Russian Carved Stones in the Hermitage] (Leningrad, 1961), p. 19, no. 32; B. V. Pavlovsky, *Dekorativno-prikladnoye iskusstvo promyshlennogo Urala* [Decorative and Applied Art from the Industrial Urals] (Moscow, 1975), p. 103; I. M. Shakinko, V. B. Semionov, *Zavod "Russkiye samotsvety"* [The Russkiye Samotsvety Factory] (Sverdlovsk, 1976), p. 106, fig. 17.

3. A. N. Voronikhina, *Malakhit v sobranii Ermitazha* [Malachite in the Hermitage Collection] (Leningrad, 1963), pp. 16, 17; A. B. Saltykov, "Kamennye vazy" [Stone Vases], *Russkoye dekorativnoye iskusstvo* [Russian Decorative Art] (Moscow, 1963), vol. II, pp. 250, 251; Yu. Ye. Yarovoi, *Tsvetnye glaza zemli* [The Colored Eyes of the Land] (Cheliabinsk, 1984), p. 201.

4. V. B. Semionov, I. M. Shakinko, *Uralskiye samotsvety. Iz istorii kamnereznogo i granilnogo dela na Urale* [Semiprecious Stones from the Urals: From the History of Stone Carving and Grinding in the Urals] (Sverdlovsk, 1982), fig. 10.

5. V. B. Semionov, *Malakhit* [Malachite] (Sverdlovsk, 1987), vol. I, pp. 37–38, fig. 53.

6. Denis Dedoux-Lebard, *Le Grand Trianon: Meubles et objets d'art* (Paris, 1975), vol. I, pp. 106, 109.

7. Inventory of Objects in the Hermitage since 1786, compiled by Ivan Lukin; manuscript in the Hermitage Archive, fund 1, inv. 6K, file 1, f. 119.

8. History Archives, fund 468, inv. 32, file 1168, f. 24v, 25.

9. History Archives, fund 468, inv. 32, file 1169, f. 24v, 25.

The State Hermitage Museum (E 6721)

73. *Egyptian Figure Holding a Granite Coupe*
Russian, 1809
Designed by Andrei Voronikhin
Coupe made at the Peterhof Lapidary Works, 1809
Bronze figure produced at the State Bronze Manufactory of the Imperial Academy of Fine Arts, St. Petersburg
Pink granite, patinated bronze; h. 39¾" (102 cm), diam. 21½" (55 cm)

Provenance: The Hermitage, St. Petersburg; transferred to the History and Art Museum, Novgorod, in 1957; transferred to the Pavlovsk Palace Museum in 1963

The design for this figure is cat. no. 91. **AV**

The Pavlovsk Palace Museum (4102-IV)

FURNITURE

74. *Chest of Drawers*
Russian (St. Petersburg), 1762–65
Palisander, mahogany, ebony, rosewood, walnut, pear wood, Karelian birch, ivory, onyx, bronze, and zinc marquetry; 29⅜ x 34⅜ x 17½" (76 x 88 x 45 cm)

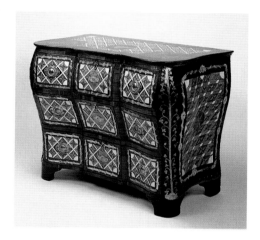

Provenance: Museum of Everyday Life, Leningrad Regional Department of Public Education; transferred to the Hermitage from the Ethnographical Museum, St. Petersburg, in 1941

An identical chest of drawers was published in Sotheby's 1969 catalogue of the sale of the Demidov collection from the Villa San Donato near Florence. The corners of the top surface are decorated with the coats of arms of the province of Siberia and in the top center is the monogram of Catherine II. Like the Demidov chest of drawers, the Hermitage piece originally had feet in the form of rococo volutes turned to the side and bronze plaques applied to the front corners bearing chased coats of arms of Siberia.

A comparison of both chests enables us to identify the work of at least three masters, while the abundance of ivory insets and marquetry ornament can be seen as characteristic of Petersburg furniture in the 1760s and 1770s. We can deduce from this the existence in the capital of a major workshop producing high-quality pieces of furniture; this chest of drawers was probably commissioned by Catherine II. We can with less certainty suggest that both chests were presented to Nikolai Demidov on the occasion of his marriage to Baroness Yelizaveta Stroganoff. Later the couple lived apart, he at San Donato, she in St. Petersburg. The arms of Siberia are of significance both for the Demidov family, which had factories in Siberia, and for the Stroganoffs, who owned extensive lands there. **NYG**

The State Hermitage Museum (ERMb-37)

75. Chandelier
Russian (St. Petersburg), c. 1804
Designed by Andrei Voronikhin
Glass (originally crystal?) and gilt bronze;
h. 91¼" (234 cm); diam. of large ring 37⅜"
(96 cm)

This chandelier in the Great Drawing Room of the Stroganoff Palace shows a certain affinity in form and detail with two chandeliers in the Pavlovsk Palace (the Tapestry Room and the Library of Maria Feodorovna) designed by the same architect. Bronze parts judging by their appearances were produced at the Bronze Manufactory of the Imperial Academy of Fine Arts in St. Petersburg. **SK**

The Stroganoff Palace

76. Door to Paul Stroganoff's Private Apartments
Russian (St. Petersburg), c. 1804
Designed by Andrei Voronikhin
Mahogany and ebony (veneering), bronze;
each leaf: 120⅞" x 33⅛" (310 x 85 cm)

Four doors of this type were produced after Voronikhin's design for two state rooms of the Stroganoff Palace, the Minor and Great Drawing Rooms. Only one of them—the door between these drawing rooms—was decorated on both sides. All four show a close resemblance in composition to the doors designed by Giacomo Quarenghi for the Italian Hall in the Pavlovsk Palace of Empress Maria Feodorovna (and restored by Voronikhin about this time, after the fire of 1803).

The mahogany veneer on the present door relates to other items found in the count's private apartments, such as the fire screens (see cat. no. 25). The bronze fixtures were most likely produced at the Bronze Manufactory of

the Imperial Academy of Fine Arts. The manufactory also made bronze fixtures for Kazan Cathedral, which was then under construction, and continued to function until Stroganoff's death. **SK**

The Stroganoff Palace

77. Settee and Armchair
Russian (St. Petersburg), c. 1807
Designed by Andrei Voronikhin
Embroidered upholstery by the K. Scheibe workshop, St. Petersburg
Birchwood; canvas upholstery: embroidered in silk; settee: 32 x 47⅜ x 21⅞" (82 x 122 x 56 cm); armchair: 32⅜ x 22⅜ x 28⅞" (83 x 58 x 74 cm)

Provenance: Pavlovsk Palace, Pavlovsk

These two pieces made of birchwood painted to imitate mahogany come from a set of twenty-two pieces produced for the Aviary (Volière) Pavilion in the Pavlovsk park. **AA**

The Pavlovsk Palace Museum (403-V, 404-V)

78. Settee, Armchair, and Chair
Russian (St. Petersburg), c. 1805
Designed by Andrei Voronikhin
Mahogany, gilt, paint, cloth upholstery embroidered in silk satin-stitch; settee: 36⅜ x 69⅞ x 21" (94 x 179 x 54 cm); chair: 35⅞ x 18¾ x 19⅛" (92 x 48 x 49 cm); armchair: 35⅞ x 20⅜ x 19⅞" (92 x 53 x 51 cm)

Provenance: State Russian Museum, St. Petersburg; transferred to the Pavlovsk Palace Museum in 1959

The pieces in this set were made of mahogany and then gilded and painted in imitation of antique bronze. **AA**

The Pavlovsk Palace Museum (1083-V, 1085-V, 1086-V)

ARCHITECTURAL AND DESIGN DRAWINGS

FEODOR I. DEMERTSOV
Russian, 1753–1823
79. Cross Section of the Picture Gallery in the Stroganoff Palace, c. 1788
India ink and watercolor on paper; 12⅞ x 17¾" (33 x 45.4 cm); mat: 13¾ x 18⅛" (34.5 x 46.6 cm)
Inscribed (in Russian) with title

Provenance: Alexander Stroganoff collection, St. Petersburg; transferred from the State Russian Museum in 1935

Demertsov, born a serf and later granted the rank of nobleman, married the sister of Alexander Stroganoff's second wife. The architect enjoyed Alexander's early patronage with commissions

for the renovation of the Stroganoff Palace and the construction of a dacha, but the projects were soon taken over by Andrei Voronikhin.

The reconstruction of the Stroganoff Palace, which had been built in the mid-eighteenth century to the designs of Francesco Bartolomeo Rastrelli for Sergei G. Stroganoff, was the first major architectural commission for both Demertsov and Voronikhin, who started as Demertsov's assistant but was later entrusted with the interior designs. The reconstruction of the palace began in 1788 and was for the most part completed in 1793. Although this author attributes the Picture Gallery and Mineral Cabinet to Demertsov, other scholars continue to attribute the design to Voronikhin.

The room chosen for the Picture Gallery was in the new east wing of the palace, whose windows overlooked the state courtyard. Measuring 30 meters long by only 6.5 meters wide, the gallery was divided into three parts; the largest, central part with its gently curved vaulted ceiling, was separated from the symmetrical, lateral parts of the room by two pairs of Ionic columns. The lateral parts were crowned with domes. **VSh**

Research Museum, Academy of Fine Arts (A-19615)

FEODOR DEMERTSOV
Russian, 1753–1823
80. Cross Section of the Mineral Cabinet in the Stroganoff Palace, 1788–93
India ink and watercolor on paper; 12⅞ x 17⅞" (33 x 46 cm)
Inscribed (in Russian) with title

Provenance: Alexander Stroganoff collection, St. Petersburg; transferred from the State Russian Museum in 1935

Like the drawing in cat. no. 79, this sheet was originally part of the five so-called Stroganoff albums in the collection of the Research Museum of the Academy of Fine Arts. The Mineral Cabinet completes the suite of state rooms on the east side of the main section of the palace, and its four windows afford a view of Nevsky Prospect; on the south side it adjoins the Picture Gallery. It housed a collection of minerals and a reference library. Glazed bookcases lined the lower part of the room, while the upper story was used for the display of mineral specimens. **VSh**

Research Museum, Academy of Fine Arts (A-19634)

ANDREI VORONIKHIN
Russian, 1759–1814
81. View of the Château de Gléné, 1787
Pencil, india ink, and watercolor on paper; 8 x 10½" (20.5 x 26.8 cm); mat: 11⅜ x 13⅞" (29 x 35.4 cm)

Inscribed: *Vue du chateau de Gléné dessiné par André Woronikin Peintre Siberien, donnée par Mr le Comte de Stroganoff Seigneur Russe en 1787*

Provenance: Alexander Stroganoff collection, St. Petersburg; transferred from the State Russian Museum in 1954

This view of the Château de Gléné is one of Voronikhin's few surviving early drawings, which once were well represented in the Alexander Stroganoff collection, particularly in travel albums. This drawing, which is tinted with watercolor, was produced during Voronikhin's tour of Switzerland in 1787. It presents an architectural view whose composition is treated in the manner of the then-predominant Neoclassical style. The trees in the right-hand foreground are used as a compositional device similar to a theatrical coulisse. The castle and its stone outbuildings complete the perspective of the middle distance, where a small garden can be seen. The romantic scene is enlivened with human figures and with cows peacefully grazing in the field. Voronikhin describes himself in the signature under the watercolor as "a Siberian painter," although his accomplishments as a painter are not evident in this sheet. The figures are rendered in a somewhat conventional manner, with an emphasis given to the architectural elements. The drawing looks like a pupil's work, and its manner of execution is markedly different from Voronikhin's efforts as a mature artist. **VSh**

Research Museum, Academy of Fine Arts (A-25641)

ANDREI VORONIKHIN
Russian, 1759–1814
82. *The Picture Gallery of Count Alexander Stroganoff,* 1793
India ink, watercolor, and gouache on paper; 16⅜ x 21⅜" (42.5 x 55.5 cm); mat: 20¼ x 24⅞" (52 x 63.8 cm)
Signed, dated, and inscribed (in Russian) in the architect's hand, bottom left: "Drawn from nature by Andrei Voronikhin in 1793"; the margin under the drawing bears an old inscription (in Russian), at left: "The Picture Gallery of His Excellency Count Alexander Sergeievich Stroganoff, Actual Privy Councillor, Arch-Chamberlain, Cavalier of the Orders of Saint Andrew the First-Called, Saint Alexander Nevsky, etc."; at right: *Galerie des Tableaux de S.E. Monsieur le Comte de Stroganoff Concillier privé Act-el G-nd Chambellan de S.M.J. Senateur et Chevalier des Ordres: de Saint André de Saint Alexandre etc.*

Provenance: Alexander Stroganoff collection, Maryino and St. Petersburg; transferred to the Hermitage in 1929

The Picture Gallery in the Stroganoff Palace was built in the early 1790s, evidently to the design of Andrei Voronikhin, the author of this watercolor. According to another opinion, the gallery may have been designed by Feodor Demertsov. The room is divided into three parts: the central room, which is covered with a coffered vault, and two others separated from the main section by pylons and columns.

The main purpose of the artist here was to create a visual record of the paintings kept in the gallery. At the time when the watercolor was produced, the collection comprised eighty-seven canvases by western European artists. The pictures were hung not only in the main hall, but also in adjoining rooms. The arrangement was quite dense, in three tiers, with the pictures hung symmetrically. Skilled in miniature painting, Voronikhin has made the pictures easily recognizable. The first canvas in the lower tier is *Girl with a Parrot* by Caspar Netscher. Above, to the left of the pylon, is Andrea del Sarto's tondo of the *Virgin and the Child Christ with Saint Elizabeth and Saint Joseph.* To the left of the pylon, in the middle tier, is the oval canvas *The Slaughter of the Innocents* by Francesco Solimena. Below it is *The Camp* by Jan Miel. On the other side of the pylon, placed symmetrically, must be the *Travelers at Rest,* also by Miel (although it is hardly visible on the drawing). Above it, in the upper tier, is *A Sage* by Johann Carl Loth, and Loth's *Bacchus* can be seen, symmetrically placed, in the distant upper corner. In the middle tier, below Loth's paintings, are two still lifes by Rachel Ruysch. Farther on, one can discern two small-scale paintings by Caspar Netscher, *Young Man in a Turban* and *Young Man with a Cage.* In the center of the main hall's wall hangs *The Adoration of the Magi* by Gerard de Lairesse, and on its left, Anthony van Dyck's *Portrait of Nicolaas Rockox* (cat. no. 122). On the right, in a symmetrical position, is *Young Woman with Her Child,* also by Van Dyck, erroneously identified in Stroganoff's time as *Princess of Orans with Her Son.* Farther right, in the upper tier, is *Portrait of Rubens and His Son Albert* by a painter of Rubens's school, then considered to be an authentic work by Rubens (cat. no. 121). In the middle tier is *The Repentant Magdalene* by Guido Reni and, symmetrically placed, also in an oval, *Saint Michael.* In the center of the bottom tier is a landscape by Jan Asselyn; on its left, *Jeremiah Lamenting over the Destruction of Jerusalem* by Rembrandt van Rijn (now in the Rijksmuseum, Amsterdam) and *A Halt* by Adriaen van de Velde (cat. no. 128). To the right of the center is *Landscape with a Colonnade and Tomb* by Jan Weenix. On the back wall, to the left of the doorway, hangs *Allegorical Composition* by Luca Giordano (above) and *Rural Life* by Domenico Fetti (now in the Art Museum, Tula). To the right of the doorway is *Allegory of the Arts* by Bernardo Strozzi (cat. no. 152). In front of the doorway stands a statue of Cupid by Étienne-Maurice Falconet (Hermitage 1856).

The gallery was illuminated by chandeliers of English workmanship and candelabra. On the console tables, made in France in the 1770s, many objets d'art of colored stone and bronze can be discerned. Along the wall stand two long settees and several armchairs upholstered in green silk (now in the Russian Museum). Also worthy of note is an elaborate ceramic stove in the right-hand part of the drawing.

The interior is enlivened with the figures of real people, identified in a note (in Russian) of a later date attached to the back of the passe-partout: "A description of the people depicted in the drawing representing the Picture Gallery of Count Alexander S. Stroganoff." The count is sitting at the table and reading a book, with his dog named Bochka (Barrel) by his feet. Across from him, near the column, stands his valet Afanasy Yurganov, and behind him are Alexei Murakhin, the former tutor of Count Alexander Stroganoff, and the butler Ivan Taskayev, a bearded man in a Russian caftan. Close to them, at the bureau, sits Andrei Voronikhin himself, and farther on are the following persons: Count Paul A. Stroganoff examining a picture through a lorgnette; Nikolai Novosiltsov; Countess Sophia A. Stroganoff and her governess Mademoiselle Boite; opposite them, on the other side of the gallery, stand Andrei Kalashnikov, a butler, and Bruyev, a valet of Count Alexander Stroganoff. **MK**

The State Hermitage Museum (41913)

ANDREI VORONIKHIN
Russian, 1759–1814
83. *View of the State Dining Room of the Stroganoff Palace in St. Petersburg,* 1793
Watercolor on paper; 7¾ x 10⅛" (19.9 x 26.1 cm)
Signed, bottom left, on passe-partout: Andrei Voronikhin
Bottom right, inscription (in Russian): "For Her Excellency, my gracious lady, / Countess Sophia Vladimirovna Stroganoff / née Princess Golitsina"

Provenance: Transferred from the Stroganoff Palace, St. Petersburg, to the State Russian Museum in 1930

The painting is Voronikhin's presentation design for the interior of the State Dining Room, also known as the Corner Hall, of the Stroganoff Palace. **OKa**

The State Russian Museum (P 23650)

ANDREI VORONIKHIN
Russian, 1759–1814
84. *Design for the Decoration of a Room in the Stroganoff Palace,* 1788–93
India ink and watercolor on paper; 10⅜ x 17¾" (27.3 x 45.6 cm); mat: 16 x 22½" (41 x 57.8 cm)

Provenance: Alexander Stroganoff collection, St. Petersburg,; transferred from the State Russian Museum in 1935

This sheet, which comes from one of the Stroganoff albums and is executed in a sketchy manner, testifies to Voronikhin's mastery as an architect and draftsman already at the early stage of his work in St. Petersburg. Most probably this design was intended for a room in the south wing of the palace, which had been allotted to Paul Stroganoff after his marriage. **VSh**

Research Museum, Academy of Fine Arts (A-20531)

ANDREI VORONIKHIN
Russian, 1759–1814
85. *An Ancient Sarcophagus in the Garden of the Stroganoff Dacha,* not before 1793
India ink on paper; 9¾ x 14⅜" (25 x 37 cm)

Provenance: Transferred from the Stroganoff Palace, St. Petersburg, to the State Russian Museum in 1930

The marble sarcophagus (third century B.C.) with bas-reliefs on subjects from the life of Achilles was set on the bank of the Round Pond in the garden of the Stroganoff dacha on Chernaya Rechka. This drawing represents the architect's suggestion for the placement of the sarcophagus. **OKa**

The State Russian Museum (P 9717)

ANDREI VORONIKHIN
Russian, 1759–1814
86. *Design for a Canopied Bed*
India ink on paper; 10½ x 7¾" (27 x 20 cm), mat: 12 x 15¾" (30.8 x 40.3 cm)

Provenance: Alexander Stroganoff collection, St. Petersburg; transferred from the State Russian Museum in 1935

This sheet, once also in one of the Stroganoff albums, demonstrates a rare situation in which Voronikhin has turned to the exotic chinoiserie style, with its indispensable dragons and fantastic birds. The design may have been intended for the Stroganoff Palace, but it was evidently not realized. Alexander Stroganoff included it in his album as an example of superb draftsmanship. **VSh**

Research Museum, Academy of Fine Arts (A-19674)

ANDREI VORONIKHIN
Russian, 1759–1814
87. *Design for a Decorative Bowl*
India ink on paper; 11 x 14⅝" (28 x 37.4 cm), mat:11¾ x 15⅞" (30 x 40.8 cm)

Provenance: Alexander Stroganoff collection, St. Petersburg; transferred from the State Russian Museum in 1935

This sheet was originally in one of the Stroganoff albums. Similar designs of objects for applied art can be found in various museum collections.

Voronikhin conceived the bowl and stand of this decorative piece to be made in stone, while the figures of two tritons supporting it were to be cast in bronze. The project was realized, but the proportions of the bowl were somewhat altered in the process of manufacture. The tritons were cast in ormolu; the stand was made of quartz and the bowl of gray-green jasper. **VSh**

Research Museum, Academy of Fine Arts (A-19636)

ANDREI VORONIKHIN
Russian, 1759–1814
88. *Sketch of a Herm for the Italian Hall of Pavlovsk Palace,* c. 1803
India ink on paper; 7 x 9⅛" (18 x 23.5 cm)

Provenance: The Shchusev Museum of Architecture, Moscow; transferred to the Pavlovsk Palace Museum in 1966

The Pavlovsk Palace Museum (3208-XII)

ANDREI VORONIKHIN
Russian, 1759–1814
89. *Design for the Upper Vestibule of Pavlovsk Palace,* c. 1803
India ink and watercolor on paper; 23⅛ x 16¾" (59.3 x 42.8 cm)

Provenance: Collection of History Documents of the Pavlovsk Palace

The Pavlovsk Palace Museum (23)

ANDREI VORONIKHIN
Russian, 1759–1814
90. *Design for a Bridge Across the Slavyanka River in Pavlovsk,* c. 1803
India ink on paper; 11⅝ x 18⅜" (29.8 x 47 cm)

Provenance: Alexander Stroganoff collection, St. Petersburg; transferred from the State Russian Museum in 1936

From 1803 on Voronikhin was in charge of an architectural project at Pavlovsk, a suburban summer residence of the Dowager Empress Maria Feodorovna (the wife of Paul I, who had been assassinated in 1801). In addition to his work on the decoration of the palace, Voronikhin designed all sorts of structures for the Pavlovsk park, including a bridge across the Slavyanka. To attain better proportions and the outline of a single-span bridge, Voronikhin added another, smaller span, which he decorated with an impressive keystone. **VSh**

Research Museum, Academy of Fine Arts (A-801)

ANDREI VORONIKHIN
Russian, 1759–1814
91. *Design for an Egyptian Figure Holding a Coupe,* c. 1809
India ink on paper; 9⅛ x 7⅞" (23.5 x 20 cm)

Provenance: The Shchusev Museum of Architecture, Moscow; transferred to the Pavlovsk Palace Museum in 1966 **NS**

The Pavlovsk Palace Museum (3209-XII)

ANDREI VORONIKHIN
Russian, 1759–1814
92. *Design for a Single-Span Wooden Bridge*
India ink and watercolor on paper; 13¼ x 19⅞" (34 x 51 cm)

Provenance: Alexander Stroganoff collection, St. Petersburg; transferred from the State Russian Museum in 1936

This is an interesting design for a simple, light, single-arched wooden bridge supported on piles, most probably for spanning a ravine. This bridge might have been designed for the park of Count Alexander Stroganoff's suburban villa, but neither the park nor the villa is extant. **VSh**

Research Museum, Academy of Fine Arts (A-900)

ANDREI VORONIKHIN
Russian, 1759–1814
93. *Design for a Single-Span Bridge in the Style of Louis XVI*
India ink and watercolor on paper; 13⅝ x 19¾" (34.8 x 50.7 cm)

Provenance: Alexander Stroganoff collection, St. Petersburg; transferred from the State Russian Museum in 1936

This single-arched bridge may also have been designed for Count Stroganoff's villa. It was to link an island in a man-made pond with the bank. **VSh**

Research Museum, Academy of Fine Arts (A-901)

ANDREI VORONIKHIN
Russian, 1759–1814
94. *Design of a Single-Span Suspension Bridge*
India ink and watercolor on paper; 10⅜ x 16⅛" (26.5 x 41.5 cm)

Provenance: Alexander Stroganoff collection, St. Petersburg; transferred from the State Russian Museum in 1936

This sheet features Voronikhin's original design for a suspended single-span bridge with arc-shaped girders anchored by cantilevers. The bridge floor is suspended on wire cables attached to the girders. **VSh**

Research Museum, Academy of Fine Arts (A-902)

ANDREI VORONIKHIN
Russian, 1759–1814
95. *Preliminary Drawings for the Design of Kazan Cathedral,* c. 1801

Graphite and india ink on paper; 12¾ x 19" (32.8 x 48.8 cm)

Provenance: Alexander Stroganoff collection, St. Petersburg; transferred from the State Russian Museum in 1934

A design competition for the cathedral attracted outstanding foreign architects active in Russia, including the Scot Charles Cameron (1743–1812), the Italian Pietro Gonzaga (1757–1831), and the Frenchman Jean-François Thomas de Thomon (1760–1813). Nevertheless, Andrei Voronikhin, then a little-known Russian architect, won the competition. The construction of the cathedral began in 1801 and lasted a decade.

This sheet of preliminary drawings illustrates the architect's approach to designing the cathedral that was to become his lifework. In keeping with Russian tradition, Voronikhin conceived a five-domed church, but eventually he abandoned this idea, probably because the five-domed scheme could not be harmoniously combined with the Latin-cross ground plan that Emperor Paul I insisted upon because he wanted Kazan Cathedral to resemble Saint Peter's in Rome. **VSh**

Research Museum, Academy of Fine Arts (A-884)

ANDREI VORONIKHIN
Russian, 1759–1814
96. *Design for the Kazan Cathedral, West Facade*, 1810
India ink and watercolor on paper; 24½ x 39" (63 x 100 cm)
Signed, bottom right (in Russian): "Architect Voronikhin"; dated and inscribed in the architect's hand (in Russian), bottom center: "The Church of Our Lady of Kazan. From the west. 1810"

Provenance: The Hermitage as of 1811, St. Petersburg

The design of Kazan Cathedral by Andrei Voronikhin was approved by Emperor Paul I on November 14, 1800. Inspired by St. Peter's in Rome, the architect boldly solved the problem of constructing a large-scale cathedral among the already existing buildings in the center of St. Petersburg. The chancel faces the Yekaterininsky (now Griboyedov) Canal, while the main facade with a semicircular double colonnade opens toward Nevsky Prospect, the city's main thoroughfare. The architect conceived a similar arc-shaped symmetrical colonnade on the other, south side of the building, but this part of the project was not realized. After numerous corrections in the working drawings Voronikhin found a successful correlation of all the volumes of the structure, joining it with the colonnade. His design displayed in the present exhibition (one of seven sheets) shows the final phase of the project.

The construction of the cathedral and its painted and sculptural decoration were carried out exclusively by Russian master craftsmen and by local artists, graduates of the Imperial Academy of Fine Arts, trained during the presidency of Count Alexander S. Stroganoff. As the head of the Committee for the Construction of the Cathedral, the count undoubtedly supported Voronikhin in his efforts, and for both of them the construction of the Kazan Cathedral became a lifetime work.

The cathedral was consecrated on September 15, 1811. After catching a cold on that day, Count Alexander Stroganoff died two weeks later, on September 27. The decoration of the cathedral continued until 1814. **MK**

The State Hermitage Museum (9252)

ANDREI VORONIKHIN
Russian, 1759–1814
97. *Design for a Fireproof Ceiling*, 1812
India ink and watercolor on paper; 18⅝ x 24⅝" (47.6 x 62.5 cm)
Signed in monogram and dated lower right; inscribed below (in Russian): "Plan of a fireproof ceiling invented to replace masonry vaults"

Provenance: Alexander Stroganoff collection, St. Petersburg; transferred from the State Russian Museum in 1936

This is an ingenious design for a prefabricated fireproof metal ceiling with a thin layer of brick. Voronikhin proposed using such light ceilings instead of heavy brick vaults in order to lessen the load on the supporting walls and to effect savings in building materials. The design shows the sequence of operations necessary to assemble such a ceiling, evidently a simple procedure that did not require highly skilled labor. Voronikhin had already employed metal in his architectural designs. He was one of the first in Russia to use a metal structure for the outer shell of the dome of the Kazan Cathedral. **VSh**

Research Museum, Academy of Fine Arts (A-824)

ANDREI VORONIKHIN
Russian, 1759–1814
98. *Design for a Memorial Column Made of Captured French Guns*, 1812
Graphite, india ink, and watercolor on paper; 25⅜ x 11⅛" (65 x 28.5 cm)

Provenance: Alexander Stroganoff collection, St. Petersburg; transferred from the State Russian Museum in 1935

This is one of Voronikhin's last projects planned to commemorate the triumph of the Russian army in the 1812–14 campaign against Napoleon Bonaparte. The architect worked out a whole series of different versions of the memorial. The present memorial in the shape of a pillar of vic-

tory modeled on Trajan's Column in Rome is perhaps the best. **VSh**

Research Museum, Academy of Fine Arts (A-826)

JEAN BALTHASAR DE LA TRAVERS
Russian, active 1780s and 1790s
99. *View of Count Alexander Stroganoff's Dacha from the Garden*, 1790
Watercolor and ink on paper; 14⅜ x 24" (36.4 x 61.7 cm)
Inscription on passe-partout, top middle (in Russian): "2nd view of the suburban house/ of Count Stroganoff/ from the garden"; bottom middle: *II.de Vue de la Maison de Campagne/ du C.te Stroganoff du côté du Jardin*

Provenance: Transferred from the Stroganoff Palace, St. Petersburg, to the State Russian Museum in 1930

Jean Balthasar de la Travers was a watercolorist, draftsman, and landscape artist who was commissioned by Count Alexander Stroganoff in 1783–97 to produce views of St. Petersburg and its environs, as well as of Moscow and other Russian towns and cities. These watercolors were part of an album entitled *A Painter Traveling Through Russia*, in which this picture was once included. It shows the Stroganoffs' house on the Chernaya Rechka designed by Antonio Rinaldi and built in 1754. **OKa**

The State Russian Museum (9720)

YERMOLAI IVANOVICH YESAKOV
Russian, 1790–1840
100. *The Stroganoff Residence in Solvychegodsk*, first quarter 19th century
Watercolor and pen and ink on paper; 10¾ x 15½" (27.5 x 39.7 cm)
Signed with the artist's monogram, bottom left. Pasted to the passe-partout frame was a label (now removed) bearing the ink legend (in Russian): "In the town of Solvychegodsk the wooden house of Messrs Stroganoff built / and stood in perfect order until 1798 and in this year dismantled / thirty-four *sazhens* [72.4 m], and a height of twenty-one *sazhens* [44.7 m] and one *arshin* [71 cm]."

Provenance: Acquired from Y. A. Savelyeva, St. Petersburg, in 1979

Yesakov was a watercolorist and landscape painter who studied at the Academy of Fine Arts from 1799 to 1809; he was given the title of academician in 1811. He was personal artist to the Stroganoffs from 1810 to 1824; from 1824 he taught literature at the Court Kapella (an establishment training singers for the court).

Nikolai Ustrialov's book *Imenitye liudi Stroganovy* (The Illustrious Stroganoff Men), published in 1842, contains an engraving by Ivan Chesky entitled *A View of the Old House of the*

Stroganoffs in Solvychegodsk, which may have been based on Yesakov's watercolor. **OKa**

The State Russian Museum (P 57039)

JULES MAYBLUM
Active in St. Petersburg 1860s
101. *The Mansion of Count Paul S. Stroganoff in St. Petersburg, Facade,* 1863–65
India ink and watercolor on paper; 19⅞ x 26½"
(51 x 68 cm)
Signed, bottom right: *Jules Mayblum*

Provenance: Stroganoff collection, St. Petersburg; transferred from the Hermitage Central Library in 1932

Count Paul Stroganoff's residence was built at the intersection of Sergievskaya and Mokhovaya Streets in 1857–59 to the design of Hippolito Monighetti (1819–1878), a well-known Italian architect active in St. Petersburg. Reflecting an eclectic trend in design, Monighetti created an imposing, well-proportioned two-story mansion, which included a number of auxiliary structures in addition to the main building. Two stories were later added to the edifice, which markedly altered its appearance. After the work was completed, Count Stroganoff employed the watercolorist Jules Mayblum to make a detailed pictorial record of the newly finished mansion. This is a view of the front of the structure overlooking Sergievskaya Street. The human figures give us an idea of the building's scale and introduce a genre element into these architectural watercolors.

Unfortunately, nothing is known about Mayblum's life and work except for the fact that in 1861 he was a student at the Academy of Fine Arts in St. Petersburg. The result of Mayblum's work was an album produced in 1863–65, which contained seventeen representations of the fronts and interiors of the building. The red leather binding has a Russian inscription stamped in gold: "St. Petersburg, 11 Sergievskaya St." **MK**

The State Hermitage Museum (41826)

JULES MAYBLUM
Active in St. Petersburg 1860s
102. *The Mansion of Count Paul S. Stroganoff in St. Petersburg, Facade and Section,* 1863–65
India ink and watercolor on paper; 19⅞ x 26½"
(51 x 68 cm)
Signed, bottom right: *Jules Mayblum*

Provenance: Stroganoff collection, St. Petersburg; transferred from the Hermitage Central Library in 1932

The drawing affords an opportunity to see interiors of the mansion built for Count Paul Stroganoff at 11 Sergievskaya Street: the state staircase, the boudoir, and the bedroom, with their typically nineteenth-century decor. Moreover, the drawing also provides a glimpse of the

stable and other auxiliary structures inside the mansion's complex. **MK**

The State Hermitage Museum (41828)

JULES MAYBLUM
Active in St. Petersburg 1860s
103. *The Green Drawing Room in the Mansion of Count Paul S. Stroganoff,* 1863–65
Watercolor, heightened with white, on paper; 21½ x 15⅜" (55.3 x 40.5 cm) on album page 26½ x 19⅞" (68 x 51 cm)
Signed, right: *Jules Mayblum*

Provenance: Stroganoff collection, St. Petersburg; transferred from the Hermitage Central Library in 1932

This state drawing room in the Louis XIV Revival style, marked by a somewhat ponderous if luxurious decor, is located on the first floor of Count Paul Stroganoff's mansion at 11 Sergievskaya Street, its four windows overlooking Mokhovaya Street. The abundance of gilded ornamentation on the ceiling, cornice, heavy ebony doors, and fireplace, in combination with the green upholstery and the greenish carpet, create the effect of highly saturated color. The furnishings, also gilded, are freely grouped in a fashion typical of the mid-nineteenth century. The interior includes some rare and attractive works of art; of particular note is the white marble head of a faun (Hermitage 512), which is set in the center of the back wall to the left of the door. The sculpture was traditionally attributed to Michelangelo, but it is now recognized as a work by Baccio Bandinelli. On the left wall are two large portraits (Hermitage 4123, 4124) painted not by Holbein, as the owner of the mansion believed, but by Nicolas Neuchâtel. On the back wall to the right a genre composition by Teniers can be seen, and on the left side are works by western European masters of the nineteenth century. It should be noted that Watteau's masterpiece, *La Boudeuse* (cat. no. 133), also decorated this drawing room, but we cannot see it because the artist did not represent the wall on which it hung.

The drawing room is decorated with various Chinese vases and a large fishbowl. Paul Stroganoff is known to have purchased a representative collection of Chinese decorations from M. Montigny, the French ambassador to China. **MK**

The State Hermitage Museum (41833)

JULES MAYBLUM
Active in St. Petersburg 1860s
104. *The Boudoir in the Mansion of Count Paul S. Stroganoff,* 1863–65
Watercolor on paper 23⅜ x 16¼" (59.8 x 41.5 cm) on album paper 26½ x 19⅞" (68 x 51 cm)
Signed, bottom right: *Jules Mayblum*

Provenance: Stroganoff collection, St. Petersburg; transferred from the Hermitage Central Library in 1932

A door from the green Drawing Room in the Stroganoff mansion on Sergievskaya Street led to the boudoir decorated in the Rococo Revival style. Here the pink-and-blue color scheme predominates. The pattern of the upholstery and draperies is echoed in the ceiling decoration, the porcelain chandeliers, and the frame of the mirror over the fireplace. French eighteenth-century marquetry pieces are mixed in with white-painted modern furniture, and every table is loaded with porcelains and objets d'art. Two Sèvres vases adorn the fireplace mantel. The room is enlivened by plants, which were used in great numbers to decorate the living quarters of urban houses in the nineteenth century. The walls of the boudoir are hung with a great number of small-scale paintings by nineteenth-century western European artists. **MK**

The State Hermitage Museum (41838)

JULES MAYBLUM
Active in St. Petersburg 1860s
105. *The Library in the Mansion of Count Paul S. Stroganoff,* 1863–65
Watercolor, heightened with white, on paper; 16¼ x 23⅜" (41.5 x 59.8 cm) on album paper 19⅞ x 26½" (51 x 68 cm)
Signed, bottom right: *Jules Mayblum*

Provenance: Stroganoff collection, St. Petersburg; transferred from the Hermitage Central Library in 1932

The Library was located on the ground floor of the mansion. Paul Stroganoff assembled a fine library on art, including a collection of sale catalogues. At the end of his life he bequeathed his library to the Imperial Society for the Encouragement of the Arts in St. Petersburg.

In the center stands a table piled high with prints and albums. On the bookcases in the left half of the Library are seventeenth-century German stoneware pieces, and to their right is a bowl on a stand made in China in the late eighteenth century, as well as nineteenth-century Chinese vases, which also adorn the bookcases on the left side. In the right half of the Library are Greek black-figure vessels. Ceramic articles are interspersed with small sculptural pieces. At the left part stands the bronze figure of Pope Clement XI ascribed to Angelo de Rossi (now in the Picture Gallery, Tambov). The fireplace is decorated on either side with terra-cotta figurines, possibly by Clodion. The most remarkable feature of the interior is the collection of paintings, which are, unfortunately, difficult to identify. In the right corner is a large painting, *The Descent from the Cross* by Charles Lebrun (now in the Art Museum, Alma-Ata, Kazakhstan); to its right

hangs *An Old Man* by Luca Giordano; in the center of the wall at the right is a triptych by Sebastiano del Piombo; and farther to the right is *The Virgin and Child* by Giampetrino (Giovanni Pietro Rizzi). **MK**

The State Hermitage Museum (41836)

PRINTS

MICHEL-FRANÇOIS DANAM-DEMARTRE
French, 1763–1827
106. *View of Nevsky Prospect,* early
19th century
Colored aquatint; 20¼ x 26¾" (51.8 x 68.5 cm)

Provenance: Transferred from the Alexei S. Suvorin collection to the State Russian Museum in the late 1920s

This depicts Nevsky Prospect from the Green (Police) Bridge looking toward the Anichkov Palace. The facade of the Stroganoff Palace is visible at the right. Farther back, beyond the line of private houses, rises the spire of the Church of the Icon of Our Lady of Kazan, which was built in 1733–37 by the Russian architect Mikhail Zemtsov, one of the first builders of St. Petersburg. This is a unique image, as the church was later torn down and on the same site, at the beginning of the nineteenth century, Andrei Voronikhin built Kazan Cathedral. At that same time the adjacent houses were demolished and the open area surrounding the cathedral was laid out in their place. This engraving is a rare and interesting view of the city, unusual for the late eighteenth century. The main thoroughfare of the capital of the Russian Empire—Nevsky Prospect—broad, perfectly straight, and neatly paved, is shown in the morning hours, when it is relatively empty. The life of the city proceeds along the road smoothly and unhurriedly. The artist seems to have been primarily attracted not to the elegant palaces and magnificent churches but to the ordinary, everyday existence of the citizens. Even the magnificent Stroganoff Palace is moved off to the right in the engraving. Its rich architectural decoration is barely indicated, so that the creation of the architect Francesco Bartolomeo Rastrelli appears far more modest than it is in reality. **NSh**

The State Russian Museum (31524)

107. *Sadovnikov's Panorama*
Russian (Ivanov Lithographers, St. Petersburg), 1830–35
Lithographs after watercolors by Vasily Sadovnikov

Provenance: Transferred from the Y. G. Schwartz collection to the State Russian Museum in 1928

"The Panorama of Nevsky Prospect: Under this title Mr. Prevaux [commissioner of the Imperial Society for the Encouragement of the Arts and custodian of its permanent exhibition] is publishing a series of lithographic pictures presenting the churches, houses, and many other architectural monuments located on Nevsky Prospect on the stretch from the Anichkov Palace to the Admiralty" (*Literaturnaya gazeta*, 1830).

The four parts included in the present exhibition belonged to the first section of the panorama, which was entitled "The Right, Shady Side of Nevsky Prospect." The work is known in the history of Russian printed graphic art as Sadovnikov's Panorama, after the artist who produced the set of watercolors on which it was based. The panorama was lithographed by two men, both with the surname Ivanov, between 1830 and 1835.

This unique composition was offered to the public as thirty lithographs that had been pasted together to form a fifteen-meter strip depicting the two sides of a single street. The grandiose artistic conception made a profound impact at the time. Sadovnikov's Panorama became an ingenious expression of the very idea of Nevsky Prospect as an urban phenomenon.

No. 1. The Right Side of Nevsky Prospect Showing the Stretch between the Municipal Duma and Kazan Cathedral, 1835
Lithograph; 11⅜ x 24⅜" (29 x 62.7 cm)

No. 2. The Right Side of Nevsky Prospect Showing the Stretch between Kazan Cathedral and the River Moika, 1835
Lithograph; 8⅝ x 24⅜" (22 x 62.7 cm)

No. 3. The Right Side of Nevsky Prospect. The House of Countess Stroganoff, 1835
Lithograph; 8⅝ x 24⅜" (22 x 62.7 cm)

No. 4. The Right Side of Nevsky Prospect. The Police Bridge, 1835
Lithograph; 8⅝ x 24½" (22.1 x 63 cm)

The right half of this lithograph shows the palace built for Sergei Stroganoff, a nobleman of Empress Elizabeth's reign, by Francesco Bartolomeo Rastrelli between 1752 and 1754 (now 17 Nevsky Prospect).

In contrast to other mansions of that time, the Stroganoff Palace is one of the first urban palaces constructed in line with the neighboring buildings. The design of its facades still retains the picturesque decorativeness of the Baroque style. The facade overlooking Nevsky Prospect is most effective. The architect marked out the second story where the state rooms are located with larger windows surrounded by more elegant architraves. The arch that served as a carriage entrance is flanked by paired columns. The whimsically designed iron grilles below the first-story windows further enhance the appearance of the building. The family coat of arms in the pediment, the proud profiles, and the lion masks all speak of the nobility and power of the owners of the palace. In the late eighteenth century

the main courtyard was reconstructed by the architect Voronikhin, who replaced the single-story wings and the walls decorated with columns with new blocks. He also reconstructed the interiors of the state rooms, including the Picture Gallery, which is well known from Voronikhin's watercolor. **NSh**

The State Russian Museum (12140, 12141, 12142, 12143)

JEAN JACOTTET REGAMI
French, b. 1806
108. *The Police Bridge,* 1840s
Lithograph after a drawing by Iosif Charlemagne (1824–1870) and Duruy
Color lithograph; 16¼ x 18⅛" (41.7 x 46.6 cm)

Provenance: Transferred from the Fabergé collection to the State Russian Museum in 1928

This view from a series entitled Views of St. Petersburg, published by Daziaro, shows Nevsky Prospect, with the Police Bridge that ran from the Stroganoff Palace toward the Admiralty and embraces the Stroganoff Palace, part of the Dutch Church building, Chicherin's house, and Kotomin's house. **NSh**

The State Russian Museum (20512)

BOOKS

109. *Irmologion (songbook) of Kriuks,* late 16th–early 17th century
Pen and ink on paper, with a stamped leather binding; 9 x 7⅛" (23.3 x 18.3 cm)

Provenance: Feodor Kalikin, St. Petersburg, until 1946

An irmologion is a collection of liturgical songs for the entire year and set for eight voices. The

manuscript, which was created in the Stroganoffs' scriptorium, is decorated with numerous illuminations, initials, and ten frontispieces, as well as ornaments and compositions in what is known as the "old printed" style. **TV**

The State Russian Museum (DR/GR 19)

110. J. J. Rive: *Histoire critique de la piramide de Cajus Cestius,* vol. 3
Paris, 1787
19½ x 12⅞" (50 x 33 cm)

Provenance: Stroganoff collection, St. Petersburg

Six of this double set of twelve prints are tinted by hand. The blue leather binding of the late eighteenth or early nineteenth century is gold-tooled and bears the super ex libris of the Counts Stroganoff on its front cover. On the flyleaf is the bookplate of the Imperial Hermitage Foreign Language Library. **IG**

The State Hermitage Museum (25882)

111. J. Ch. Poncelin: *Chef-d'oeuvres de l'antiquité*
Paris, 1784
Green leather binding, gold-tooled spine; 15⅜ x 7⅞" (40 x 26 cm)

Provenance: Stroganoff collection, St. Petersburg

The flyleaf bears two bookplates stating the ownership of Grigory A. Stroganoff, one with a baronial crown above a shield and the other with a count's crown. In 1826, when Baron Grigory A. Stroganoff was awarded the title of count, a new bookplate, bearing a count's crown, was pasted over the earlier one. The earlier bookplate was uncovered at the Graphics Restoration Laboratory of the Hermitage in 1998. **IG**

The State Hermitage Museum (88698)

112. M. Ilyinsky: *Opyt istoricheskogo opisaniya o nachale goroda Moskvy* (An Attempt to Present a Historical Description of the Beginnings of the City of Moscow)
Moscow, 1795
98 pp., 7⅜ x 4½" (19 x 11.5 cm)

Provenance: Stroganoff collection, St. Petersburg

On the front and back covers of the brown leather binding is the Stroganoff arms gold-tooled with a legend in Russian: "Book Deposit[ory] of Count Stroganoff." **IG**

The State Hermitage Museum (39763)

113. *Collection d'Estampes d'après quelques tableaux de la galerie du comte A. de Stroganoff*
St. Petersburg, 1807
158 pp., 16⅜ x 12½" (42 x 32 cm)

Provenance: Stroganoff collection, St. Petersburg

This collection of seventy-five prints executed by students of the Imperial Academy of Fine Arts after paintings and objets d'art in the art galleries of Count Alexander Stroganoff is bound in cardboard with a gold-tooled leather spine. The flyleaf in the front of the book bears the bookplate of the Picture Department Library of the Imperial Hermitage. It is preceded by a pasted-in page with the engraved portrait of Count Alexander Stroganoff by Ignace Sebastian Klauber. **IG**

The State Hermitage Museum (14592)

114. A. Tsarsky: *Istorichesky vzgliad na razvitiye knigopechataniya v Rossii* (A Historical Survey of Book Printing in Russia)
Moscow, 1846
Green silk binding; 24 pp., 6¼ x 4⅜" (16 x 11 cm)

Provenance: Stroganoff collection, St. Petersburg

The pasted half of the endpaper bears the lithographic ex libris of Count Sergei G. Stroganoff. On the flyleaf is a presentation inscription in Russian by the book's author: "To His Excellency Count Sergei Grigorievich Stroganoff, an ardent lover of enlightenment and patron of the sciences and arts, with reverence dedicates this book [to] the honorary inspector of the [town of] Ruza district school A. Tsarsky. Moscow. 1846. April 17." **IG**

The State Hermitage Museum (39381)

115. *Manuscript*
Russian, 19th century
9½ x 7⅞" (24.5 x 20 cm)

Provenance: Stroganoff collection, St. Petersburg

This manuscript by an unknown author describes a late-antique silver dish in the collection of Alexander Stroganoff (cat. no. 193) depicting a scene in which Ajax quarrels with Odysseus about Achilles' armor. The dedication to Count Alexander following the title page indicates that the work dates before his death in 1811, a date further supported by the Empire style of the green leather and gold-tooled binding. A number of books from the Stroganoff collection have similar bindings, which suggests that they may have been made in a Stroganoff workshop. **IG**

The State Hermitage Museum (39581)

116. *Photograph Album: The Art Gallery of Count Sergei Stroganoff, April 1897*
St. Petersburg, 1897
8⅞ x 12½" (23 x 32 cm)

Provenance: Empress Alexandra Feodorovna, St. Petersburg

This album, manufactured at the Scamoni shop in St. Petersburg, contains six black-and-white photographs of the public exhibition of art from the collections of the Stroganoffs and other noble families, held in the Stroganoff Palace in

honor of the coronation of Nicholas and Alexandra. The photographs were taken by Major-General Alexander Nasvetevich. The ex-libris on the endpaper indicates that this was a personal souvenir of the young empress. **IG**

The State Hermitage Museum (135905/1–6)

ARCHIVES

117. *Charter of Tsar Ivan the Terrible,* January 2, 1564
Paper, seal of red wax; 30⅜ x 14" (78.5 x 36 cm)

This charter, one of the few dating from the reign of Ivan the Terrible to have reached us in fairly good condition, grants Grigory Anikiev Stroganoff permission to construct and fortify a settlement on the Kama River, as well as legal and financial privileges.

The Russian State History Archives (fund 1411, inv. 1, no. 50)

118. *Charter of Tsar Mikhail Feodorovich,* July 30, 1614
Paper, seal of red wax; 22⅞ x 16⅜" (58.5 x 42 cm)

This charter granted to Maxim Yakolevich Stroganoff confirms his title to the inherited estate on the Chusovaya and Yanka Rivers.

The Russian State History Archives (fund 1411, inv. 1, no. 52)

119. *Charter of the Tsars Ivan Alexeievich and Peter Alexeievich [Peter the Great] to Grigory D. Stroganoff,* July 25, 1692

Parchment lined with taffeta and brocade, with seals of red wax in a silver-gilt case; charter: 30⅜ x 135¾" (78 x 348 cm)

Written during the brief joint reign of the brothers Ivan and Peter, this charter confirms Grigory Stroganoff's ownership rights, as well as his legal, financial, trade, and other privileges, and defines his territorial possessions. At this time, the rights were renewable, not hereditary. The borders are lavishly illustrated and include reserves with

symbols of the major cities of Russia. The parchment roll of six large-format sheets is considered a rarity.

The Russian State History Archives (fund 1411, inv. 1, no. 56)

120. *Letters Patent of the Holy Roman Emperor Francis I,* June 9, 1761

Parchment, in velvet binding, with a state seal in a metal case, in a box covered with morocco leather; letters: 14⅜ x 10¾" (37 x 27.5 cm)

Signed by Emperor Francis I, the Letters Patent (in Latin) grant Alexander Stroganoff the title of count and the family coat of arms.

The Russian State History Archives (fund 1411, inv. 1, no. 351)

WESTERN EUROPEAN ART

PAINTINGS

DUTCH AND FLEMISH

SCHOOL OF PETER PAUL RUBENS
Flemish, 1577–1640
121. *Portrait of Rubens and His Son Albert,* mid-17th century
Oil on canvas; 52 x 43¾" (133.5 x 112.2 cm)

Provenance: Alexander Stroganoff collection, St. Petersburg; transferred to the Hermitage in 1932

This portrait depicts the great Flemish painter Peter Paul Rubens (1577–1640), whom Alexander Stroganoff called the "Raphael of Flanders," using a phrase coined by the French writer Dezallier d'Argenville. Next to the artist stands his elder son, Albert (1614–1657), who became a lawyer, secretary of the Privy Council in Brussels, and the author of several archaeological volumes.

The 1793 and 1800 catalogues of Alexander Stroganoff's collection record this portrait with certainty as being by Rubens, an attribution that was generally accepted until the early twentieth century, when the legacy of the great master was reconsidered and the portrait removed from the corpus of his authenticated works. Later the portrait was ascribed to some of his followers, including Anthony van Dyck (1599–1641) and Jan Cossiers (1600–1671). The most plausible suggestion is that this is an old copy from a now-lost Rubens self-portrait made by an artist in the Rubens atelier, a suggestion supported by a number of facts. The portrait is based on a self-portrait drawing by Rubens in the Albertina, Vienna, which in turn corresponds closely with his self-portrait in oil in the Rubenshuis, Antwerp. The main components of the Hermitage painting conform to Rubens's portrait style; the

artist is surrounded with accessories that indicate his interests as an antiquarian and a humanist. The marble figure in the niche in the background at the right represents a statue of the goddess Hecate from the artist's collection, now in the Rijksmuseum van Oudheden, Leyden. (In 1618 Rubens had bought a collection of antique marbles from Sir Dudley Carleton, the English ambassador at The Hague.) The classical lamp held by the goddess, which probably symbolizes the fire of Knowledge, occurs in several works by Rubens. Last but not least, the gestures of the two sitters betray their close family relationship and resemble those of Rubens and Isabella Brant in the portrait at the Alte Pinakothek, Munich. Albert's age in this portrait suggests that the picture was conceived in the late 1610s and painted most likely by the mid-seventeenth century. **NG**

The State Hermitage Museum (7728)

ANTHONY VAN DYCK
Flemish, 1599–1641
122. *Portrait of Nicolaas Rockox,* 1621
Oil on canvas, 47¾ x 45⅜" (122.5 x 117 cm)

Provenance: Nicolaas Rockox collection, Antwerp; purchased by Anna Theresia van Halen, Antwerp, in 1749; purchased by Frederik Graaf van Thoms, Leyden, in 1750; purchased by Alexander Stroganoff in Paris between 1769 and 1779; transferred to the Hermitage in 1932

Nicolaas Rockox (1560–1640) was a public figure in the Southern Netherlands. He was a qualified lawyer and was nine times elected burgomaster of Antwerp (1603–36). A well-known humanist, scientist, numismatist, collector, and patron of the arts, he was Rubens's close friend and more than once commissioned paintings from him. In this portrait Rockox is surrounded by his favorite books and classical sculptures. On the table near which Rockox is sitting are a marble head of Jupiter (Nationalmuseum, Stockholm) and a bronze head of Hercules. The portrait was painted in 1621, shortly before Van Dyck had left Antwerp for Italy, and it displays features characteristic of the Flemish portrait tradition, as well as the pronounced influence of Titian. The latter became especially marked after Van Dyck had acquainted himself with the rich royal collections during his visit to London in 1620–21.

Count Alexander Stroganoff, who bought the portrait of the Antwerp burgomaster while he was in Paris, regarded it as of great value and described it as a Van Dyck masterpiece in his 1793 catalogue. Because he wanted to use this picture as a model for the painting students at the Academy of Fine Arts, in 1807 he commissioned from the Russian painter Orest Kiprensky (1782–1836) the copy that is now in the State Russian Museum, St. Petersburg (2148). As Stroganoff reported to the Academy, the painter "han-

dled his job well" and produced an exact copy of the picture, "the coloristic splendor of which will be used for the benefit of the students."

In May 1931, together with other works from the Stroganoff collection, the picture was in the R. Lepke sale in Berlin but came back unsold. **NG**

The State Hermitage Museum (6922)

ANTHONY VAN DYCK
Flemish, 1599–1641
123. *Portrait of a Young Man,* c. 1634–35
Oil on canvas; 30⅞ x 24¾" (79 x 63.5 cm)

Provenance: Paul Stroganoff collection, St. Petersburg; transferred to the Hermitage in 1932

The hair style and costume depicted in this portrait suggest that the sitter is Spanish. The picture can be dated to the mid-1630s on stylistic grounds; it was presumably painted on one of the artist's visits to Brussels and Antwerp in 1634–35. In May 1931 the portrait was offered in the R. Lepke sale in Berlin but came back unsold. **NG**

The State Hermitage Museum (6839)

ADRIAEN VAN OSTADE
Dutch, 1610–1685
124. *The Smoker,* c. 1655
Oil on panel; 6⅞ x 6" (17.5 x 15.5 cm)
Signed, bottom right, on the table edge:
Av. Ostade

Provenance: Paul Stroganoff collection, St. Petersburg?; transferred to the Hermitage in 1922

It was Peter the Great who acquainted Russia with the work of Adriaen van Ostade in 1716, when he brought *The Brawl* to St. Petersburg (now in the Hermitage, 799). Pictures by this artist remained widely popular with Russian art collectors over the next two centuries. His paintings were represented in twelve private collections, in addition to the Hermitage and the Academy of Fine Arts Museum.

The manuscript catalogue of Paul Stroganoff's collection (1864) mentions a signed picture by A. van Ostade, painted on wood, 17 x 15 cm, but the subject is not specified. The artist's signature (without date), the similarity of the measurements and the fact that this is the only picture by this artist in the catalogues of the Stroganoff collections give us every reason to identify it as *The Smoker.* The picture mentioned in the Paul Stroganoff catalogue was bought from Rhöen in Paris for 2,000 francs. **SS**

The State Hermitage Collection (4085)

BARTHOLOMEUS VAN DER HELST
Dutch, 1613–70
125. *Portrait of a Woman,* 1649
Oil on canvas; 27⅝ x 23⅝" (70 x 60 cm)

Signed and dated, top right corner: *B. van der Helst 1649*

Provenance: Comte (?) de Rhöen, Paris, before 1857; purchased by Paul Stroganoff in 1857; transferred to the Hermitage in 1932

This half-length portrait is notable for its painterly perfection and a refined coloristic effect, produced by the sitter's light red dress decorated with silver laces against a grayish-olive background. The rich attire and jewelry testify to the high social status of the model, who has not been identified. There was likely a companion male portrait.

The present picture was included in Paul Stroganoff's collection catalogue of 1864 under no. 50, where it was listed as "Barthelemy van der Helst. Portrait d'une dame, robe rouge décolletée. 5000 frcs." In 1931 the picture was in the R. Lepke sale in Berlin but came back unsold. **IS**

The State Hermitage Museum (6833)

GOVAERT FLINCK
Dutch, 1615–1660
126. *Portrait of Cornelia Haring,* 1645
Oil on canvas; 26⅞ x 23⅜" (69 x 60 cm)
Signed and dated, right, on the background: *G. Flinck f. 1645*

Provenance: La Motte Fouqué collection, Paris; bought by Paul Stroganoff in 1857; transferred to the Hermitage in 1933

This painting was called *Portrait of a Woman* in the Paul Stroganoff collection (which was kept first at his Znamenskoye country estate and later in St. Petersburg) and in the Hermitage catalogues. Stroganoff bought it for 2,000 francs in Paris. The identity of the sitter was established by J. Moltke, the author of a monograph on Govaert Flinck, published in 1965. He offered convincing evidence that the portrait represented Cornelia Haring, the wife of Jan de Saint Gilles. The companion portrait depicting her husband is in the B. Berghaus collection, New York. **IS**

The State Hermitage Museum (6835)

PIETER JANSSENS ELINGA
Dutch, 1623–1682
127. *A Dutch Interior,* late 1660s
Oil on canvas; 24 x 23" (61.5 x 59 cm)

Provenance: Comte (?) de Rhöen collection, Paris; bought by Paul Stroganoff in Paris in 1859; bequeathed to the Hermitage in 1912

A Dutch Interior, as well as nearly all other works by Elinga, has often been attributed to the Delft artist Pieter de Hooch (1629–1684), whose interior compositions were a source of inspiration for Elinga. The 1864 manuscript catalogue of the Paul Stroganoff collection, in which this picture is listed under no. 75 as *L'Interieur avec figure de femme,* notes that the picture was purchased in 1859 from Comte de Rhöen for 6,000 francs in

Paris and was kept in the Stroganoff country estate Znamenskoye in Tambov Province.

In 1912, after Paul Stroganoff's death, this painting and seven other canvases were bequeathed to the Hermitage. Ernest Liphart, curator of the museum, later proposed that the artist was Pieter Janssens Elinga, a forgotten follower of De Hooch whose name was not rediscovered until the late nineteenth century.

Nearly all of Elinga's works repeat the same interior setting with slight variations. These domestic scenes glorify the Dutch house with its characteristic cult of order, a measured rhythm of life, and a good housewife. This canvas is without doubt one of the best works by the artist. It must have been popular, for there are two other known versions, which differ only slightly from one another. One of them was in the Rikoff collection sale in Paris (Dec. 4–7, 1907, lot 10); the other is in the Musée du Petit Palais in Paris. **IS**

The State Hermitage Museum (1013)

ADRIAEN VAN DE VELDE
Dutch, 1636–1672
128. *A Halt,* 1666
Oil on canvas; 34¾ x 43⅜" (89 x 111 cm)
Signed and dated, bottom left: *A. v. Vedle fe 166(6?)*

Provenance: Blondel de Gagny collection, Paris, until 1776; Lebrun collection, Paris; purchased by Alexander Stroganoff between 1780 and 1793; transferred to the Hermitage in 1932

This picture under the title *Les Voyageurs* was reputed as one of the masterpieces in the collection of Blondel de Gagny, Tresorier Genéral du la Caisse des Amortissement. In a posthumous sale of the collection in 1776 the picture was bought by the artist and dealer Lebrun for the impressive price of 14,980 francs. The following year this picture by Van de Velde was engraved by R. Daudet for an album of prints, *Première Suite de douze Estampes, gravées sous la Direction du Sr. Le Brun, Peintre . . .* (Paris, 1777, no. 36).

The historian Jacob Stählin (1709–1785) wrote that in 1780 Count Stroganoff, the privy counselor, senator, and chamberlain, had brought from Paris a small but refined collection of about twenty pictures, including some paintings of the Brabant School. It is not certain whether this collection contained *A Halt,* but taking into consideration Stroganoff's particular fondness for landscape painting, it seems quite possible. *A Halt* can be seen in Voronikhin's 1793 watercolor (cat. no. 82) depicting Alexander Stroganoff's Picture Gallery, and it is included in Stroganoff's catalogue of the same year. The inclusion of this canvas in an album of engravings after paintings exhibited in the Stroganoff gallery (1807) testifies to the owner's high opinion of the work. In 1931 the canvas was in the R. Lepke sale in Berlin but came back unsold. **IS**

The State Hermitage Museum (6827)

FRENCH

NICOLAS POUSSIN
French, 1594–1665
129. *Rest on the Flight into Egypt,* 1655–57
Oil on canvas; 40⅞ x 56½" (105 x 145 cm)

Provenance: Chantelou collection, France, 1658; acquired by Alexander S. Stroganoff between 1793 and 1800; transferred to the Hermitage in 1931

The attribution and dating of the picture are based on Poussin's letters to his friend Chantelou, who commissioned this composition for Madame de Montmort. The letters indicate that the artist started his work in 1655 and completed it in 1657. The subject is taken from Matthew 2:13–14.

In the 1800 catalogue of his collection Stroganoff extolled Poussin to the skies, calling him the greatest painter that France had ever produced and the one who had no equals in contemporary French art, "since it is in Italy that his talent had always been exercised." Stroganoff, himself an ardent admirer of Italian art, attached primary importance to the ability of an artist to utilize the manner of Italian old masters: "The composition . . . asserts the equality of Poussin's genius to that of Raphael, whose principles he had always followed and for whom he had always shown a particular preference."

Analyzing the artistic qualities of *Rest on the Flight into Egypt,* Stroganoff remarks that to give the Virgin Mary a dignified appearance Poussin used as a model "the head of Niobe, who, as Winckelmann asserts, will forever remain the model of true beauty." Well acquainted with the art literature of his day and fully aware of the critical attitude of his contemporaries toward the subdued palette of the French master, Stroganoff tries to account for this peculiarity of Poussin in his catalogue, arguing that "so that the [color scheme] would not distract the viewer from emotion and contemplation with an ephemeral visual impression, the artist's goal was to attract the viewer rather than to dazzle him."

The painting was offered at the R. Lepke sale in Berlin in 1931 but came back unsold. **NS**

The State Hermitage Museum (6741)

ATTRIBUTED TO JACQUES BLANCHARD
French, 1600–1638
130. *Saint Cecilia,* c. 1636
Oil on canvas; 40¾ x 54⅜" (104.5 x 140 cm)

Provenance: Acquired by Alexander S. Stroganoff, St. Petersburg, between 1800 and 1805; transferred to the Hermitage in 1930

The painting, whose subject is taken from the *Golden Legend* (164: 771–77), was purchased by Alexander Stroganoff as the work of Eustache Le Sueur. Subsequently, this attribution proved to be wrong, but it is clear that the canvas was

painted by a French artist of the first half of the seventeenth century who was strongly influenced by Italian art, the Venetian School in particular. At present the painting is tentatively given to Jacques Blanchard.

After 1635 classicist tendencies started to prevail over the Baroque traits typical of Blanchard's earlier period. His later work is characterized by a monumental and rather static composition, precise drawing, graceful forms, and elongated proportions. All these features are present in this Hermitage painting, which indicates a date in the artist's later years, somewhere around 1636.

The 1800 Stroganoff catalogue does not include this painting, but it is described by the German scholar Heinrich von Reimers in his 1805 book on eighteenth-century St. Petersburg, which devoted many pages to the art collections of the Russian capital. The painting, still attributed to Le Sueur, was highly praised by the author for its "splendid design, well-chosen colors, and overall grace and verity." According to Reimers, the picture was not mentioned in the Stroganoff catalogue because it was acquired after 1800 but not later than 1805. **NS**

The State Hermitage Museum (6546)

CLAUDE LORRAIN (CLAUDE GELÉE)
French, c. 1602–1682
131. *Landscape with Dancers,* 1669
Oil on canvas; 39⅜ x 52¼" (102 x 134 cm)

Provenance: Duke of Kingston collection, England, 1742–43; Duchess of Kingston collection, England, 1773; temporarily housed, with two other pictures, in the St. Petersburg palace of Ivan Chernyshov, who eventually acquired it (after 1776); purchased by Alexander S. Stroganoff, St. Petersburg, between 1793 and 1800; transferred to the Hermitage in 1930

This painting can be dated to 1669 on the basis of a print by J.-B. Châtelain and Vivares engraved in 1742. The date is reproduced on the print, but has disappeared from the canvas itself. In his 1800 catalogue Alexander Stroganoff places the picture in the section devoted to the Roman School and describes it as one of the gems of the duchess of Kingston's collection. He expresses his profound admiration for Claude, writing that his painted representations of nature rival nature itself. The painter "represents nature not as our eye is wont to see it, but joining together all the beauties that belong to it and that in nature itself came forth separately."

It is to this landscape that Stroganoff dedicated one of the most inspired passages in his catalogue: "It is impossible to better render the fading of objects with the distance, to give a better feeling of the vaporous haze separating the viewer from the far-away prospects, to make better use of colors in producing the semblance of truth." This passage is followed by a genuine

stylistic analysis of the work, giving a detailed account of Lorrain's artistic idiom: "[In] the variety, richness, and color harmony involved in their composition, we can distinguish every kind of tree; the leaves seem to be agitated by the wind, one can almost hear them rustle. . . . Everything is held together, everything belongs to the whole; both artist and his art are forgotten—it's not a canvas any more, it is nature itself, it is a part of the Universe that we are facing." **NS**

The State Hermitage Museum (6552)

JEAN-FRANÇOIS DE TROY
French, 1679–1752
132. *The Rape of Proserpine,* 1721
Oil on canvas; 47¾ x 62¾" (122.5 x 161 cm)
Signed and dated, bottom left, on vase's rim:
DE TROY. 1721

Provenance: Klostermann, St. Petersburg, 1786; purchased by Alexander S. Stroganoff, St. Petersburg, before 1793; transferred to the Hermitage in 1930

The painting, whose subject is taken from Ovid's *Metamorphoses* (V: 391–404), was purchased by Alexander Stroganoff from the well-known St. Petersburg antiquarian Klostermann and was included in the first catalogue of the Stroganoff collection (1793), where Stroganoff includes this brilliant and vivid description: "Pluto sits on his chariot, holding Proserpine on his knees; the latter, her mouth slightly opened, her hands outstretched, seems to call the whole universe to her rescue. But who would dare oppose a divinity so awesome? Pluto, meanwhile, gives his horses rein and drives on. Syane, one of the fairest Sicilian nymphs, who lived nearby in the pond that bears her name, plunges ahead to prevent Pluto from driving away. The God, however, infuriated with the new obstacle set on his way, vigorously urges his horses onwards and strikes the Earth with his trident; fire and thick smoke spew from the opening chasm, by which Pluto can now reach his kingdom. The abduction seems to be assisted by Cupid and Hymen, both of them soaring over the chariot."

In spite of the emotional description given to the work, Stroganoff does not show any particular esteem for de Troy, being of an opinion that the nine years he spent in Italy to study the old masters were, to a large extent, wasted: Having failed to adopt their refined taste he came back an accomplished decorator, rather than a master of history painting.

The critical attitude shown by Alexander Stroganoff toward the majority of contemporary French painters in his collection is largely due to his predilection for Dutch, Flemish, and Italian masters, as well as for those French painters of the seventeenth century who proved successful in emulating the achievements of their Italian predecessors. **YeD**

The State Hermitage Museum (7526)

ANTOINE WATTEAU
French, 1684–1721
133. *La Boudeuse,* 1717–18
Oil on canvas; 16⅜ x 13¼" (42 x 34 cm)

Provenance: Sir Robert Walpole collection, England, 18th century; Horace Walpole collection at Strawberry Hill, England, before 1842; acquired by Paul S. Stroganoff from Meffré in Paris (1859); transferred to the Hermitage in 1923

The painting is considered to be among the best *fêtes galantes* of Watteau's later period. Its dating on stylistic grounds to 1717–18 is supported by comparison to *The Feast of Love* in Dresden. During the eighteenth century the picture must have been in the possession of the British prime minister Sir Robert Walpole; later it belonged to his son, Horace Walpole, and can be seen in an anonymous watercolor of a room in Horace's Strawberry Hill residence where it was displayed. In the two decades that followed the sale of the Horace Walpole collection in 1842, *La Boudeuse* changed hands several times and settled finally in the collection of Paul Stroganoff. The manuscript catalogue of his paintings (1864), where it is listed as no. 79, records that the picture was bought in 1859 from Meffré for 5,000 francs. The Paul Stroganoff collection was housed in his Znamenskoye manor house, near the town of Tambov. Later, when Paul Stroganoff had a house built for him in St. Petersburg, most of his collection was transferred to the capital. *La Boudeuse* is the only work by Watteau that belonged to the Stroganoffs, while as early as the mid-1770s the collection of Catherine II included at least seven paintings by this great artist. **YeD**

The State Hermitage Museum (4120)

JEAN-MARC NATTIER
French, 1685–1766
134. *Portrait of Peter the Great,* 1717
Oil on canvas; 55⅜ x 43" (142.5 x 110 cm)

Provenance: Imperial Academy of Fine Arts, St. Petersburg, until 1850; transferred to the Hermitage in 1918

Peter I (1672–1725) was the son of Tsar Alexei Mikhailovich and his second wife, Natalia Kirillovna Naryshkina. Following the death of his elder brother, Tsar Feodor, in 1682, Peter ruled Russia jointly with his brother Ivan, and after Ivan's death in 1696 he ruled alone, becoming the first Russian emperor in 1721. An outstanding statesman and military commander, Peter the Great also reformed many areas of traditional Russian life and culture. Known as the "carpenter" tsar because of his interest in science and industry, Peter strove to integrate Russia with the rest of Europe. He actively encouraged and fostered talented Russians and was genuinely proud of their achievements. In 1722 Peter the Great gave the honorary title of baron to Grigory Dmitrievich Stroganoff and his sons, Nikolai, Alexander, and Sergei.

This portrait is presumably a version of the portrait painted in Paris in 1717 as a pair to the portrait of Catherine I painted earlier in 1717 in the Hague (Hermitage). **IK**

The State Hermitage Museum (1856)

JEAN-BAPTISTE GREUZE
French, 1725–1805
135. *Portrait of Count Paul Stroganoff as a Child,* 1778
Oil on canvas; 19½ x 15⅝" (50 x 40 cm)

Provenance: Painted for Alexander S. Stroganoff in Paris in 1778; transferred to the Hermitage in 1923

This portrait of young Paul Alexandrovich Stroganoff (1772–1817) was painted, along with its companion piece, the head of a girl, when the family was living in Paris, where Paul was born. The 1793 Stroganoff catalogue describes the two portraits as follows: "Two busts: one of my son, aged six; the other of a young girl of more or less the same age. These charming and infinitely lovable portraits have a really spiritual quality about them." Later, however, in spite of his favorable comment on the portrait, Stroganoff didn't seem to have kept in contact with the artist.

In 1931 the picture was included with other works from the Stroganoff collection in the R. Lepke sale in Berlin, but it came back unsold. **YeD**

The State Hermitage Museum (4063)

HUBERT ROBERT
French, 1733–1808
136. *Set of Six Architectural Landscapes,* 1773

a. *Landscape with an Arch and the Dome of Saint Peter's in Rome*
Oil on canvas; 117 x 76" (300 x 195 cm)
Signed and dated, bottom left: *H. Robert 1773*

b. *Decorative Landscape with an Obelisk*
Oil on canvas; 116¼ x 74½" (298 x 191 cm)
Signed, on the base: *Obeliscum H. Robert pictet*

c. *Landscape with a Waterfall*
Oil on canvas; 116¼ x 74½" (298 x 191 cm)

d. *Landscape with Rocks*
Oil on canvas; 117 x 75½" (300 x 193 cm)

e. *Landscape with a Triumphal Column*
Oil on canvas; 117 x 28⅞" (300 x 74 cm)

f. *Cypresses*
Oil on canvas; 117 x 28½" (300 x 73 cm)

Provenance: Series painted in Paris for Alexander S. Stroganoff in 1773; transferred to the Hermitage in 1932

This suite of landscapes is an excellent example of an interior design ensemble, an art form that flourished during the last three decades of the eighteenth century with Hubert Robert as its

chief exponent. At that time sets of large panels, called *tableaux de place,* made to fit into a specific interior design, came into fashion. Louise-Élisabeth Vigée-Lebrun, a well-known portrait painter and Robert's friend, notes in her memoirs that "it was stylish and magnificent to decorate your salon with paintings by Hubert Robert." During his stay in Paris, Alexander Stroganoff, paying tribute to this fashion, commissioned from the painter a decorative ensemble for one of the halls on the first floor of his St. Petersburg palace.

The set includes six canvases: four of them were designed for the larger walls, the two narrow ones for the piers. The date, 1773, and the signature are to be found on the best-known canvas of the series, *Landscape with an Arch and the Dome of Saint Peter's in Rome.* Its companion is the *Decorative Landscape with an Obelisk.* Another pair of companion pieces comprises the two compositions showing "pure" nature, while the narrow panels show cypresses and a triumphal column. This set of themes would be repeated in most of the decorative suites painted by Robert over the next thirty years.

It is particularly interesting to compare the best composition of the series, *Landscape with an Arch and the Dome of Saint Peter's in Rome,* with a drawing of the same scene in the Cleveland Art Museum. The architectural motifs in both are very similar. The drawing was for many years attributed to Jean-Honoré Fragonard (1732–1806), since the inscription it bears had been interpreted as "divo *Fragonard.*" It was only after the illegible word was correctly read as "divo *Stroganoff*" that the drawing was acknowledged to be by Robert. It is possible that the drawing represents the first version of the composition for the painting commissioned by Stroganoff.

One of the characteristic features of Robert's architectural fantasies is a whimsical combination of French and Italian monuments from different epochs. Thus the *Landscape with an Arch and the Dome of Saint Peter's in Rome* combines antique ruins with a Renaissance temple, while the *Decorative Landscape with an Obelisk* shows an Egyptian monument and a rounded arcade reminiscent of monuments decorating the parks around Roman villas. The inscription, "Obeliscum H. Robert pictet," on the base of the obelisk seems to confirm the imaginary character of the architectural motif.

In his collection catalogues Stroganoff provides a warm appreciation of the suite's artistic merits, as well as a discussion of the aesthetic pleasures his contemporaries took in these fantasies: "They are painted with admirable ease; the freedom and confidence in the use of color tones serve to strengthen their effect. . . . The able artist, who spent a part of his life in Italy, chose the sites that have long been nourishing the imagination of the Italian landscape-painters and added to the natural views offered by their

country those of the marvelous monuments that embellish or used to embellish it. The mountains, rushing torrents, ruins surrounded by beautiful countryside add to the charms of the village life and are particularly dear to those melancholic hearts who take pleasure in comparing nature, ever young and newborn, with the monuments of man's hand, of which even the most lasting are subject to decay, until they are turned into ruins."

The whole series was offered at the R. Lepke sale in Berlin in 1931 but came back unsold. **YeD**

The State Hermitage Museum (7733, 7734, 7735, 7736, 8409, 8410)

HUBERT ROBERT
French, 1733–1808
137. *Laundresses in the Ruins,* 1760
Oil on canvas; 28 x 34⅜" (72 x 88 cm)

Provenance: Acquired by Alexander S. Stroganoff between 1793 and 1800; transferred to the Hermitage in 1926

A red-chalk drawing dated 1760 now in the Louvre was once attributed to Hubert Robert and was considered to be a study for this painting. Later, when the inscription on the drawing was read correctly, it proved to be a copy of the picture, or of a sketch for it, made by Robert Angot, a friend of Robert's who spent all his life in Rome, knew many pensioners of the French Academy, and often earned his living by selling copies drawn from the works of his young compatriots. This has enabled scholars to date the Hermitage picture in the year of Robert's studies in Rome.

The collection of paintings in Alexander Stroganoff's manor house called Maryino, later inherited by one of his granddaughters, is known to have included *Roman Ruins,* a small composition by Hubert Robert that was sold abroad in 1920. Fortunately, it was found recently in the Palais Galliera sale catalogue of November 26, 1975; its dimensions (72.5 x 87.5 cm) and its general composition coincide with those of *Laundresses in the Ruins.* A watercolor sketch for *Roman Ruins,* signed and dated 1760 (Sotheby's, Monaco, Dec. 5–6, 1991), enables us to date the picture in the same year. Finally, in the Angers sale catalogue of December 4, 1977, appears a red-chalk drawing, undoubtedly by Robert Ango, which is a copy of *Roman Ruins.* Signed exactly like the one in the Louvre, "A. Roberti Romae. 1760," it is also very similar in size. Both drawings are certain to have been made simultaneously from two companion paintings by Robert.

Taking into consideration all of these facts, we can thus assume that the two Robert paintings were undoubtedly companion pieces acquired by Count Stroganoff as a pair and kept in the

Stroganoff family's Maryino manor house until the beginning of the twentieth century. We would also like to make here another conjecture on the basis of our research. The 1800 catalogue of the Stroganoff collection includes two recently acquired landscapes by Robert, enthusiastically praised by the owner: "I know nothing by this painter, nor by any other, that could equal the exquisite noble touch and the delicious brushwork of those two charming canvases: in a word, this is a masterpiece of this charming artist."

Unfortunately, the descriptions in the catalogue are written in a vague, poetic style and are of little help in identifying the works: "This is a picturesque variety of objects, not a confusion, it's a charming harmony, it's a sublime union of majesty, opulence, and poverty; attributes characteristic of the class of the most indigent are displayed against the ruins of the temple of Jupiter and the palace of August." The classical monuments mentioned in the description do not make things clear, since in the eighteenth century many similar structures were defined as temples of Jupiter and palaces of August. More revealing is the next passage in the text, which deals with the dismal lot of the great architectural monuments of the past: "The place where the fates of nations and kings were decided—what has become of it? A shed to hang out the washing, a refuge of a laundress, a stable of sorts." What the Hermitage picture shows is exactly that—the laundresses hanging out the washing under the magnificent vaults of the palace—while its companion piece features peasants riding horseback amid the ruins of an antique temple with its two rows of columns. The way in which the two Robert pictures match the Stroganoff descriptions suggests that the catalogue refers to *Laundresses in the Ruins* and *Roman Ruins*. The date of the purchase suggests that it was meant to provide a financial and moral support for the painter, who had served a term in jail and lost most of his clients. **YeD**

The State Hermitage Museum (5806)

JEAN-LAURENT MOSNIER
French, 1743 or 1744–1808 (active in Russia 1795–1808)
138. *Portrait of Alexander Sergeievich Stroganoff, President of the Imperial Academy of Fine Arts,* 1804
Oil on canvas; 50⅛ x 36⅝" (128.5 x 99 cm)
Signed, center left: *J.L. mosnier, 1804*

This portrait was probably painted for the Assembly Hall of the Academy of Fine Arts. Mosnier was invited to St. Petersburg in 1801, and in 1802 he was given the title of academician and subsequently professor of the Academy.

Count Alexander Sergeievich Stroganoff (1733–1811) was the son of Sergei Stroganoff and Sophia Kirillovna Stroganoff, née Naryshkina. From 1752 to 1757 he studied abroad. In 1761

he was awarded the title of count of the Holy Roman Empire. In 1762 he became a chamberlain, in 1770 a chief councilor, in 1775 an actual privy councilor and senator, in 1796 arch-chamberlain, and in 1798 a count of the Russian Empire. In 1784–1811 he was marshal of the nobility for St. Petersburg Province. From 1800 he was president of the Academy of Fine Arts, and in 1801 he became a member of the State Council. Stroganoff is shown in the uniform of the Academy as redesigned in June 1804—a dark blue jacket with collar and cuffs of gold-embroidered velvet. He wears the Order of Saint Andrew the First Called, with its blue ribbon, as well as the Order of Saint John of Jerusalem. A rendering of Kazan Cathedral is displayed on the table beside him. **VB**

Research Museum, Academy of Fine Arts (Zh-1186)

JEAN-LAURENT MOSNIER
French, 1743 or 1744–1808 (active in Russia 1795–1808)
139. *Portrait of Count Alexander Pavlovich Stroganoff,* 1805
Oil on canvas; 21 x 17½" (54 x 45 cm)
Signed and dated, bottom left: *J.L. mosnier f. 1805*

Provenance: Transferred from the Stroganoff Palace, St. Petersburg, to the State Russian Museum in 1930

Count Alexander Pavlovich Stroganoff (1794–1814), only son of Paul Stroganoff, joined the Russian army in the field together with his father in 1813. He participated in the battle of Leipzig and died in the battle of Craonne on February 23, 1814. **NK**

The State Russian Museum (4594)

JEAN-LAURENT MOSNIER
French, 1743 or 1744–1808 (active in Russia 1795–1808)
140. *Portrait of Count Paul Alexandrovich Stroganoff,* 1808
Oil on canvas; 26⅞ x 22" (69 x 56.5 cm)
Signed and dated, bottom left: *J.L. mosnier f. 1808*

Provenance: Stroganoff collection, St. Petersburg; transferred to the State Russian Museum in 1930

Count Paul Alexandrovich Stroganoff (1772–1817), the only son of Alexander Sergeievich Stroganoff, took part in the wars against Napoleon. He was a cavalier of the highest orders in Russia, a lieutenant-general, senator, and friend of Emperor Alexander I. He is depicted here in his general's uniform with the Order of Saint George, Third Class, which he was awarded on August 22, 1808, and a badge of the Order of Saint John of Jerusalem. **NK**

The State Russian Museum (4596)

JEAN-LAURENT MOSNIER
French, 1743 or 1744–1808 (active in Russia 1795–1808)
141. *Portrait of Countess Sophia Vladimirovna Stroganoff,* 1808
Oil on canvas; 26⅞ x 21⅞" (69 x 56 cm)
Signed and dated, bottom left: *J.L. mosnier f. 1808*

Provenance: Stroganoff collection, St. Petersburg; transferred to the State Russian Museum in 1930

The daughter of Duke Vladimir Borisovich Golitsin and Duchess Natalia Petrovna (née Countess Chernyshova), Sophia Vladimirovna (1775–1845) married Paul Stroganoff in 1793. Her salon in St. Petersburg was frequented by many outstanding literary figures, and the countess was herself no stranger to creative work, having translated the second part of Dante's *Divine Comedy* into Russian. **NK**

The State Russian Museum (4595)

MARIE-LOUISE-ÉLISABETH VIGÉE-LEBRUN
French, 1755–1842
142. *Self-Portrait,* 1800
Oil on canvas; 30⅝ x 26½" (78.5 x 68 cm)
Signed and dated, bottom left: *Vigée Le Brun à Petersbourg 1800*

Provenance: Painted for the Imperial Academy of Fine Arts, St. Petersburg, 1800; transferred to the Hermitage in 1922

Known as a favorite painter of Marie-Antoinette, Vigée-Lebrun was forced to leave France with her small daughter at the onset of the Revolution in 1789. She lived abroad for twelve years, going from Florence and Rome (1789–90) to Naples (1790–91), back to Rome, and then to Vienna (1792–95). She enjoyed great success at aristocratic salons throughout Europe and was showered with commissions. Finally, in June 1795, the painter arrived in St. Petersburg at the height of her fame. In Russia she stood in high favor with the nobility, and the royal family, with the exception of Catherine the Great, graciously received her. Vigée-Lebrun wrote that she painted as many as forty-eight portraits in Russia, although in fact she painted even more than that.

The year before the artist left Russia, she was appointed honorary member of the Imperial Academy of Fine Arts by its director, Count Alexander Stroganoff. She mentioned the event in her memoirs: "Immediately after, I painted a self-portrait for the St. Petersburg Academy; I represented myself painting, with a palette in my hand." For more than a century her self-portrait was displayed, among other portraits, in the Academy's Council Hall. Vigée-Lebrun always cherished her memories of the country where she had taken refuge and of the Academy of Fine Arts, which honored her so highly. In her will, which was sent to the Academy in 1843, she bequeathed "100 francs a year for striking a gold

medal to be used as an award for one of the academy students from the painting class."

Vigée-Lebrun was on friendly terms with the family of Alexander Stroganoff, whom she came to know during his stay in Paris. In her memoirs she often recalls their meetings in St. Petersburg, as well as the stories the count told her about the tsar, Paul I, who had always held Stroganoff in great esteem and confidence. Vigée-Lebrun was a close friend of the count's son, Paul, and his wife, Sophia, whose portraits she also painted in St. Petersburg. At Paul's invitation, she would often visit the Stroganoff dacha outside St. Petersburg during the summertime.

In this picture the painter shows herself at work on a portrait of Paul I's wife, Maria Feodorovna, who wears the so-called smaller regalia—a tiny crown studded with diamonds. This portrait of Maria Feodorovna (its present whereabouts are unknown) is a half-length variant of her official full-length portrait painted by the artist in 1799 (Hermitage 1272). **YeD**

The State Hermitage Museum (7586)

MARIE-LOUISE-ÉLISABETH VIGÉE-LEBRUN
French, 1755–1842
143. *Portrait of Baron Grigory Stroganoff*, 1793
Oil on canvas; 35⅞ x 25¾" (92 x 66 cm)
Signed and dated, left, on the background:
L. E. Vigée le Brun B Vienne 1793

Provenance: Painted in Vienna for Grigory A. Stroganoff, 1800; Stroganoff collection, St. Petersburg; V. A. Sheremetov collection, St. Petersburg; transferred to the Hermitage in 1920

Grigory Alexandrovich Stroganoff (1770–1857) was the son of Baron Alexander Nikolaievich Stroganoff. After retiring from the army in 1795 in the rank of captain, he entered on his diplomatic career. In 1805 he was sent to Spain for five years as minister plenipotentiary; he was appointed envoy extraordinary to Stockholm in 1812 and to Constantinople in 1816. In 1826 Grigory and his descendants were made counts, and the following year he became a member of the State Council; in 1838 he was appointed envoy extraordinary to England to be present at the coronation of Queen Victoria.

In this portrait Grigory Stroganoff is shown at the age of twenty-three, when he was in the army and had already been given the minor court title of gentleman of the empress's bedchamber. In her memoirs Vigée-Lebrun mentions having also painted a companion portrait (present location unknown) of his wife, Baroness Anna Stroganoff. The artist recalls her meetings with the Stroganoffs in Vienna with great affection. She was particularly impressed by the cheerful, easygoing personality of Grigory Stroganoff: "He had an unsurpassed gift to charm and animate those around him; Vienna delighted in his dinner parties, theatrical performances, and balls, where everybody sought to be invited. I

have known few men more amiable and cheerful than Baron Stroganoff. When taken with the urge to laugh and amuse himself, he invented all imaginable follies." **YeD**

The State Hermitage Museum (5658)

MARIE-LOUISE-ÉLISABETH VIGÉE-LEBRUN
French, 1755–1842
144. *Portrait of Baroness Anna Stroganoff and Her Son*, 1795–1801
Oil on canvas; 35⅜ x 28½" (90.5 x 73 cm)

Provenance: Painted for Grigory A. Stroganoff, St. Petersburg, in 1795–1801; transferred to the Hermitage in 1931

Anna Sergeievna Stroganoff (1764–1824) was a daughter of Prince Sergei Trubetskoi and a sister of Countess Yekaterina S. Samoilova, a famous belle during the time of Catherine the Great, for whom she was a maid of honor. In 1791 she married Grigory Alexandrovich Stroganoff and bore him five sons and a daughter.

For a long time this portrait was thought to have been painted in Vienna, like the portrait of her husband (cat. no. 143). From the artist's memoirs we learn, however, that her friendship with the baroness continued in St. Petersburg, where it is likely that this portrait of the baroness with her son was painted. In any case, the comparison of this portrait and the one of the husband, painted in Vienna, throws doubt upon their being companion pieces. First of all, this picture began as a shoulder-length, small-scale composition; a seam clearly marks the initial canvas of a square-shaped format. The painting on the attached sections of canvas is also by Vigée-Lebrun. It is possible that the painter changed her initial conception, or it may have been her clients who wished to have a full-length portrait, so that it had to be made about three times larger.

In 1931 the painting was offered at the R. Lepke sale in Berlin, but it came back unsold. **YeD**

The State Hermitage Museum (7587)

GERMAN

JOHANN BAPTIST LAMPI THE ELDER
German, 1751–1830
145. *Portrait of Grand Duchess Maria Feodorovna*, not later than 1795
Oil on canvas; 21⅜ x 15⅜" (55 x 40 cm)

Provenance: Transferred from the Stroganoff Palace to the State Russian Museum, St. Petersburg, in 1930

Grand Duchess Maria Feodorovna (1759–1828) was born Princess Sophia Dorothea Augusta Louisa of Württemberg-Stuttgart and adopted her Russian name when she converted to the Orthodox faith. Her husband was Grand Duke

Pavel Petrovich, who became Emperor Paul I in 1796. **LV**

The State Russian Museum (4560)

ITALIAN

BARTOLOMEO VIVARINI
Italian, c. 1430–1491(?)
146. *Virgin and Child*, 1490
Tempera on canvas (transferred from panel); 22⅝ x 18⅛" (57.5 x 46.5 cm)
Signed and dated, on the parapet: *Bart. Vivar. F. 1490*

Provenance: Purchased by Paul Sergeievich Stroganoff from the dealer Paolo Fabris in Venice in 1857; transferred to the Hermitage in 1922

Unlike other major art collections in Russia, the Stroganoff collection was not rich in paintings of the Venetian School, and Vivarini's *Virgin* was one of the few examples of early Venetian art. It is not surprising that Paul Stroganoff, who had a special interest in early Renaissance painting, should have chosen this particular work for his collection.

This painting belongs to Vivarini's late period; its rigid compositional arrangement and technique derive from the artist's early impressions of the work of Andrea Mantegna. This compositional formula, repeated more than once in his work, has been perfected to the degree of refined elegance, which is manifested in the precise outline, the peculiar turn of the Virgin's head, and the flowing rhythm of gestures emphasized by delicate chiaroscuro modeling. **IA**

The State Hermitage Museum (4116)

SANDRO BOTTICELLI (ALESSANDRO DA MARIANO DI VANNI DI AMADEO FILIPEPI)
Italian, 1445–1510
147. *Saint Jerome*, c. 1500
Tempera on canvas (transferred from panel); 17⅜ x 10⅛" (44.5 x 26 cm)

148. *Saint Dominic*, c. 1500
Tempera on canvas (transferred from panel); 17⅜ x 10⅛" (44.5 x 26 cm)

Provenance: Grigory Sergeievich Stroganoff collection, St. Petersburg; transferred to the Hermitage in 1922

Together with two leaves depicting the Annunciation, now in the Pushkin Museum of Fine Arts in Moscow, these two Hermitage panels formed a single altarpiece. Attempts have been made to identify all four panels with those painted by Botticelli for Francesco del Puliese.

It has been suggested that Saint Dominic in the Hermitage panel bears a resemblance to the Florentine monk and preacher Girolamo Savonarola, who was put to death in Florence on May 23, 1498. The scene of Christ showing his

wounds to Saint Dominic probably alludes to Savonarola's death. **TK**

The State Hermitage Museum (4076, 4077)

GIAN FRANCESCO MAINERI
Italian, active 1489–1540s
149. *Christ Bearing the Cross*
Oil on panel: 23¼ x 17¾" (59.5 x 45.5)

Provenance: Marescalchi Gallery, Bologna, 1840s; acquired by Paul Sergeievich Stroganoff from Marquis Venusti in Rome in 1854; bequeathed to the Hermitage in 1912

In the 1864 manuscript cataloguing the Paul Stroganoff collection, this work is listed under no. 18 as a painting by Francesco Maineri. The catalogue also indicates that the owner, Paul Stroganoff, had at one time seen the panel in the Marescalchi Gallery, where it was attributed to Bernardino Luini.

This painting is one of the most successful versions of this subject, which Maineri depicted at least a dozen times. The composition is based on a wood engraving of *Christ Bearing the Cross* by an anonymous Lombard artist of the late fifteenth century. **TK**

The State Hermitage Museum (286)

GIAMPETRINO (GIOVANNI PIETRO RIZZOLI)
Italian, active 1508–49
150. *Virgin and Child*, 1520s
Oil on canvas (transferred from panel); 22⅝ x 15¼" (58 x 39 cm)

Provenance: Agueda Gallery, Paris; acquired by Paul Sergeievich Stroganoff from Wolsey Moreau, Paris, in 1859; transferred to the Hermitage in 1922

The 1864 catalogue of Paul Stroganoff's collection lists the *Virgin and Child* under no. 19 as a work by Giampetrino, acquired by Count Stroganoff from the art dealer Wolsey Moreau for 10,000 francs.

A number of works by Giampetrino are very close to the Hermitage example in their dimensions and composition, such as paintings from the Castello Sforzesco in Milan or the Martello collection in Florence. **TK**

The State Hermitage Museum (4130)

BARTOLOMEO SCHIDONE
Italian, 1576–1615
151. *The Holy Family*
Oil on canvas (transferred from panel); 25½ x 19½" (65.5 x 50 cm)

Provenance: Calonne collection ?, Paris; acquired by Alexander Sergeievich Stroganoff between 1793 and 1800; transferred to the Hermitage in 1929

In Alexander Stroganoff's 1800 catalogue of

his collection this painting is said to have come "from the sale of the beautiful collection of M. de Calonne."

Schidone treated the subject of the Holy Family many times, repeating the images and varying the composition slightly. **TK**

The State Hermitage Museum (4058)

BERNARDO STROZZI (IL CAPPUCCINO, IL PRETE GENOVESE)
Italian, 1581–1644
152. *Allegory of the Arts*, 1635–40
Oil on canvas: 59¼ x 54⅝" (152 x 140 cm)

Provenance: Sagredo collection?, Venice; Poullain collection, Paris; Lebrun collection, Paris; collection of Alexander Sergeievich Stroganoff, St. Petersburg; transferred to the Hermitage in 1930

The three women personify the three Arts: Painting, with her canvas, brushes, and palette; Sculpture, with a marble bust, hammer, and chisel; and Architecture, with a plummet. In his 1793 and 1800 collection catalogues Alexander Stroganoff indicates that the *Allegory* came from the Poullain collection, but the date and circumstances of its purchase remain uncertain. Although not included in the 1780 sale catalogue of the Poullain collection, this work was reproduced in the album of engravings after paintings in the collection, published a year later, indicating that it may been sold before the 1780 sale. It is not known whether Stroganoff himself acquired it directly, or whether it entered his collection later, via Lebrun, a well-known art dealer of the time and the husband of the artist Louise-Élisabeth Vigée-Lebrun. Lebrun did possess an identical picture of the same dimensions, which was reproduced in the album of engravings after paintings in his collection, published in 1809. Since no other version of this composition is recorded, we have every reason to suppose that the painting came to the Stroganoff collection through Lebrun and was already in St. Petersburg when Lebrun published his album. As for Stroganoff, it was only natural for him to describe the painting in his catalogue as coming from Poullain, a well-known art collector, rather than from the art dealer Lebrun.

In the Poullain collection the canvas was ascribed to Domenico Fetti, but in his catalogues Stroganoff, who retaining this attribution, notes that some experts consider the painting to be by Bernardo Strozzi. The Strozzi attribution was generally accepted beginning with the *Collection d'éstampes . . . Stroganoff . . . 1807* (a collection of prints executed by students of the St. Petersburg Academy of Fine Arts), which may account for the fact that Lebrun reproduced the picture as being "by Strozzi of Genoa" but pointed out the affinity of Strozzi's paintings to those of Fetti, to whom they are sometimes attributed.

It is possible that this is the same painting

seen by the French engraver and connoisseur Charles-Nicolas Cochin while traveling in Italy from 1746 to 1751, when he recorded two half-figure compositions by Bernardo Strozzi, *Les trois arts* and *Les parques,* in the Palazzo Sagredo in Venice. **SV**

The State Hermitage Museum (6547)

CESARE DANDINI
Italian, 1595–1656
153. *The Holy Family*
Oil on canvas; 57½ x 43¼" (147.5 x 111 cm)

Provenance: Prince de Conti collection, France, before 1777; Lebrun collection, Paris, before 1791; acquired by Alexander Sergeievich Stroganoff, St. Petersburg, before 1793; transferred to the Hermitage in 1932

When this painting was in the collection of the famous military leader Louis-François de Bourbon, prince de Conti, it was attributed to the Bolognese painter Agostino Carracci. This attribution was not questioned until the picture entered the Hermitage collection, where the canvas was first ascribed to another Bolognese painter, Carlo Cignani, and then finally acknowledged as a work by the Florentine artist Cesare Dandini.

In 1791 Lebrun sold off the art collection he had acquired over several years, and it is after this sale that *The Holy Family* must have entered Alexander Stroganoff's collection, since it was included in his 1793 catalogue.

The collection of the prince de Conti was famous in Europe. In 1777, when the collection was being sold, several paintings by Italian masters were acquired for Catherine the Great. **SV**

The State Hermitage Museum (7138)

LUCA GIORDANO
Italian, 1634–1705
154. *The Battle of Lapiths and Centaurs,* c. 1688
Oil on canvas; 101½ x 152" (260.5 x 390 cm)

Provenance: Count (later Duke) of Kingston collection, England, late 17th century; Duchess of Kingston collection, England, 1773; St. Petersburg after 1776; Count Ivan Chernyshov collection, St. Petersburg; acquired by Ivan Melissino, 1790s; acquired for the Senator M. F. Soimonov collection, St. Petersburg, before 1797; purchased by Count Alexander S. Stroganoff, St. Petersburg, between 1797 and 1800; transferred to the Hermitage in 1930

The subject of this canvas is based on a story from Ovid's *Metamorphoses* (12: 210–468) and Plutarch's *Lives* (Theseus: 30). Its composition relates to Pietro da Cortona's *Victory of Alexander the Great over Darius* (Capitoline Museum, Rome). Giordano's painting, with its huge size, rich color scheme, violent movement, and complex foreshortening, has always been a focus of

attention wherever it has been exhibited, from private collections to the Stroganoff Palace to the Hermitage.

A document published in 1991 records that on December 30, 1688, the San Giacomo Bank in Naples paid Luca Giordano 600 ducats for a picture representing the battle with centaurs ("delle nozze di Piriteo con la battaglia di Centauri"). The canvas was bought by the count of Kingston through George Davies, the English consul in Naples. Until the second half of the eighteenth century, the picture remained in the Kingston family. In 1776 (or 1777) the duke of Kingston's widow came to St. Petersburg to settle there for good and brought her art collection with her. The pictures were temporarily housed in the palace of Count Ivan Chernyshov, and *The Battle of Lapiths and Centaurs,* together with some other paintings, was later presented to him by way of compensation for his troubles. At the beginning of the 1790s the picture was bought by Ivan Melissino, procurator general of the Holy Synod, probably for Senator M. F. Soimonov: at any rate Stanislas August Poniatowski, king of Poland, saw this picture at Soimonov's house in 1797. In less than three years Giordano's painting found a new owner, Count Alexander Stroganoff, who included it in the 1800 catalogue of his paintings collection. **SV**

The State Hermitage Museum (4705)

Francesco Solimena
Italian, 1657–1747

155. *Allegory of the Reign,* 1690
Oil on canvas; 28 x 24½" (72 x 63 cm)
Signed and dated, bottom left corner:
F. Solimenus f. 1690
Inscribed (in the last quarter 18th century), along medallion's edge: CATARINA II AUGUSTA ROSSIA IMP.

Provenance: Monsignore Filippo Antonio Gualtieri collection, Italy; Louis XIV collection; E. M. Bouret collection in the castle of Croix Fontaine; acquired by Alexander Sergeievich Stroganoff before 1793; transferred to the Hermitage in 1930

This painting was commissioned by Filippo Antonio Gualtieri, the pope's nuncio in France (1701) and cardinal (1706). It was described in detail by Solimena's biographer Bernardo de Dominici. The allegory glorifies the monarch whose portrait is shown in the bronze medallion. Pallas commands History to record the events of the reign in the book that lies open on the shoulders of Time; to the right one can see Heresy exiled and Hydra turned to stone. The portrait of the sovereign is surrounded by Virtues.

The portrait in the medallion was initially that of Louis XIV, for it was to him that Gualtieri presented the picture, which is recorded as having received His Majesty's praise and the approval of the court. The composition may have

been inspired by the marble group *Glory Recording the Deeds of the King Louis XIV in the Book of History Supported by Time,* executed in 1685 by Domenico Guidi. The sculpture was commissioned for the king by Colbert to adorn the fountain of Neptune in the park of Versailles.

The Solimena painting enjoyed tremendous success, and many engravers used it as a model for glorifying various monarchs, thereby creating great confusion as to the identity of the person represented. This accounts for the mistake made by Alexander Stroganoff, who erroneously identified Louis XIV as Charles V in his catalogue, where he notes that in the mid-eighteenth century the painting was in the possession of Étienne-Michel Bouret, who was visited in his castle by King Louis XV in 1759. "It is certain," Stroganoff wrote, "that by the time of the visit, Bouret, out of love for Louis XV, had the portrait of this sovereign painted over that of Charles V. On my part," he adds, "I had the head of Louis XV effaced to replace it with that of the Empress Catherine II." X radiography clearly reveals the portraits of both French kings beneath that of Catherine the Great.

Heinrich von Reimers, in his book *St. Petersburg am Ende seines ersten Jahrhunderts* (St. Petersburg, 1805), mentions that the picture hung in the Stroganoff Palace in a gilded frame adorned with a double-headed eagle holding a broken silver crescent in its claws—undoubtedly a symbol of Russia's victory over Turkey, which brought glory to the reign of Catherine the Great. **SV**

The State Hermitage Museum (6548)

Alessandro Marchesini
Italian, 1663–1738

156. *The Sacrifice of a Vestal,* 1720s–1730s
Oil on canvas; 46⅞ x 66⅜" (120 x 171 cm)

Provenance: Acquired by Alexander Sergeievich Stroganoff before 1793; transferred to the Hermitage in 1926

The Alexander Stroganoff collection included two companion pictures, one of them showing the sacrifice of a vestal (based on a passage in "A Commentary on Virgil's *Aeneid*), the other a bacchanal (Hermitage 6377). To underscore their symbolic meaning, Stroganoff entitled them *Le Regne de l'Innocence* and *Le Regne des Plaisirs* in his catalogue, adding "The two pictures we have described deserve the name of masterpiece . . . for the elegance of the composition, the sublimity of thought, the delicacy of brushstroke, the beauty of shapes, and the arrangement of figures, as well as for chiaroscuro effects."

The first picture depicts the rite of consecrating a vestal, which was part of the ancient cult of Vesta, the Roman goddess of the hearth. The priestesses were chosen at the age of six or seven from among the daughters of noble families; they had to remain virgins for thirty years or face the pain of a cruel death. Their duties

included participating in sacrificial ceremonies and keeping the fire in the temple burning perpetually as the symbol of the firmness and stability of the state.

In his collection catalogue Stroganoff gives a vivid and picturesque description of the event shown on the canvas: "The scene takes place in a magnificent temple. The sacred fire is kindled. The seated Great Vestal, Vestalis maxima, presides at the sacrifice, and several vestals are busy around the altar; some carry the sacred vessels, while others bring the incense. In a corner of the picture six young girls being led to the steps of the altar by two vestals (one of them with her finger to her lips, indicating that silence must be kept during the ceremony) are carrying patera-shaped vessels in which the sacred fire is burning. On the other side fathers and mothers of the young virgins consecrated to the goddess are depicted in prayer at the entrance of the temple, some of them kneeling, some standing erect. In the upper part of the picture Diana, the patroness of Chastity, accompanied by several nymphs, contentedly watches the scene."

In his first catalogue (1793) Stroganoff attributes both pictures to the Roman painter Pietro da Cortona. The Russian collector's insight and erudition, however, allowed him in the 1800 edition of his catalogue to attribute the picture to the Veronese painter Alessandro Marchesini. The art of this painter, who spent most of his mature years in Venice, remains deeply rooted in the traditions of the Bolognese School. After six years of apprenticeship in the workshop of Carlo Cignani in Bologna, Alessandro Marchesini developed an original type of small picture showing mythological subjects and inhabited by a multitude of graceful and elegant figures, enlivened by delicate tints of color and the soft play of light and shade. Some of his compatriots called him "our Albani, the pride of Verona," while others, exasperated at his success, named him a "ladies' painter." Deeply hurt by this criticism, he left Verona for a short time.

Today the name of Alessandro Marchesini is nearly forgotten. Only a few of his paintings are extant, and these are scattered over several museum collections, which makes dating them a difficult problem. Alexander Stroganoff, apart from appreciating the outstanding quality of this painter's work, helped to preserve his name for posterity. **TB**

The State Hermitage Museum (6376)

Antonio Vighi
Italian, 1764–1845
Pietro Scotti
Italian, 1768–1838

157. *Arabesque Panels,* 1800
Tempera and oil on canvas; each central panel: 165¾ x 20⅜" (425 x 53 cm); side panels: 165¾ x 8⅞" (425 x 23 cm); central panel and two side panels, with frame: 170⅜ x 39" (437 x 100 cm)

Provenance: Mikhailovsky Palace, St. Petersburg; transferred to the Stroganoff Palace after 1802

Panels with paintings from the so-called Arabesque Hall of the Stroganoff Palace are not documented, so their authorship and provenance can be suggested only tentatively. In Russia the first attempt to decorate rooms with arabesque panels was made in 1783–92, when the architect Giacomo Quarenghi built a gallery in the Winter Palace consisting of thirteen loggias, which Catherine the Great wished to have decorated with copies of murals of the celebrated Raphaels in the Vatican. The copies had been made by the German artist Christopher Unterberger in 1778. At about the same time Count Alexander Stroganoff resolved to decorate his palace with arabesque panels, but in 1782 he sold his twelve compositions painted on marble to Grand Duchess Maria Feodorovna for her boudoir in the Pavlovsk Palace.

In 1800 a gallery with seven loggias, similar to the Vatican prototype, was built in the Mikhailovsky Castle. August Kotzebue, who compiled a description of the castle published after Paul I's death,[1] wrote that the arabesques were painted by two Italian artists, Pietro Scotti and Antonio Vighi. According to Kotzebue, the work was not completed, which accounts for the fact that the Stroganoff set that came to the Stroganoff Palace from the Mikhailovsky Palace is incomplete, with only twenty narrow side panels instead of the twenty-eight that would be needed for fourteen large panels. The Arabesque Hall was decorated with this set of panels in the 1830s or 1840s. Several panels mounted around mirrors and three overdoor decorations were produced especially for this hall (see cat. no. 158), depicting subjects that Stroganoff had seen during his visit to Cicero's villa in Pompeii in 1755. Similar panels can be found in the Etruscan Hall in the Sheremetev Palace, St. Petersburg (1837).

SK

1. A. Kotzebue, *Kurze Beschreibung des Michailowischen Pallases: Das Murdigwustum Jahr meines Lieben* (Berlin, 1802), pp. 146–97.

The Stroganoff Palace

UNKNOWN RUSSIAN PAINTER
158. *Overdoor Panel,* 1830s–1840s
Oil on canvas; 56½ x 62⅞" (145 x 161 cm)

This was one of three overdoor panels produced for the Arabesque Hall. The subject of this panel is a centauress and a nymph. **SK**

The Stroganoff Palace

SCULPTURE

CARLO BARTOLOMEO RASTRELLI
Italian, 1675?–1744
159. *Neptune,* 1723

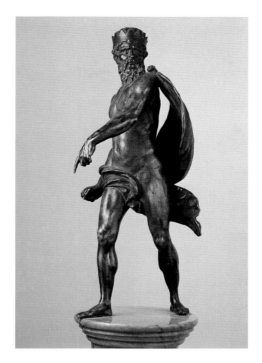

Bronze, marble (base); 16⅜ x 6 x 6" (42 x 15.5 x 15.5 cm)

Provenance: Transferred from the Stroganoff Palace, St. Petersburg, to the State Russian Museum in 1930

In the early nineteenth century, Alexander S. Stroganoff, president of the Imperial Academy of Fine Arts, supervised the renovation of the sculptural decor of the Great Cascade at the royal residence at Peterhof. This famous palace-and-park complex dates back to the time of Peter the Great, and the artist who played a leading role in creating decorative compositions for numerous Peterhof fountains was Carlo Bartolomeo Rastrelli, Peter the Great's favorite sculptor (and father of the architect Francesco Bartolomeo Rastrelli, who designed the Stroganoff Palace). He arrived in Russia in 1716 and found a wide sphere of activity for himself, making an important contribution to the development of Russian sculpture. Particularly famous among Rastrelli's surviving works are his portraits of the first Russian emperor—a bronze bust and a wax effigy of Peter the Great, now in the Hermitage, as well as a monument in front of the Mikhailovsky Castle.

This small statue of Neptune is traditionally regarded as a model for Rastrelli's Peterhof work, which was lost, like so many other pieces, as early as the eighteenth century. Looking at this dynamic piece, one can imagine the degree of elation and vigor that once imbued the Baroque statues of the Great Cascade fountains created after Russia's victory in the Great Northern War with Sweden (1700–1721). **YeK**

The State Russian Museum (SC 1457)

GIOVANNI PICHLER
Italian, 1734–1791
160. *Cameo: Hebe, Mercury, and Cupid,*
last quarter 18th century
Two-layer sardonyx, gold; 1 x ¾" (2.6 x 1.9 cm); with setting: 1 x ⅞" (2.8 x 2.1 cm)
Signed at the bottom: Pichler f.

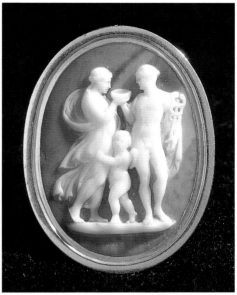

Provenance: Acquired from the St. Morys collection, Paris, for the Hermitage in 1792

This cameo reproduces the three-figure group at the left in Raphael's fresco *The Gathering of the Gods* from the ceiling of the Loggia of Cupid and Psyche in the Villa Farnesina, Rome. It demonstrates all that is best in the work of a representative of the famous Pichler family of gem carvers. Originally from the Tyrol, the Pichlers settled in Italy, first in Naples and then in Rome. They exerted enormous influence on European glyptics during its last great period, when Giovanni Pichler was widely recognized as head of the European school of gem engraving. In recognition of his achievements he was buried in the Pantheon in Rome, the only carver to be so honored.

By the time of his death this cameo was already in France in the gem collection of St. Morys, counselor to the Paris Parlement. Removed from revolutionary Paris in 1792 and brought to St. Petersburg by the émigré antiquarian Alphonse Miliotti, this collection was acquired by Catherine II. In the first Hermitage inventory of carved gems, compiled during the empress's lifetime by her librarian Alexander Luzhkov, the entry for this cameo is marked: "de la collection St. Morys."

In Miliotti's manuscript catalogue of the St. Morys collection, we learn details of the cameo's early history: "M. Vauhorn, for whom this fine cameo was carved, having waited three years in order to receive it and during this time

chance having procured for him another stone by M. Pichler, was keen to give up this cameo." On the other hand, museum documents contain information, unfortunately without reference to the source, that "Pichler engraved it for Count Stroganoff, president of the Academy of Arts." If this is true, we can only suppose that for some reason the purchase did not take place. It is possible that Alexander Stroganoff refused to acquire the cameo because he felt that the price was too high: we know that over the period required to make this piece the price of works by Giovanni Pichler grew several times, until they were considerably more expensive than even antique gems. **JK**

The State Hermitage Museum (K 1818)

DECORATIVE ARTS

ENGLISH

161. *Platter with the Arms of the Barons Stroganoff*
English (London), 1726–27
Made by Paul de Lamerie, 18th century
Silver; diam. 25¾" (66 cm)
Marks: Maker's mark; *"Britannia"; London; 1726–1727*

Provenance: Countess Ye. V. Shuvalova collection, St. Petersburg; transferred to the Hermitage in 1925

This platter bears the arms of the barons Stroganoff, executed after a design by the court genealogist Count Franz M Santi (active in Russia in the 1720s). A similar shield can be found on a basin Lamerie produced in 1723 for George Treby. The Hermitage basin was probably commissioned to commemorate the coming of age of Grigory D. Stroganoff's younger son, Sergei. The title of baron was conferred on the Stroganoffs by Peter the Great in 1722. **ML**

The State Hermitage Museum (E 13483)

FRENCH

162. *Wall Clock*
French (Paris), 1750–60
Clockworks by François Viger
Gilt bronze; 40⅜ x 23⅜ x 7⅞" (104 x 60 x 20 cm)
Signed on dial and movement: *Viger A Paris*

Provenance: Stroganoff collection, St. Petersburg; transferred to the Hermitage in 1925

François Viger became master in the Paris guild of clockmakers in 1744, and from 1745 to 1783 he ran a shop of his own in the Rue Saint-Denis. **YuZ**

The State Hermitage Museum (1163)

163. *Snuffbox with Miniatures of the Stroganoff Dacha*
French (Paris), 1755–56; miniatures 1790s
Made by Julien Berthe; miniatures painted by Jean Ducrollay
Gold, glass, miniatures in gouache on paper; 1⅜ x 3¼ x 2⅜" (3.7 x 8.4 x 6.3 cm)
Marks: Maker's mark; *Paris 1755–56; fermier Julien Berthe 1750–56*

Provenance: Stroganoff collection, St. Petersburg; transferred to the Hermitage in 1925

We know that the land at the mouth of the Chernaya Rechka, just outside St. Petersburg, was from 1743 the property of the Stroganoff family. On the lid and bottom of this snuffbox are views of the country house of Count Alexander Stroganoff, which was built on that land to a design by Antonio Rinaldi in the mid-1750s. With the exception of very insignificant details, these miniatures are copies of watercolors produced by Balthasar de la Travers, showing views of the palace from the Neva River and from the garden (cat. no. 99).

The date of Jean Ducrollay's snuffbox, which bears the Paris date stamp for 1755–56, accords with the date of Rinaldi's palace, but the miniatures on the sides date to a later period. The sarcophagus was moved to the park and put in place only in the 1770s and the bridges and summer house we see here appeared only in the 1790s. Clearly, the snuffbox was reworked after its arrival in St. Petersburg, and the miniatures were added later. Such snuffboxes were widespread in Russia and many were specially commissioned to commemorate places and events. **OK**

The State Hermitage Museum (E 17190)

164. *Secretary Desk*
French (Paris), mid-18th century
Made by Jean-François Dubut
Rosewood, ivory, mother-of-pearl, with gilt bronze mounts; 56⅛ x 43¼ x 18¾" (144 x 111 x 48 cm)
Stamped: *J. Dubut*

Provenance: Stroganoff collection, St. Petersburg; transferred to the Hermitage through the State Museum Reserve in 1931

The polychrome marquetry on this desk, with its incrustations of brightly tinted ivory and mother-of-pearl, is not typical of French works of the period. Scholars have noted that Jean-François Dubut (d. 1778) was an extremely unusual master whose works defy immediate identification. Kjellberg sets the Hermitage desk somewhat apart in Dubut's work and sees it as having been created on commission from a foreign client.[1] Since the piece comes from the Stroganoff collection in St. Petersburg, this seems very likely,

although there is no surviving documentary evidence regarding the commission. The desk was listed among works from the Stroganoff collection that were in the R. Lepke sale in Berlin in 1931, but it came back unsold. **TR**

1. P. Kjellberg: *Le mobilier français du XVIII siècle. Dictionnaire des ébenistes et menuisiers* (Paris, 1989), p. 284.

The State Hermitage Museum (E 5211)

165. *Jeton Dies*
French (Paris), 1774
Engraved steel, in wood box: 2⅞ x 4⅞ x 2⅜" (7.5 x 12.5 x 6.3 cm)
Marks: Maker's mark and date, on the die with a coat of arms; *B. Duvivier f.*

Provenance: Ethnographic Museum, St. Petersburg; transferred to the Hermitage in 1941

This set of two dies was for stamping out octagonal metal jetons, which were used as a unique kind of visiting card. The dies were produced during Count Alexander Stroganoff's stay in Paris in the 1770s. One of them is engraved with a reversed coat of arms of the counts Stroganoff, and on the other appears in reverse "Alexandre comte de Stroganoff, conseil.er prive, chambellan actuel de Sa M. Imp.ale de toutes les Russies, chev.er de Plus.rs ordres." After Alexander Stroganoff returned to Russia, jetons were produced from the same dies at the Petersburg mint.

Benjamin Duvivier (1730–1819) was a French medal maker, who was appointed chief engraver to the French mint in 1774. Here he has treated the heraldic elements of the Stroganoff arms somewhat freely. The symbolic sables supporting the shield have become gamboling beasts. The long-nosed animal we see is totally unlike the Russian brown bear, whose head should have appeared on the Stroganoff arms, not to mention the form of the shield itself, which has become oval. Heraldic restraint has given way to French license, combining flights of fancy with virtuoso execution. **IS**

The State Hermitage Museum (ERM 4811ab)

166. *Snuffbox with Bacchanalian Scenes*
French (Paris), 1776–77
Gold, enamel, glass, pearls, miniatures in gouache on paper; 1¼ x 2⅞ x 2¼" (3.1 x 7.3 x 5.7 cm)
Made by Pierre-François Drais
Marks: Maker's mark; *Paris 1776–77; fermier Jean-Baptiste Fouache 1775–1781*

Provenance: Stroganoff collection, St. Petersburg; transferred to the Hermitage in 1925

Descriptions of the Stroganoff collection in the early twentieth century include mention of

numerous snuffboxes made of various materials: metal, tortoiseshell, stone, and mother-of-pearl. Among the "stone" works we find snuffboxes that provide evidence of Count Alexander Stroganoff's interest in the collection of minerals. Some of these pieces, as we learn from Alexander Stroganoff's correspondence, were produced by Paris goldsmiths. He most likely purchased this box in Paris, where he lived from 1771 to 1778, as a fine example of French Neoclassicism with its compositions *à l'antique,* such as the grisaille bacchanalian scenes. Examples of Drais's use of grisaille painting are to be found in a number of his works in the Louvre. **OK**

The State Hermitage Museum (E 8989)

167. *Pair of Perfume Burners*
French (Paris), 1780s
Gilt bronze, with black lacquer inlaid with mother-of-pearl, on a marble plinth; 11⅛ x 4⅝ x 4⅝" (28.6 x 11.7 x 11.7 cm)

Provenance: Stroganoff collection, St. Petersburg; transferred to the Hermitage in 1925

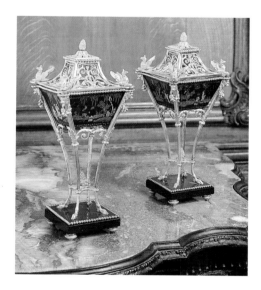

The gilt bronze basin of each incense burner is faced with rare, early-eighteenth-century Chinese lacquers inlaid with figures in a landscape in a technique known as *laque burgauté.* They have been decorated with figures of men in a landscape fashioned from inlaid mother-of-pearl. **YuZ**

The State Hermitage Museum (9242, 9243)

168. *Mantel Clock: The Fall of Phaeton*
French (Paris), 1810s
Gilt bronze; 23⅜ x 21⅞ x 5⅞" (60 x 56 x 15 cm)
Inscription on face: *a Paris*

Provenance: Stroganoff collection, St. Petersburg; transferred to the Hermitage in 1925

The bronze maker Pierre-Étienne Romain registered his exclusive rights to the scupltural

design of this clock by depositing his drawing of the model in the Bibliothèque Nationale in March 1800. He had already produced clocks of the model, however, as one was in the rue Chantereine residence of Napoleon Bonaparte before 1799 and was transferred to the Tuileries. It is therefore possible that this clock was acquired by the Stroganoffs well before 1814, when Russian travelers began purchasing French bronze work on the advice of the well-known connoisseur Nikolai Demidov. While the French State (Mobilier National) has examples of the model signed on the dial by the clockmakers Lepaute and Breguet and a third signed by Romain himself, the present clock bears only the designation "a Paris." The bronze case may have been sold by Romain without works, allowing the option to the clockmaker who subsequently supplied them to add his signature to the dial. **YuZ**

The State Hermitage Museum (6194)

169. *Pair of Candelabra with a Figure of Victory Holding a Cornucopia*
French (Paris), 1820s
Gilt bronze; h. 52⅝" (135 cm)

Provenance: Stroganoff collection, St. Petersburg; transferred to the Hermitage in 1925

The Hermitage has in its collection four pairs of similar six-light candelabra with a figure of Victory, each differing from the other in the ornamental details. One pair came from the Stroganoff collection and another from the Yusupov collection; the other two came from the Winter Palace. **YuZ**

The State Hermitage Museum (750, 751)

GERMAN

170. *Tea Service*
German (Augsburg), 1695–1700
Made by Tobias Baur
Silver gilt with painted enamel on copper; teapot: h. 4½" (11.5 cm); tea caddy: 3⅞" (10 cm); sugar bowl: 1⅞" (5.1 cm); cup: 2" (5.3 cm); diam. of saucer: 3⅞" (10.1 cm)
Marks: Maker's mark, Augsburg

Provenance: Stroganoff collection, St. Petersburg; transferred to the Hermitage in 1925

By the 1690s tea and coffee had become very popular in Europe, but no special vessels for these new beverages had yet been designed. European masters working on tea and coffee services turned to Chinese porcelain wares for inspiration. At first such sets usually included a coffeepot or a teapot and a tea caddy, two sugar bowls, and cups, although the assortment of items later varied according to the customer's wishes. This service consists of a hexahedral teapot on a low foot, with a spout in the shape of a dragon and six enamel medallions on the

body, a tea caddy shaped like a flask, waisted in the upper part, a sugar bowl in the form of a covered oval box, and four cups with saucers. Some of the pieces bear labels inscribed in Russian: "Property of Countess Yu. P. Stroganoff. 1695–1700."

The well-known Augsburg jewelers of the Baur family had a kind of monopoly for producing tea and coffee services. Tobias Baur (c. 1660–1735), in particular, owned a large workshop where craftsmen of various professions—enamelers, engravers, and stonecutters—were employed. Notable examples of the workshop's output are services with agate and chalcedony insets now in the Munich Schatzkammer der Residenz and in the Staatliche Kunstsammlung in Kassel. **ML**

The State Hermitage Museum (E 9127–9132, 9137)

171. *Cabinet with a Clock*
German (Augsburg), 1700–1705
Johann Valentin Gevers (c. 1662–1737)
Wood, silver, tortoiseshell, ivory, bronze; h. 37⅜" (96 cm); stand: 31⅜ x 13" (80.5 x 33.5 cm)
Marks (on silver decoration): Maker's mark, Augsburg

Provenance: Stroganoff collection, St. Petersburg; transferred to the Hermitage in 1925

The upper part of the cabinet has a small clock with a bronze dial and a rotating wooden ball above it indicates the change of day and night. In the middle part, behind the hinged doors, are ten drawers decorated with pierced silver plates. Inside the doors are hexagonal oil paintings of amorous scenes. Silver reliefs decorate the outside surface of each door. At the foot is a large drawer with sockets for a toilet set, and below that is a rectangular sliding mirror. **ML**

The State Hermitage Museum (E 14937)

172. *Beaker*
German (Augsburg), 1708–10
Made by Esias II Busch (1641–1705)
Silver gilt with painted enamel on copper; h. 5⅛" (13.2 cm); diam. of top: 3½" (9 cm)
Marks: Maker's mark, Augsburg

Provenance: Stroganoff collection, St. Petersburg; transferred to the Hermitage in 1925

The body of this beaker has a copper sleeve of painted enamel that depicts *The Magnanimity of Alexander the Great (The Family of Darius and Alexander the Great),* which is based on Charles Lebrun's composition in the Galerie d'Apollon at the Louvre. This object and another one in the exhibition (cat. no. 173) are magnificent examples of the art of Augsburg goldsmiths and enamelers, which reached the height of its development in the first decades of the eighteenth century. Helmut Seling dates these pieces 1708–10, but

the style of Augsburg's hallmark suggests that they were done earlier.[1] ML

1. Helmut Seling, *Die Kunst der Augsburger Goldschmiede 1529–1868* (Munich, 1980), pl. xxiva.

The State Hermitage Museum (E 9200)

173. *Beaker*

German (Augsburg), 1708–10
Made by Esias II Busch (1641–1705)
Silver gilt with painted enamel on copper; h. 5⅛"
(13.2 cm); diam. of top: 3½" (9 cm), base: 3⅛"
(8.1 cm)
Marks: Maker's mark, Augsburg

Provenance: Stroganoff collection, St. Petersburg; transferred to the Hermitage in 1925

The body of this beaker has a copper sleeve of painted enamel that depicts *The Entry of Alexander the Great to Babylon* (see also cat. no. 172). Both tumblers attest to the jeweler's superb mastery of technique. The bright, saturated color scheme with deeper shades predominating and the assured draftsmanship betray the hand of a talented enameler. It was general practice for enamel artists to base their complex compositions on prints. The color scheme, however, was usually their own creation, and therefore a successful choice of colors and their harmonious combination depended entirely on the enameler's talent. ML

The State Hermitage Museum (E 9201)

ANTIQUITIES

CLASSICAL

MARBLE

174. *Head of a Goddess*

Italian, 18th century, from a Roman copy of a Greek example of 4th century B.C.
Marble; h. 103⅜" (265 cm)

Provenance: Stroganoff collection, St. Petersburg; transferred to the Hermitage in 1930

A female head is mentioned in the three inventories of the Stroganoff Palace—in 1884 as "an ancient female head of white marble" kept in the Palace Library (no. 9) and in the 1920 and 1922 inventories as "an antique stone head representing a woman with hair curled and parted."[1] According to the 1920 inventory, the sculpture was placed in the Raphael Room under no. 307 next to another female head (cat. no. 175), to which it closely corresponds. Datable to the modern times, this work is an excellent imitation of an antique piece. The modeling of the face and the hair follows a somewhat dry, classicizing manner of Roman copyists of the second century A.D. The condition of the surface, which bears numerous stains and crumbled areas, gives a convincing impression of authenticity, but, unlike well-known Roman prototypes, this work is more eclectic: it adapts at once two Hellenistic models produced by sculptors close to the circle of Praxiteles—the so-called large Herculanensis, a female statue of the Herculaneum type,[2] and the Aphrodite of the late Praxitelean style. Note also the unnatural asymmetry, which is never found in antique sculpture. The face is turned slightly to the right, whereas the position of the neck and bust is frontal.

It is remarkable that, although the head was carved of low-quality marble, it has survived without any serious damage. At the same time the entire surface of the face has apparently been treated with acid, and the lower part of the bust (its sides and back) bears crude traces of modern burins. Evidently, the bust was carved from a large block, probably to give the head an appearance of an ancient fragment.

It may be surmised that both female busts from the Stroganoff collection, which are variations of the same sculptural type, were produced in the same workshop. (Although this piece is an obvious, and successful, imitation modeled on several original examples, its counterpart is a Neoclassical version of an ancient prototype.) It is known that a similar sculptural type was popular in the antiquarian studio of the well-known Roman restorer Bartolomeo Cavaceppi. Selecting and restoring ancient pieces for the collection of Cardinal Alessandro Albani, Cavaceppi worked on a colossal bust of Aphrodite (now in the Capitoline Museum in Rome).[3] It is known that a marble copy of Aphrodite derived from an antique original was carved in Cavaceppi's studio.[4] It is likely that the ancient image inspired the master to create several purely decorative busts, which were extremely popular in the palatial interiors of the eighteenth century. AT

1. Archive of the State Hermitage Museum, fund 1, inv. s, file 55, f. 57, no. 9; fund 1, inv. Ô, file 49, f. 38, no. 307; fund 1, inv. X, file 51, f. 59, no. 445; fund 1, inv. Ô, no.19a, no. 2262.

2. Oscar Waldhauer, *Die Antiken Skulpturen der Ermitage*, vol. III (Berlin, 1936), p. 74, no. 334, pl. 85.

3. H. Stewart-Jones, *A Catalog of the Ancient Sculpture Presented in the Municipal Collections of Rome. The Sculptures of Museo Capitolino* (Oxford, 1912), no. 49, p. 122, fig. 31.4; W. Helbig, *Führer durch die offentllicher Sammlungen klassischer Altertumer in Rom* (Leipzig, 1891), p. 1235; *Lexicon iconographicum Mithiologiae Classicae* (Munich 1981), vol. II, no. 1068.

4. C. Caspari, O. Ghiandoni, *Lo Studio Cavaceppi e le collezioni Torlonia* (Rome, 1994), p. 215, pl. 17, fig. 279.

The State Hermitage Museum (A 903)

175. *Head of a Woman*

Italian, 18th century?, from a Roman copy of Greek example of 4th century B.C.
Marble; h. 16⅝" (43 cm)

Provenance: Stroganoff collection, St. Petersburg; transferred to the Hermitage in 1930

According to the 1920 inventory of the Stroganoff Palace, this piece was kept in the Raphael Room; the bust was also mentioned in the inventories of 1922 and 1925–26.[1] In all inventories it was listed as an antique work ("antique marble head of a young woman with a hair band"). For that reason, when the collection was transferred to the Hermitage in 1930, the sculpture entered the Department of Classical Antiquity. However, a careful study of the piece makes one question its authenticity. For example, the marble surface at the dividing line between hair and brow is treated smoothly and faultlessly, with no scratches or traces of patina. Similarly smooth are the outlines of the pupils and eyelids. These are traits not to be found in ancient Roman sculptures imitating the Greek type of female head dating from the fourth century B.C.; besides, the hair above the band fits the head more tightly in old Roman imitations, without forming a "pile" as in the present bust. The slightly swollen lips, not typical of Greek prototypes, and a marked affectation of the half-open mouth, which lend the face a somewhat infantile look, seem to be more characteristic of works by sculptors of a much later period.

Attention must be also paid to the fact that, although carved of a single block of marble, this bust has suffered very little damage and has survived as an integral unity almost without chips. The tip of the nose and the knot of hair piled up high were broken off and then put in place, probably deliberately, to enhance the impression of authenticity. With no hard evidence as to the provenance of this sculpture, we can only and with a great degree of reservation offer some suggestions, which rest on a comparison of this sculpture with the so-called Head of Artemis[2] that was purchased during the reign of Catherine the Great, in 1787, as part of the collection of the English banker Lyde Browne. Both pieces show a number of similarities in marble, state of preservation, and manner of execution. The Lyde Browne collection was formed in Italy in the 1750s and 1760s with the help of the English artists Thomas Jenkins and Gavin Hamilton, as well as the Italian sculptor and restorer Bartolomeo Cavaceppi,[3] who was also known to have produced imitations of antique sculptures.[4] In our opinion, both the Stroganoff head and its counterpart from the Lyde Browne collection could have been executed either by Cavaceppi himself or in his studio. The sculpture was most likely bought by Count Alexander Stroganoff during his travels around Italy in the 1750s or 1770s, when an interest in classical art was rather widespread and unscrupulous imitators could easily sell him such an "antiquity."

It is worth noting that such a well-known expert in antique sculpture as Oscar Waldhauer, the author of a three-volume catalogue of the Hermitage collection, did not include the Stroganoff bust in his comprehensive publication, although it had entered the Department of Clas-

sical Antiquity before he finished his work on the catalogue. It is probable that he doubted its authenticity. **LD**

1. Archive of the State Hermitage, fund 1, inv. s, file 49, f. 38, no. 306; file 51, f. 59, no. 444; file 19a, f. 211, no. 2261.

2. Oscar Waldhauer, *Die Antiken Skulpturen der Ermitage*, vol. III (Berlin, 1936), p.. 70, no. 327, figs. 73, 74.

3. O. Ya. Neverov, "Kollektsiya Laida Brauna (K istorii skulpturnogo sobraniya Ermitazha)" [The Lyde Browne Collection (on the History of the Hermitage's Sculptural Collection)], in *Trudy Gosudarstvennogo Ermitazha* [The Papers of the State Hermitage], no. 24, p. 5.

4. C. Casparo, O. Ghiandoni, *Lo Studio Cavaceppi e le collezioni Torlonia* (Rome, 1994), p. 214, fig. 279.

The State Hermitage Museum (A 1024)

176. *Fragment of a Double-Sided Relief*
Roman, second half 1st century A.D.
Marble; 13¼ x 9⅜" (34 x 24 cm)

Provenance: Stroganoff collection, St. Petersburg

This fragment is the right half of a composition belonging to the type of a pictorial relief called a pinax. A high-relief profile representation of the mask of Dionysus has survived on the front side, above the basket (cist) whose cover is shifted aside, allowing bunches of vine and leaves to issue from it. To the left of the cist an inclined thyrsus can be partially seen, and near the edge of a break is a round rim, probably of a tympanum. The reverse of the tablet bears a low-relief mask of a bald Silenus, with a beard and a moustache, placed on a rocky surface. This type of ancient relief is well known, thanks to the finds in Rome, Pompeii, and Herculaneum.[1] The use of the pinax varied, depending on its size—small pinaces were suspended like oscillae in the intercolumniations of a peristyle garden, while large ones, like the Stroganoff fragment, were installed in the garden on rectangular marble pylons about one meter high, decorated with a relief, mostly a vegetal pattern. Stationary pinaces constitute a rather extensive group of reliefs preserved in various collections. Among compositions incorporating a mask of Dionysus, there are two examples bearing a similar low-relief representation of a Silenus mask on the reverse—a marble pinax in the Uffizi Gallery with a mask in front of the *cista mysyica* placed on a rocky elevation,[2] and a pinax in the Capitoline Museum, with a lit torch near the mask.[3] Similar attributes also could have been depicted on the lost half of the Stroganoff relief.

The mask of Dionysus with a half-open mouth is treated here in the archaic style. The master who carved the relief did not drill a hole for an eye (a very simple technique in view of the marble-drilling technique widely used by this artist) and probably modeled his work on the famous sculptural type of Dionysus. However, stylistic analysis indicates that the Roman master eclectically combined the Greek sculpture's Archaic features, characteristic of the austere style and preserved in some works until the early 4th century B.C., and features characteristic of Roman copies produced in the similar austere style.[4]

If one compares various representations of Dionysus masks, one cannot help but note a great affinity between all of them. The Stroganoff piece is distinguished by virtuoso modeling of the openwork diadem, the strings of beads, the rosettes, and the curls. Thanks to the publications of H.-U. Cain,[5] who has systematized Roman pinaces, the Stroganoff relief, which is close in its stylistic features and iconography to a piece in the Museo Nazionale in Rome, can be put into a group of similar works found in Rome and its environs and supposedly created in the same Roman studio. **AK**

1. H.-U. Cain, "Chronologie, Ikonographie und Bedeutung der romischen Maskenreliefs," *Bonner Jahrbucher*, vol. 188 (1988), pp. 107–221; E. Dwyer, "Pompeiian Oscilla Collections," *RM*, vol. 8, no. 2 (Fasz, 1981), pp. 255–56, 285–88, pls. 128–30; A. Maiuri, *Ercolano* (Rome, 1936), pp. 349–51, fig. 282.

2. G. A. Mansuelli, *Galleria degli Uffizi. Le Sculture*, part I (Rome, 1958), p. 192, no. 181, pl. 181a, b.

3. D. Mustilli, *Il Museo Mussolini* (Rome, 1939), p. 52d, pl. xxxv, pp.146, 147.

4. A. V. Kruglov, "Arkhaisticheskiye relyefy v kollektsii Ermitazha" [Archaic Reliefs in the Hermitage Collection], *VDI* [Herald of Ancient Art], no. 4 (1991), pp. 218–21.

5. H.U. Cain, "Chronologie," cat. no. 82, figs. 41–42, cat. nos. 79, 86, 87, 91, pp. 139 ff.

The State Hermitage Museum (A 884)

TERRA COTTA

177. *Canopic Vase Cover*
Etruscan (Clusium, Chiusi), second half 6th century B.C.
Terra cotta; 9¾" (25 cm)

Provenance: Stroganoff collection, St. Petersburg; transferred to the Hermitage in 1926

This male head (hollow, with a round aperture for firing at the top) which served as a cover for a canopic vase (funerary urn) is executed in a generalized manner, not depriving it, however, of individual features. The hair curls, the beard, and the moustache are rendered by engraving. **YeKh**

O. Neverov, "Terrakotovaya golova-Ckryshka ilaliyskoi urny" [A Terra-Cotta Head—The Cover of an Italic Urn], *Soobshcheniya Gosudarstvennogo Ermitazha* [Reports of the State Hermitage], no. 27 (Leningrad, 1966), p. 39.

Kultura i iskusstvo Etrurii [The Culture and Art of Etruria], exh. cat. (Leningrad, 1972), p. 59, cat. no. 174.

Antichnaya koroplastika. Gosudarstvenny Ermitazh [Antique Kore Sculpture: The State Hermitage], exh. cat. (Leningrad, 1976), p. 78, cat. no. 237.

The State Hermitage Museum (G 1489)

178. *Antefix Shaped like a Gorgoneion in the Shell*
Etruscan or Campanian, late 6th–early 5th century B.C.
Terra cotta; h. 13¼" (34 cm)

Provenance: Stroganoff collection, St. Petersburg; transferred to the Hermitage in 1926

The painting on this vase was restored in the nineteenth century. **YeKh**

Kultura i iskusstvo Etrurii [The Culture and Art of Etruria], exh. cat. (Leningrad, 1972), p. 59, cat. no. 171.

Antichnaya koroplastika. Gosudarstvenny Ermitazh [Antique Kore Sculpture: The State Hermitage], exh. cat. (Leningrad, 1976), p. 78, cat. no. 238.

The State Hermitage Museum (G 1524)

179. *Votive Female Head*
Etruscan, first half 5th century B.C.
Terra cotta; h. 11½" (29.5 cm)

Provenance: Stroganoff collection, St. Petersburg; transferred to the Hermitage in 1926

The head is hollow, open below, and covered with a complex headgear consisting of a band, myrtle wreath, and diadem. On the neck are a smooth ring and a bulla (a memorial case with an amulet) on a thin cord. This is a rare example of early votive sculpture. **YeKh**

Kultura i iskusstvo Etrurii [The Culture and Art of Etruria], exh. cat. (Leningrad, 1972), pp. 60, 59, cat. no. 175.

Antichnaya koroplastika. Gosudarstvenny Ermitazh [Antique Kore Sculpture: The State Hermitage], exh. cat. (Leningrad, 1976), p. 78, cat. no. 241.

Die Welt der Etrusker. Archäologische Denkmäler aus Museen der sozialistischen Länder (Berlin, 1988), p. 289, fig. 3.2.

The State Hermitage Museum (G 1488)

180. *Black-Figure Hydria-Kalpis*
Attica, c. 500 B.C.
Terra cotta; h. 13¼" (34 cm)

Provenance: Gift of Count Grigory S. Stroganoff to the Imperial Society for the Encouragement of the Arts, St. Petersburg; transferred to the Hermitage in 1930

The vase by the Eucharides Painter is undamaged, with minor traces of wear. Some details are highlighted with purple. A belt of palmettes runs in the area of the horizontal handles. The small metope on the shoulder is occupied by the scene of Hercules fighting the Cretan bull. **LU**

AA, vol. 45 (1930), pp. 27–29, pls. 7–8.

The State Hermitage Museum (G 5571)

181. *Red-Figure Skyphos*
Attic, c. 460 B.C.
Terra cotta; h. 6⅞" (17.7 cm)

Provenance: Sergei G. Stroganoff collection, St. Petersburg; transferred to the Hermitage in 1926

The edge of the foot is composed of fragments glued together; the surface is slightly worn. One handle is horizontal and the other is vertical. There is a double palmette under each of them;

the vertical handle is adorned with a lotus flower. The painter of this skyphos is the so-called Penthesilea Painter. The two scenes on the vase include the following figures:

(A) A hetaera (courtesan) and a man who is offering his purse to her with his right hand and is holding a coin in his left hand. The scene is set inside a house (note a lekythos hanging on the wall). At either side of the group is an inscription (in Greek): "the beautiful youth."

(B) A hetaera and a youth resting on a stick: she offers him a lekythos with incense. The same inscription is given twice. **LU**

A. Peredolskaya, *Krasnofigurnye atticheskiye vazy v Ermitazhe* [Red-Figure Attic Vases in the Hermitage] (Leningrad, 1967), no. 151, pls. 106, 107, 2, 177, 4–7.

J. D. Beazley, *Attic Red-figure Vase-painters (Oxford, 1942)*

The State Hermitage Museum (G 4224)

182. *Red-Figure Crater, with a Naked Warrior*
Southern Italian (Campania), c. 350 B.C.
Terra cotta, h. 6¾" (17.5 cm)

Provenance: Stroganoff collection, St. Petersburg; transferred to the Hermitage in 1926

The state of preservation includes minor chips along the edge of the rim and foot; small indentations on the body; traces of lacquer and paint wear in some places; and a deep crack in the bottom, which developed during manufacture.

This small bell-shaped crater has on the front a depiction of a naked youth bending down, his right foot on a boulder. He is holding a spear in his right hand, while his left hand rests on a shield that lies on the ground. On either side of the crater is a large fan-shaped palmette framed with voluted petals.

The crater was decorated by the Cassandra Painter, who owes his nickname to the vase found in Capua and housed there that depicts Cassandra seeking salvation from Ajax' importunities at the altar of Athena. The Cassandra Painter was not only an outstanding artist at the end of the first half of the fourth century B.C., but also the founder of the ceramic school known as the Capuan School I. He exerted a marked influence on Capuan vase painters of his time and also on numerous artists of the second half of the fourth century B.C. The crater showing the young naked warrior is a fine work produced by an eminent master; it reflects the characteristic features of his artistic style, such as the elegance and precision of drawing, skillful proportions, and elaborate decorative design. **YeA**

The State Hermitage Museum (G 4159)

183. *Black-Lacquer Hydria*
Southern Italian (Campania),
late 4th century B.C.
Terra cotta; h. 11⅜" (29 cm)

Provenance: Stroganoff collection, St. Petersburg; transferred to the Hermitage

The condition of this unpublished hydria includes minor chips along the edge of lip and stand; tiny indentations on the body; a deep scratch on the front, under the garland; two small holes through the back; and a painted-over lip.

Southern Italian craftsmen of the third and fourth centuries B.C. manufactured black-lacquer fluted vases, mostly hydrias, oinochoes, and pelikes, modeling them on Attic examples and striving to preserve their elegance of shape and harmony of proportions. The neck of the vessel could bear either a gilded ornamental frieze resembling a necklace of jewels or a gilded twig with fruit. The rim of the hydria's lip as a rule was left unpainted (the chromatic intensity of clay's natural color was enhanced by brown-red slip), while the rim flange was adorned with a three-dimensional belt of egg-and-dart design and sometimes gilded. The flange of the Stroganoff hydria is decorated with a wave pattern, which was very popular in Southern Italian vase painting. This decoration was discovered by a restorer in the course of cleaning the painted lip rim of the hydria at a spot near the vertical handle. When and where it was painted is unknown. **YeA**

The State Hermitage Museum (G 4162)

184. *Architectural Relief*
Roman, 1st century A.D.
Terra cotta, with mica insertions; 18⅞ x 19⅞" (48.5 x 51 cm)

Provenance: Stroganoff collection, St. Petersburg; transferred to the Hermitage in 1926

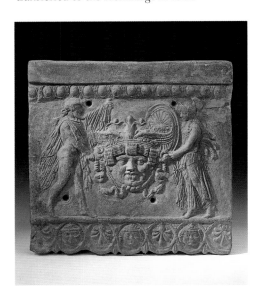

This relief has four holes for fixing the relief on a wall. The central field features Perseus and Athena holding the head of the Gorgon Medusa. The composition is bordered by an egg-and-dart frieze above and by a frieze of masks of the Gorgon Medusa alternating with palmettes below.

This example illustrates the archaizing style in Roman decorative art. **YeKh**

E. Khodza, "Dekorativny terrakotovy relyef" [A Decorative Terracotta Relief], *Soobshcheniya Gosudarstvennogo Ermitazha* [Reports of the State Hermitage], no. 29 (Leningrad, 1974), pp. 36–39.

Antichnaya koroplastika. Gosudarstvenny Ermitazh [Antique Kore Sculpture: The State Hermitage], exh. cat. (Leningrad,1976), p. 96, no. 289.

The State Hermitage Museum (G 1526)

BRONZES

185. *Pectoral with Pendants*
Italian (Piceno), 7th–6th century B.C.
Bronze; l. 8⅝" (22 cm)

Provenance: Stroganoff collection, St. Petersburg; transferred to the Hermitage in 1926

This rectangular plate with pendants in the shape of cylinders extending downward and hanging on chains served as a breast decoration, or pectoral. Its main part consists of two riveted plaques decorated with a chased dotted ornament. Double spirals of thin wire are attached to the upper part of the plaque. The pendants are made of sheet bronze. Several volutes in the upper part are missing. **NPG**

Antichnaya khudozhestvennaya bronza [Antique Bronzes], exh. cat. (Leningrad, 1973), p. 54, cat. no. 121.

The State Hermitage Museum (B 1935)

186. *Etruscan Torch*
Etruscan, 7th–6th century B.C.
Bronze; l. 14⅞" (38.2 cm)

Provenance: Stroganoff collection, St. Petersburg; transferred to the Hermitage in 1926

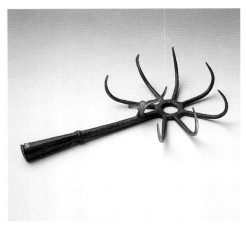

This unpublished Etruscan torch made in the form of a hollow faceted rod tapering upward is topped with a ring from which seven crooked teeth are diverting radially. A protrusion with two hooks is on the rod under the ring. In the lower part of the rod is a rollerlike narrow belt ensuring a firmer grip. The tip of one tooth is broken off. **NPG**

The State Hermitage Museum (B 1913)

187. Rod Finial: Half-length Female Figure
Etruscan, 6th century B.C.
Bronze; h. 3¾" (9.6 cm); with rod: 5⅜" (14 cm)

Provenance: Stroganoff collection, St. Petersburg; transferred to the Hermitage in 1926

The purpose of this rod is not clear. It is massive, with freely rotating hinges and plates, and crowned with a half-length female figure. The woman in a tight-fitting chiton stands in a frontal position, her hands on her hips. Her head is adorned with a diadem; the long hair falls down her shoulders and back. The face is rendered in the Archaic style. The massive plates bear signs in relief (probably letters). The tip of the nose is broken off. **NPG**

Kultura i iskusstvo Etrurii [The Culture and Art of Etruria], exh. cat. (Leningrad, 1972), p. 26, cat. no. 47.

The State Hermitage Museum (B 1902)

188. Lion
Italian (Vulci), second half 6th century B.C.
Bronze; l. 4⅜" (12 cm)

Provenance: Stroganoff collection, St. Petersburg; transferred to the Hermitage in 1926

The lion is shown seated with an open mouth, his tongue hanging out. Its paws are treated in a generalized manner and almost merge into a hardly discernible mass. The mane is rendered by a number of overlapping waves with incisions along the edge. The lion's tail is coiled up. On the neck, under the mouth, are two holes. **NPG**

Antichnaya khudozhestvennaya bronza [Antique Bronzes], exh. cat. (Leningrad, 1973), p. 64, cat. no. 170.

The State Hermitage Museum (B 1916)

189. Hercules
Italian (Oscan Campania), mid 4th century B.C.
Bronze; h. 11⅜" (29 cm)

Provenance: Sergei G. Stroganoff collection, St. Petersburg; transferred to the Hermitage in 1926

The naked Hercules is shown standing with his right leg slightly to the side. His right arm is raised; the left, with a lion skin thrown over it, is lowered. The muscles of his body are rendered in a generalized yet expressive manner. The expression of his beardless, elongated face framed with short hair is calm and severe. The left foot and an object held in his right hand are missing. **NPG**

Antichnaya khudozhestvennaya bronza [Antique Bronzes], exh. cat. (Leningrad, 1973), p. 59, cat. no. 145.

The State Hermitage Museum (B 1804)

190. Hercules
Etruscan, 4th century B.C.
Bronze; h. 7⅞" (20.3 cm)

Provenance: Sergei G. Stroganoff collection, St. Petersburg; transferred to the Hermitage in 1926

The beardless Hercules is standing in a tranquil pose. He wears the lion's skin like a cloak; the lion's head forms a kind of a helmet, and its paws are tied on his breast with the lower part of the skin draped around his left arm. Hercules' body is modeled with a crude expressiveness. The lion's hair is designated with roughly engraved lines. The right hand is supported by a rod; the object it originally held is missing. **NPG**

Kultura i iskusstvo Etrurii [The Culture and Art of Etruria], exh. cat. (Leningrad, 1972), p. 30, cat. no. 62.

Antichnaya khudozhestvennaya bronza [Antique Bronzes], exh. cat. (Leningrad, 1973), p. 60, cat. no. 151.

Die Welt der Etrusker. Archäologische Denkmäler aus Museen der sozialistischen Länder (Berlin, 1988), p. 276, cat. no. D 2. 41.

The State Hermitage Museum (B 1887)

191. Vessel in the Shape of a Female Head
Etruscan, 4th–3rd century B.C.
Bronze; h. 4⅜" (11.2 cm)

Provenance: Stroganoff collection, St. Petersburg; transferred to the Hermitage in 1926

The hair on the back of the woman's head is brought together to form a knot and tied with a band; the ears are decorated with vase-shaped earrings. The tip of the head has an extension with two loops to which chains for suspending the vessel were attached. A third chain was fixed to the plug of the vessel. The chains, bottom, and plug have not survived. **NPG**

Kultura i iskusstvo Etrurii [The Culture and Art of Etruria], exh. cat. (Leningrad, 1972), p. 38, cat. no. 104.

Antichnaya khudozhestvennaya bronza [Antique Bronzes], exh. cat. (Leningrad, 1973), pp. 66–67, cat. no. 182.

Die Welt der Etrusker. Archäologische Denkmäler aus Museen der sozialistischen Länder (Berlin, 1988), p. 269, fig. D 7.

The State Hermitage Museum (B 1954)

CARVED GEM

192. Scaraboid with Representation of a Warrior
Ionian (workshop of Hellenizing gems), 4th century B.C.
Stone; 1¼ x 1⅞" (2.9 x 2.2 cm)

Provenance: Stroganoff collection, St. Petersburg; transferred to the Hermitage in 1926

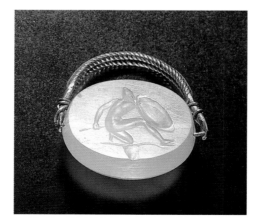

This scaraboid belongs to the so-called Greco-Persian type of gems. It depicts a kneeling naked warrior with a shield and spear who has probably been defeated by a mounted Persian warrior. The Ionic master must have fulfilled the wish of his Persian commissioner. **ON**

The State Hermitage Museum (Zh 574)

LATE-ANTIQUE SILVER

193. Dish: Ajax Quarreling with Odysseus about Achilles' Armor
Asia Minor, 6th century
Silver; diam. 10⅜" (26.6 cm)

Provenance: Found near the village of Sludka, Perm Province, in 1780; Stroganoff collection, St. Petersburg; transferred to the Hermitage in 1926

This silver dish, found together with a Byzantine dish of a horse under a tree and Sasanian dishes, depicts a scene from Homer's *Trojan War* in which Ajax and Odysseus quarrel about Achilles' armor, which can be seen in the lower part of the dish. The dish bears no marks; the reverse side is embellished with grapevine scrolls, birds, and fruits, identical in design to that on the reverse side of a plate depicting the dispute of philosophers (now in the J. Paul Getty Museum).[1] In the center of the dish is the enthroned Athena, who is trying to stop the quarrel. Her left hand is raised up to bless Ajax, who stands at her side. This dish is a typical example of the so-called Byzantine antiques, although, according to Kurt Weitzmann,[2] the scene on the Hermitage dish deviates from the antique model. The dish in question is a characteristic example of *pasticcio,* a Byzantine imitation of an antique object.

The figure of the shepherd in the background is to be found neither in Homer nor in the works of the Cyclic Poets, but Quintus of Smyrna (4th–5th century A.D.) uses a shepherd narrator for his poem about the Trojan War,[3] including an episode devoted to the dispute about the arms of Achilles. Quintus' poem was popular in Byzantium and was used for educational purposes, taking the place of the forgotten works of Homer and the Cyclic Poets,[4] and may be the source for the Hermitage dish. A similar shepherd, also placed apart from the main composition, can be found in the top left part of a dish showing Bellerophon and Pegasus (Musée d'Art et d'Histoire, Geneva).[5] Since the poem by Quintus of Smyrna also describes the episode with Bellerophon,[6] it seems clear that the shepherd in this composition goes back to this poem.

The Geneva dish is dated to the sixth century. Its reverse, like the reverse of the Hermitage dish, has no assay marks. Taking into consideration all we know about silver marks in sixth-century Byzantium, we have every reason to believe that both vessels were produced somewhere outside the city, possibly in the same pro-

duction center, as they were made during the same period and were based on the same literary source. We suggest that both dishes illustrating episodes from a poem written in Smyrna were manufactured in a seaside town in Asia Minor, where the output of local silversmiths showed a close affinity to that of Byzantium. **VZ**

1. A. Cutler, *The Disputed Plate in the J. Paul Getty Museum and Its Cinquecento Context* (Malibu, 1986), pp. 1–37.

2. K. Weitzmann, "The Survival of Mythological Representations in Early Christian and Byzantine Art and Their Impact on Christian Iconography," *Dumbarton Oaks Papers*, no. 14 (1960), pp. 46–49.

3. A. Zimmerman, ed., *Quinti Smyrnaei Posthomericorum*, Book 14 (Lipsiae, 1891), vol. 12, p. 310.

4. *Tusculum-Lexikon griechischer und lateinischer Autoren des Altertums und des Mittelalters* (Munich, 1963), p. 129.

5. M. Lozovic, et al., *Objets byzantins de la collection du Musée d'art et d'histoire*, vol. XXV (Geneva, 1977), pp. 8–9, fig. 5.

6. *Quinti Smyrnaei, Op. cit.*, vol. 10, p. 162.

The State Hermitage Museum (S 279)

194. *Dish: A Royal Banquet*

Eastern Iran (Merv?), early 9th century
Silver; diam. 10⅛" (26 cm), d. 1¼" (3.1 cm)

Provenance: Found before 1860; bought by Sergei G. Stroganoff from a dealer in St. Petersburg; inherited by Princess M. G. Shcherbatova; given to the Hermitage in 1911

When Count Sergei Stroganoff bought this dish depicting a royal banquet, another example, depicting a hunting scene in the same manner and probably part of the same find, was acquired for the Hermitage. The Stroganoff dish shows a king crowned with a diadem and seated on a throne supported by two lions and covered with a luxurious carpet. The king is surrounded by servants and musicians. This is the earliest example of a royal reception scene belonging to Islamic iconography and is typical of the ninth to thirteenth century. Its style combines Sasanian and Central Asian (Sogdian and Tokharistanian) elements. The carpet's ornamental design also betrays a Chinese influence. The dish was most likely produced in the early ninth century in Merv, where the future khalif Mamun, the son of Harun al-Rashid (known as a character from *The Arabian Nights*) ruled. That was a period of Mamun's rivalry with his brother Amin (808–817), who stayed in Baghdad. Mamun leaned for support on the Persian and Central Asian nobility, which preserved pre-Islamic traditions and regarded their sovereign as a successor of the Sasanians.

On the outer surface of the dish there are a few barely visible drawings scratched by the inhabitants of the northern part of the Kama River or Ob River regions in the ninth to eleventh century: a man wearing a "crown" with three triangular projections, a man with the head of a beast, a "dancer," a wolf, and a deer. **BM**

Ya. I. Smirnov, *Vostochnoye serebro* [Oriental Silverware] (St. Petersburg, 1909), fig. 64.

I. A. Orbeli and K.V. Trever, *Sasanidsky metall* [Sasanian Metalware] (Moscow/Leningrad, 1935), pl. 18.

B. I. Marshak, *Silberschätze des Orients. Metallkunst des 3.–13. Jahrhunderts und ihre Kontinuität* (Leipzig, 1986), pp. 50, 51, 57, 65, 76–79, 84, 93, 94, 303, 304; figs. 30, 32, 33.

The State Hermitage Museum (S 4)

195. *Dish: King Hunting a Tiger*

Sasanian Iran, 7th century
Silver with niello; h. 1⅜" (3.6 cm); diam. 9¾" (25 cm)
Owner's inscription on outside (in Middle Persian): "Weight 244 [drachmae, or 64 staters]. Property of Perozan"

Provenance: Found in Maltsevo, Perm Province; bought by A. B. Teploukhov for Sergei G. Stroganoff in 1878; transferred to the Hermitage in 1925

The dish, found by a peasant, I. V. Plotkin, plowing his field in the village of Maltsevo, Perm Province, was bought for Count Sergei Stroganoff, together with five other silver pieces: three Byzantine dishes manufactured in 613–30, a seventh-century Sogdian jug featuring a winged camel, and a seventh-century Sasanian dish with the eagle tearing apart an antelope. All six objects come from the same hoard and are now in the Hermitage. The dish with a king hunting a tiger is of great historical and artistic interest, as it reveals more graphically than other silver vessels the typical features of the late Sasanian style. The conventional treatment of proportions, such as the large square head with huge eyes, and the precise rendition of minute details of the clothing and equipment (particularly representative are the three pendants at the collar) give grounds for dating the dish to the first half of the seventh century.

Here, as on other dishes representing hunting scenes, the beast is shown twice, alive and killed. The mounted hunter is portrayed in royal attire, but the absence of the crescent—a necessary element in the ruler's diadem since the fifth century—suggests that he may be the king of a section of the country but not the king of kings of all Iran. **BM**

Ya. I. Smirnov, *Vostochnoye serebro* [Oriental Silverware], (St. Petersburg, 1909), fig. 60.

I. A. Orbeli and K.V. Trever, *Sasanidsky metall* [Sasanian Metalware] (Moscow/Leningrad, 1935), pl. 15.

K. V. Trever and V.G. Lukonin, *Sasanidskoye serebro. Sobraniye Gosudarstvennogo Ermitazha* [Sasanian Silverware from the Collection of the Hermitage] (Moscow, 1987), pp. 80, 121, 123, 142, cat. no. 11, pls. 22, 23.

The State Hermitage Museum (S 13)

MEDIEVAL ART

196. *Three Plaques with Christ between Saints Peter and Paul and Two Apostles*

Southern German, first half 12th century
Ivory; 3⅛ x 2¼" (8.2 x 5.6 cm); 1⅜ x 2⅛" (3.7 x 5.3 cm); 1⅜ x 2¼" (3.7 x 5.7 cm)

Provenance: Stroganoff collection, St. Petersburg; transferred to the Hermitage in 1925

Portable altars, often combining ivory with metal and enamels, were widespread in Germany from the end of the eleventh century, and it is from one of these altars that these plaques probably came. The large plaque would have been attached either to the center of the front wall or on the side, with the others arranged along the perimeter, along with eight other reliefs depicting the remaining apostles. Another plaque from this group, purchased in Vienna in 1886 from the Stieglitz collection, is in the Hermitage (F 3191), the location of the others is unknown. The altar was probably broken up a little before 1886, making the plaques available to be acquired by both Sergei and Grigory Stroganoff.

These are among the most interesting examples of Romanesque ivory work. Very close in style, but probably earlier, are the reliefs from a book cover in the Bavarian State Library, Munich (Clm 15713), which were also originally attached to a portable altar but formed part of a more detailed program. Scholars have also noted a certain similarity between these plaques and the works of Master Rogier of Helmarshausen, but for all the confidence and decorative nature of the drawing typical of both artists, the images of the latter are more majestic and calm, while in the Hermitage reliefs we sense greater tension and inner dynamism, probably deriving from the works of a master from Echternach. **MJK**

The State Hermitage Museum (F 1041, 1042, 1043)

197. *Reliquary Chasse with Christ, Angels, and Saints*

French (Limoges), late 12th century
Champlevé enamel on copper, wood carcass; 10⅛ x 7⅞ x 3½" (26 x 20.2 x 9.1 cm)

Provenance: Grigory S. Stroganoff collection, St. Petersburg; donated to the Imperial Society for the Encouragement of the Arts, St. Petersburg, 1870s; transferred to the Hermitage in 1919

The Hermitage curator Alfred Kube doubted the medieval origin of this reliquary and moreover considered its crest a modern addition. However, the quality of metalwork—its engraved designs and applied relief—and the close affinity of the piece to the best specimens of Limoges in its heyday, as well as its perfect conformity with the peculiarities of the Romanesque style, allow us to date the reliquary to the late twelfth century.

The reliquary's iconography is quite unusual: Christ is shown on the front roof plaque only, while the primary place, in the center of the front side, is given to the figure of a saint carrying a palm. In the catalogue of the Society for the Encouragement of the Arts this figure is identified as Christ, but the absence of the cruciform nimbus contradicts this opinion and suggests that the choice of the saint was stipulated by the commissioner of the reliquary. **MJK**

The State Hermitage Museum (F 1459)

198. *Reliquary Chasse with Christ in Glory, Saints, and the Crucifixion*
French (Limoges), 1190–1210
Champlevé enamel on copper, wood carcass; 7⅜ x 8⅝ x 3½" (19 x 22.2 x 9.1 cm)

Provenance: Grigory S. Stroganoff collection, St. Petersburg; donated to the Imperial Society for the Encouragement of the Arts, St. Petersburg, 1870s; transferred to the Hermitage in 1919

This is a good example of Limoges enamels of the late twelfth to early thirteenth century, with finely modeled figures on a background of blue enamel. In its general character as well as in the ornaments on its borders, the reliquary is close to cat. no. 197. Apart from similar iconography, these articles have the same green cross in the Crucifixion scene and the same green leaves on end panels. **MJK**

The State Hermitage Museum (F 1460)

199. *Five Arched Plaques with Inscriptions and Ornaments*
German (Cologne), late 12th–early 13th century
Champlevé enamel on copper; w. 3⅛", 3⅛", 3⅜", 3½", 3⅞" (8, 8, 8.8, 9, 10.2 cm)
Inscriptions: S.MAVRICV; S.MARTYR; S.ANCTVS.S. ANCTORVM

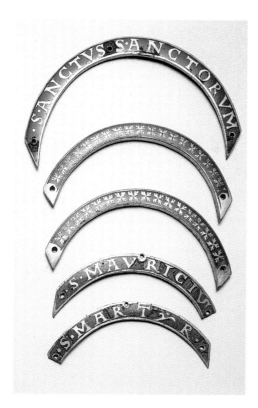

Provenance: Baur collection, Paris, 1867; Grigory S. Stroganoff collection, St. Petersburg in the 1870s; donated to the Imperial Society for the Encouragement of the Arts; transferred to the Hermitage in 1919

These plaques represent varied fragments from reliquary chasses of the late twelfth or early thirteenth century found in the valleys of the rivers Rhine (mainly in Cologne) and Maas. Museums in Paris, Darmstadt, and Cologne have many different details, including some with inscriptions, taken from the same reliquaries, which seem to have been dismantled in the 1860s, but their provenance has not been precisely identified. The Hermitage pieces, to judge by the form, color, and quality of the enamel, derive from three different reliquaries. The plaques that bear inscriptions seem to have been made in a small secular workshop by illiterate craftsmen, since in the word S.MARTYR (holy martyr) the letter y bears little likeness to a letter at all and was probably not understood by the craftsman, while on the large piece, in both words of S.ANCTVS.S.ANCTORVM (the holiest of holies) there are dots after the initial letter S, indicating that the author was copying a model and understood the inscription as the names of Saint Anctus and Saint Anctorum. This kind of error would have been impossible if the plaques had been produced by a monk.

In the catalogue of the Society for the Encouragement of the Arts these works were dated to the thirteenth and fourteenth centuries, but they seem in fact to date to the end of the twelfth. The arched plaques decorated with ornament are of higher quality, and the type of ornament itself, in the form of gold rosettes, dates to the early thirteenth century. It is found, for instance, in the Shrine of the Three Kings by Nicolas of Verdun, which makes it likely that these Hermitage plaques were produced in his workshop. **MJK**

The State Hermitage Museum (F 1443, 1444, 1445, 1446, 1447)

200. *Reliquary Plaque with the Crucifixion and Two Saints*
French (Limoges), 1200–1210
Champlevé enamel on copper; 3⅝ x 6⅝" (9.2 x 16.9 cm)

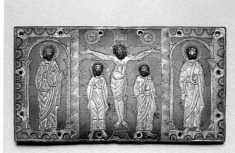

Provenance: Sergei Stroganoff collection, St. Petersburg; donated to the Imperial Society for the Encouragement of the Arts, St. Petersburg, 1870s; transferred to the Hermitage in 1919

This typical example of the Limoges school of the late twelfth–early thirteenth century shows a similar approach in the treatment of figures as on a plaque in the Musée des Arts Décoratifs in Paris, on a casket in Tulle Cathedral, and on another Hermitage piece (F 1460). **MJK**

The State Hermitage Museum (F 1420)

201. *Top of a Crozier*
Italian, 13th century
Ivory; h. 10⅛" (26 cm)

Provenance: Grigory S. Stroganoff collection, St. Petersburg; donated to the Imperial Society for the Encouragement of the Arts, St. Petersburg, 1870s; transferred to the Hermitage in 1919

This piece once topped the simplest type of crook-shaped pastoral staff once widespread in Italy. The painted birds on the stem brings to mind patterns on early Italian textiles, while the dragon head shows an affinity with the monsters decorating crooks of the exuberantly carved Italian croziers of the thirteenth and fourteenth centuries. Along the volute is the text of the Ave Maria prayer. **MJK**

The State Hermitage Museum (F 3578)

202. *Triptych with the Virgin and Child and Angels*
Northern French?, first third 14th century; wood frame 19th century
Ivory; 12¾ x 11⅛" (32.7 x 28.5 cm)

Provenance: Piotr S. Stroganoff collection, St. Petersburg, 1868; transferred to the Hermitage in 1925

An interesting trend in the "post-Soissons style" is seen in a number of reliefs with exaggeratedly refined figures that continue the tendency toward elongated proportions and free vertical drapery typical of the group known as Workshop of the Soissons Diptych. The Hermitage triptych, which differs from the latter group only in that the Virgin is shown seated rather than standing, should nevertheless be connected with those reliefs. The seated pose was far more rarely used in medieval folding altarpieces than in sculpture in the round, probably because of the elongated vertical format of Gothic plaques and because of the difficulty involved in conveying in relief the seated figure viewed head-on. This master coped superbly with the task, however, and his work is also notable for its elegant silhouettes, flowing natural folds, and confident carving stylistically typical of works from the first half of the fourteenth century. Although the elongation of the figure and the arrangement of the angels' wings are closer to the mid-fourteenth century, the simple arches, the robe that envelops the right elbow, the wings themselves with their elastic contours, and the unusual fanlike depiction of feathers permit us to date the triptych to the first third of the century. At the same time the rare depiction of the robe thrown across the

Virgin's knees from left to right is not found in the works of Parisian carvers, and this suggests a different origin, possibly the north of France. **MJK**

The State Hermitage Museum (F 1048)

203. *Diptych with the Annunciation, the Nativity, the Adoration of the Magi, and the Crucifixion*
French, mid-14th century
Ivory; 3⅞ x 3⅞" (10.1 x 10 cm)

Provenance: Stroganoff collection, St. Petersburg; transferred to the Hermitage in 1925

This diptych represents a typical example of the carving technique of French craftsmen. The nearest analogues are the diptychs from the Louvre and the former Kofler-Truniger collection in Lucerne. The quatrefoil framing of the scenes frequently occurs in different monuments of fourteenth-century French art. **MJK**

The State Hermitage Museum (F 1518)

204. *Diptych with the Nativity and the Crucifixion*
Flemish?, second half 14th century
Ivory, with traces of gilding and painting; 2⅞ x 4⅛" (7.4 x 10.6 cm)

Provenance: Stroganoff collection, St. Petersburg; transferred to the Hermitage in 1925

Although typical of carved ivory pieces of the second half of the fourteenth century in its iconography and pictorial manner, this diptych stands out owing to a peculiar trait: the representation of Christ's abdomen in the shape of an encircled quatrefoil. The provenance of the articles sharing this feature remains uncertain, art historians suggesting France, Germany, or Flanders. In our opinion, this trait provides sufficient evidence for their coming from the same workshop. As for the country, this is a matter for further research. **MJK**

The State Hermitage Museum (F 1039)

205. *Processional Cross with the Crucifix*
Italian (Venice?), 15th century
Rock crystal, copper gilt; h. 23¾" (61 cm)

Provenance: Stroganoff collection, St. Petersburg; donated to the Society for the Encouragement of Artists, St. Petersburg, 1871; transferred to the Hermitage in 1929

Rock crystal was highly valued by medieval jewelers. The art of stone polishing had long been known in Italy, especially in Venice, where the production of rock-crystal crosses, monstrances, and vessels of any kind started as early as the thirteenth century. The metal knops along the edge of the cross are also a typically Italian feature. **MJK**

The State Hermitage Museum (F 1564)

206. *Triptych with the Crucifixion and Saints*
Italian (Embriachi workshop, Venice), 1420s–40s
Bone, wood; 14⅛ x 9⅜" (36 x 24 cm)

Provenance: Grigory S. Stroganoff collection, St. Petersburg; donated to the Imperial Society for the Encouragement of the Arts, St. Petersburg; transferred to the Hermitage in 1919

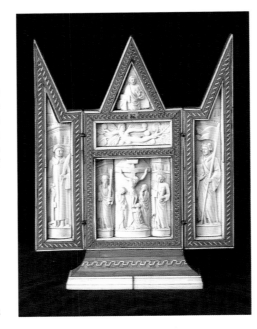

This triptych was produced at a prominent Venetian workshop where several generations of bone carvers from the Embriachi family worked during the fifteenth century. The nearest parallel is the triptych from the Reiner Winkler collection, with the Crucifixion in its central panel and the figures of the apostles Peter and Paul in its side leaves. The Hermitage triptych, however, has other saints represented on the leaves, while Peter and Paul appear on the central panel flanking the Crucifix. According to Theuerkauff,[1] a certain roughness of execution suggests that the Winkler triptych can be dated to the 1420s–40s. The composition and stylistic features of the Hermitage piece bear, despite minor differences, a close affinity to the Winkler triptych, which suggests that it belongs to approximately the same date. **YeSh**

1. Ch. Theuerkauff, *Elfenbein: Sammlung Reiner Winkler* (Elfenbein, 1994), no. 16.

The State Hermitage Museum (F 1506)

ANCIENT AMERICAN ART

207. *Figurine of a Standing Man*
Mexican, late 1st millennium B.C.
Jade; h. 4⅝" (12 cm)

Provenance: Stroganoff collection, St. Petersburg

The iconography of this figurine has much in common with that of artifacts made by the

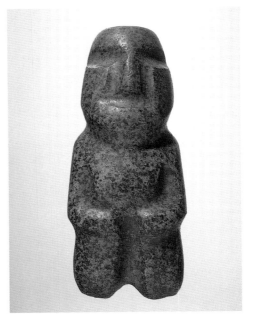

Olmec people, who originated the earliest culture in Mexico, although it cannot be called a typical example of their art. Similar figurines were found in tombs, probably placed there during funerary rites, but what role the ancient Mexicans believed they played in the afterlife is not understood. **MD**

The State Hermitage Museum (DM 237)

208. *Mask*
Mexican (Teotihuacan), 5th–8th century
Jade, with obsidian insets; 5⅝" x 5⅞" (14.5 x 15 cm)

Provenance: Stroganoff collection, St. Petersburg

The iconographic peculiarities of this mask testify to its provenance from Teotihuacan, one of the largest centers of ancient Mexican civilization. Museums all over the world possess a large number of similar artifacts, but their function is uncertain as none of them has been found in situ. Some scholars believe that these masks were attached to the mummified remains of the deceased and suggest that the holes on the reverse side of the masks were used for this purpose. Stone carvings from Teotihuacan are usually rather expressive, but the Hermitage mask stands out for its artistic merits: the shining obsidian pupils impart animation to the face, while the flared nostrils of the thin, firmly delineated nose and the half-open mouth produce an impression that the mask is breathing. The narrow, rectangular ears are pierced for earrings, which were probably made of some other material. **MD**

The State Hermitage Museum (DM 233)

209. *Mask*
Mexican, 14th–15th century
Alabaster; 7 x 5⅞" (18 x 15 cm)

Provenance: Stroganoff collection, St. Petersburg

The function of this Aztec mask was probably the same as that of the mask in cat. no. 208, although the hollow eye-sockets, the pointed nose, and the deathly pale color of the stone suggest that the sculptor was striving to depict a dead man. The left eye is carved much more deeply than the right, so that the mask resembles a face with a blind eye. According to R.V. Kinzhalov,[1] it was in this way that Mexican carvers rendered the appearance of a man who had journeyed to the world of the dead and returned. **MD**

1. R.V. Kinzhalov, "Drevnemeksikanskaya alebastrovaya maska [The Ancient Mexican Alabaster Mask]," *Sbornik Muzeya antropologii I etnografii* (Papers of the Museum of Anthropology and Ethnography) 22 (1964), pp. 250–53.

The State Hermitage Museum (DM 234)

210. *Figure of a Seated Goddess*
Mexican, 14th–15th century
Gray stone; h. 10⅜" (26.6 cm)

Provenance: Stroganoff collection, St. Petersburg

The water goddess Chalchiutlicue is depicted here sitting cross-legged, a pose characteristic of carved images produced by the Aztecs, who were the rulers of much of Mexico at the time of the Spanish Conquest. The figure's attire consists of her usual headdress, embellished with two heavy tassels on either side, and a wrap resembling a poncho, which would originally have been painted red. **MD**

The State Hermitage Museum (DM 240)

CHINESE DECORATIVE ARTS

211. *Vase*
Chinese (Ming dynasty, 1368–1644), end of 15th century–beginning of 16th
Bronze, cloisonné enamel, champlevé enamel, gilding; h. 11⅜" (29 cm)
Ching-tai four-character reign mark (1450–56) on the bottom

Provenance: Acquired in 1928 from the Stroganoff collection, St. Petersburg

This unpublished vase with a globular body and tall, cylindrical neck originally had two small cylindrical handles at the mouth and was intended for use in a popular Chinese game in which arrows were thrown into the neck of the vase. At some point, probably at the end of the sixteenth or the beginning of the seventeenth century, broken parts of the vase were repaired; the handles were replaced with stylized phoenixes of bronze and champlevé enamels; the neck was cut short at the bottom and replaced with the new gilded bronze mounts. The new gilded bronze bottom and the newly inserted mouth was made to protect the enamels from breaking.

Still, this is a beautiful and rare example of early Chinese cloisonné. The enamel is vitreous and semitranslucent, with the bright, clear colors traditionally used during the fifteenth cen-

tury: the turquoise color of the background contrasts to the red, white, green, yellow, and black or dark brown enamels of the flowers, leaves, and tendrils. In some cloisonné examples two colors of the enamels are mixed—red with green and green with dark brown—to give the impression of semiprecious stones, such as jasper and heliotrope. The body of the vase is decorated with six large lotus flowers, the foot with chrysanthemums. The neck has branches of white camellia on one side and branches of red camellia on the other. The combination of camellia flowers with other flowers or subjects was used only at this period; later, enamels became duller, darker in color, and mixed.

The best cloisonné in China is called "Ching-t'ai lan" (Ching-tai blue). The Ching-t'ai reign mark was added to the vase at the time it was repaired late in the Ming dynasty, although the vase was, in fact, produced after the Ching-t'ai reign. This mark was added to indicate the high quality of the piece, not to falsify its date or authenticity. A popular Chinese legend has it that enamel originated from the burned palace of the Ching-tai period, when different precious materials were melted down and beautiful, bright enamels were found. Because of that, some later enamelers, in an effort to deceive, placed Ching-tai marks on their objects.

This early piece ranks first in the Stroganoffs' collection of enamels. It stood on the side table near the Baroque Gallery with another vase of the Ming period. Even now it is a monument to the wonderful taste and good eye of the collector. It is exhibited in the permanent display of the Chinese decorative arts. Smaller vases of similar shape and decoration are in the collection of Dr. Uldry in Switzerland, where they are dated to the end of the fifteenth century. **MM**

The State Hermitage Museum (LM 597)

212. *Altar Set*
Chinese (Imperial Workshops, Beijing), second half 18th century
Bronze with cloisonné enamel and gilding; incense burner with lid: h. 15⅜" (40 cm); pair of vases: h. 15⅞" (41 cm), base: 6¼ x 6¼" (16 x 16 cm); pair of pricket candlesticks: h. 19½" (50 cm), base: 6¼ x 6¼" (16 x 16 cm)

Provenance: Stroganoff collection, St. Petersburg, before 1884

Sets used for the decoration of altars in Buddhist temples traditionally included either three or five pieces. This set of five pieces (*wugong*) comprises a pair of vases and a pair of candlesticks flanking an incense burner. In form, these pieces recall ancient bronze vessels used in the rites of sacrifice, although they have been highly stylized. The incense burner is of a *fangding* type, set on four legs emerging from lions' heads, with two handles and a perforated lid with a knob shaped like a lion playing with a brocade ball. Both the

candlesticks and the flower vases are of a quadrangular *fangzun* type. Altar sets intended for Buddhist temples of both the capital and the imperial court were produced in vast amounts during the Qianlong period (1736–95) of the Qing dynasty, because the emperor was an adherent of Buddhism.

In this previously unpublished altar set the main motif in the enamel decoration is the archaistic *taotie* monster mask, which is also predominant in the ornamentation of ancient sacrificial objects; the lotus blooms symbolize the purity of the Buddhist faith. The color range of the enameling includes several bright colors, including pink, as well as the usual turquoise and cobalt blue.

Complete eighteenth-century altar sets are very rare. The largest (about 1.5 m high) and most significant set known was donated to the main temple of the Lamaist monastery of Yonghe Gong in Beijing by the Qianlong emperor. This set must have entered the Stroganoff collection before 1884, when it was listed in an inventory with numerous other Chinese works of art. A similar set is in the collection of Dr. Uldry, Switzerland.[1] **MM**

1. H. Brinker, A. Lutz, *Chinese Cloisonné* (New York, 1989), fig. 267.

The State Hermitage Museum (LM 501–505)

213. *Pair of Hatstands*
Chinese (Qing dynasty), second half 18th century
Bronze, cloisonné enamels, gilding; h. 11⅜" (37 cm)

This pair of hatstands is decorated with cloisonné enamel, mainly of dark blue and turquoise colors with lotus, leaf, and bat designs. The stands are designed in the shape of a mule standing on a rectangular platform within a fence. The animal's form derives from the ancient *zun*, a Zhou dynasty (c. 1050–221 B.C.) vessel for wine. Across its back lies a cover decorated with depictions of mountains, and on the lid is a double-gourd vase with ribbons. A five-winged hat supporter is placed in the vase. The wings are decorated with a gilded geometric relief of archaistic dragon heads with turquoise cloisonné enamel. The support is topped by a bronze circle with a pierced flowering branch. The bronze wires and details are heavily gilded.

This previously unpublished pair of stands was made for the symmetrical display of ceremonial hats of a high-ranking official of the Chinese emperor's court during the time when they were not in use (possibly seasonally). While the figural stands were decorative household items in themselves, they enabled the owner to demonstrate his pride of office. Such stands could be made in wood, lacquer, gilded metals, or enamel, but these are exceptional for their cloisonné enameling and amusing animal form. **MM**

The State Hermitage Museum (LM 639, 640)

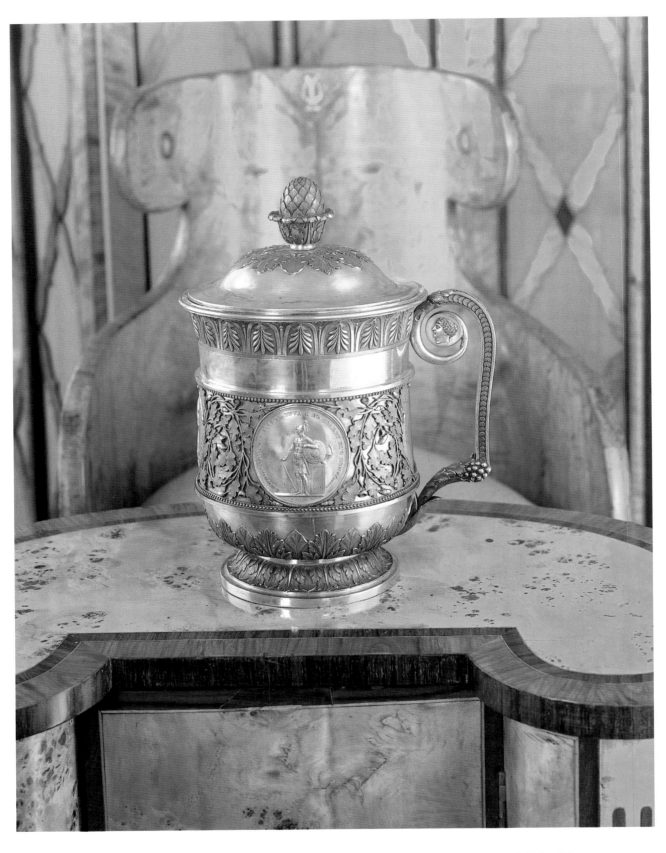

This silver tankard (cat. no. 56) was presented to Alexander Stroganoff on his seventy-fifth birthday. It features impressions of two medals struck with his portrait, one honoring him as marshal of the nobility of St. Petersburg, the other as president of the Academy of Fine Arts.

LIST OF ILLUSTRATIONS

Objects described in the catalogue of the exhibition are illustrated as indicated below:

BIBLIOGRAPHY

Akty pistsovogo dela 1644–1661 gg. (Documents of the Scribe's Occupation, 1644–1661). Moscow, 1977.

Antichnaia khudozhestvennaia bronza (Antique Decorative Bronzes). Exhibition catalogue, State Hermitage Museum. Leningrad, 1973.

Antichnaia koroplastika (Antique Terra-Cotta Figures). Exhibition catalogue, State Hermitage Museum. Leningrad, 1976.

Antonova, V. I., and N. E. Mneva. *Katalog drevnerusskoi zhivopisi. Opyt istoriko-khudozhestvennoi klassifikatsii. XVI–nachalo XVIII veka* (Catalogue of Ancient Russian Painting: An Experiment in Art-Historical Classification, 16th–early 18th century), vol. 2. Moscow, 1963.

Beazley, J. D. *Attic Red-Figure Vase-Painters.* Oxford, 1942.

Benois, A. N. "Stroganovskii dvorets i Stroganovskaia galereia" (The Stroganoff Palace and Stroganoff Gallery), *Khudozhestvennye sokrovishcha Rossii* (Art Treasures of Russia) 9 (1901), pp. 165–80.

Berniakovich, Z. A. *Russkoe khudozhestvennoe serebro XVII-nachala XX veka v sobranii Gosudarstvennogo Ermitazha* (Russian Decorative Silver from the 17th to the early 20th Century in the Collection of the State Hermitage), cat. no. 123. Leningrad, 1977.

Cain, H.-U. "Chronologie, Ikongraphie und Bedeutung der romischen Maskenreliefs," *Bonner Jahrbucher* 188 (1988), pp. 107–221.

Caspari, C., and O. Ghiandoni, *Lo Studio Cavaceppi e le collezioni Torlonia.* Rome, 1994.

Catalogue raisonné des tableaux qui composent la collection du Comte A. de Stroganoff. St. Petersburg, 1793, revised edition, 1800.

Chenevière, A. *Russian Furniture: The Golden Age, 1780–1840.* London, 1988.

Chereisky, L. A. *Pushkin i ego okruzhenie* (Pushkin and His Circle), pp. 420–22. Moscow, 1988.

Collection d'Estampes d'après quelques tableaux de la galerie du comte A. de Stroganoff. St. Petersburg, 1807; revised edition, 1835.

Die Welt der Etrusker: Archäeologische Denkmäler aus Museen der sozialistischen Länder. Berlin, 1988.

Dmitriev, A. A. *Permskaia starina* (Old Perm). Perm, 1980, no. 2, pp. 70–71; 1985, no. 4, pp. 175–84.

Dmitriev, Iu. N. *Putevoditel'. Gosudarstvennyi Russkii muzei. Drevnerusskoe iskusstvo* (Guide to the State Russian Museum: Ancient Russian Art). Leningrad / Moscow, 1940.

———. "'Stroganovskaia shkola' zhivopisi"(The Stroganoff School of Painting). In I. E. Grabar', ed., *Istoriia russkogo iskusstva* (History of Russian Art), vol. 3, pp. 643–76. Moscow, 1955.

Dolgorukoi, F. *Rodoslovnyi shornik (s gerbami)* (Genealogical Collection [with coats of arms]), no. 1. St. Petersburg, 1913.

Dolgorukov, P. V. *Rossiiskaia rodoslovnaia kniga* (Russian Genealogy Book), part 2, pp. 208–22. St. Petersburg, 1885.

Drevnie ikony staroobriadcheskogo kafedral'nogo sobora pri Rogozhskom kladbishche v Moskve (Ancient Icons of the Old Believer Cathedral at the Rogozhskoe Cemetery in Moscow). Moscow, 1956.

Dwyer, E. J. "Pompeiian Oscilla Collections," *RM,* vol. 88, no. 2 (1981), pp. 255–56, 285–88, pls. 128–30.

Eshkilov, V. A. *Sol'vychegodsk i pamiatniki byloi ego kul'tury* (Solvychegodsk and Monuments of Its Past Culture). Ustiug, 1926.

Evdokimov, I. *Sever v istorii russkogo iskusstva* (The North in the History of Russian Art). Vologda, 1921.

Forita de Piles. *Voyage de deux françaises dans le Nord de l'Europe, 1790–1792.* Paris, 1796.

Fotoal'bom. Dvorets Stroganovykh. Ital'ianskaia portretnaia fotografiia khudozhnika I. Bianki na Mikhailovskoi ploshchadi v dome Bodisko, kv. 15 (Photograph Album: Stroganoff Palace: Italian portrait photograph of the artist I. Bianchi on Mikhailovskaia Square in the Bodisko house, apt. 15). St. Petersburg, 1865.

Furtwängler, A. *Meisterwerke der griechischen Plastik: Kunstgeschichtliche untersuchungen.* Leipzig, 1895.

Gel'd, G. "Stroganovskii sarkofag" (The Stroganoff Sarcophagus). *Germes* (Hermes) 19 (1916), pp. 298–300.

Georgi, I. G. *Opisanie rossiisko-imperatorskogo stolichnogo goroda Sankt-Peterburga i dostoprimechatel'nostei v okrestnostiakh onogo* (Description of the Russian Imperial Capital City of St. Petersburg and Notable Attractions in Its Outlying Districts). St. Petersburg, 1896.

Gur'ianov, V. P. *Litsevye sviatsy XVII v. Nikol'skogo edinovercheskogo monastyria v Moskve* (Illuminated 17th-century Church Calendars from the St. Nikola Edinoverie Monastery in Moscow). Moscow, 1904.

Helbig, W. *Führer durch die offentlichen Sammlungen klassischer Altertumer in Rom.* Leipzig, 1891.

Howard, S. *Antiquity Restored: Essays on the Afterlife of the Antique.* Vienna, 1990.

Iskusstvo stroganovskikh masterov. Issledovaniia. Problemy (The Art of the Stroganoff Masters: Research, Problems). Exhibition catalogue, All-Russian Grabar Conservation Center, Moscow, 1991.

Iskusstvo stroganovskikh masterov v sobranii gosudarstvennogo Russkogo muzeia (Art of Stroganoff Masters in the Collection of the State Russian Museum). Exhibition catalogue, All-Russian Grabar Conservation Center, Moscow, 1987.

Karger, M. K. "Materialy dlia slovaria russkikh ikonopistsev" (Materials for a Dictionary of Russian Icon Painters). In *Materialy po istorii russkogo iskusstva* (Materials on the History of Russian Art), part 1, pp. 112–36. Leningrad, 1928.

Kazakevich, T. E. "Ikonostas tserkvi Il'i proroka v Iaroslavle i ego mastera" (The Iconostasis at the Church of the Prophet Elijah in Yaroslavl and Its Creators). In *Pamiatniki russkoi arkhitektury i monumental'nogo iskusstva* (Monuments of Russian Architecture and Monumental Art), pp. 13–64. Moscow, 1980.

Khodza, E. N. "Dekorativnyi terrakotovyi rel'ef" (Decorative Terra-Cotta Relief). *SGE* 39 (1974), pp. 36–39.

Kinzhalov, R. V. "Drevnemeksikanskaia alebastrovaia maska" (The Ancient Mexican Alabaster Mask), *Shornik muzeia antropologii i etnografii* (Collection of the Museum of Anthropology and Ethnography) 22 (1964), pp. 250–53.

Kiserizky, G. *Der Apollo Stroganoff: Mitteilungen des K. Deutschen Arch. Instituts.* Athens, 1899.

Knats, E. V. "K voprosu o tekhnike drevnerusskogo zolotnogo shit'ia v sviazi s predmetami shit'ia riznitsy Solovetskogo monastyria" (On the Question of Ancient Russian Gold Embroidery Technique in Connection with Embroidered Objects in the Vestry of Solovetsky Monastery). In *Izobrazitel'noe iskusstvo* (Fine Art). Leningrad, 1927.

Kondakov, N. P. *Russkaia ikona* (Russian Icon), 4 vols. Prague, 1929–33.

Kruglov, A. V. "Arkhaicheskie rel'efy v kollektsii Ermitazha" (Archaic Reliefs in the Hermitage Collection). *VDI.* 4 (1991).

Kul'tura i iskusstvo Etrurii (Culture and Art of Etruria). Exhibition catalogue, State Hermitage Museum. Leningrad, 1972.

Kurbatov, V. Ia. *Peterburg* (Petersburg). St. Petersburg, 1912.

Lexikon iconographicum Mithiologiae Classicae, vol. 2. Munich, 1981.

Likhachev, N. P. *Istoricheskoe znachenie italo-grecheskoi zhivopisi. Izobrazheniia Bogomateri v proizvedeniiakh italo-grecheskikh ikonopistsev i ikh vliianie na kompozitsii nekotorykh proslavlennykh russkikh ikon* (The Historical Significance of Italo-Grecian Painting: Depictions of the Virgin Mary in Works of Italo-Grecian Icon Painters and Their Influence on the Compositions of Several Illustrious Russian Icons). St. Petersburg, 1911.

———. *Materialy dlia istorii russkogo ikonopisaniia. Atlas snimkov* (Material for a History of Russian Icon Painting: Atlas of Photographs), parts 1, 2. St. Petersburg, 1906.

Likhacheva, L. D. *Drevnerusskoe shit'e XV–nachala XVIII veka v sobranii gosudarstvennogo russkogo muzeia* (Ancient Russian Embroidery from the 15th through the Early 18th Century in the Collection of the State Russian Museum). Exhibition catalogue, State Russian Museum. Leningrad, 1980.

Lobanov-Rostotskii, A. B. *Russkaia rodoslovnaia kniga* (Book of Russian Genealogy), vols. 1, 2. St. Petersburg, 1895.

Maiuri, A. *Ercolano.* Rome, 1936.

Makarenko, N. *Iskusstvo drevnei Rusi u Soli Vychegodskoi* (Art of Ancient Rus' at Solvychegodsk). Prague, 1918.

Malkov, Iu. G. "Zhivopis" (Painting). In *Ocherki russkoi kul'tury XVII veka. Dukhovnaia kul'tura* (Essays on 17th-century Russian Culture: Religious Culture), part 2, pp. 208–38. Moscow, 1979.

Mneva, N. E. *Iskusstvo moskovskoi Rusi. Vtoraia polovina XV–XVII vv.* (Art of Muscovite Rus': The Second Half of the 15th through the 17th Century). Moscow, 1965.

Muratov, P. "Stroganovskaia shkola. Epokha Mikhaila Fedorovicha" (The Stroganoff School: The Era of Mikhail Fedorovich). In I. Grabar', ed., *Istoriia russkogo iskusstva* (History of Russian Art) 6, pp. 347–408. Moscow [1913].

Mustilli, D. *Il Museo Mussolini.* Rome, 1939.

Nekrasov, A. I. *Drevnerusskoe izobrazitel'noe iskusstvo* (Ancient Russian Fine Art). Moscow, 1937.

Nemilova, I. S. *Frantsuzskaia zhivopis' XVIII veka. Gosudarstvennyi Ermitazh. Sobranie zapadnoevropeiskoi zhivopisi* (French 18th-century Painting: State Hermitage Museum, Western European Paintings Collection). Moscow, 1985.

Neverov, O. Ia. "Kollektsiia Laid Brauna (k istorii skul'pturnogo sobraniia Ermitazha)" (The Laid Braun Collection [Toward a History of the Hermitage Sculpture Collection]). *TGE* 24, p. 5.

———. "Terrakotovaia golova—kryshka italiiskoi urny" (Terra-Cotta Head Is the Lid of an Italian Urn), *SGE* 27 (1966), p. 39.

"O gerbe baronov Stroganovykh" (On the Stroganoff Barons' Coat of Arms), *Gerboved* (Coat-of-Arms Scholar) (March 1913), pp. 53–56.

Otchet Imperatorskoi Arkheologicheskoi komissii (Report of the Imperial Archaeological Commission), p. 204. St. Petersburg, 1874.

Otchet Imperatorskoi Arkheologicheskoi komissii (Report of the Imperial Archaeological Commission), table 7, no. 3, p. 200. St. Petersburg, 1875.

Otchet Imperatorskoi Arkheologicheskoi komissii (Report of the Imperial Archaeological Commission), table 6, no. 3, p. 161. St. Petersburg, 1878–79.

Otchet Russkogo muzeia Imperatora Aleksandra III za 1912 god (Report of the Emperor Alexander III Russian Museum for 1912). St. Petersburg, 1914.

Pamiatniki russkoi kul'turoi pervoi chetverti XVIII veka v sobranii Gosudarstvennogo Ermitazha (Monuments of Russian Culture from the First Quarter of the 18th Century in the Collection of the State Hermitage Museum). Leningrad / Moscow, 1966.

Parfent'ev, N. P., and N. V. Parfent'eva. *Ural'skaia (stroganovskaia) shkola v russkoi muzyke XVI–XXVII vekov* (The Ural [Stroganoff] School in Russian Music of the 16th and 17th Centuries). Cheliabinsk, 1993.

Peredol'skaia, A. A. *Krasnofigurnye atticheskie vazy v Ermitazhe* (Red-Figure Attic Vases in the Hermitage). Leningrad, 1967.

Petrov, P. N. *Istoriia russkogo dvorianstva* (History of the Russian Nobility), vol. 1, pp. 307–8. St. Petersburg, 1886.

Pleshanova, I. I., and L. D. Likhacheva. *Drevnerusskoe dekorativno-prikladnoe iskusstvo v sobranii Gosudarstvennogo Russkogo muzeia* (Ancient Russian Decorative Applied Art in the Collection of the State Russian Museum). Leningrad, 1985.

Prikhodo-raskhodnye knigi moskovskikh prikazov 1619–1621 (Account Books of Muscovite Departments, 1619–1621). Moscow, 1983.

Pyliaev, M. *Zabytoe proshloe okrestnotei Peterburga* (The Forgotten Past of Petersburg's Outlying Districts). St. Petersburg, 1889.

Reimers, H. C. von. *St. Petersburg, am Ende seines ersten Jahrhunderts,* vol. 2. St. Petersburg, 1805.

Rod Stroganovykh. Prakticheskoe posobie dlia istorikov, kraevedov genealogov (The Stroganoff Family: A Practical Aid for Historians, Local Historians, and Genealogists), compiled by A. N. Onuchin. Perm, 1990.

Rummel', V. V., and V. V. Golubtsov. *Rodoslovnyi sbornik russkikh dovrianskikh familii* (Genealogical Collection of Russian Noble Surnames), vols. 1, 2. St. Petersburg, 1886–87.

Savvateev, P. *Stroganovskie vklady v sol'vychegodskii Blagoveshchenskii sobor po nadpisiam na nikh* (Stroganoff Contributions to the Solvychegodsk Annunciation Cathedral according to their Inscriptions). St. Petersburg, 1886.

Sidorova, N. A., O. V. Tugusheva, and V. S. Zabelina. *Antichnaia raspisnaia keramika iz sobraniia Gosudarstvennogo muzeia izobrazitel'nykh iskusstv im. A. S. Pushkina* (Antique Painted Ceramics from the Collection of the Pushkin Museum of Fine Arts). Moscow, 1985.

Sokolova, T. M. *Ocherki po istorii khudozhestvennoi mebeli XV–XXIX vv.* (Essays on the History of Decorative Furniture from the 15th through 19th Centuries), p. 126. Leningrad, 1967.

Sokolova, T. M., and K. A. Orlova. *Russkaia mebel' v Gosudarstvennom Ermitazhe* (Russian Furniture in the State Hermitage Museum), nos. 35, 36. Leningrad, 1973.

Soskin, A. I. *Istoriia goroda Soli Vychegodskoi* (History of Solvychegodsk). Syktyvkar, 1997.

Sotheby's (London) Catalogue. April 1989.

State Hermitage Museum, Department of Western European Art. *Katalog zhivopisi* (Catalogue of Paintings), vol. 1, p. 214. Leningrad, 1976.

Stephani, L. *Apollon Boedromoion: Bronze-Statue im Besitz seiner Erlaucht des Grafen Sergei Stroganoff.* St. Petersburg, 1860.

Stewart-Jones, H. *A Catalog of the Ancient Sculpture Presented in the Municipal Collections of Rome: The Sculptures of Museo Capitolino.* Oxford, 1912.

Stroganovy i permskii krai: materialy nauchnoi konferentsii 4–6 fevralia 1992 g. (The Stroganoffs and the Perm District: Materials from a Scientific Conference held February 4–6, 1992). Perm, 1992.

Taktashova, L. E. "'Stroganovskaia shkola' ikonopisi" ("Stroganoff School" of Icon Painting). *Iskusstvo* (Art) 4 (1981), pp. 64–69.

Teletova, N. K. *Zabytye rodstvennye sviazi A. S. Pushkina* (Forgotten Familial Ties of A. S. Pushkin), p. 164. Leningrad, 1981.

Trei, G. *Ukazatel' skul'pturnogo muzeia imperatorskoi Akademii khudozhestv. Skul'ptura drevnikh narodov* (Guide to the Sculpture Museum of the Imperial Academy of Fine Arts: The Sculpture of Ancient Peoples). St. Petersburg, 1871.

Trubetskaia, E. E. *Skazaniia o rode kniazei Trubetskikh* (Tales of the Family of the Trubetskoi Princes), pp. 149, 151. Moscow, 1891.

Tselishcheva, L. N. *Stepan Semenovich Shchukin, 1762–1828,* p. 99. Moscow, 1979.

Vilinbakhova, T., and N. Pivovarova. *Ikony iz kollektsii Sergeia Grigor'evicha Stroganova* (Icons from the Collection of Sergei Grigorievich Stroganoff). St. Petersburg, 1996.

Vlas'ev, G. A. *Potomstvo Riurika. Materialy dlia sostavleniia rodoslovii* (Riurik's Descendants: Materials for Compiling Genealogies), vol. 1, part 3. St. Petersburg, 1907.

Vvedenskii, A. A. *Dom Stroganovykh v XVI–XVII vekakh* (The Stroganoff House in the 16th and 17th Centuries). Moscow, 1962.

———. "Ikonnye gornitsy u Stroganovykh v XVI–XVII vv." (Stroganoff Icon Chambers in the 16th and 17th Centuries). In *Materialy po istorii russkogo iskusstva* (Materials on the History of Russian Art), vol. 1, pp. 55–56. Leningrad, 1928.

Waldhauer, O. F. *Die Antiken Skulpturen der Ermitage,* vol. 3. Berlin, 1936.

Zapiski Iakoba Shtelina ob iziashchnykh iskusstvakh v Rossii (Notes of Iakob Shtelin on the Fine Arts in Russia), vol. 1, p. 387. Moscow, 1990.

INDEX

Italic page numbers refer to illustrations. **Boldface** numbers refer to principal discussions.
"Cat. no." indicates a catalogue number in the section starting on page 200.

Fontainebleau Palace, 112
Fortia de, Piles, 89
Fragonard, Jean-Honoré, 79, 86, 224
Francis I, Emperor, 221
Franklin, Benjamin, 33, 148
Frederick William III, 178
Fredi, Bartolo di, *The Ascension,* 87
Freemasonry, 34, 147–48
Freer Gallery of Art, 101
French, mid-14th c., diptych, *Annunciation, the Nativity, the Adoration of the Magi, and the Crucifixion,* 106, **238**; cat. no. 203
French (Limoges)
 1190–1210, reliquary chasse, *Christ in Glory, Saints, and the Crucifixion,* 104, 105, **237**; cat. no. 198
 late 12th c., reliquary chasse, *Christ, Angels, and Saints,* 104, 105, **236**, 237; cat. no. 197
 1200–1210, reliquary plaque, *Crucifixion and Two Saints,* 104, **237**, 237; cat. no. 200
French (Northern?), first third 14th c., triptych, *Virgin and Child and Angels,* 107, **237–38**; cat. no. 202
French (Paris)
 1780s, perfume burner(s), pair, **231**, *231;* cat. no. 167
 1810s, clock, mantel, *The Fall of Phaeton,* 40, **231**; cat. no. 168
 1820s, candelabra, pair, with a figure of Victory holding a cornucopia, *40,* **231**; cat. no. 169
French Academy in Rome, 224
French painting, 78, 79, 222–26
Füger, 79
furniture, Russian, 213–14
Furtwängler, Adolf, 97

Gambs, Heinrich, 104, 178
Garofalo, Benvenuto da, 79
Gatchina, 177
gem carving, 206, 229–30
Georghi, Johann, 91
German (Cologne), late 12th–early 13th c., plaques, arched, five, with inscriptions and ornaments, *237,* 237; cat. no. 199
German (Southern), first half 12th c., plaques, three, *Christ between Saints Peter and Paul and Two Apostles,* 106, **236**; cat. no. 196
German painting, 79, 226
Gevers, Johann Valentin, cabinet with a clock, *28,* *29,* **231**; cat. no. 171
Giampetrino (Giovanni Pietro Rizzoli)
 Virgin and Child, 130, **227**; cat. no. 150
 The Virgin and Child, 219
Giordano, Luca, 79, 228
 Allegorical Composition, 215

The Battle of Lapiths and Centaurs, 136–37, 227–28; cat. no. 154
 An Old Man, 219
Golitsyn, Prince Vasily, 38
Golitsyn, Duke Vladimir Borisovich, 225
Golitsyn family collection, 88
Gonzaga, Pietro, 217
Gospel cover, corner piece of a, Russian, late 17th c., 66, *67,* **210**; cat. no. 61
"Gothic Cabinet" (from Stroganoffs' Maryino estate), 104
Gothic Revival style, 104
Goyen, Jan van, 79
Great Northern War, 23, 229
Greuze, Jean-Baptiste, 33, 34, 78, 79, 145, 224
 Portrait of Count Paul Stroganoff as a Child, 145, *145,* **224**; cat. no. 135
Grimm, Melchior, 149
Gualtieri, Filippo Antonio, 228
Guidi, Domenico, *Glory Recording the Deeds of the King Louis XIV in the Book of History Supported by Time,* 228

Halt, A (Adriaen van de Velde), *121,* 215, **222**; cat. no. 128
Hamilton, Gavin, 89, 232
Haring, Cornelia, 222; cat. no. 126
Hatstands, pair, Chinese, Qing dynasty (second half 18th c.), *113,* **239**; cat. no. 213
Head, votive female, terra cotta, Etruscan, first half 5th c. B.C., 92–96, *92,* **233**; cat. no. 179
Head of a goddess, Italian, 18th c. copy of a Roman copy of a Greek original, 89, *89,* **232**; cat. no. 174
Head of a woman, Italian, 18th c. (?) copy of a Roman copy of a Greek original, 88, *89,* 232, **232–33**; cat. no. 175
Hebe, Mercury, and Cupid, cameo (Giovanni Pichler), 229–30, *229;* cat. no. 160
Heine, Karl, cup, covered, 38, *43,* **209–10**; cat. no. 57
Helbig, H., 92–96
Helmet (shishák), Russian (Moscow?), second half 16th c., *25,* **208–9**; cat. no. 50
Helst, Bartholomeus van der, *Portrait of a Woman,* *118,* **221–22**; cat. no. 125
Herakles Hurls Lichas into the Sea, intaglio (Alexei Akimovich Yesakov), *158,* 207; cat. no. 42
Hercules (Etruscan, 4th c. B.C.), *94,* **235**; cat. no. 190
Hercules (Italian [Oscan Campania], mid 4th c., B.C.), *95,* **235**; cat. no. 189
Hermitage, 87, 91, 97, 101, 105, 150, 229
 Stroganoff donations to, 86, 87
Histoire critique de la piramide de Cajus Cestius, book (J. J. Rive), *86,* *139,* **220**; cat. no. 110

Hoff, Ivan, 158
Holy Family, The (Cesare Dandini), *132,* **227**; cat. no. 153
Holy Family, The (Bartolomeo Schidone), *134,* **227**; cat. no. 151
Honthorst, Gerrit von, 79
Hooch, Pieter de, 222
Houdon, Jean-Antoine, 33, 78, 206
Hydria, black-lacquer, Italian (Campania), late 4th c. B.C., *96–97,* **234**; cat. no. 183
Hydria-kalpis, black-figure, Attic, c. 500 B.C., *96–97,* **233**; cat. no. 180

Icon
 An Angel Protecting a Sleeping Man's Soul and Body (Nikifor Istomin Savin), 61, *61,* **202**; cat. no. 16
 The Annunciation with Scenes from the Life of the Virgin (Russian, 1580s–90s), 53, 55, 56, **200**; cat. no. 3
 The Baptism (Mikhail), *56,* 58–61, **202**; cat. no. 11
 The Descent into Limbo (Mikhail), *57,* 58–61, **202**; cat. no. 14
 The Descent of the Holy Spirit (Russian, second half 17th c.), **202–3**, *203;* cat. no. 20
 The Entry into Jerusalem (Mikhail), *57,* 58–61, **202**; cat. no. 13
 Massacre of the Holy Fathers at Mount Sinai and in the Rhaithou Desert (Pervusha), *60,* 61–62, **202**; cat. no. 19
 The Old Testament Trinity (Nikita Ivanov Pavlovets), *62,* 65, **203**; cat. no. 21
 The Raising of Lazarus (Mikhail), *56,* 58–61, **202**; cat. no. 12
 Saint Basil the Blessed (Russian, late 16th c.), 48, *49,* **201**; cat. no. 7
 Saint Dmitry the Tsarevich (Nazary Istomin Savin), 48, *49,* 50, 54, 56, **201**; cat. no. 9
 Saint George Slaying the Dragon (Nikifor Istomin Savin), *59,* 61, **202**; cat. no. 17
 Saint Nicholas of Myra with Twenty Scenes from His Life (Russian, late 16th c.–early 17th c.; local tier of iconostasis, Annunciation Cathedral, Solvychegodsk), 55, **200–201**, *201;* cat. no. 5
 Saint Nikita (Russian, early 17th c.), 55, *55,* **201**; cat. no. 8
 The Story of the Prophet Jonah (Russian [Stroganoff School], first half 17th c.), *63,* 64–65, **202**; cat. no. 18
 The Three Young Men in the Fiery Furnace (Yemelyan Moskvitin), **202**, *202;* cat. no. 15
 The Trinity with Scenes from the Old Testament (Russian, 1580s–90s), *52,* 55, 56, **200**; cat. no. 2